FRENCH PAINTINGS

in the MUSEUM *of* FINE ARTS, BOSTON

VOLUME I

Artists born before 1790

FRENCH PAINTINGS

in the MUSEUM of FINE ARTS, BOSTON

VOLUME I
Artists born before 1790

ERIC M. ZAFRAN

with the assistance of
Katherine Rothkopf and
Sydney Resendez

Copyright © 1998 by Museum of Fine Arts, Boston, Massachusetts

All Rights Reserved

Library of Congress Catalog Card No. 98-066061

ISBN 0-87846-461-1

Composition in Janson Text by Dix, Syracuse, New York

Designed by Peter M. Blaiwas, Vernon Press, Inc., Boston, Massachusetts

Edited by Troy Moss, Sydney Resendez, and Brian Hotchkiss

Photographs by Photographic Services Department, Museum of Fine Arts, Boston

Printed by Arnoldo Mondadori A. M. E. Publishing Ltd., Verona, Italy

This publication was supported by grants from The Florence Gould Foundation and the National Endowment for the Arts. Additional support was provided by The Christian Humann Foundation.

Jacket illustrations:

Front: François Boucher, *Halt at the Spring*, 1765 (detail)

Gift of the Heirs of Peter Parker 71.2

Back: Claude Lorrain, *Apollo and the Muses on Mount Helicon*, 1680

Picture Fund 12.1050

Printed in Italy

CONTENTS

ACKNOWLEDGMENTS

This catalogue was several years in the making. It was begun in 1989, when I joined the Museum of Fine Arts, and completed by the time I departed, in March 1995. Subsequent publication and exhibition references continued to be added. From the first, the project was encouraged by Peter C. Sutton, who was the Mrs. Russell W. Baker Curator of European Paintings until March 1994. George T. M. Shackelford, his successor since 1996, has overseen the final publication. However, both the collection documented here and the research on it represent over a century of devotion by earlier museum directors, curators, and departmental assistants. One has to acknowledge the contributions to our knowledge by such distinguished Museum predecessors as George Harold Edgell, W. G. Constable, Charles Cunningham, Jean Guiffrey, Thomas Maytham, Perry T. Rathbone, Laura Giese, Richard McLanthan, Charles Hawse, Angela Rudenstine, Scott Schaefer, Alexandra R. Murphy, Eunice Williams, John Walsh, and Philip Conisbee. Staff of other curatorial departments within the Museum from whom I received helpful information were Anne Poulet, Jeff Munger, Cornelius Vermeule, John Hermann, and Sue Reed.

Naturally many outside experts also provided insights and opinions. Of particular help have been Colin Bailey, Joseph Baillio, Martin Eidelberg, Marc Gerstein, Alastair Laing, Sylvain Laveissière, Marianne Roland Michel, Edgar Munhall, Pierre Rosenberg, and Alan Wintermute.

During the period in which the catalogue was written, I had a succession of very talented intern/assistants—Bruce Edelstein, Clarina Notz, Seanna O'Connor, Leslie Reed, Antoinette Roesle, and Allison Schwartz. Entering the text into the computer has been carried out with great skill by two extremely able assistants—first Barret Tilney, and then Regina Rudser. Marie-Laure de Rochebrune and Ethan Lasser helped to check dates and facts, and in the final stages corrections to the manuscript were made by Deanna M. Griffin and Erika M. Swanson. The whole publication has been overseen with tremendous diligence by Sydney Resendez, to whom I am most indebted. Katherine Rothkopf, who worked at the Museum from 1991 to 1993, not only researched but also drafted a number of the entries on the nineteenth-century works before her departure to the Phillips Collection.

As always, a great variety of individuals and departments at the Museum have collaborated to produce the final results on this project effectively. The Museum's Department of Paintings Conservation has been essential for its successful completion, providing the most advanced scientific investigation, making significant discoveries, and always offering wise counsel. The condition notes for the paintings were drafted by Jim Wright, Rita Albertson, Irene Konefal, Rhona Macbeth, Patricia O'Regan, Brigitte Smith, Lydia Vagts, and Jean Woodward, and those on the pastels by Roy Perkinson. All the paintings were photographed by the Museum's staff: Gary Ruuska and Tom Lang under the supervision of Janice Sorkow. This process was facilitated and easy access to the works as well as several insights into the compositions were provided by Andy Haines, the Paintings Department's Exhibition Preparator.

In the Library of the Museum of Fine Arts, Joanne Donovan helped track down obscure publications, and the archivist, Maureen Melton, made her splendid resources readily available, which proved especially helpful in the writing of the introduction. Other research facilities consulted included the Frick Art Reference Library, the Witt Library, the Documentation du Département des Peintures du Louvre, the Boston Athenaeum (with special help from its curator, Michael Wentworth), the Boston Public Library, and the Harvard University Libraries.

Thanks to a three-month J. Paul Getty Museum visiting fellowship, I had the luxury of working on the project in the idyllic environment of the J. Paul Getty Center at Santa Monica, whose libraries and archives—including the Provenance Index under the direction of Burton Frederickson—contributed greatly.

The production of the catalogue was carried out by Cynthia Purvis, and I was most pleased that the splendidly sensitive editing and indexing could be undertaken by Troy Moss, with additional editing done by Fronia W. Simpson.

To publish any museum catalogue nowadays requires the assistance of various funding organizations, and to deal with the process of applications Marjorie Saul and Cathy Emmons of the Museum's Development Department were most helpful. Our combined efforts resulted in a very generous grant for publication from the National Endowment for the Arts, which followed one received earlier for the research phase. To these were added welcome grants from the Florence Gould Foundation and the Christian Humann Foundation, for which I am personally grateful to the respective directors, John R. Young and Claus Virch.

—ERIC M. ZAFRAN

Organization of the Catalogue

This catalogue is arranged in chronological order, according to the birthdate of the artist, and the presumed date of the work. In the measurements, height precedes width.

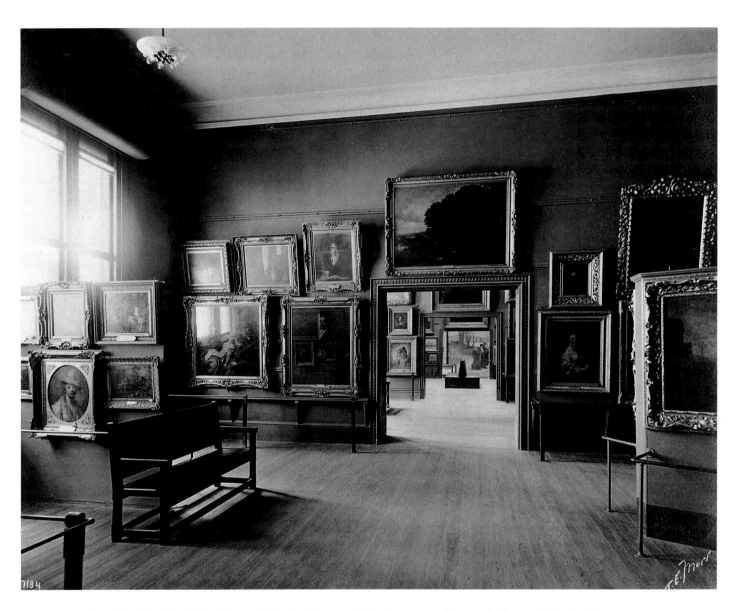

Fig. 1. Gallery of French and English paintings, Museum of Fine Arts, Boston, at Copley Square, 1902. Photograph, Museum of Fine Arts, Boston

INTRODUCTION

Of the various national schools within the European painting collection at the Museum of Fine Arts, Boston, the French school is by far the largest. This is owing to Bostonians' love and assiduous collecting of first Millet and the Barbizon school and then Monet and the Impressionists. The history of those aspects of the collection has been dealt with in detail in previous publications.[1] The present catalogue is devoted to French artists born before 1790, and thus this introduction will survey the less well-known history of the collecting of earlier French paintings.

Throughout most of the nineteenth century, the primary location in the city to view French works was the Boston Athenaeum Gallery. From 1827 to 1873, the annual exhibitions there included paintings attributed to such noted artists as Boucher, Bourdon, Philippe de Champaigne, Claude, Antoine Coypel, David, Fabre, Greuze, Grimou, Hué, Lancret, Charles Le Brun, Robert Lefèvre, Le Nain, Mignard, Natoire, Poussin, Scheffer, Claude Vernet, and Watteau.[2] Of these, only a handful can now be traced, but fortunately a few entered either the Athenaeum's or the Museum's collections and are still in Boston.

One of the earliest and finest French works to appear was the painting by Jean-Baptiste Greuze, which we call *The White Hat* (cat. 54). By 1827 it was already in the collection of Thomas Dowse, who showed it that year in the Athenaeum's first exhibition, under the title *Le Neglige* [*sic*].[3] Born in 1772, in Charlestown, Dowse became what was described as "a leather dresser and wool merchant," and his success was such that he could settle in Cambridgeport, build a substantial house, and form a notable collection of books, watercolors, and paintings. At his death in November 1856, Dowse's executors decided to present fifty-two watercolors after old master paintings and several original paintings to the Athenaeum, where they were all exhibited the following year.[4] The source of the paintings is unknown. The Greuze, under the title either *Head of a Girl* or *Femme au chapeau blanc*, was greatly admired. It was transferred for exhibition along with the other Athenaeum works to the new Museum of Fine Arts in 1876 and can be seen easily at the left in the photograph from 1902 of the gallery of French paintings at the Museum's Copley Square building (fig. 1).[5] Boston's preeminent art critic of the late nineteenth century, Willam Howe Downes, wrote in 1888:

> The painting of a young woman's head by J. B. Greuze, which, under the fanciful title of the Chapeau Blanc, has been for many years the object of much admiration, and of which many copies have been made, has a certain delicate and old-fashioned beauty of its own, but, like the rest of Greuze's

works, is rather thin in sentiment. Cool and pearly-gray tones run all through it. The flesh, the dress, the powdered hair, the hat, and the background, are all gray. On the face is a little mole which has been considered by countless school-girls vastly to enhance the beauty of the unknown model. She appears well satisfied with her own personal appearance, and if a little affectation enters into her pose, there is almost none in her expression, and it may easily be pardoned. This is a first-rate example of Greuze, as good as anything by him in the Louvre.[6]

According to the Museum's French-born curator Jean Guiffrey, writing in the early twentieth century, the painting had by then "attained a popularity in Boston almost equal to the same artist's *Cruche cassée* or *La Laitière* in Paris."[7] Unlike most of the other Athenaeum paintings, it was not returned for sale but acquired by the Museum in 1975. Walter Muir Whitehill aptly described the work as "this engaging young person, the sweet disorder of whose

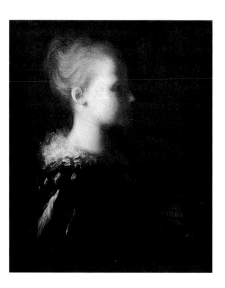

Fig. 2. Jean-Alexis Grimou, *Head of a Girl.* Formerly collection of the Boston Athenaeum. Photograph, Museum of Fine Arts, Boston

dress seems better suited to eighteenth-century Versailles than nineteenth-century Cambridgeport."[8]

One other notable eighteenth-century French painting belonging to Dowse and given to the Athenaeum in 1858 was *Head of a Girl* by Jean-Alexis Grimou (fig. 2), which was also exhibited at the Museum of Fine Arts in 1876 and, according to the records of the Athenaeum, deposited there in 1895. It won praise in 1910 from the writer Julia de Wolf Addison, who wrote that "the soft enameled head probably by Grimou is an exquisite piece of eighteenth century work; the light delicate profile on the dark background is most attractive."[9] Sadly, in 1980 it was reclaimed by the Athenaeum and sold.[10]

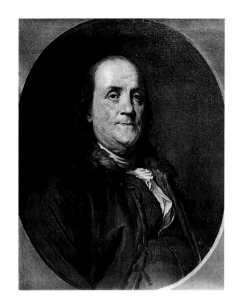

Fig. 3. School of Duplessis, *Portrait of Benjamin Franklin.* Formerly collection of the Boston Athenaeum. Photograph, Museum of Fine Arts, Boston

Another work also believed to be by Greuze that came early to Boston and the Athenaeum was a portrait of Benjamin Franklin (fig. 3), purchased in Paris by Thomas Jefferson in 1786. It hung in the parlor at the former president's home, Monticello.[11] After Jefferson's death, it, with thirty-seven other works, was sent in 1828 for exhibition and sale to the Athenaeum by Jefferson's grandson-in-law, Joseph Coolidge, Jr. It was the only work to be sold and was acquired for two hundred dollars by the Athenaeum.[12] In 1883 the painting was more correctly identified as by Joseph-Siffred Duplessis, and the Museum's *Handbook* (1906 ed.) claimed that "this version of Duplessis's portrait of Franklin . . . is considered the best."[13] In 1910 Addison observed: "The portrait of Benjamin Franklin by J. S. Duplessis is a good straightforward painting without imagination. It was executed during Franklin's stay in Paris between 1776 and 1783, and was one of several replicas. It was the property of President Jefferson, from whom, through Mr. Joseph Coolidge, it came to the Boston Athenaeum. In 1780 Franklin wrote from France: 'I have at the request of friends sat so much and so often to painters and statuaries, that I am perfectly sick of it.' "[14]

This painting, too, was withdrawn from the Museum and sold by the Athenaeum, but fortunately it found an appropriate home; it was returned to Monticello.[15]

In October 1834, in exchange for three paintings and a fee of two hundred dollars, the Boston dealer William I. Davis was granted the rental of a room in the Athenaeum for a week. The donated works were a supposed *Market Scene* by Velázquez, a Sébastien Bourdon *Landscape,* and, most significantly, Jean-François Hué's *Shipwreck* (fig. 4).[16] The last was transferred to the Museum of Fine Arts in 1876 but withdrawn and sold at public auction in 1979.[17] Even more notable were several of the other paintings exhibited by Davis. Included among them was a set of four large Panninis, *The Monuments of Ancient and Modern Rome,* commissioned by the duc de Choiseul and later in the collection of the marquis de Gouvello, which the Athenaeum purchased. Two were traded away and one was sold to the Museum.[18]

Also among Davis's pictures was a noteworthy painting by François Boucher, *The Apotheosis of Aeneas* (fig. 5). It was purchased by Jonas Chickering, who lent it to the Athenaeum's exhibition in 1835 as *Venus Presenting Mars to the Gods.* It was exhibited again, this time for sale, at the 1843 exhibition. However, it remained with the descendants of the Chickering family in Boston into the 1970s. This Boucher, signed and dated 1747, had in fact been painted for Louis XV's apartments at the château of Marly. After its proper identification, the painting was acquired by the Marcos family of the Philippines, only to be sold in 1991, after their downfall, on behalf of the Republic.[19] It was then fittingly reacquired by the museum at Marly. This work, as Michael Wentworth has speculated, was probably "the first documented Boucher in an American collection."[20]

A surprising taste for this quintessential rococo artist—and on a grandiose scale—was manifested in Boston in the 1840s. Edward Preable Deacon, who in 1841 had married Sarahann Parker, daughter of Peter Parker, a wealthy Boston merchant, traveled to Paris twice in the late 1840s to seek out appropriate works for the lavish French-style house built by his father-in-law for the young couple on Washington Street in the South End (fig. 6). On one of these trips Deacon must have obtained the two enormous Boucher pastorals (cat. 42, 43) that had been sold in Paris in 1846. For what became known as the Deacon House he also acquired paintings by Fragonard and a set of fine French boiseries. Deacon died of consumption in 1851, and his wife and children went to live abroad, so the house reverted to Mr. Parker.[21]

After Parker's death in 1871, a major house sale was conducted by Frank A. Leonard on February 1–3 of that year. The catalogue for this included "Four large oil paintings by Fragonard on the subject of the history of love," in the salon; two lunettes of cupids by Boucher, a ceiling painting by Fragonard of cherubs at play, all in the Marie Antoinette boudoir; and in the dining room the Boucher oil paintings called *Going to Market* and *Returning from Market.*[22]

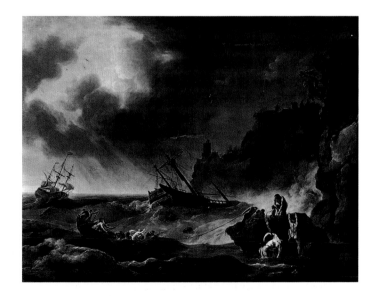

Fig. 4. Jean-François Hué, *The Shipwreck.* Formerly Museum of Fine Arts, Boston. Photograph, Courtesy of Christie's, New York

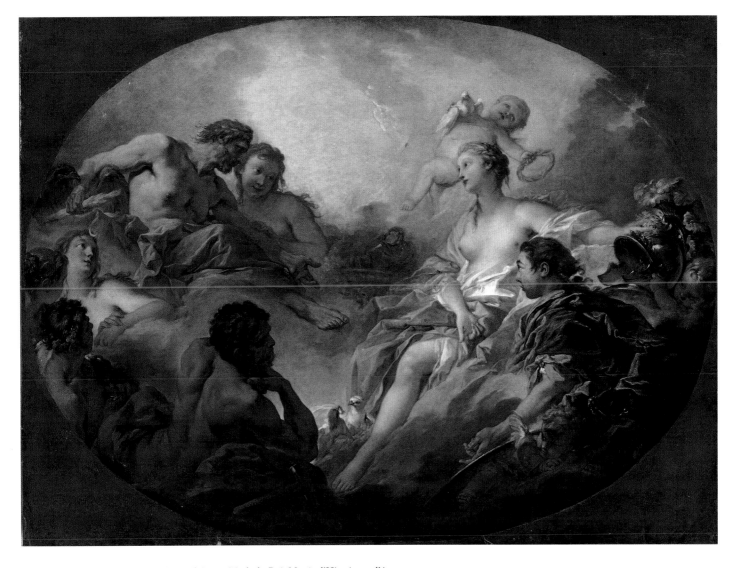

Fig. 5. François Boucher, *The Apotheosis of Aeneas*. Marly-le-Roi, Musée d'Histoire et d'Art

The Fragonards and Boucher cupids have vanished, but the two pastorals were bought in by Parker's heirs and donated to the Museum. These large works thus became the first European paintings accessioned by the fledgling Museum of Fine Arts in the year after it was founded. The minutes of the March 10, 1871, trustees meeting records that "[t]he President read a letter from Charles T. Slummin, Esq., one of the executors of the will of the late Peter Parker, presenting to the Museum on behalf of the heirs, two pictures by Boucher, called Night and Morning. On motion of Mr. Gray, it was voted that the pictures be accepted and that the thanks of the corporation be presented to the donors, by the President for their valuable gift to the Museum."[23] These works were lent later that same year to the special exhibition "for the benefit of the French" at the Athenaeum. The first Annual Report of the Museum, published in 1873, referred only to "2 pictures by F. Boucher,"[24] but the Museum's *Catalogue of Works of Art* (1872) employed French titles for the paintings, *L'Aller et le retour du marché.*[25] Later they became known as *La Halte à la fontaine* and *L'Aller au marché.*[26]

Early-nineteenth-century French paintings were only sparingly collected in Boston. To the Athenaeum's 1827 opening exhibition, a Mr. Timothy K. Jones lent a very large *Portrait of Napoleon in His Coronation Robes,*[27] one of many produced by the studio of Robert Lefèvre (cat. 74). How this version, signed and dated 1812, came to Boston is unknown, but by 1837 and until 1856, when it was frequently lent to the Athenaeum, it was the property of Leonard Jarvis. Later it was acquired by the renowned collector of oriental art, William Sturgis Bigelow, and bequeathed with his other holdings to the Museum of Fine Arts in 1926.[28]

The neoclassical manner of the revolutionary painter Jacques-Louis David seems to have held little appeal for Bostonians. The Athenaeum had exhibited supposed examples of his work—a painting entitled *Fowls* in 1838 and a *Napoleon* in 1842.[29] A very modest work attributed to this master was owned by the Boston painter Seth Wells Cheney, who died in 1856. This *Hector at the Car of Achilles* (cat. 85), as it was then called, was given by his widow, the writer Mrs. Ednah Dow Cheney, to the Museum in 1877.[30]

The Museum's French collection progressed slowly in its first

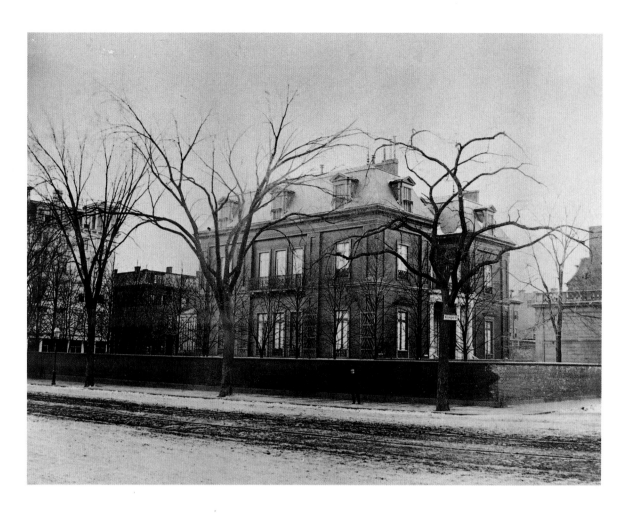

Fig. 6. Deacon House, Boston. Photograph, Museum of Fine Arts, Boston

decade. After the donation of the Bouchers, the next eighteenth-century painting came as part of the large and generally mediocre bequest by Senator Charles Sumner in 1874.[31] Much of this was sold immediately, but among those paintings kept was a *Portrait of a Woman as Diana* from the Thomson collection (fig. 7), then attributed to Nattier but later to Tocqué. Guiffrey described it as having "fresh color and a supple facture,"[32] but this work was also deaccessioned in more recent times.

Concern for the growth of the young museum led to acts of great generosity on the part of philanthropic Boston families. Thus, by coincidence, both of the Museum's Chardin still lifes were given in the 1880s. On October 16, 1880, Elizabeth S. Hooker of 89 Mount Vernon Street wrote the following note to the Museum's first director, General Charles Loring: "My aunt, Mrs. P. C. Brooks, asks the acceptance by the Art Museum Committee on Pictures, of the accompanying picture of 'Still Life' by Chardin. It was purchased some years ago by her late husband, who valued it highly, but my aunt feels that it can be of more use at the art museum than it can be here—where it is rather lost—and therefore she sends it."[33]

Mr. Brooks, who had died earlier in 1880, had been one of the wealthiest Bostonians and was also one of the first to collect the Impressionists.[34] His widow's benefaction was noted by the *American Art Review:* "Mrs. Peter C. Brooks has given the Museum a picture by J. B. S. Chardin, a still life representing kitchen utensils and a dead fowl, which is by good judges pronounced to be an

admirable specimen of the artist."[35] This fine work, *The Kitchen Table* (cat. 35), has a distinguished provenance, but we do not know how it entered Mr. Brooks's collection. On the other hand, the Museum's other Chardin still life (cat. 36) was sold in Paris in 1883, then acquired and immediately donated by Martin Brimmer,[36] the Museum's devoted president, who may have felt that Brooks's small gem needed a companion.

A bequest in 1885 from Mrs. Margaret Barker Sigourney brought three paintings to the Museum, of which *Portrait of the Duchess of Longueville* (fig. 8), given to Santerre, was highly praised by Downes. The attribution was later changed to seventeenth-century French, the title to *Woman Holding a Mask*, and the work was ultimately deaccessioned.[37]

Perhaps the leading family in terms of collecting and philanthropy to the Museum in these early years was "the Warrens of Mount Vernon Street."[38] Mr. Samuel Dennis Warren, Sr., a successful paper manufacturer, served as a trustee of the Museum from 1883 until his death in 1888. In keeping with Boston's taste for Millet he had already presented one of that artist's greatest single figures, *The Young Shepherdess*, to the Museum in 1877.[39] Warren's wife and then widow, Susan, was the much more active collector, and she filled their Mount Vernon Street home with a wide assortment of pictures ranging from works by such old masters as Lippi and Wohlgemuth, to those by moderns, including Gérôme and painters of the Barbizon school.[40] Following her death, Mrs. Warren's collection was exhibited at the Museum in April 1902 and then

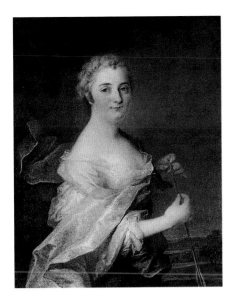

Fig. 7. Attributed to Tocqué, *Portrait of a Woman as Diana.* Formerly Museum of Fine Arts, Boston. Photograph, Museum of Fine Arts, Boston

sold in New York. It included a Greuze, an Ingres, and three paintings by Delacroix.[41]

During her life, however, Mrs. Warren had already enriched the Museum's French collection. On February 15, 1889, she sent the following note to General Loring: "Dear Sir, I caused to be sent to the Museum of Fine Arts, which I suppose you will receive this morning, a case containing an oil painting by Horace Vernet from the Stebbins collection which I think may be of use to students in drawing and painting. . . . If the Trustees are pleased to accept the gift of it to the Art Museum, I shall be gratified."[42] Mrs. Warren may have felt the voluptuous study of Judith (cat. 91) would be suitable for aspiring artists because Vernet painted it while he was director of the French Academy in Rome, a fact stressed in the Stebbins sale catalogue.

The importance of local collections, especially those at the Museum, for both students and connoisseurs was of particular interest to William Howe Downes, who, in 1888, published an extensive series of articles on Boston collecting. Some of his remarks have already been quoted, but his general assessment of the Museum's French holdings merits inclusion: "The school of France, from the seventeenth century down to to-day, promptly invites our study by the surprising abundance of its works. From Santerre, Chardin, Boucher, Greuze, Géricault, and Ary Scheffer to Corot, Troyon, Courbet, Rousseau, Millet, Couture, Bastien-Lepage, and Regnault is but a step; yet what a journey, full of wonders and contrasts! There are, of course, wide gaps to be filled one day, if we would gain a complete understanding of the school in its historical relations, but to contemplate what has been done already within a few years gives substantial encouragement with regard to the future."[43]

Of the eighteenth-century works in the Museum, Downes gave glowing notices to the Chardins: "An artist who could so glorify a raw loin of lamb, a loaf of bread, a gray jug; who by his arrangement, choice of light and shade, refinement of drawing, wise contrasts and subtle combinations, above all by his perception of color, could make every-day kitchen utensils appear so beautiful that one would like almost to kiss them, was indeed the prince of still-life painters."[44]

Referring specifically to the gifts of Mrs. Brooks and Mr. Brimmer, he continues: "There are two small still-life pieces by this master in the Museum, and they are simply delicious. One of these represents a group of edibles and vessels on a kitchen table; the other a gray tea-pot, a pear, and a big bunch of white grapes, and two plums. No works could do justice to the modesty, the quietude, and the incomparable harmony of these works. Other still-life painters have displayed more strength than Chardin, and some of the old Dutchmen were marvelously literal copyists of nature, but for exquisite taste and a perfect perception of the intimate character of inanimate objects, the Frenchman takes the palm."

Of the two large Bouchers, Downes was inclined to be critical:

François Boucher, who reflected in his factitious idylls the shallow but decorative life of Louis XV's giddy time,—a continual *fête champêtre*, rather silly, but undeniably pretty to look on,—was a contemporary of the more sober-minded Chardin. His pair of large pictures, the titles of which, Going to Market and The Return from Market, seem far-fetched, were intended as models for Beauvais tapestries. Both of them are crowded with a meaningless mass of figures, animals, and still-life, well painted with a free brush; the gray tones are delectable, and the color in general frank, gay, and pure, if not of great depth.

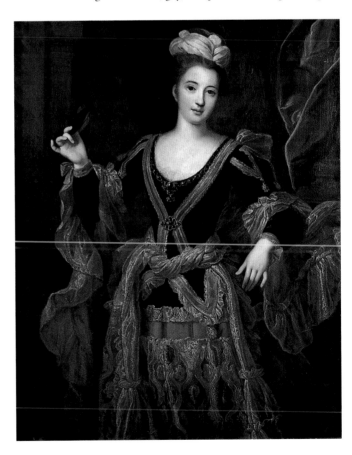

Fig. 8. French, seventeenth century, *Woman Holding a Mask.* Formerly Museum of Fine Arts, Boston. Photograph, Museum of Fine Arts, Boston

13

Boucher and Chardin represent the two Frances of the eighteenth century—the one incorrigibly light, frivolous and worldly, the other grave, thoughtful and industrious. When the former undertook to emulate the latter's kitchen interiors, it is said that he made a Venus of the cook, from sheer force of habit.[45]

Turning to the nineteenth-century school, Downes recognized that the so-called David was not a good representative: "Jacque Louis David, the famous head of the classical school, whose place in French art always will be important, is meanly represented by a rough study of his Hector Drawn at the Chariot of Achilles, which gives no notion whatever of his merit of design. It was on the strength of his Death of Hector, by the way, that David was received by the Academy."[46]

Although not discussed at length by Downes, there was, for Bostonians with the right connections, another rather special location at which to see a continually growing and varied collection of paintings in the late nineteenth and early twentieth centuries. This was at the literally palatial house-museum of Isabella Stewart Gardner. Mrs. Gardner acquired only a handful of French paintings. After she began her association with Bernard Berenson, in 1895 she purchased *Portrait of the Dauphin François* from the Bonomi-Cereda collection in Milan. Berenson wrote to her that it was "a genuine Clouet—and genuine Clouets are rare—and the price I could get it for—8,000 lire—is absurdly cheap."[47] It is now catalogued as "after Corneille de Lyon."[48]

Two years later Berenson wrote Mrs. Gardner, "Please let me know by return whether a Watteau would tempt you? A very, very lovely one has swum into my ken which could be got for between £5000 and £6000."[49] Then again he wrote, "Eureka! Eureka! I have found it, as lovely a Watteau as one can possibly ask for. All his winsome wistfulness, all his refinement, all his subtlety of feeling and grace of movement. How you feel the coolness of the clustering and the crispness and swish of silk. It really is a gem among Watteau's even. . . . I can get for you for a ridiculous price £2,200."[50] This was one time, however, when Berenson's flowery language failed to convince Mrs. Gardner, and we do not even know which painting he was suggesting. This happened again in June when Berenson wrote, "A singular lacuna in your taste is Watteau. I worship him, and it is of a very fascinating picture by him that I am sending you the photograph." He described it more fully:

You see it is an open air picture of a couple dancing the pavane to the fluting and piping of musicians while another couple are flirting. It combines famous motives, and you seem to see the music—the picture is so lyrical. It is 40 cm. high, and 60 cm. wide, in exquisite preservation, and painted on a gilt panel which in places shines slightly through giving it much distinction. If I can get it at all—of which I am not quite certain—it will not be for less than £8,000. Miss James's little Watteau no

better in quality, and only about half the size, sold recently at Christie's for £5,250.

I have said nothing about the colour. It is very light and exquisite—pinks, and blue on whites making an enchanting harmony, and have the effect as you look, of the finest violin music.

Please look at this also, and let me know your decision *quanto primo*. And please return the photographs of the pictures, either or both, if you won't have them.[51]

Claiming that she did not have enough money for it, Mrs. Gardner replied, "Of course I should adore having such a Watteau if it did not cost so much. Perhaps some day another that you love may turn up, cheaper. Am I not wise?"[52] Mrs. Gardner did add a rococo picture to her holdings when, in 1902, through her agent in Paris, she purchased from Wildenstein Boucher's *Car of Venus*,[53] a work Guiffrey described as a "charming picture."[54]

The Museum also missed some opportunities in the 1890s. A chance to acquire a great sensuous eighteenth-century painting, unlike anything then or now in the collection, occurred in 1898 when Loring was offered the opportunity to bid on Natoire's *Toilette of Psyche*. Once owned by Joseph Bonaparte in Bordentown, New Jersey, it had been exhibited in Boston at the Armory Hall in 1845 and then acquired at auction that same year by James Robb, a banker from New Orleans. It was now being sold for the benefit of a hospital in that city by Robb's former office boy, who had become a picture dealer. The price was $5,000, although "well worth $10,000."[55] This must have been deemed either too expensive or too sexy a work for Boston, for it remained in New Orleans.[56]

In the early part of the twentieth century, one of Boston's most prodigious collectors—and the Museum's most generous as well as industrious patrons—was the artist, writer, and Harvard professor Denman W. Ross.[57] In 1906 he made an important gift of a portrait by Philippe de Champaigne (cat. 16). It was described in Addison's 1910 book:

In 1906 a treasure was added in the shape of a portrait by Philippe de Champaigne, of Arnauld d'Andilly. Not only is this portrait very important as a work of art, but the fact is interesting that Philippe de Champaigne and Arnauld were friends at Port Royal. They died in the same year. On the records at Port Royal the name of Philippe de Champaigne appears near that of Andilly, and he is described as "a good painter and a good Christian." St. Cyran says of Arnauld that he was "solidly virtuous"; while he had a great advocate in La Fontaine, who describes him as a man with bright eyes and a steady carriage, a full rich voice, and great skill in horsemanship. This portrait was painted in 1647, when he was fifty-eight. At this time he had spent fourteen years at Port Royal, dividing his time between his books, his garden, and his prayers and meditations.[58]

In 1907 Ross was already traveling abroad looking for works and lamenting that he wished the Museum "were buying instead of building."[59] European paintings, French ones in particular, formed only a small portion of his acquisitions. On August 12, 1920, he wrote to Morris Gray, the Museum's president, in a letter full of cheerful collecting news: "From Venice I sent you a picture, attributed by the Director of the Academia in Venice to Nicholas Poussin, and it may very well be by him. I have described it in the invoice as of his school. It is a picture which will please you I am sure." He wrote as well to Arthur Fairbanks, the Museum's director, stating that of the two pictures he was sending, "one is attributed to Nicholas Poussin, perhaps correctly," and that it "is a gift to the Museum."[60] The doubts he may have felt are justified, for this lovely picture is a work by one of Poussin's Italian followers, Andrea de Leone.[61]

In February of the following year, Ross was in Naples and wrote Fairbanks of his "big haul in Rome," which he believed comprised "two Fragonards and an Ingres portrait."[62] They were on their way, as a gift to the Museum. In another letter he wrote more fully and contritely: "I did not intend to buy any more things for the Museum at this time, having spent much more than my income. I ought to keep away from temptation for some time. Habits, however, become our masters, and I have failed to resist temptation. I have purchased of Alessandro Contini . . . two exquisite landscapes with figures by Fragonard and a portrait of Jean Fleury by Ingres. For these I have promised to pay nine thousand five hundred dollars. . . . The portrait by Ingres is slightly damaged . . . the Fragonards are in wonderful condition. . . . I expect to be congratulated on buying a good portrait by Ingres for $1,500! It was bought 'cheap' from someone of the Henry family [sic] who resides in Rome."[63]

Then from Spain in June Dr. Ross wrote, "I rejoice in the safe arrival of the Fragonards and the Ingres. My getting these three was a great piece of luck. Just think what they are worth in Paris and what I paid for them in Rome!"[64] Again, the attributions were overly enthusiastic. The two so-called Fragonards were later given to Mola, but are now categorized simply as Italian school (acc. nos. 21.751 and 21.752). The purported Ingres portrait is by Papety (acc. no. 21.753).

In 1877 the most cosmopolitan of Bostonians, Thomas G. Appleton, had published his *Companion to the Catalogue of the Museum of Fine Arts*, intended as a cheerful and informative guide through the recently opened galleries. Speaking of the French landscapes on view, he noted that "Poussin, and Claude after him, are the two great landscapists of the early time."[65] Based on his wide experience of traveling in Europe, he wrote: "[T]he charm of Poussin consists in his mastery of bowery foliage, the gleam of waters between dusky stems, and the broken hillside fading in air and crowned with the castle or town of the Italy he studied in. Claude is almost the genius of aerial perspective. . . . In the movement of water, the dark blue surface of the Mediterranean with the rays of the setting sun danc-

ing over it, he is wholly without a rival." This led him to observe on the many gaps, not only in Boston, but also in our country in general: "And speaking of Claude, I am reminded in what infancy are yet the museums of America. We have no specimens worthy of the name, of the old masters; not only no Claude, no satisfactory Poussin, but no Raphael, no Titian, no Fra Beato Angelico, no Sebastino, no Caravaggio, nor even any thing from the fading academic school of Bologna."[66]

To address this situation, a significant turning point in the Museum's collecting history occurred in 1911 when the trustees hired, for a period of three years, Jean Guiffrey, the Louvre's curator of paintings. As the Annual Report for that year noted, "Mr. Guiffrey in accepting the position of Curator of Paintings, asked that his department be given $100,000 a year to spend in developing the Museum's collection."[67] "Generous friends," as they were characterized, promised these amounts, and the curator in his own report could write that it was his "endeavor to acquire only works of the first rank, in good condition, and representing as well as possible a master, a school, or a period of art. Need I add that I am also attempting to fill the gaps which still exist in the Museum's gallery of painting."[68] By the publication of the Annual Report of 1912, the director could note that "Mr. Guiffrey has visited Europe twice and traveled widely in the effort to find desirable European paintings for the Museum."[69]

Guiffrey's major French acquisition was to fill the gap noted earlier by Appleton: Claude Lorrain's *Apollo and the Muses on Mount Helicon* (cat. 11). As the curator himself explained, "Examples of the classical masters of pictures mythologic or historic in subject, are still rare in America, where collectors have mainly sought after works by the realistic masters, the Spaniards, the Dutchmen, and the modern French. This is a fact which the stranger visiting the museums and private collections of America observes at once. Hence the picture by Claude Lorrain representing Parnassus fills at our Museum a double lack."[70]

Not everyone was enthusiastic about Guiffrey's acquisitions, perhaps because they felt his purchases cut them out of the action. There certainly seems to be an element of this in the attitude of Richard Norton, the son of the Harvard professor Charles Eliot Norton, the director of the American School in Rome, and sometime advisor to the Museum.[71] Apparently in answer to charges made against him, Norton wrote from England, on November 29, 1912, to Gardiner Lane, then president of the Museum, stating: "I beg to say that I have not told *anybody* that 'Guiffrey is loading up the Museum with unimportant pictures.' Nor have I told 'people' that the 'Gainsborough' Landscape and the 'Claude Lorrain' are not authentic. . . . I have simply said exactly what I have told Fairbanks, Forbes, you, and Guiffrey himself, that speaking for myself alone . . . the 'Claude' was a very poor one. I have since . . . obtained evidence which I will verify and send you in a few days that this opinion is the one held over here by those who know the picture." The evidence that followed in a letter of December 3 was that, in the sale of 1912 the work "fetched there 180 guineas. Previ-

ously it was in the collection of the Rev. Holwell Car, Walsh Porter (at whose sale it fetched £294), Wynn Ellis (at whose sale it fetched £315), and William Grasher (at whose sale, in 1886, it fetched £409.10). The fact that during the last hundred years the picture has never fetched more than £409.10, and that since 1886 its value sank to 80 guineas shows conclusively that my opinion about it is correct." Fortunately, time has proven Norton's judgment wrong and Guiffrey's correct.

Guiffrey's final French acquisition for the Museum was noted in the 1913 Annual Report. There it is related that Guiffrey "purchased in Paris at the H. Rouart sale a painting by P. P. Prud'hon entitled 'L'Abondance' [cat. 76]. . . . [T]he unfinished state of the picture gives the students of the School an opportunity to study the technique of the master, and has allowed the coloring to retain its first freshness, a circumstance perhaps unique in the work of Prud'hon."[72]

Guiffrey concluded his three-year tenure on April 1, 1914, and the Museum's *Bulletin* noted the following appreciation of the trustees:

M. Guiffrey brought to this position wide knowledge and keen appreciation of art as well as the practical wisdom essential to make that knowledge and appreciation effective. During his tenure of office paintings of importance were acquired, plans were devised for the better exhibition of the entire collection in galleries now in process of construction, and careful studies were made not only of the paintings owned by the Museum but also of those owned privately in Boston. The Trustees regret the termination of a relationship at once so valuable to the Museum and so pleasant to themselves.

In closing, the Trustees beg to express the abiding gratitude that they feel for the splendid service that the Louvre, in itself and its inspiration, renders to art in America.[73]

It may have been in part to make up for the loss of Guiffrey and his expertise that the Museum trustees and staff began to make more use of the painter Walter Gay (1856–1937) as their Paris agent. Gay, who was born in Hingham, Massachusetts, went to France at age twenty and was employed by the Museum from 1902 onward.[74] With regard to French painting, Gay wrote to Fairbanks on November 7, 1918, and included photographs of a portrait by Rigaud belonging to Baron de Wisenes (?) of the château de la Garde: "[T]hough the price is high, the owner says he would not take less than 100,000 francs."[75] This work did not come to Boston but the next year Gay arranged for the shipment of a portrait by Corneille de Lyon (cat. 7).[76]

On December 15, 1923, John Singer Sargent wrote to Morris Gray from the Copley Plaza Hotel: "My friend the French painter and etcher Paul Helleu writes me that he wishes to sell for $12,000 a Watteau, and asks me to show you and the authorities of the Boston Art Museum the accompanying photographs." The Museum turned to Walter Gay. On January 18, 1924, Arthur Fairbanks wrote to Gay in Paris: "Through Mr. John Sargent M.

Helleu has offered us a Watteau (damaged, repainted and recently cleaned) which I believe you know. . . . The main question is whether in its present state it is a highly important picture for us to buy, particularly as we have recently purchased a Watteau from England." Gay responded immediately by cable from Paris: "examined Helleu Watteau before it left, good quality bad condition."[77]

The Helleu Watteau arrived in Boston at the end of March[78] and was reviewed and rejected by the collections committee on April 3. At Sargent's behest, Coolidge, who had underwritten the cost of its shipment, then had photographs of the Watteau sent to the Cleveland Museum.[79] Undoubtedly the Boston committee felt satisfied with *La Perspective* (cat. 30), the great example of the artist's work that had been purchased from Durlacher Brothers and of which Gay, when he received the photographs, commented that it was indeed "a beautiful Watteau."[80]

Gay's eye and judgment were again called into service in 1927. Word came to the Museum that a Mrs. Hanway Cumming, who was then living in Paris, offered by means of a student of the Museum School a painting described as *Portrait of Madame Récamier* by Gérard for $600.[81] Gay saw the painting and cabled that he approved of it, but that the price was actually $1,600.[82] Even if not by Gérard (cat. 84) and not of Madame Récamier, it still seems a bargain.

A major advancement for the Museum's Department of Paintings occurred in 1911 when Maria Antoinette Evans agreed to fund the building of the grand paintings galleries on the Fenway side of the Museum in honor of her husband, the mining and rubber magnate Robert Dawson Evans. These opened to the public in 1915 with an exhibition that included many works belonging to Mrs. Evans. When she died in 1917, she bequeathed nearly fifty paintings and a large purchase fund to the Museum.[83] Among the works she had housed along with English portraits in the music room of her Gloucester Street mansion (fig. 9) was an outstanding eighteenth-century French work then believed to be *Portrait of the Artist's Daughter* by Vigée-Le Brun but is probably one of that painter's Russian sitters (cat. 73). Mrs. Evans's only other French work was a supposed Nattier painting, *Mlle de Bourbon-Conti as Venus* (fig. 10), which Mr. Evans had purchased in 1904 from the New York dealer T. J. Blakeslee.[84] It was later assigned to Pierre Gobert and deaccessioned.[85]

In the 1920s, with the new, spacious painting galleries to fill, the Museum witnessed the accumulation of a varied group of French paintings. The imposing vista of Roman ruins by Turpin de Crissé (cat. 89) was received as a bequest of Emma B. Culbertson in 1920. The following year another Corneille de Lyon was purchased (cat. 6), this one from Durlacher Brothers,[86] the gallery, that had also supplied the Museum's impressive Watteau. It must have been with reference to this that Fairbanks wrote to Paff of Durlacher's on November 5, 1923: "[I]t is a picture of the type for which I have been looking for years—and now we have no funds for it." Fortunately, before the end of the year the financial situation improved, and news of the acquisition of *La Perspective* was published in the February 1924 *Bulletin* by Charles Hawes, who called it a "valuable

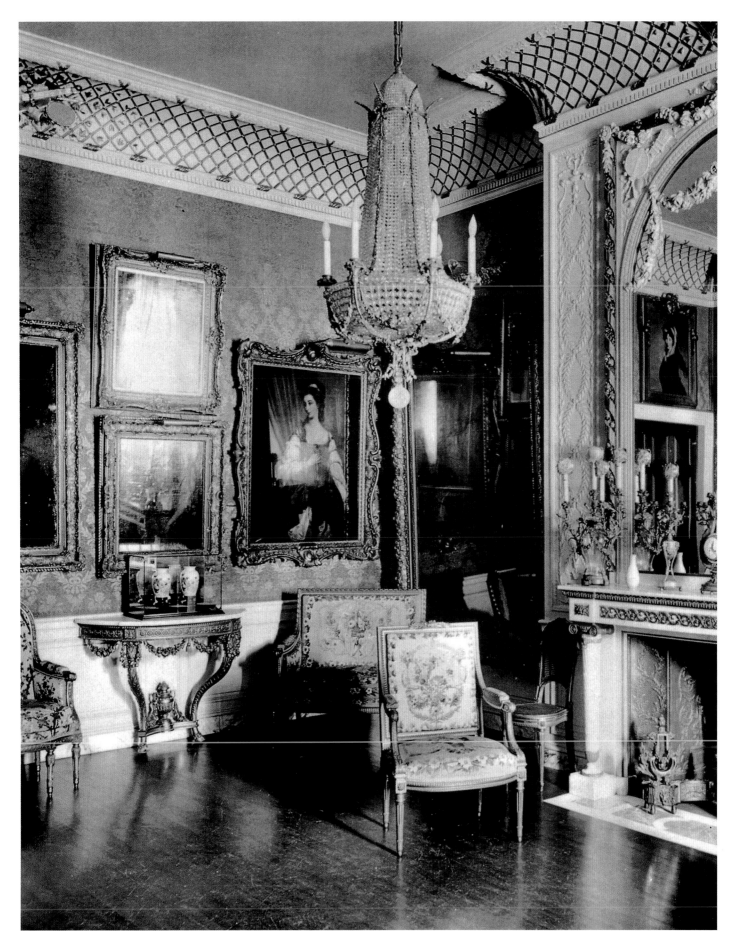

Fig. 9. Music room, Robert Dawson Evans House, Boston. Photograph, Museum of Fine Arts, Boston

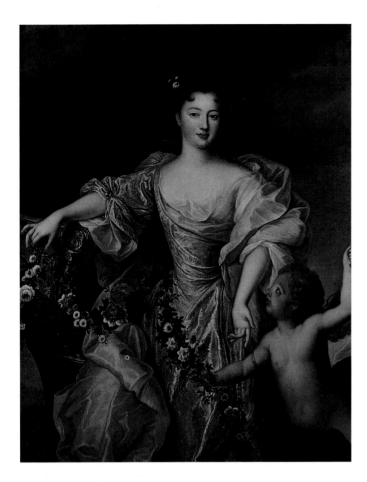

Fig. 10. Pierre Gobert, *Mlle de Bourbon-Conti as Venus.* Formerly Museum of Fine Arts, Boston. Photograph, Museum of Fine Arts, Boston

addition to the French paintings of the period already in the Museum's collection." He wrote that the "history of the painting is briefly told. It is mentioned by Pierre J. Mariette as having been engraved by Crespy from the picture which hung in the study of M. Guenon carpenter to the King. Later it appeared at the Saint sale in 1846, and again in the Murray Scott sale in London in 1913."[87]

Whereas the Watteau and the Vigée-Le Brun were masterpieces of the eighteenth century, acquisitions in the seventeenth- and nineteenth-century areas were not as successful. A peasant scene by Le Nain (cat. 12) was purchased in 1922. Although then considered the original, it was later discovered that the clearly better, prime version is the one now in the Fine Arts Museums of San Francisco.[88] Even earlier works added in these years were a third Corneille de Lyon, *Portrait of a Man* (cat. 5), purchased in 1924, and in 1925 a supposed portrait of Peter II, duke of Bourbon (cat. 1) attributed to the Maître de Moulins.[89] In 1928 another unidentified *Portrait of a Bearded Man* was acquired as French school but is now also given to Corneille de Lyon (cat. 4).[90]

The Museum's efforts to obtain paintings by the major figures of the early nineteenth century continued to prove even more unsatisfactory. A minor *cause célèbre* was the purchase in July 1924 of a supposed Ingres portrait of a man said to be Rosario Persico, painted in 1814, from Robert C. Vose. On July 14 Boston's premier dealer wrote to the Museum's director, Arthur Fairbanks, following the latter's visit:

Enclosed please find a brief story of the portrait by Ingres. I wish you could hear the remarks of the artists to whom I show this picture. I say without hesitation that I have never had a picture which excited so much enthusiastic admiration on the part of our artists than this one and practically all of them have stated the earnest wish that the Museum might own it. It is very rare that a work by Ingres comes on the market and few of them are of any importance. I am willing to sell this picture to the Museum for ninety-five hundred dollars, which I think fair and below its real value.[91]

According to the Museum's file, Fairbanks then wrote to John Singer Sargent to ask if he thought it a "really desirable acquisition for the Museum," and he received on July 28 this answer from Sargent, "I think the Ingres is a good Ingres, and the hands have the best quality, but the picture as a whole is not one of his most beautiful." Fairbanks reported this on July 22 in a letter to Denman Ross and also that "the committee was greatly charmed by the portrait of 'Rosario Persico' by Ingres which Vose had acquired from the Heilbuth Collection in Denmark. We had money for it in the Denio Fund and bought it at once." The same day Robert Vose, just returned from the country, wrote Fairbanks, "I am happy to hear that you have purchased the Ingres. I am very happy that it is to remain in Boston." And in a postscript he added, "I presume you have no objection to our going to the press and magazines with the news of this important picture?" It was thus that the painting was featured prominently on the first page of *Art News* on September 13, 1924. The optimistic attribution of the painting to Ingres, however, was attacked quickly by the French expert Henry La Pauze in his journal, *La Renaissance.*[92]

Vose, naturally upset, wrote to Fairbanks on October 17: "I have a telegram stating that a Frenchman has attacked the authenticity of the Ingres and that this has been noted in the press. This is astonishing as well as very disturbing but I cannot believe there is any ground for it except malice. The picture was consigned to me by the Ehrich Galleries and is such a superb achievement— to which fact almost all our leading Boston artists have given enthusiastic testimony—and so characteristic of this master draughtsman—that it seems absurd to question it."

Unfortunately, the questioning was justified and the painting was later more correctly identified as by Fabre (cat. 83). An Ingres was also offered by the active advisor to the museums in Cleveland and Kansas City, Harold Woodbury Parsons.[93] On January 5, 1932, he wrote from the Waldorf Astoria in New York to Charles Hawes that it was one of several pictures of unusual quality recently brought from Paris by Richard Owen.

The 1930s were, in fact, to prove a very active decade in the presentation and acquisition of French works from a wide variety of dealers. The Museum's curator from 1934—and then director the following year—was Harold Edgell, a specialist in early Italian painting. Where the Museum was concerned, however, his taste was catholic in the extreme. Having studied and taught at Harvard,

Edgell continued to use the Fogg's respected assistant director, Paul Sachs, as a sounding board for his acquisitions. Thus on April 15, 1935, *à propos* of a Poussin being proposed for purchase, Edgell wrote, "we need a Poussin." Professor Sachs replied the next day that this particular example, from Stephen Bourgeois and the Ehrich Galleries, "is *not* the Poussin you are looking for." The same year a Fragonard from the Otto Kahn collection was offered for sixty thousand dollars, and they both agreed that that was too much to spend at the time.[94]

A Fragonard that did come to Boston was offered to the Museum, along with works by Perronneau and Hubert Robert, in November 1934, by Josef Stransky of Wildenstein.[95] The Fragonard was *The Good Mother* (cat. 58). This picture must have been brought to the attention of the collector Robert Treat Paine II, who acquired it.[96] Still hoping to persuade the Museum to purchase its own example of this artist's work, the same gallery wrote on January 24 of the next year to Edgell about one entitled *Le Retour à logis*, which they believed to be "as important in the oeuvre of Fragonard as *Le Mezzetin* [which they had just sold to the Metropolitan Museum of Art] in that of Watteau." Although considered a work of "tremendous importance" that would "command a price of $150,000 or more," the price to the Museum was only $59,000.

To encourage the purchase of the picture by the acquisitions committee, Stransky himself came to Boston on the day of their meeting, April 4, 1935. Most likely in hopes of influencing the purchase, he met with Paine, and he wrote that morning from the Copley Plaza Hotel to Edgell that "Mr. Paine told me, to my surprise that he is no longer on your Acquisitions Committee, therefore I did not dwell particularly on the Fragonard and just invited him to inspect it." After more praise of the painting he notes, "Mr. Paine asked me how it compared with his example. I told him that while his is exceedingly fine and fits better in a home, this one is a typical Museum picture." Unfortunately, the committee did not agree and the purchase was rejected, perhaps with the expectation that Paine's more modest work would eventually come to the Museum.

This was again the case with two Fragonards offered by Jacques Seligmann and Co., in 1935, *Portrait of Hubert Robert* from the Rudinoff collection and a reduced version of the Wallace Collection's *Fontaine d'amour*.[97] Then on June 13, 1940, Colin Agnew sent a telegram from London offering a "superb important Fragonard priced ten thousand pounds." Writing on December 26 of that year with "the fervent hope that 1941 may be a less terrible year than the one just passed," the Museum's English-born curator since 1937, W. G. Constable, noted with regard to the Fragonard that he was "fighting hard to get this. It has aroused extraordinary differences of opinion." In the end this picture also did not come, for as Constable wrote to Agnew on April 1, 1941, "Mr. X (who you know) announced quite definitely that his Fragonard was to come to the Museum." The "Mr. X" was most certainly Robert Treat Paine, whose Fragonard, *The Good Mother*, was in fact bequeathed in 1944.

Colnaghi's in London was another firm with which both

Edgell and especially Constable liked to deal. A painting then attributed to the Maître de Ribaucourt (a *Lute Player* now thought to be Flemish, 34.541) was acquired in 1934.[98] Then, in 1938, the gallery's James Byam Shaw was offering a Claude for £1,500 but, as Constable wrote him, while "some of the Trustees, basing themselves on the photograph are very well inclined toward the picture . . . there were however 2 or 3 other acquisitions of considerable importance likely to come up."[99] When this work was sent to Boston in December, Constable advised: "I judged it wiser not to put it up at once for our December meeting. People here do not like being rushed and Claude is not an easy master to grasp. . . . Personally I like it better and better. On the other hand, it has had a very mild reception among the members of the Committee who have seen it."[100] After consideration, it was rejected and, at the dealer's request, sent on to Ottawa.[101]

The Museum ended the 1930s with a special exhibition in 1939. *Art in New England* consisted of loans from many private collections. The eighteenth-century French paintings in the Boston area that would eventually come to the Museum were Paine's Fragonard and the Jean van Loo *Portrait of a Man* (cat. 29), then supposed to be by Rigaud, from Amelia Peabody. Others that did not remain were the eighteenth-century portrait of the duc d'Angoulême as a child, which belonged to Mrs. Richard P. Strong of Boston; a pair of Nattier portraits from the Gardiner family of Maine; and, most important, Watteau's *Pierrot Content*, lent by Mrs. Charles P. Curtis.[102]

The year 1940 not only marked the start of a new decade but was also something of a watershed in the international art market, as there was a scramble to get works out of war-torn France and England. Museums in America could benefit from some bargain-basement prices brought about by the desperation. The Parisian dealer André Weil was in this predicament and offered to Boston Lancret's *Escaped Bird* (cat. 32). On July 20, 1939, Weil sent a photograph of it to Constable with the information that the price was three thousand pounds and that he "should be very happy if this masterpiece could take a place in your celebrated Museum." By October 3 he wrote that he had not yet been called into service and continued to pursue his business. The case with the painting was packed and waiting to be sent. It was his hope that "we could deal with all these questions of art in another atmosphere than that in which we actually live; it is a great shame for Art and for Civilization."

Constable replied a short time later that "it is very doubtful" that the trustees would acquire the work at the quoted price. He suggested lowering it and sending the picture without a guarantee of purchase, but the Museum would provide "the convenience" of a place to care for the work.[103] In reply Weil asked for an approximation of the price the Museum would pay and noted that he was afraid to send it because of the risk of submarine attacks. However, a friend of his was going to America at the end of the year on an Italian ship that might be on a safe route. He concluded by offering a magnificent Degas portrait of a woman.[104] Constable wrote to

Weil that a price of eight thousand dollars would "meet with a very favorable consideration."[105] Weil's response to this at the beginning of 1940 noted that he would arrange for the shipment, which might be delayed by circumstance, and that he would settle for ten thousand dollars, which constituted a "veritable Bargain."[106] By the end of January he could report that "all the formalities have been accomplished for the shipment of the fine painting by Lancret." He also tempted Constable with a catalogue of the exhibition he organized for the centennial of Monet, which included the great *Déjeuner sur l'herbe* that was available for purchase.[107] In his recommendation of June 13 to Edgell, Constable wrote:

> I regard the Lancret as a very good example of the artist's work which is very suitable for the Museum. The picture was exhibited at Frankfort about fifteen years ago and was one of the small group of Lancrets chosen by the French authorities for exhibition at the Royal Academy on the occasion of the big French exhibition there. Quite apart from the charm of the picture it would be a good complement to the Watteau which the Museum owns. The price which is asked, $10,000, is quite reasonable, even in present circumstances. I am however, in negotiation with the owner to get it reduced to $9,000 if possible, though owing to present conditions in Europe it is difficult to keep in touch with him. If the Trustees are willing to acquire the picture, may I suggest they authorize an expenditure of up to $10,000, leaving it to you to make the better bargain if possible.

Sometime before June 1940 Weil was mobilized and left Paris; Eric Stiebel of the New York firm of Rosenberg and Stiebel, whose brother had been in Paris, acted as the intermediary.[108] Then on July 20 came a cable to the Boston Museum from Weil himself, who was at a hotel in Cahors, France, asking if the Museum was still interested in the Lancret. When Stiebel was informed of this he concluded that Weil had moved to "the unoccupied zone."[109] In early August another cable came from the Hôtel Suisse in Cannes, stating that Weil would now accept nine thousand dollars for the painting, payment to be made to Stiebel in New York. Constable told this news to Stiebel[110] but raised the question whether "works of art coming from occupied territories in Europe are to be treated in the same way as money and securities," because the Museum wanted to be certain that Stiebel, as the agent for Weil, had the power to transfer the picture to the Museum with good title. Fortunately the Federal Reserve Bank of New York authorized the transfer.[111] Weil survived the war and was in New York in 1945, able to write Constable requesting a photograph of the Lancret.[112] The Annual Report dryly observed that the work "got out of France only just before the defeat of that country."[113]

The war also stranded paintings in America, which was the case with what was to become one of the Museum's major early-nineteenth-century works. On October 18, 1940, Constable received a most unexpected letter from the New York dealer Julius H. Weitzner. It began quite directly:

> Would you consider taking an important painting by Baron Gros on exhibition for the duration of the war or longer. I have just received here the famous "Bonaparte visiting Jaffa" belonging to the Duc de Trevise. It is reproduced in the recent Knoedler, 'Gros-Gericault' show as number 3. It is an unusually fine example by Gros and in a perfect state of preservation. This is not only a good chance to show this painting to Boston but also a sort of friendly gesture to safe-guard it for the Duc. Of course there are many Museums who would be glad of the chance but I would prefer the Boston Museum. I might also arrange to let you have, if you wish, another important Gros or perhaps important Gericaults. Let me know what you think of this idea.

For some unknown reason Weitzner's kind offer was refused, and the painting was instead placed at the Rhode Island School of Design's museum in Providence for the war's duration. Seven years later Weitzner again sent a letter to Constable:

> No doubt you know that I have been the authorized agent for the Duc du Trevise. Among various items, which were hitherfore not for sale are two paintings by Baron Gros. . . .
> . . . I just had a phone call from Paris that if I work fast I can sell these two paintings at a most attractive price. You see the Duc recently died, and if I do not sell them soon, they are to go to the Louvre.
> Mr. Lebel, my partner is in Paris—and he is now arranging for the sale of the Collection at Public Auction (those items which the Louvre does not want). I have the legal, moral and financial rights to sell these two paintings now. I wrote to Providence for the return and it is Mr. Washburn who writes that Boston might be interested in them. If you wish I give you the right to phone Providence and have the Gros brought to Boston. I will discuss the price later—but urgency is required.

In a note added above his address Weitzner gave the information that "the two paintings reproduced in the Knoedler Exhibition Catalogue Gros-Gericault were 1. Pesthouse at Jaffa and 2. Portrait of Legrand."[114]

Constable replied immediately that "the Le Grand is much too big and I prefer the Pestilence," but that "I am in a quandary. I don't think we have got the money but I feel I ought to see the *Pestilence at Jaffa*. . . . I haven't much hope but I do feel we ought to consider very seriously the chance."[115] By May Constable was seeking further information. Weitzner wrote him:

> I know very little concerning this painting except that it first came to this country for the big exhibition held at Knoedler's about 1939. . . . I do know positively that the Napoleon at Jaffa was not for sale, as Knoedler's had a few good inquiries for it. I do know it was valued at $25,000. I will perhaps cable to Lebel and he might know something about its provenance. I will also ask Mr. Sterling about it, although this might be a little dangerous. The canvas was in my place awaiting shipment to

France when war was declared and in order to save insurance I thought it a good idea to farm these large paintings to various Museums. The painting as I recall is in "mint" condition and crying to be cleaned and relined. I am quite sure that the origin and history of the canvas is well known. As I told you I have no definite price on it. . . . It is a positive fact that this Gros is not included in the forthcoming [Trévise] sale and if returned to France is to be given to the Nation.[116]

Constable and Weitzner discussed the matter further by phone on May 15, and the following day Weitzner wrote that he had received a cable from Paris that allowed him to make the following offer: "You can have the Baron Gros painting 'Napoleon at Jaffa' for $6,500 net, which includes a very minimum commission to me which I am dividing with the Paris representative of the Trévise estate." He continues, "You will never regret the purchase of this representative example of French art for the Boston Museum—it is unquestionably the first, finest and only Baron Gros owned by any American Museum."

Constable wrote on May 19 to thank Weitzner for having "acted so promptly and so generously" and informing him that "the painting will come before the Committee on June the twelfth." Sometime before that date Weitzner must have supplied the document with the doubtful provenance information, for Constable in his recommendation to Edgell wrote: "I have ascertained that this picture cannot be regarded as a preliminary version for the big painting in the Louvre, but that it is a replica on a smaller scale . . . believed to have been commissioned by Marshal Mortier, who became Duc de Trévise. It did not, however, remain in the family, but was apparently bought from an English collection by the last holder of the title, who died last year. . . . I have never heard the least doubt thrown upon its authenticity."

He argued that, "from the point of view of the Museum, it would be a very important acquisition. It virtually represents the beginning of romantic painting and is the forerunner of Delacroix and of other artists whose work is one of the strengths of the Museum collections."[117] This is still true, despite our present belief that the work is, in fact, a replica by Gros's pupil Debay (cat. 86). On June 13 Edgell himself could write to Weitzner, "I am glad to say that the committee of the Museum voted yesterday to purchase the Gros 'Bonaparte Visiting the Pest-Ridden of Jaffa' for $6,500."

As Edgell had noted in 1935, a work by Poussin remained one of the greatest lacunae in the collection of French paintings. Various paintings had been proposed since the director's observation: In 1937 Weitzner had a Poussin he offered for ten thousand dollars, but it was sent back.[118] Then, in April 1939, a protracted correspondence began between Constable and Paul Byk of Arnold Seligmann, Rey, and Co. over Poussin's *Bacchanal before the Temple* from Lady Lane, offered for twenty thousand dollars. Constable wrote the dealer, "You and I are both enthusiasts over the Poussin. Other people, however, do not feel the same. As it happens a very important and costly picture is on offer to the Museum."[119] This

must have been Gauguin's great *Where Do We Come From?* which overshadowed all other proposed acquisitions.

Byk was persistent, however, and wrote in December, "It occurred to me that as you are without a Poussin, you might be interested in the 'Death of Britanicus,' in the Barberini Collection."[120] The actual subject was the death of Germanicus, and Constable had to reply with regard to this that he was "in somewhat of a quandry [sic]" for "it may well be that within the next few weeks a very important Poussin will be offered to us which I should prefer."[121] Not to be put off, Byk wrote on January 16, 1940, that he had "just heard that it may be possible to get the famous Poussin from the Munich Pinakothek representing *The Adoration of the Shepherds.*" Constable answered this time that this work "is a good picture but I do not personally think it as good as some of the others in the Munich collection, or indeed as other pictures which are in the market or may be coming into the market."[122]

In fact, the negotiations for a major Poussin had begun already on April 13, 1939, when Dr. H. M. Roland of the London firm Roland and Delbanco sent the following cable to Constable in Boston: "Are in direct personal contact with Viscount Harcourt who would now consider offer for his wonderful Poussin Mars and Venus Exhibits 17th century exhibition Burlington House; wire whether interested and whether can start negotiations." Interest was expressed with the phrase, "should welcome news of Poussin," but given the unstable conditions in Europe, nothing was arranged until Roland contacted Constable again on October 13:

It is very unfortunate, that during the eventful days preceding the war I have been unable to get into touch with you.

If you have not heard from me since your departure, you must not think that I have been entirely inactive. I have written to Lord Harcourt about his picture. He is serving with the army and after some time I had a reply from Lady Harcourt, telling me, that she would not consider sending the picture abroad unless it was bought and paid for beforehand.

Thereupon I wrote back and explained, that it was impossible for your Museum to buy the picture without seeing the original. I asked her to agree to a compromise and to entitle me to submit to you the following proposition:

She should let the picture leave Nuneham Park and go to the United States, provided you pay for the transport and for the insurance. Should the picture be rejected by the trustees, you would also be responsible for the costs of returning the picture.

Some time elapsed before I had an answer from Lady Harcourt. Yesterday however I received a favourable reply stating, that if you were agreeable to above conditions, and only then, she would be willing to let the picture go, yet unsold, and at the same time then quote you a definite price for it. I am sure you will understand: I have suggested these conditions only to make a deal possible, as otherwise she would not let the picture leave her house.

On the other hand, you now know the picture and the question of bearing all costs of transport and insurance is for

you a pure matter of calculation, once you are sure, that you want the picture for your gallery.

Constable's return wire stated: "Price of Poussin should first be named. If price satisfactory Trustees willing to pay transport and insurance provided reasonable rates possible. Please quote cost of insurance and transport. Letter follows."[123] To this, Roland gave the answer: "Lady Harcourt after keeping me waiting for weeks quotes seven thousand pounds for Poussin."[124] Unfortunately, one more delay ensued, as Lady Harcourt agreed to pay only half of the dealer's commission, feeling the Museum should pay the other half. Since another Poussin was being offered to the Museum, and Constable needed the matter resolved, in June the Museum agreed to pay two hundred pounds of the commission. Constable wrote the following enthusiastic recommendation to Edgell on April 11, 1940:

The *Mars and Venus* which belongs to Lord Harcourt and is offered to the Trustees through Mr. Roland for £7,000, I consider one of the finest of Poussin's earlier works. It seems to have been painted comparatively soon after his settlement in Rome, perhaps for Cassiano dal Pozzo. The Venetian influence in it is strong and gives it a richness of colour and decorative quality which is unusual. The picture is in good condition though there are some breaks on the upper edge and one or two obvious repairs. It is very dirty; but on removal of the old varnish and this dirt would, I believe, be brilliant in colour. Even in its present condition when it was exhibited in the Seventeenth Century Exhibition at the Royal Academy, London, 1938, it dominated the room hung with fine examples of Poussin, Claude and their contemporaries.

The price is high, but I do not think unduly high since it is most unlikely that such an imposing and first-rate example of the painter is likely to come into the market in the near future. It must be taken into account in considering the price that the Trustees have already paid approximately $650 to bring the picture over from Europe. Also, you will notice that Dr. Roland in his cable of January 25th asks the Trustees to consider paying him £200 to make up his commission of 5% since Lord Harcourt would only consent to pay half that commission.

Although the work was not yet Museum property, Constable informed Paul Sachs the next week that "Lowe has begun cleaning the Poussin and I am delighted to say that no undisclosed defects have appeared. The only damages seem to be those which were apparent beforehand. The colour is developing very well indeed."[125] The Annual Report of 1940 could observe, with satisfied understatement, that it was "gratifying to have secured from the collection of Viscount Harcourt, after long negotiations, the *Mars and Venus* by Nicolas Poussin, one of the finest and best preserved of the painter's earlier works. This filled a serious gap in the Museum's collection."[126]

Word of the next Poussin to be purchased, a work of his late period, was sent to Constable in 1946 from Felix Wildenstein in New York. "Pursuant to our previous correspondence regarding the Poussin 'Achilles with the Daughters of Lycomedes,' I am pleased to be able to inform you that the picture is now available. The price of our fine painting is $36,000. for the Museum."[127] According to its previous owner, the Parisian dealer d'Atri, Wildenstein had, in fact, almost lost the painting. Writing to the Museum about the *Achilles* on October 10, 1946, Monsieur d'Atri recalled:

I bought it in 1924 from Mr. Reyre in London. On June 24 I sold it to Wildensteins. Some time after Wildenstein told me that on buying this picture he made a bad purchase. . . . To prove him his mistake I offer to buy the half amount paid, what I did and I got the picture back with me. Short time later Mr. Walter Friedlander came to see me, and was extremely glad to find this picture. He told me that since 20 years he was looking for it. He promise me to illustrate the picture in a art revue and he [wrote or sends] me an expertise [which] corresponds to what he wrote on the Revue. When Wildenstein knows of this expertise he offered me a bargain which unfortunately I accepted and gave him back the picture with expertise. . . . I hope that all this details are good for you.

The acquisition of this second Poussin allowed the *Bulletin* to state that "now The Museum is fortunate in having two important paintings which well represent the two dominant aspects of his oeuvre, the *Mars and Venus* of the earlier '30s, a work in the Ionic mode which reflects his interest in the Venetian Renaissance, and the *Achilles on Skyros*, recently added to the Museum's collections, in the Phrygian mode and both more classical and more Raphaelesque."[128]

With the end of the Second World War, Constable could resume his annual summer visits to the European galleries. In 1947 he saw and reserved at Colnaghi's in London a beautiful Eustache Le Sueur, which was sent to Boston in September. Offered for twelve hundred guineas, it was then known as *A Sacrifice to Diana* (cat. 21). In his recommendation to Edgell of January 8, 1948, Constable gave a well-reasoned justification for its purchase:

This painting by Le Sueur is a first rate example of one of the outstanding figures among seventeenth century French painters. In Le Sueur the French academic tradition found complete expression and from him descends a long line of distinguished painters who have exercised great influence throughout the western world. His color and feeling for light give the work of Le Sueur very personal and distinct characteristics, which are apparent in this painting.

Apart from its artistic importance, the picture would be of great value to the Museum. Our French pictures are one of the strongest parts of the collection; and recently the representation of the seventeenth century French has been considerably

developed. We lack, however, paintings of the type which the Le Sueur so admirably represents. This, indeed, is the case throughout the United States, for I do not know of any other example of the painter in any other Museum.

Also purchased from Colnaghi's in 1952 was the large *Landscape with Saint Jerome and the Lion* (cat. 17) that Constable and Byam Shaw believed to be by Francisque Millet and that Anthony Blunt attributed to his putative Silver Birch Master, but it has more reasonably been identified as a fine example of Gaspard Dughet.

Many offers of French paintings continued to come to the Museum during the 1940s. An especially active relationship was maintained with the New York dealer David Koetser. In 1942 he offered a landscape by Boucher, which was not acquired; the following year he tried again with a Claude Lorrain formerly in Lord Yarborough's collection.[129] This was not pursued, either, but in 1944 Constable learned that the sharp-eyed dealer had acquired at auction an early Claude misidentified as an Everdingen. Koetser was willing to sell it for only six thousand dollars and sent it off to the Museum that February.[130] Constable wrote to him on March 10 that "the Committee decided to acquire" the work but that "it was not, however, easy going, though I am personally delighted." This early work of the master (cat. 10) provides a marked contrast to the late *Apollo and the Muses on Mount Helicon*, which coincidentally had also formerly been in the great Wynn Ellis collection.[131]

Although Koetser wrote on March 4, 1944, that he had received a cable from his brother in London stating "that our gallery had been hit by a bomb and the paintings were destroyed," he continued his activities and on November 14 reported buying another Claude Lorrain in London,[132] as well as a Boilly, *Madame Maryshkina at Her Easel.* These were not purchased, but in 1947 a *Seaport* believed to be an unrecorded Claude from the collection of the earl of Drogheda was acquired from him for $7,500.[133] It, however, did not hold up and was later deaccessioned.

Of the great nineteenth-century masters, the Museum still owned neither a David nor an Ingres. In 1936 Felix Wildenstein offered an Ingres self-portrait,[134] and Paul Byk of Arnold Seligmann offered David's large *Count Potocki on Horseback.* In 1948 two paintings by Ingres, an *Angelica* and a *Stratonice*, were on the market, the former with Wildenstein, but Constable, in a memo of May 13 to Edgell, rated them of less importance than works by Titian, Tintoretto, Caravaggio, and Hals also being considered.

It seems that in the 1940s Constable became interested in acquiring examples of earlier nineteenth-century French landscapes. He was considering an upright landscape by Bertin and two attributed to Michallon, both at the Vose Galleries in Boston. Robert C. Vose wrote, "I regret I have no information as to the European source from which my Father got these three pictures. They were purchased in the early [18]70s when Father, William H. Hunt, and Thomas Robinson were the triumvirate of art dealers in New England." He concluded his endorsement by stating, "I absolutely

guarantee these three paintings, two by Michallon and one by Victor Bertin. All my life I have seen them in Father's collection, with the exception that the Michallon I have here, he sold to his close friend, our family physician, Joseph C. Ely, of Providence."[135] The one Michallon acquired from Vose in 1943 is now given to Bidauld (cat. 75), and the Museum's charming Bertin (cat. 87) came in 1944 from the Prendergast bequest.

During the late 1940s two great private collections—those of Maxim Karolik and John T. Spaulding—were added to the Museum. Although neither is thought of in terms of earlier French paintings, they each added a work to that area of the Museum's holdings. In the collection of works by both identified and unknown primitive American artists that was formed by Karolik, and donated by him in 1947,[136] was a still life that is definitely seventeenth-century French (cat. 25). Spaulding, one of Boston's greatest collectors of European art, had a particular fondness for still lifes, which were exhibited in 1931. When his bequest came to the Museum in 1948, in addition to many of the later nineteenth- and twentieth-century examples was an eighteenth-century work believed to be a Chardin.[137] This painting (cat. 37) has proven problematic, however, and the discovery of a portrait underneath suggests it may be of a later date.

At the end of the 1940s and the beginning of the 1950s several portraits were added. A young boy by Greuze, given by Edwin H. Abbot in 1949 (cat. 55), had a distinguished provenance from the sculptor Pigalle and was then sold from the Pushkin Museum by the Soviet government. From Mrs. Albert J. Beveridge in 1947 came *Portrait of a Woman*, believed to be Mademoiselle Desmares, after Santerre (cat. 26). A Rigaud-school portrait of a magistrate (cat. 28) was given by the Gardiners in 1950.[138]

Following the death of Edgell in 1954 and the retirement of Constable in 1957, Perry T. Rathbone assumed both of their positions. He, too, was fortunate during his tenure in obtaining major collections for the Museum of Fine Arts. In 1961, with the French paintings gallery handsomely reinstalled (fig. 11), the Annual Report stated: "One of the most important gifts of painting ever received by the Museum of Fine Arts was the presentation of nine works by the Fuller Foundation in memory of Governor Alvan T. Fuller."[139] The governor, who had made a fortune from automobile sales, had in his collection works by Greuze and Hubert Robert, but presented to the Museum was "the little Shepherd Boy by François Boucher," described as "a delightful bucolic fragment from the age of Marie Antoinette. . . . This small easel painting [cat. 41] adds substantially to our French rococo collection."[140]

The year 1965 was the most significant in terms of increasing the Museum's holdings of eighteenth-century French art for, through Rathbone's blandishments, it received in that year the collection of the connoisseur Forsyth Wickes (fig. 12). This extensive bequest consisting of over nine hundred objects, including paintings, pastels, drawings, furniture, sculpture, porcelain, silver, and glass, had been housed at Wickes's residence, Starbord House,

Fig. 11. French paintings gallery, 1963. Reproduced from Annual Report for 1963. Photograph, Museum of Fine Arts, Boston

Newport (fig. 13).[141] The collection, with its notable paintings by Boucher, Fragonard, Robert, Lancret, and others, was installed in galleries re-creating the settings of the house (fig. 14) and opened to the public on October 20, 1968.[142]

In Rathbone's era diverse paintings were purchased by the Museum, including several of the earlier French school. Having a great interest in still life, he acquired in 1963 the mysterious picture signed "Nichon" but copied after Stosskopf's *Still Life with Carp* (cat. 24). As the Annual Report related:

> The purchase of a *Still Life with Carp* by P. Nichon brings to the collection its first example of the school of *Réalité* that flourished in seventeenth century France, a foil to the intellectual Classicism of Poussin and Claude. Despite its humble subject, the painting reveals a refinement of abstract composition and subtle color harmony of the highest order. Although the only known work by this artist, it is an accomplished amalgamation of baroque vitality with French rationality.
>
> [The report continued]: The elegant sophistication of French art at the end of the following century is evident in the polished virtuosity of the portrait of the sculptor *Jean Jacques Caffieri*, by Adolphe-Ulrik Wertmüller (1751–1811). Like so many promising young men of his time this youthful Swede was drawn to Paris to work in that artistic center as it flourished under Jacques Louis David. Painted as a *morceau de réception* for the Académie in 1784, its translation of subtle textures and rich colors rivals the work of his master, David, whose false signature it had in fact carried for many decades.[143]

This truly grand eighteenth-century portrait (cat. 71) was purchased from Kleinberger and Co.

A fine but problematic religious painting—a *Crucifixion*—presents a mystery as to its origins. Having been added as a Flemish work, it is probably of the Le Nain school (cat. 14). Rathbone's

buying culminated with a series of acquisitions for the centennial of the Museum in 1970. These were displayed in the exhibition *Art Treasures for Tomorrow*. One of the single most striking paintings presented was the large *Bacchus and Ariadne* (cat. 20). From a private collection in South America, it was sold to the Museum by Heim Galleries of London as a Vouet. Even at that time, however, the exhibition catalogue noted that "the supposition has been made that the Museum's *Bacchus and Ariadne* could be an early work by Vouet's famous pupil Le Sueur."[144] Also added were two other works of great scale—the pair of biblical paintings by Sébastien Bourdon purchased in 1968 from Wildenstein (cats. 18 and 19).[145]

A decade would pass before the Paintings Department, now under the direction of John Walsh, again actively began acquiring French paintings. The acquisition of unusual and distinctive works commenced in 1978 with Mathieu Le Nain's *Entombment of Christ* (cat. 13), purchased and presented by John Goelet in memory of George Peabody Gardner. That same year a rococo history piece, Noël Hallé's *Death of Seneca*, was acquired from Heim Gallery (cat. 49). An unusual seventeenth-century painting of St. Stephen mourned by Gamaliel and Nicodemus was also purchased that year. Although from the circle of Saraceni, it has sometimes been attributed to the French-born artist Jean Leclerc.[146]

As the 1980s began, some distinctive nineteenth-century works were obtained. Turpin de Crissé's large *Bay of Naples* (cat. 90) and Taillasson's *Cleopatra* (cat. 69) came in 1980 and 1981, respectively, from London dealers. One of the grandest of the Museum's superb portraits, Largillière's *Portrait of François-Armand de Gontaut, Duc de Biron* (cat. 27), was acquired in 1981 from Cailleux Gallery of Paris just in time to be lent to the extensive monographic exhibit in Montreal. That same year a delicate portrayal of a sad young girl by Lépicié (cat. 64) was purchased from Somerville and Simpson. Then, in 1982, *Portrait of a Man* by Greuze (cat. 53), which had long been in a Massachusetts collection, was bought "at an advantageous price" (as John Walsh noted at the time), from the family. At the end of the year, a painting by Boilly depicting a young woman ironing (cat. 78) was purchased from the London firm Hazlitt, Gooden and Fox, shortly after it appeared at auction. As the gallery wrote, they were "delighted that everyone concerned is charmed by the picture."[147] A number of gifts also increased the range of French paintings. From Mrs. Charles Sumner Bird came what John Walsh described as a "fascinating group of pictures,"[148] which included works by Bertin, Mallet, and one after Ducreux (cats. 88, 77, and 62). The dealer Colnaghi graciously presented the Museum with two small but brilliant depictions of La Fontaine fables by Subleyras (cats. 38 and 39) in 1983.

The most recent addition to the Museum's holdings of French paintings found in this catalogue is a work from the remarkable collection formed by William A. Coolidge, which had long been on deposit at the Museum, and came as a bequest in 1993 from the generous trustee. As Peter C. Sutton noted, Mr. Coolidge was "unusual by Boston standards in his appetite for Old Master paintings, especially his enthusiasm for religious paintings."[149] In fact, his one

Fig. 12. Forsyth Wickes in Paris. Photograph, Museum of Fine Arts, Boston

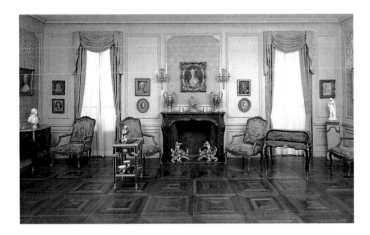

Fig. 13. Salon at Forsyth Wickes's home, Starbord House, Newport, Rhode Island. Photograph, Museum of Fine Arts, Boston

Fig. 14. Forsyth Wickes Gallery, Museum of Fine Arts, Boston. Photograph, Museum of Fine Arts, Boston

earlier French painting, the superb portrait of a Carmelite prior by Philippe de Champaigne (cat. 16), falls into this category. In the same writer's words, it "offers a sort of pictorial apostolic succession in the form of a portrait."[150]

1. See A. R. Murphy, "French Paintings in Boston, 1800–1900," in Museum of Fine Arts, Boston, *Corot to Braque* (Boston, 1979), pp. xvii–xlvi; E. Zafran, "Monet in Boston," in Tokyo 1992, pp. 25–76; and also C. Troyen and P. S. Tabbaa, in Boston 1984, pp. 11–40.

2. As recorded in R. F. Perkins, Jr., and W. J. Gavin III, eds., *The Boston Athenaeum: Art Exhibition Index, 1827–1874* (Boston, 1980).

3. Boston 1827, p. 5, no. 181.

4. W. M. Whitehill, "The Centenary of the Dowse Library," *Proceedings of the Massachusetts Historical Society* 71 (1953–57), pp. 177–78; P. H. Rodgers and C. Sullivan, eds., *A Photographic History of Cambridge* (Cambridge, Mass., 1984), p. 19.

5. J. P. Harding, "The Painting Gallery," in Boston Athenaeum, *A Climate for Art: The History of the Boston Athenaeum Gallery, 1827–1873* (Boston, 1980), p. 18.

6. Downes 1888, p. 501.

7. Guiffrey 1913, p. 542.

8. Whitehill, "Dowse Library," p. 178.

9. Addison 1910, p. 88.

10. Sale Sotheby's, New York, June 4, 1980, no. 52.

11. See S. R. Stein, *The Worlds of Thomas Jefferson at Monticello* (New York, 1993), p. 137.

12. See C. Sellers, *Benjamin Franklin in Portraiture* (New Haven, 1962), p. 253.

13. See Harding, "Painting Gallery," p. 10; and *Handbook of the Museum of Fine Arts* (Boston, 1906), p. 94.

14. Addison 1910, p. 89.

15. Stein, *Worlds*, p. 136, no. 12.

16. M. M. Swan, *The Athenaeum Gallery, 1827–1873: The Boston Athenaeum as an Early Patron of Art* (Boston, 1940), p. 124.

17. Sale Sotheby's, New York, May 30, 1979, no. 286.

18. Harding, "Painting Gallery," p. 13.

19. Sale Christie's, New York, January 11, 1991, no. 7.

20. Letter, June 19, 1991, Athenaeum files.

21. See M. C. Crawford, "Edward Preable Deacon House," *New England Magazine* (April 7, 1901), pp. 15–18; Whitehill 1959, pp. 125–26; and Whitehill 1970, vol. 1, p. 35.

22. Frank A. Leonard, *Catalogue of the Valuable Original Oil Paintings . . . of the "Deacon House"* (Boston, 1871), pp. 12–13 and 24.

23. From the Trustees' Minutes of 1871, microfilm, William Morris Hunt Memorial Library, Museum of Fine Arts, Boston.

24. Museum of Fine Arts, Boston, *Annual Report* (1873), p. 11.

25. Museum of Fine Arts, Boston, *Catalogue of the Collection of Ancient and Modern Works of Art* (Boston, 1872), p. 31.

26. Whitehill 1970, vol. 1, p. 18.

27. Perkins and Gavin, *Boston Athenaeum Art Exhibition Index*, p. 91.

28. *BMFA* 25, no. 147 (1927), p. 10.

29. Perkins and Gavin, *Boston Athenaeum Art Exhibition Index*, p. 46.

30. Museum of Fine Arts, Boston, *Annual Report* (1877).

31. On the Sumner collection, see A. B. Johnson, "Recollections of Charles Sumner," *Scribner's Monthly* 10 (Nov. 1874), pp. 109–10; W. G. Constable, "A Cranach from the Sumner Collection," *BMFA* 41, no. 246 (Dec. 1943), pp. 64–68; and Troyen and Tabbaa, in Boston 1984, p. 12.

32. Guiffrey 1913, pp. 542–43.

33. Note of October 16, 1880, in Museum files. (Hereafter it will be understood that manuscript and typescript correspondence is held in either object files in the Paintings Department or the Archives of the Museum of Fine Arts, Boston, and shall be referred to as "Paintings Department files.")

34. See Zafran, "Monet in Boston," in Tokyo 1992, pp. 27–28; and Troyen and Tabbaa, in Boston 1984, p. 16.

35. "American Art Chronicle, Museum of Fine Arts, Boston," *The American Art Review* 1–2, no. 3 (Nov. 1880), p. 37.

36. See Whitehill 1970, vol. 1, pp. 11–12; and Annual Report for 1883, p. 7. For Brimmer, also see E. W. Emerson, *The Early Years of the Saturday Club* (Boston, 1918), pp. 366–75.

37. Acc. no. 85.255. See Annual Report for 1885, p. 15; and Downes 1888, p. 500. See also Murphy 1985, p. 103.

38. See Martin Green, *The Mount Vernon Street Warrens* (New York, 1989).

39. Acc. no. 77.249. See Alexandra R. Murphy, *Jean-François Millet* (Boston, 1984), p. 207, no. 141.

40. See Green, *The Mount Vernon Street Warrens*, p. 38; Troyen and Tabbaa, in Boston 1984, p. 20; E. Zafran, "On the Collecting of Early Italian Paintings in Boston," in Laurence B. Kanter, *Italian Paintings in the Museum of Fine Arts, Boston*, vol. 1 (Boston, 1994), p. 24; and E. E. Hirshler, "Mrs. Gardner's Rival Susan Cornelia Warren and Her Art Collecting," *Fenway Court* (1988), pp. 51–52.

41. Green, *The Mount Vernon Street Warrens*, p. 57; and Museum of Fine Arts, Boston, *Special Exhibition of Paintings from the Collection of the Late Mrs. S. D. Warren* (Boston, 1902).

42. Paintings Department files.

43. Downes 1888, p. 500.

44. Ibid., pp. 501.

45. Ibid.

46. Ibid., pp. 501–502.

47. R. van N. Hadley, ed., *The Letters of Bernard Berenson and Isabella Stewart Gardner, 1887–1924* (Boston, 1987), p. 40.

48. P. Hendy, *European and American Paintings in the Isabella Stewart Gardner Museum* (Boston, 1974), p. 58.

49. Hadley, *Letters*, p. 84.

50. Ibid., p. 85.

51. Ibid., p. 104.

52. Ibid., p. 105.

53. Hendy, *European and American Paintings*, p. 45.

54. Guiffrey 1913, p. 540.

55. Letter to General Loring, August 3, 1898. On the painting, see C. B. Bailey, in Kimbell Museum, *The Loves of the Gods* (Fort Worth, 1991), p. 148, no. 39.

56. P. N. Dunbar, *The New Orleans Museum of Art, the First Seventy-Five Years* (Baton Rouge and London, 1990), pp. 4–6 and cover ill.

57. On Ross see Whitehill 1970, vol. 1, p. 15; Troyen and Tabbaa, in Boston 1984, p. 21; and Zafran, "Collecting of Early Italian Paintings," p. 18.

58. Addison 1910, p. 88. For "The Ross Gift" see *BMFA* 4, no. 22 (Oct. 1906), pp. 35–37.

59. Letter, July 17, 1907.

60. Letter, June 27, 1920. See *BMFA* 18, no. 110 (Dec. 1920), p. 66.

61. Acc. no. 20.1630. See Murphy 1985, p. 165.

62. Letter of February 27, 1921.

63. Letter of February 12, 1921.

64. Letter of June 18 or 27, 1921.

65. T. G. Appleton, *A Companion to the Catalogue* (Boston, 1877), p. 55.

66. Ibid., p. 56.

67. Annual Report for 1911, p. 17.

68. Ibid., p. 115.

69. Annual Report for 1912, p. 1.

70. Ibid., p. 109.

71. See Zafran, "Collecting of Early Italian Paintings," p. 28.

72. Annual Report for 1913, pp. 112–13.

73. *BMFA* 12 (1914), p. 34.

74. On Gay's role for the Museum see Zafran, "Collecting of Early Italian Paintings," p. 27, and in general the exhibition catalogue, *Walter Gay, a Retrospective*, Grey Art Gallery and Study Center, New York University (New York, 1980).

75. Gay to Fairbanks, November 7, 1918.

76. August 14, 1919. See *BMFA* 17, no. 104 (Dec. 1919), p. 64.

77. Cable of January 30, 1924.

78. According to a cable from the Museum to Helleu, March 21, 1924.

79. Correspondence between Fairbanks and Coolidge of April 25 and 26, 1924.

80. Morris Gray to Fairbanks, January 31, 1924.

81. Charles Hawes to Gay, June 15, 1927.

82. June 30, 1927.

83. See Troyen and Tabbaa, in Boston 1984, p. 25.

84. Invoice of February 1904 in the Paintings Department files gives the sale price as $8,270 and states the work came from the collection of the baron de Beurnouville. Mrs. Evans's collection was subject to a life-interest gift to Miss Belle Hunt and only came to the Museum after the latter's death. See Annual Report for 1936, p. 36.

85. Acc. no. 17.3220. See Murphy 1985, p. 119. Sale Christie's New York, January 14, 1993, no. 34.

86. Letter of March 4, 1921, from Mr. Paff (of Durlacher's) to Fairbanks.

87. *BMFA* 22, no. 127 (Feb. 1924), p. 2.

88. See Rosenberg and Stewart 1987, p. 67.

89. *BMFA* 22, no. 132 (Aug. 1924), p. 1; and *BMFA* 23, no. 138 (Aug. 1925), p. 41.

90. *BMFA* 26, no. 158 (Dec. 1928), p. 114.

91. Letter of July 14, 1924.

92. H. La Pauze, "Un Ingres qui n'est pas un Ingres," *La Renaissance* 7, no. 11 (Nov. 1924), p. 620.

93. On Parsons see Zafran, "Collecting of Early Italian Paintings," pp. 29 and 31; and also D. Sox, "Harold Woodbury Parsons 'Marchand Amateur,'" *Apollo* 141, no. 400 (June 1995), p. 19.

94. Letters of March 29 and April 9, 1935.

95. Letter of November 30, 1934.

96. On Paine see Troyen and Tabbaa, in Boston 1984, p. 29.

97. Letters from René Seligmann to Edgell of January 28 and March 9, 1935.

98. Sold for £1,700 according to cables of October 4 and 5, 1934, and letter of

October 5. See P. C. Sutton, in Museum of Fine Arts, Boston, *The Age of Rubens* (Boston, 1993), p. 400, no. 61.

99. Letter of October 14, 1938.

100. Letter of December 6, 1938.

101. Cable of January 12, 1939.

102. Museum of Fine Arts, Boston, *Art in New England* (Boston, 1939), nos. 45, 47, 86, 87, 111, and 138.

103. Letter of October 17, 1939.

104. Letter of November 21, 1939.

105. Letter of December 6, 1939.

106. Letter of January 3, 1940.

107. Letter of January 31, 1940.

108. Letter from E. Stiebel, June 16, 1940.

109. Letter of August 6, 1940.

110. Letter of August 8, 1940.

111. As reported to Stiebel, August 23, 1940.

112. Letter of June 25, 1945.

113. Annual Report for 1940, p. 42.

114. Letter of March 17, 1947.

115. Letter of March 19, 1947.

116. Letter of May 8, 1947.

117. Memorandum of June 12, 1947.

118. The unidentified painting is mentioned in correspondence of March 12 and April 7, 1937.

119. Letter of May 11, 1939.

120. Letter of December 18, 1939.

121. Letter of December 20, 1939.

122. Letter of January 20, 1940.

123. The cable is undated but the follow-up letter is dated October 24, 1939.

124. Cable of November 19, 1939.

125. Letter of April 17, 1940.

126. Annual Report for 1940, p. 42.

127. Letter of April 29, 1946.

128. *BMFA* 45, no. 259 (Feb. 1947), p. 2.

129. October 21, 1942, and July 12, 1943.

130. Letter of February 26, 1944.

131. Smith 1837, no. 27. Both works were sold at Christie's, London, on June 17, 1876 (nos. 4 and 6). For this collection see Ivan Gaskell, in Canterbury Museums, National Gallery, *Master Paintings from the Collection of Wynn Ellis of Whitstable* (Canterbury, 1990).

132. Letter of March 4, 1944.

133. Letter of June 12, 1947.

134. Letter of April 28, 1936, from Felix Wildenstein to Charles Cunningham.

135. Letter of February 9, 1943, from Vose to Constable.

136. Troyen and Tabbaa, in Boston 1984, pp. 36–38.

137. Ibid., p. 31.

138. Annual Report for 1950, p. 36.

139. Annual Report for 1961, p. 64.

140. Ibid.

141. See Rathbone 1968a; and Munger et al. 1992.

142. Annual Report for 1968, p. 45.

143. Annual Report for 1963, pp. 65, 66.

144. Museum of Fine Arts, Boston, *Centennial Acquisitions: Art Treasures for Tomorrow* (Boston, 1970), p. 74, no. 46.

145. Ibid., pp. 76–77, nos. 47 and 48.

146. Acc. no. 1978.140. See Paris 1982, cat. 42; and Rosenberg 1984, p. 30.

147. Letter of December 14, 1982.

148. Letter of September 9, 1981, from Walsh to Mrs. Bird.

149. Sutton 1995, p. 18.

150. Ibid.

FRENCH PAINTINGS
in the MUSEUM *of* FINE ARTS, BOSTON

CATALOGUE *Artists born before* 1790

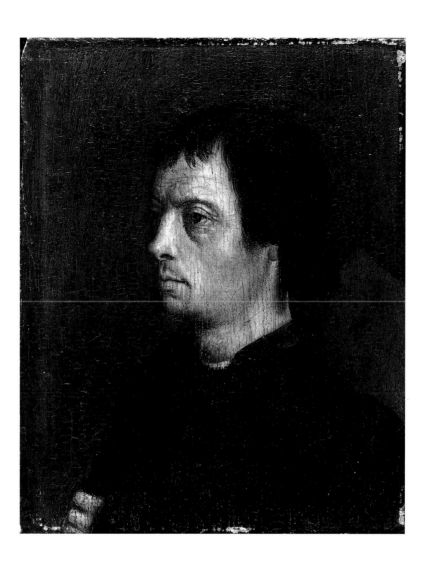

French School

I. *Portrait of a Man*, about 1500

Oil on panel
7 × 6 in. (18 × 15 cm)
Maria Antoinette Evans Fund
25.48

PROVENANCE: Fritz von Gans, Frankfurt am Main; K. W. Bachstitz, The Hague, ca. 1920; P. Jackson Higgs, New York, 1920–25.

EXHIBITION HISTORY: The Hague, The Bachstitz Gallery, 1920, cat. 48; The Hague, The Bachstitz Gallery, *Primitive Masters*, 1922, cat. 9.

REFERENCES: *International Studio* 79 (Sept. 1924), cover ill.; Hawes 1925; J. Held, "Zwei Ansichten von Paris beim Meister des Heiligen Ägidus," *Jahrbuch der Preussischen Kunstsammlungen* 53 (1932), p. 12; P. Wescher, "Die französischen Bildnisse von Karl VII bis Franz I," *Pantheon* 21 (1938), p. 8; Ring 1949, p. 231, no. 250; Boston 1955, p. 41; Murphy 1985, p. 181 (as Master of Saint Giles); Sterling 1990, pp. 288–89, fig. 258; Girault 1994, pp. 14–15, no. 8, fig. 14.

CONDITION: The support is a vertically grained wood panel, beveled at the back edges. The paint is applied thinly over a pale ground. Infrared and radiographic examination reveals the second hand of the sitter beside his visible left hand, which was painted over in a previous restoration. The paint layer is abraded and is in poor condition. Overpaint covers much of the background, a thin green (copper resinate?) layer can be seen in the cracks and around the head of the man, and there are some abrasions in the darks and also some discrete losses along the grain of the wood in some areas, many of which have been retouched.

In 1920 Max Friedländer attributed this portrait to the Maître de Moulins,[1] and it was published as such by C. H. Hawes in 1925 with the tentative identification of Peter II, duke of Bourbon, and the observation that "[t]he flesh tones of the face, which is moulded with remarkable success for one of such miniature proportions, are charmingly balanced against a green-blue background and clothes of a rich mulberry black."[2] In 1932 Julius Held attributed it to the Master of Saint Giles, as did P. Wescher in 1938.[3] The key works by this master are a pair of pendant portraits in the Musée Condé, Chantilly, although they have also been assigned to Gerard David.[4] Grete Ring rejected the attribution of the Boston portrait to the Master of Saint Giles and considered it a Flemish work of about 1480.[5] Charles Sterling, who in 1943 had suggested it might be half of a diptych,[6] wrote more recently that as the man does not hold a rosary, it is an independent secular portrait. While acknowledging some superficial similarity to the *Portrait of a Man* by the Master of Saint Giles at Chantilly, he notes that the condition of the Boston panel mitigates against a final judgment. Nonetheless, he hazards that it is probably by a French artist, working in Paris about 1495–1500, under the influence of the Master of Saint Giles.[7] Pierre-Gilles Girault was willing to postulate that the work was a collaboration of the Master of Saint Giles and a French assistant.[8] Given the work's small size and poor state of preservation, this

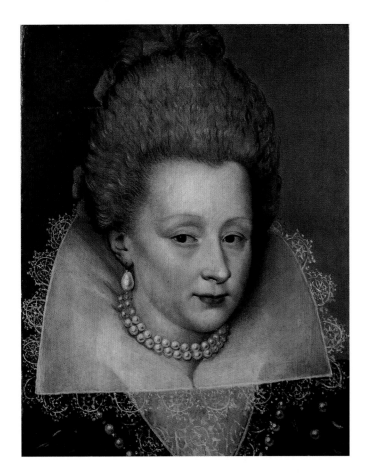

Attributed to Etienne Dumonstier
1520–1603

2. *Portrait of a Woman*

Oil on panel
14 1/2 × 10 3/4 in. (36 × 27.2 cm)
The Forsyth Wickes Collection
65.2642

PROVENANCE: Château de Montbreson (?); Forsyth Wickes.

REFERENCES: Murphy 1985 (as French, fourth quarter, 16th century), p. 103; Zafran, in Munger et al. 1992, p. 69, no. 8.

CONDITION: The support is a cradled and thinned wood panel, laminated to a second layer of wood. The paint is thinly applied over a double ground, composed of a cream-colored layer below a partial gray layer. The topmost paint layer has become transparent with age and is badly abraded. Overpaint covers large areas of the face, collar, and background.

The Dumonstiers (or Dumontiers) were a dynasty of painters employed by the royal court of France from the sixteenth into the seventeenth century.[1] The most famous members were Pierre and his cousin Daniel. This particular example, however, was attributed by Louis Réau to Etienne,[2] who worked for a succession of monarchs from Henri II, François II, Charles IX, and Henri III, to Catherine de' Medici. A portrait that is very similar in facial type, hairstyle, clothing, and jewelry is that of "la belle Corisande," Diane d'Andouin, which is also attributed to Etienne Dumonstier.[3] Although formerly identified as Catherine de Gonzaga, the woman in the Wickes painting actually bears a stronger resemblance to supposed portraits of Gabrielle d'Estrées (mistress of Henri IV).[4]

1. See J. Guiffrey, "Les Dumonstier," *Revue de l'art ancien et modern* 18 (1905), pp. 136–46, and J. Adhémar, "Les Dessins de Daniel Dumonstier du cabinet des estampes," *GBA* 75 (1970), pp. 129–50.

2. In an expertise written on the back of an old photograph of the Wickes painting in the Service de la Documentation, Musée du Louvre.

3. At Versailles, M.V. 3895.

4. Dimier 1924–26, vol. 1, pl. 56.

School of François Clouet
French (?), mid-16th century

3. *Portrait of a Man*

Oil on paper mounted on wood panel
4 1/2 × 3 1/4 in. (11.4 × 8.9 cm)
The Forsyth Wickes Collection
65.2668

PROVENANCE: Edouard Warneck, Paris; Galerie Georges Petit, Paris, May 27–28, 1926, no. 9 (as Maître français, *Portrait présumé de Comte de Gordes [simiane]*,

seems unlikely. However, the same writer's observation that there is evident here a reminiscence of Rogier van der Weyden and Hugo van der Goes is apt. Especially striking is the severe, even strained expression, often found in Hugo's portraits. What would have been equally characteristic of that source of inspiration is the second hand of the sitter, probably in an attitude of prayer, which has been overpainted.[9] The discovery of this hand suggests that Sterling's original idea—that the panel is one half of a diptych—may be correct.

1. According to the information supplied by the dealer Higgs in 1925.

2. Hawes 1925, p. 41.

3. A letter from Prof. Held, January 3, 1942, Paintings Department files, notes that he made his attribution from photographs and that Wescher "came independently to the same attribution."

4. Sterling 1990, p. 287, no. 28. In correspondence, Colin Eisler has noted a similarity of the Boston painting to works by David.

5. Ring 1949, p. 231, no. 250.

6. In a verbal opinion of March 26, 1943, recorded in the Paintings Department files.

7. Sterling 1990, pp. 288–89.

8. Girault 1994, p. 15.

9. For examples by Hugo in New York and Baltimore, see J. Sander, *Hugo van der Goes* (Mainz, 1992), pp. 127–39, pls. 24–25.

mignon de Henri III); private collection, Paris; Wildenstein and Co., New York; purchased December 22, 1958, by Forsyth Wickes.

REFERENCE: Zafran, in Munger et al. 1992, p. 67, no. 5.

CONDITION: The pale paper support is unevenly attached to a vertically grained wood panel. The paint is thinly applied, with some impasto describing the sitter's garments. The thin, descriptive lines appear slightly abraded. The painting is in good condition.

The Warneck sale catalogue of 1926 was rightly cautious in attributing and identifying this small painting, noting that "it has also passed as a portrait of the duc d'Alençon, brother of Henry III. A later inscription on the *dos du panneau* [back of the panel] attributes it to Janet (F. Clouet) and dates it 1571. It resembles the style of Clouet, but the uncertainties that exist around the French portrait painters of this period do not permit a definite attribution." In many ways this confusing state has not improved since 1926 and no other convincing attribution has been put forward. The quality of the painting is high, the characterization sharp and precise, comparable to several of Clouet's portraits,[1] but it is not impossible, as Pierre Rosenberg has suggested,[2] that the work is actually English, growing out of the miniature tradition of Hilliard.

1. See, for example, *Portrait of Jacques de Savoie* at Chantilly and *Portrait of Henri II* at the Louvre; the similarity of his features to François, duc d'Anjou et

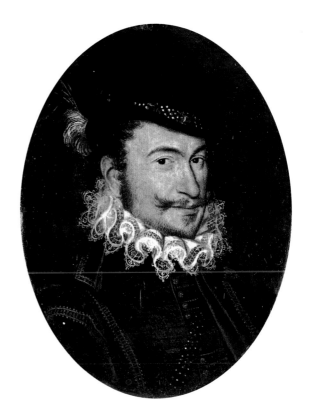

d'Alençon, can be seen in the Palazzo Pitti, *Pittura francese nelle collezioni pubbliche fiorentine* (Florence, 1977), no. 174.

2. In conversation, February 1990.

CORNEILLE DE LYON

active by 1534–1575

A master portraitist in miniature, Corneille de Lyon was born in The Hague and probably received his training in Flanders. However, he acquired his name and fame at Lyon, where he was resident by 1533. The following year he was made a court painter to Queen Eléonore and then to the dauphin, the future Henri II. In 1551 Corneille de Lyon, who had become a French citizen in 1547, was given the title *peintre et valet de chambre du roi*. The artist established a large studio, which included his children, and thus it is often difficult to distinguish his original works from the many other characterful portraits, usually set against green backgrounds, that the studio produced.

4. *Portrait of a Bearded Man*

Oil on panel
6 3/4 × 5 1/4 in. (17.1 × 13.4 cm)
Seth K. Sweetser Fund
28.821

PROVENANCE: Montbrison collection, Paris; sale Galerie Georges Petit, Paris, May 8, 1891, no. 18 (as François Clouet); Monsieur Gallay, Paris, 1891; to his heirs, to 1928; Félix Landry, Paris, 1928.

REFERENCES: *BMFA* 26 (Dec. 1928), p. 114; Boston 1932, ill.; Murphy 1985, p. 57 (as Workshop of).

CONDITION: The wood panel has been thinned and cradled. The right side of the panel, roughly from the sitter's ear to the edge, is a replacement section. The paint is thinly applied over a smooth, light-colored ground; underdrawing is visible, especially at the sitter's nose and mouth. The paint layer has been abraded; retouched areas include the background and the sitter's right ear. Several raised channel lines of paint caused by worm tunnels are detected.

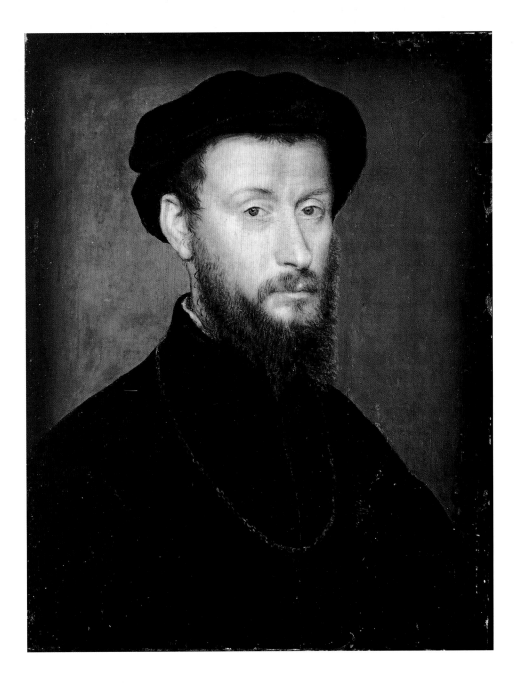

Against an olive green background, a bearded gentleman wearing a black coat is shown bust-length. His head is turned but his gaze is directed at the viewer.

When sold in the nineteenth century, this portrait was given to Clouet (q.v.), but the dealer Félix Landry noted that by the time he had the painting, the more convincing attribution to Corneille de Lyon had been made by "experts."[1] This was supported by Charles Sterling in 1943, who considered it "of the first quality, justifiably to be attributed to Corneille de Lyon himself and a mature work."[2] More recently Anne Dubois de Groër has also accepted it as a work by Corneille, noting that another version of it also by him is in the Musée Fabre in Montpellier,[3] but that it is difficult to establish which came first.[4] A portrait seemingly of the same man was at Newhouse Galleries, New York, in February 1990.[5] Another of just the head and shoulders is in the Musée d'Art et d'Histoire,

Geneva.[6] Quite similar in type, and of equally high quality, is the *Portrait of a Man* in the Fine Arts Museums of San Francisco, in which, as Rosenberg and Stewart have noted, "the sitter's sharp, clear features are subtly highlighted by the black costume and green background."[7]

1. Letter, November 24, 1928, Paintings Department files.

2. Recorded verbal opinion, March 26, 1943, Paintings Department files.

3. A. Joubin, *Catalogue Musée Fabre* (Paris, 1926), no. 812.

4. In a letter of November 23, 1990.

5. Advertisement in *TBM* 132 (Feb. 1990), p. iii.

6. Oil on panel, 12.6 × 9.3 cm, inv. no. 1928-13.

7. Rosenberg and Stewart 1987, p. 26.

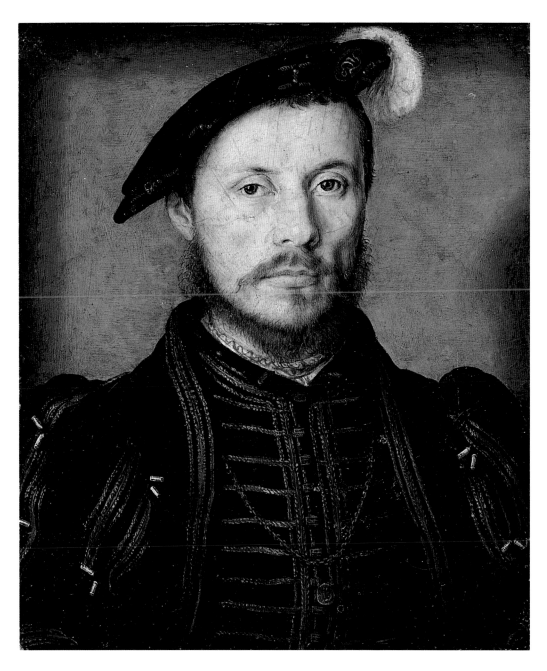

5. *Portrait of a Man*

Oil on panel
6 1/2 × 5 1/4 in. (17 × 14 cm)
Charles Augustus Vialle Fund
24.264

PROVENANCE: Polignac collection, St. Pal de Chalançon, Vivary; Wildenstein, New York, 1924.

REFERENCES: *BMFA* 22, no. 132 (Aug. 1924), p. 1; de Groër 1978, pp. 41–42, fig. 12; Murphy 1985, p. 56.

CONDITION: The pine panel support with horizontal grain has a slight convex warp. The paint is thinly applied over a white ground. Retouching is confined to the larger, disfiguring age cracks and the background to the sitter's left. Some of the pigments have faded over time. The painting is in good condition.

Against a blue background, the man dressed in a black jacket and hat with gold braiding makes a striking impact. As with the best of Corneille de Lyon's portraits, this one has a lively immediacy and, like *Portrait of a Young Man* (cat. 6), shows the sitter looking directly at the viewer. The garments are enhanced by brilliant, sparkling touches of gold, but the greatest emphasis is on the rather tragic face with a curious dark spot on the left cheek. The light source at the left casts a shadow to the right, which adds to the illusion of depth.

Another version of identical size, attributed to Corneille de Lyon and his studio, was recently sold.[1] In it, the doublet is brown and probably unfinished, and there is none of the gold braiding.

1. Sale Christie's, New York, October 15, 1992, no. 5.

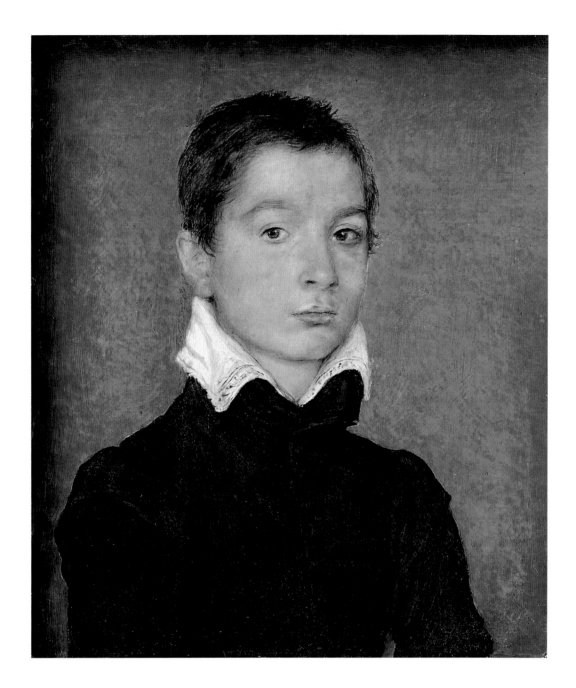

Attributed to Corneille de Lyon

6. *Portrait of a Young Man*

Oil on panel
7 1/8 × 6 in. (18.1 × 15.2 cm)
Helen and Alice Colburn Fund
21.137

PROVENANCE: Negroni collection; Landor collection; Turene collection;[1]
Durlacher Brothers, New York, 1921.

EXHIBITION HISTORY: Paris 1937, no. 50.

REFERENCES: Boston 1932, ill.; de Groër 1978, p. 41, fig. 13; Murphy 1985, p. 56
(as Corneille de Lyon).

CONDITION: The support is a thin, cradled wood panel. The paint is thinly applied over a pale ground, which is visible in areas. The paint layer is abraded and
the coat and background have been extensively overpainted.

Against a light olive green ground, the young man is shown in a
black jacket with a high white collar. This sitter with an innocent
expression is presented without the accoutrements of fame or fortune usually seen in Corneille's work. Charles Sterling, in 1943,
accepted it as "a fine mature work" by the artist,[2] and Anne Dubois
de Groër characterized it as "one of the best and finest portraits of
Corneille."[3] Unfortunately, recent scientific examination of the
painting reveals that there has been much paint loss and most of the
surface is repainted. Therefore, although at first glance or in photographs this seems a satisfactory work, the very patchy nature of
the painting means that judgments of its original quality can only
be speculative.

1. The provenance was supplied by the seller, the dealer Durlacher Brothers, in a
 letter of March 9, 1921, but no corroboration has been found.

2. Note of March 26, 1943, in the Paintings Department files.

3. De Groër 1978, p. 41.

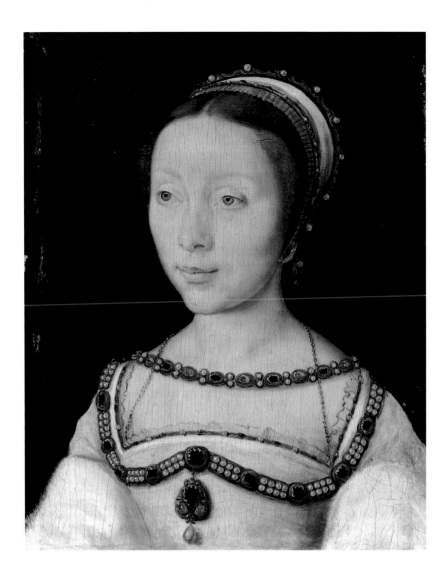

School of Corneille de Lyon
16th century

7. *Portrait of Françoise de Longuy*

Oil on panel
5 7/8 × 4 3/4 in. (15 × 12 cm)
Francis Bartlett Fund
19.764

PROVENANCE: François Flameng, Paris; sale Galerie Georges Petit, Paris, May 26–27, 1919, no. 10; bought at the sale by Walter Gay, Paris, for the Museum.

EXHIBITION HISTORY: Brussels, Hôtel Goffinet, *L'Exposition de la miniature*, 1912, no. 937; Cambridge, Mass., Fogg Art Museum, *French Paintings*, teaching exhibition, July 1–Aug. 14, 1938.

REFERENCES: *GBA* 7 (1912), p. 497, ill.; C. Saunier, "Collection François Flameng," *Les Arts* 14, no. 165 (1918), p. 10; C. H. Hawes, "A Miniature Panel Portrait by Corneille de Lyon," *BMFA* 17, no. 104 (Dec. 1919), pp. 64–65; Boston 1921, p. 81, no. 198; Boston 1932, ill.; Boston 1955, pp. 13–14; Murphy 1985, p. 57 (as Workshop of).

CONDITION: The cradled wood panel support is bordered on all sides by .5 cm wood strips. The paint is thinly applied over a pale ground and abraded. Some pigments have faded, most notably in the rosy tones of the sitter's face and garment. A network of fine cracks appears throughout, which is most distracting in the flesh tones.

Against a black background, the sitter is shown in a robe of pink and white. When it was acquired by Walter Gay at the Flameng sale, this work was catalogued as by Corneille de Lyon, but Gay described it as "in the style of Clouet."[1] On a visit to the Museum in 1943, Charles Sterling suggested it was by Corneille de Lyon, possibly an early work.[2]

This painting is actually a somewhat wooden version of one at Versailles which is crudely inscribed along the top edge MADAME LADMIRALE, namely Françoise de Longuy, l'admirale de Briom. The same sitter, at a slightly later time, appears in a drawing at Chantilly.[3] She was the daugher of Jean de Longuy and Jeanne d'Angouleme (the illegitimate sister of François I). In 1527 she married Philippe de Chabot, known as Admiral de Briom. At one time, the Versailles portrait was also ascribed to Clouet (q.v.),[4] but was later given to the atelier of Corneille de Lyon.[5]

1. Letter of May 29, 1919, to the Museum's director, Arthur Fairbanks.

2. Recorded verbal opinion of March 26, 1943, in the Paintings Department files.

3. School of Clouet, no. 7520. See E. Moreau-Nélaton, *Chantilly: Crayons français du XVIe siècle. Catalogue* (Paris, 1910), no. 226.

4. E. Moreau-Nélaton, *Les Clouets et leurs émules* (Paris, 1924), vol. 2, pp. 147–48.

5. Dimier 1924–26, vol. 2, p. 67.

NICOLAS POUSSIN

1594–1665

orn at Les Andelys in Normandy, Nicolas Poussin received some basic training there before departing for Paris about 1612. His earliest works, done in a late mannerist style, were illustrations of classical mythology and to better understand his subjects and perfect his technique, he went to Italy. Poussin was settled in Rome by 1624 and after several years of struggling found an understanding patron in the humanist poet, Cassiano dal Pozzo, who in turn introduced him to Cardinal Francesco Barberini, the pope's nephew. Poussin painted his first major work, *The Death of Germanicus*, for the cardinal, completing it early in 1628, the same year he received a commission for a large altarpiece, *The Martyrdom of Saint Erasmus*, for St. Peter's cathedral. While continuing to paint such grand religious compositions, including a remarkably original set of the *Seven Sacraments* for Cassiano, Poussin also began producing more modest paintings, works with a sense of color;

concerning poetic, mythological subjects, often on the theme of love; and inspired by Venetian art, especially Titian. Word of Poussin's fame reached France, and Cardinal Richelieu, after commissioning works for himself, summoned the painter in 1640 to return home to work for the King Louis XIII. For the next two years, Poussin toiled unhappily in Paris on large-scale projects until 1642, when he returned to Rome on a pretext. He spent the remainder of his life there. Poussin's late works, including another set of the *Seven Sacraments*, reveal his development of a graver, more austere manner, with expressive use of color to portray scenes of concentrated human emotion and the most harmonious of landscapes. Poussin's refined baroque manner, codified as "Poussinism" became the basis for much French art, not only during the remainder of the seventeenth century but over the following centuries as well.

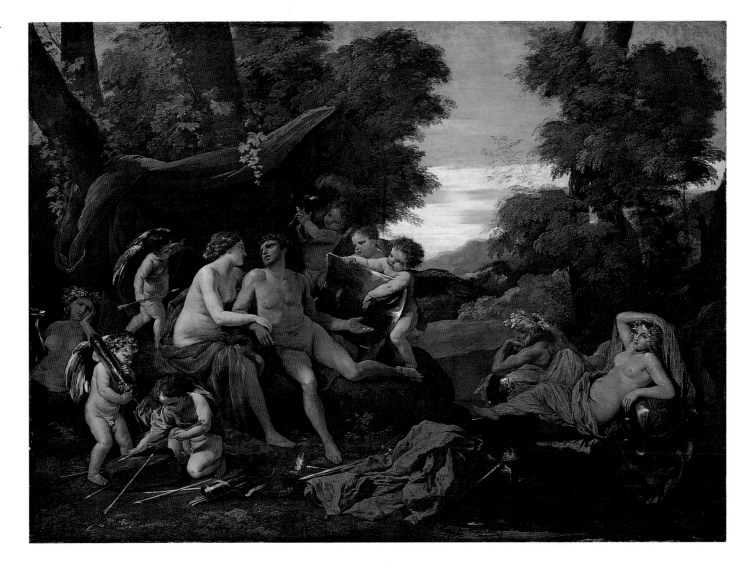

8. *Mars and Venus*, about 1630

Oil on canvas
61 × 84 in. (155 × 213.5 cm)
Augustus Hemenway Fund and Arthur William Wheelwright Fund
40.89

PROVENANCE: Cassiano dal Pozzo, Rome, d. 1657; to his brother, Carlo Antonio dal Pozzo, d. 1689; to his son Gabriele dal Pozzo, d. 1695; to his widow, Anna Teresa, the Marchesa Lancellotti; on her remarriage, about 1703, to her son Cosimo Antonio dal Pozzo; sold 1730, probably to Henry Furnese, d. 1756, Gunnersbury Park; to his sister; sale London, February 4, 1758, no. 55; Simon Harcourt, 1st earl Harcourt (d. 1777), Nuneham Courtenay, Oxfordshire; by descent in the Harcourt family to William Edward Harcourt, 2d viscount Harcourt, d. 1940; Roland and Delbanco, London, 1940.

EXHIBITION HISTORY: London, British Institution, 1823, no. 175; London, Royal Academy of Arts, 1833, no. 194; London, Burlington House, *Seventeenth-Century Art in Europe*, 1938, no. 320; Toledo Museum of Art, *Nicolas Poussin*, 1959, no. 10 (traveled to the Minneapolis Institute of Arts); Paris 1982, no. 86; Fort Worth, Kimbell Art Museum, *Poussin: The Early Years in Rome*, 1988, no. 80; Paris 1994–95, no. 23 (Paris), no. 7 (London).

REFERENCES: *Description of Nuneham-Courtenay in the County of Oxford* (1797), p. 32; J. P. Neale, *View of the Seats of Noblemen and Gentlemen in England, Wales, Scotland, and Ireland* (London, 1823), n.p. (listed as in the Octagon Drawing Room of the Harcourt estate at Nuneham Courtenay); Smith 1837, no. 197; Waagen 1857, p. 350; "Notice sur des tableaux de divers peintres français, conservés dans des collections particuliéres," *Revue universelle des arts* 9 (1860), p. 226; E. W. Harcourt, ed., *The Harcourt Papers* (Oxford, 1880–1905), vol. 3, p. 233, no. 14; Grautoff 1914, vol. 1, pp. 103–104, vol. 2, p. 55, no. 32; *Seventeenth-Century Art in Europe—Illustrated Souvenir* (London, 1938), pl. 80; E. Waterhouse, "Seventeenth-Century Art in Europe at Burlington House," *TBM* 72 (Jan. 1938), p. 4; T. Borenius, "The French School at Burlington House," *TBM* 72 (Feb. 1938), pp. 54–63; A. Blunt, "The Royal Academy Exhibition of Seventeenth Century Art," *Apollo* 26 (Jan. 1938), pp. 7, 9; Cunningham 1940, p. 10; idem, "Poussin's Mars and Venus," *BMFA* 38 (1940), pp. 55–57, ill.; Friedlaender 1942, pp. 17ff.; A. Blunt, *The French Drawings in the Collection of His Majesty the King at Windsor Castle* (Oxford and London, 1945), p. 37; idem, "Poussin Studies—I: Self-Portraits," *TBM* 89, no. 83 (Aug. 1947), p. 219; Friedlaender and Blunt 1953, vol. 3, pp. 30–31; F. S. Licht, *Die Entwicklung der Landschaft in den Werken von Nicolas Poussin* (Berlin, 1954), p. 107; S. Somers-Rinehart, "Poussin et la famille Dal Pozzo," in *Actes* 1960, vol. 1, pp. 29–30; A. Blunt, "La Première Période romaine de Poussin," in *Actes* 1960, vol. 1, p. 167; A. Blunt, "The Leadership of Poussin: I. The Artist's Pictures Come to America," *Art News* 58, no. 9 (Jan. 1959), p. 33, ill.; Haskell and Rinehart 1960, p. 324; D. Mahon, "Poussiniana," *GBA* 60 (July–Aug. 1962), p. 20; Davies and Blunt 1962, p. 214, no. 122; Friedlaender 1964, pp. 22, 25, 118, pl. 13; A. Blunt, "Poussin and His Roman Patrons," in *Walter Friedlaender zum 90. Geburtstag* (Berlin, 1965), p. 61; idem 1966, p. 130, no. 183; idem 1967, pl. 62; K. Badt, *Die Kunst des Nicolas Poussin* (Cologne, 1969), pp. 512, 611–13, no. 18, pl. 80; New York 1970, p. 55, no. 33; Brejon de Lavergnée 1973, p. 87; Baumstark 1974, pp. 182–87; Thuillier 1974, p. 90, no. 45, ill. and p. 116 under no. B29; Takashina and Goto 1977, p. 98 and pl. 16; A. Blunt, *The Drawings of Poussin* (New Haven and London, 1979), p. 194, no. 10; Wild 1980, vol. 2, p. 53; D. Sutton, "Aspects of British Collecting: Part II, New Trends," *Apollo* 116, no. 250 (Dec. 1982), pp. 361–62, fig. 9; R. Verdi, review of *Nicolas Poussin, Leben, Werk . . .* by Doris Wild, *TBM* 124, no. 949 (April 1982), p. 249; Tsuji and Takashina 1984, pl. 22; Wright 1984, pp. 35–36, no. 44; Murphy 1985, p. 231; Wright 1985, p. 248; Stebbins and Sutton 1986, p. 49; E. Cropper, *Pietro Testa, 1612–1650* (Philadelphia, 1988), pp. 23, 26, fig. 136; Del Bravo 1988, p. 166, no. 5; Léveque 1988, p. 63; Standring 1988, pp. 611–13; J. Thuillier, *Poussin* (Paris, 1988), p. 124; Y. Zolotov, *Nicholas Poussin* (Leningrad, 1988), pl. 198; D. Carrier, "Poussin in Fort Worth," *Arts Magazine* 63 (March 1989), p. 63; Mérot 1990, pp. 48, 278, no. 148; Sutherland Harris 1990, p. 151; Dempsey 1992, pp. 435–62; G. Fischer, "Figuren und Farbkomposition in ausgewählten Werken des Nicolas Poussin," *Ars Faciendi* (Frankfurt am Main, 1992), pp. 87–96, 367, 386, fig. 10; Carrier 1993, p. 124, fig. 20, p. 181; A. Sutherland Harris, "Poussin dessinateur,"

in Paris 1994–95, p. 41; Paris 1994, pp. 47, 50; Rosenberg and Prat 1994, vol. 1, pp. 66–67, fig. 35d; Rosenberg, Prat, and Damian 1994, p. 84, fig. 12b; Thuillier 1994, p. 249, no. 61, p. 245 under no. 33, details pp. 47, 115.

CONDITION: The original support, a twill fabric, has been glue-lined with the tacking edges trimmed. The paint is applied over a granular, dark red ground. There are several visible pentimenti in the placement of the draperies, and infrared examination reveals several indistinct compositional changes. The natural ultramarine drapery on the reclining female figure at right has changed and become chalky in appearance, probably the result of past cleaning with acidic solvents. Although some original glazes appear to be missing, the painting is in remarkably good condition.

As Anne Sutherland Harris has written, "what Poussin painted and drew before 1630 and in what order is the most difficult problem of connoisseurship concerning any major 'old master' artist still to be resolved."[1] The date, authorship, and provenance of this exquisite large painting, as well as the exact subject—its meaning, sources, and significance—have all been questioned.

The central figures in the composition, seated on a grassy bank set before a suspended drapery, are Venus, the goddess of love, entwined with her temporary lover, Mars, the god of war. He is identified by his weapons and armor, with which six putti play. His sword and cloak are on the ground at the center, flanked by two torches sometimes associated with the putti or Mars, but perhaps more accurately interpreted by Charles Dempsey as symbolizing the planetary aspects of the two deities—the one glowing gold for Venus, the morning star, and the other the angry red of the planet Mars.[2] To the right of the central group are a pensive river god and a voluptuous nymph; at the left is another melancholy nymph.

A drawing by Poussin in the Louvre, which has sometimes been described as a preliminary study for the painting (fig. 8a),[3] includes a similar grouping of the two gods, although both are draped. The nymph and river god at the right are absent, and the actions of the putti are quite different: One at the lower left rides

Fig. 8a. Nicolas Poussin, *Venus and Mars.* Pen and bistre wash. Paris, Musée du Louvre, Cabinet des Dessins

on the back of a she-wolf, one at the far right is blindfolded and gesturing toward the central figures, and one kneels to untie Mars's sandal.

Another drawing by Poussin of Mars and Venus from the same period in the Musée Condé, Chantilly,[4] shows their positions reversed, with the nude Venus lying to the right and reaching up to pull Mars toward her. Several putti playing with Mars's arms and armor are at the right. This drawing may have served as the basis for a related painting, now in the Louvre, by a Poussin follower.[5]

The early provenance of the Boston painting has been the source of some controversy, due in part to confusion over the work's subject. A *Mars and Venus* by Poussin was included in the inventory made about 1689 by Robert de Cotte of paintings in the collection of Cassiano dal Pozzo,[6] a leading Roman connoisseur and collector from whom Poussin learned much about antiquity and for whom he painted a great many paintings, often of mythological subjects. Whether Cassiano specifically commissioned the *Mars and Venus* is impossible to determine, but we know that he owned a number of the lives of the gods and of bacchanals by Poussin. In later inventories of Cassiano's collection, as it passed to his heirs, the painting seems to have been mistakenly retitled as *Venus and Adonis.* This discrepancy led Arnauld Brejon de Lavergnée to conclude that the Boston painting had not been in the dal Pozzo collection.[7] Subsequently, however, Timothy Standring discovered other dal Pozzo family inventories and documents from which he could deduce that, despite the misidentification of the subject, the painting did pass through the dal Pozzo family as indicated in the provenance given above. Gabriele dal Pozzo's widow, Anna Teresa, retained ownership of the collection until she married the Marchese Scipione Lancellotti, at which time it reverted to her son from her first marriage, Cosimo Antonio dal Pozzo. As Standring writes, "a legal declaration of 22nd July 1731, records that in 1730 'certi inglesi' in Florence had contracted with Cosimo Antonio to purchase four paintings by Poussin then held in Rome by the Marchesa Ginnetii Lancellotti."[8] Standring further elaborated in a letter to the Museum that this document described the painting as "Il Bacchanale, o sia veneres in braccio e Adone con multe figure della medu" and its size as "otto e dodici" the same as the *Pyramus and Thisbe* (now in the Städelsches Kunstinstitut, Frankfurt.)[9] The Englishman in Florence, as Standring quotes Denis Mahon as having suggested, was probably either Sir Robert Furnese (d. 1733) or his cousin Henry Furnese (d. 1756); the former's notable collection passed to the latter and, when sold in 1758, included the Boston *Mars and Venus*, still misidentified as a *Venus and Adonis.*[10] Bought by Lord Harcourt, the painting remained in his family until it was acquired by the Museum of Fine Arts.

When in the collection of the Harcourt family, the Boston painting was always believed to be by Poussin. It was published as such in the early monograph by Grautoff (1914), and this traditional attribution has been endorsed by most subsequent scholars including Friedlaender (1964), Blunt (1966), Thuillier (1974), Rosenberg (1982), Wright (1985), Oberhuber (1988), and Mérot

(1990). Only two scholars have doubted it: Kurt Badt (1969), citing stylistic questions and what he deemed a certain lack of narrative logic in the presentation of the subject, believed it to be the work of an imitator. Doris Wild (1980) also regarded it as a work by a follower of Poussin and suggested either Fabrizio Chiari (creator of the engraving after the Louvre drawing) or Pierre Lemaire. She found some weakness in the way the sky was painted. This observation may be due to the painting's condition, for as Waagen had already observed in 1857, "unfortunately the picture has darkened, and is now much sunk."[11] According to Charles C. Cunningham, when the painting came to the Museum "a heavy brown varnish was removed."[12] A restoration of the painting in the early 1980s in preparation for the Paris exhibition revealed its high quality, and seeing the painting in the context of the even more thorough Paris exhibition of 1994–95 further confirmed not only the attribution to Poussin but the unusual scale and remarkable quality of the work.

The leading scholars of Poussin place the painting sometime in the late 1620s or early 1630s, based on their differing chronologies for the artist's development: Thuillier and Rosenberg have assigned it to 1627–28, shortly after the *Death of Germanicus* (Minneapolis Institute of Arts) dated 1627. Three others assign the work to 1629: Mahon (1629), Blunt (just before 1630), and Oberhuber (possibly begun in the spring of 1629 and finished that fall, close to the Dulwich College *Rinaldo and Armida*). A characteristic aspect of Poussin's work of this period found here is his use of a striking color contrast between red and blue garments. Seen in the Boston *Mars and Venus*, this appears in such contemporary paintings as the *Apollo and Phaeton* from Berlin, *Les Andrians* in the Louvre, *Venus Lamenting Adonis* from Caen, and *The Lamentation* in Madrid.

Writing in 1942, Friedlaender believed he had identified the literary source of Poussin's composition in Vincenzo Cartari's *Vere e nove imagine degli dei degli antichi*, a mythology handbook of which an edition had been printed at Padua in 1615. In it the author abridges a story from the Roman writer Statius, in which "it is told that Mars recited to Venus a beautiful hymn in her praise after he had found amorous solace in her arms and had been ordered by Zeus to make war between Eteocles and Polynices for the rule of Thebes." Friedlaender wrote: "In Poussin's representation of the scene, it is not Venus but her lover who makes the oratorical gesture. Mars is explaining to Venus why he has to leave her much though he appreciates the fact that she is the only one who can give him repose from battles, sacred joy, and unique peace of the soul— despite all this he must obey the behests of the Fates and the order of the Supreme Father."[13]

The year before the Museum acquired this painting, the eminent art historian Erwin Panofsky published a study of humanistic themes in which he touched on the subject of Mars and Venus. He described their union as that "between beauty and valour" and noted that of the ancient writers Lucretius "interpreted Venus as the great generative force in nature [that] alone is capable of neutralizing the destructive principle symbolized by Mars."[14] To further explicate the Museum's painting, the curator Charles Cun-

ningham wrote to Panofsky for his interpretation of it. In his response Panofsky identified the main literary source for Poussin's painting as a very popular passage from Lucretius's *De rerum natura*. There the poet invokes as his inspiration "Nurturing Venus . . . who alone governs the nature of things" and who "alone can bless mankind with tranquil peace, since it is mighty Mars who is the Lord of War and all its brutal works, and he often lies in your lap, entirely conquered by the eternal wound of love, and looking upward with his shapely neck bent back, he feasts his avid eyes upon you, hungry for love; his breath is hanging upon your lips as he reclines. And you, O goddess, bend over him as he lies there upon your holy body, and shed your honeyed words, and for your Romans, glorious goddess, seek placid peace."[15] As Panofsky summarized it, "Mars stands for the principle of strife and conflict which has to be pacified by Venus in order to produce 'harmony.' "[16]

Thus is a contrast established between an interpretation of the painting as a narrative event (Friedlaender) on the one hand, and on the other as a poetic meditation on love in a mythological guise (Panofsky). A continuing element in this debate is the role of the subsidiary characters: the nymphs, river god, and above all, the putti. Three putti are to the right of Mars. The closest holds the god's plumed helmet—but has he just removed it or is he preparing to place it on Mars's head? The other two raise the god's shield or breastplate, one holding onto its strap. To the lower left of Venus two putti are shown; one holds Mars's quiver upside down, from which the arrows have fallen to the ground. The other unwinged cupid is sharpening one of the arrows on a stone, and above, a third putto seems to approach the enraptured goddess from behind, holding one of those arrows pointed at her.

In his letter of 1940, Panofsky made the following observations:

I do not think that any special significance must be attached to the two nymphs and the river god. They all hold urns, and are thus uniquely determined as aquatic divinities. This does not exclude, however, that they may reflect, in a general way, the various modes, or moods, of nature or even the universe. The figure on the far left has, if you like, a nocturnal character while the river god gives the impression of *crepuscolo* and the nymph on the right of dawn. Or else, one might say that the three figures reflect the three temperaments of Melancholy (on the left), Phlegm (the river god) and Sanguine (the nymph), with Mars standing for the fiery or choleric nature. All this is, however, merely "associative characterization" and not in any sense iconographic identification. I think it is impossible to tag any label to these concomitant figures; they just act as a soundboard echoing the overtones of the main scene. . . . It is amusing that the *putti* partly turn Mars' weapons against himself. One Cupid uses his shield as a mirror to show him the beauty of Venus, upon which he reacts with looking up to her and comparing the original with the image (hence his funny gesture), another is about to point one of the stolen arrows at Mars' heart. This is very much in keeping with Lucretius' "in

gremium quie saepe tuum se / Reicit aeterno devictus vulnere amoris."[17]

Still seeking further explication of the painting, Cunningham wrote again to Panofsky, asking if Venus's gesture "symbolized the union of the two characters" and inquiring after the "source for the representation of Mars and Venus in a sylvan setting."[18] The scholar's response this time reveals his famous combination of erudition and popular culture:

1. I would not say that the gesture of Venus means that Poussin was familiar with the tradition of a legal marriage. I think that this whole question, just because of the Lucretian background, does not constitute a real alternative: the two lovers are just "lovers" in the broadest—and deepest—possible sense.
2. The sylvan setting, again, is easily understood from Lucretius' concept of Venus: she was "essentially the early Italic goddess of flowers, gardens, and the quickening life of spring, with touches of the Greek Aphrodite, goddess of love," all this sublimated into a general principle of Nature. This is indeed quite different from Homer's Walter Winchell interpretation and accounts for the fact that the lovers meet in a setting characterizing Venus as a goddess of natural productivity.[19]

A more recent study of the painting by Charles Dempsey confronts a notable point that previous critics had failed to mention: The nude god Mars seems to have no genitalia. Based on this, Dempsey interprets the work as an evocation of the impotence of Mars in the face of love. He points out that although there are significant differences between the Louvre drawing and the Boston painting, the former shows Mars's sword, which in the painting is "cast to the ground," lying "menacingly across Mars's lap,"[20] thus conveying the same message of castration. According to Dempsey's argument, this aspect of Lucretius's poem may have come to Poussin from his reading of Montaigne, who in an essay compared Lucretius's description of Venus's seduction of Mars to that of Vulcan by Venus as told by Virgil in the *Aeneid*. This helps to explain the putto riding a she-wolf in the Louvre drawing, as a reference to the Roman wolf tamed by love in much the same way as Mars was. Less convincing, however, is Dempsey's attempt to relate Mars's "venereal wound" to the venereal disease that afflicted Poussin himself during these years.[21] Dempsey's interpretation of the Boston painting by Poussin also leads him to consider it as closely related to another painting, now known in fragments, one of which includes Anteros, the son of Mars and Venus, vanquishing sexual love.[22] That painting was engraved by Chiari as a pendant for his *Mars and Venus* after the Louvre drawing, providing a gloss on two contrasting aspects of the goddess of love. As Gilles Chomer and Sylvain Laveissiére further note, however, while the two prints work as pendants, the formats

of the two surviving paintings do not,[23] and this leaves open the tantalizing question of whether, as Thuillier believes, there was indeed another, now lost, painting of Mars and Venus based on the Louvre drawing.[24]

Our suspicion is that there is not. We believe that the Boston painting was originally closer to the Louvre drawing and changed by Poussin as he worked on it—a practice that has been documented in some other cases.[25] Following the publication of Dempsey's article and preceding the Poussin exhibition in Paris in 1994, a thorough scientific examination of the painting revealed that the seeming lack of Mars's genitalia may be due to abrasion of that area of the painting, which has thinned the already transparent shadows. Examination also revealed that the artist had substantially changed the composition on the canvas from one much closer to the Louvre drawing to what we now see. X-radiographs showed that originally the sword was across the god's leg, Venus's hair flowed more freely, and the putto on the right holding the shield projected further into the landscape. This leads to the observation that the Louvre drawing, which includes only one nymph at the right, is a more balanced composition than the Boston painting. In the latter, although in part due to darkening of the tonalities, there is nevertheless an imbalance between the two figures at the right and the more elaborate group at the left. In the drawing the artist bridged this gap by the putto's outstretched arm. It is clear in the drawing that Poussin intended to show the partial reflection of the putto in the pool at the lower-right corner, and he maintained this effect in the painting but with a different figure. Instead of the connotation of blind love, the river god and nymph serve as mute but timeless witnesses to the drama being played out before them. Poussin and his school often used such figures of river gods and nymphs to frame the main action, for example in a drawing of the dead Rinaldo (Paris, Louvre).[26]

Just as a variety of literary sources provided inspiration for Poussin's original painting, so, too, did a number of favorite visual sources. The most obvious that played a role in so many of his mythologies were the series of *Bacchanals* by Titian, which he was able to study at the Villa Ludovisi. Most especially, *The Bacchanal of the Andrians* (Madrid, Prado), both in the landscape arrangement and the figure of the reclining nymph, influenced Poussin, as also, no doubt, did Titian's *Feast of Venus* (Madrid, Prado), which inspired some of the winged putti. Poussin was also familiar with examples of the original ancient works that had served Titian as the source of his motifs, and as Cunningham observed, Poussin took many elements of his Mars and Venus composition from an ancient sarcophagus relief.[27] It has also been proposed by Reinhold Baumstark that Poussin's arrangement of Mars and Venus derived from a print after a painting by Rubens of the same subject.[28] Similar are the poses of the gods as well as the figure of a putto removing Mars's helmet. The major difference is that in Rubens's work Mars is still fully dressed. Panofsky insightfully observed that "the posture of Mars, with his left leg outstretched in such a way that the lower part appears strictly horizontal, seems to derive, perhaps

through an intermediary source, from Michelangelo's *Ignudo* on the left of Jeremiah" in the Sistine ceiling frescoes.[29] Michael Jaffé observed that the nymph at the right is copied after a reclining male figure by Annibale Carracci in the ceiling of the Palazzo Farnese, which Poussin changed into a female figure.[30]

Poussin's series of mythological paintings from the late 1620s and early 1630s, with their concern for love and rooted in ancient art and poetry, were intended for a knowledgeable circle of collectors and scholars. The modern viewer must work more assiduously to understand such works but is here still readily enveloped by the sensuous beauty of Venus's idyllic realm.

1. Sutherland Harris 1990, p. 144.

2. Dempsey 1992, pp. 435–36.

3. Louvre R. F. 5893, Friedlaender 1942, p. 26; Friedlaender and Blunt 1953, p. 30, no. 206; Rosenberg and Prat 1994, vol. 1, pp. 66–67, no. 35. Thuillier 1974, p. 116 under B29, and Thuillier 1994, p. 245 under no. 33, hypothesize that the drawing is actually a preliminary study for another painting, now lost. A poor copy of the Louvre drawing is in the royal collection at Windsor Castle (Royal Library, no. 11975). An engraving of the Louvre drawing by Fabrizio Chiari is dated 1635. Andresen 1863, no. 349; Wildenstein 1957, no. 122. Based on this print, Smith in 1837 and Grautoff in 1914, without knowing of the present work, included a *Mars and Venus* in Poussin's *oeuvre*.

4. Friedlaender and Blunt 1953, p. 30, no. 207; and Rosenberg and Prat 1994, vol. 1, pp. 92–93, no. 49. See also Rosenberg, Prat, and Damian 1994, pp. 84–85, no. 12.

5. Thuillier 1974, no. R97, and Thuillier 1994, no. R84; also in Paris 1994, p. 48, no. 8.

6. For de Cotte's inventory, see Haskell and Rinehart 1960, p. 324.

7. Brejon de Lavergnée 1973, p. 87.

8. Standring 1988, pp. 611–12.

9. Letter, January 8, 1988, in the Paintings Department files.

10. Standring 1988, pp. 612–13.

11. Waagen 1857, p. 350.

12. Cunningham 1940, p. 58.

13. Friedlaender 1942, pp. 23–24.

14. E. Panofsky, *Studies in Iconology* (1939; New York, 1972), p. 164.

15. Lucretius, *De rerum natura*, bk. 1, ll. 1–40, trans. J. H. Martinband (New York, 1965), p. 2.

16. Panofsky to Cunningham, June 18, 1940, in the Paintings Department files.

17. Ibid. "Mars . . . who often casts himself upon your lap wholly vanquished by the ever-living wound of love." Lucretius, ll. 33–34, trans W. H. D. Rouse (Cambridge, Mass., 1975), p. 5.

18. Cunningham to Panofsky, June 20, 1940, in the Paintings Department files.

19. Panofsky to Cunningham, June 24, 1940, in the Paintings Department files.

20. Dempsey 1992, p. 441.

21. Ibid.

22. These fragments are *Mercury and Venus* at the Dulwich College Picture Gallery, London, and a *Group of Putti* in the Louvre. See Thuillier 1994, p. 245, nos. 34A and B.

23. Paris 1994, pp. 47–48.

24. Thuillier 1994, no. 33.

25. See in particular Richard Beresford in The Wallace Collection, *"A Dance to the Music of Time,"* by Nicolas Poussin (London, 1995), pp. 33–39.

26. Louvre no. 32435; see Friedlaender 1949, vol. 2, no. 144, pl. 111.

27. Cunningham 1940, pp. 55–58.

28. Baumstark 1974, pp. 182–84, fig. 39.

29. Panofsky to Cunningham, June 18, 1940.

30. Undated note in the Paintings Department files. Jaffé perhaps had in mind the figure of Hercules resting or other subsidiary figures in the scenes of *Perseus and Medusa* or *The Triumph of Bacchus and Ariadne.* See J. R. Martin, *The Farnese Gallery* (Princeton, 1965), pls. 11, 23, 69.

9. *Achilles on Skyros*, about 1649–50

Oil on canvas
38 × 51 in. (96.5 × 129.5 cm)
Juliana Cheney Edwards Collection
46.463

PROVENANCE: Lacurne de Sainte-Palaye; prince de Conti; sale Paris, April 8, 1777, no. 531; purchased by Rémy for Nicolas Beaujon; sale Paris, April 25, 1787, no. 83; Desmaretes; John Knight, London; sale Phillips, London, March 23, 1819, no. 100; Stephen Jarrett, 1837–65; James Fenton, London; sale Christie's, London, February 26, 1880, no. 121; Hudson; Anthony F. Reyre, London; d'Atri, Paris 1924; Wildenstein and Co., Paris and New York, by 1925.

EXHIBITION HISTORY: Hartford, Wadsworth Atheneum, *Exhibition of Italian Painting of the Sei- and Settecento,* 1930, no. 38; Pittsfield, Mass., Berkshire Museum, *Landscape Painting from the Sixteenth to the Twentieth Century,* 1937, no. 7; Baltimore Museum of Art, *The Greek Tradition in Painting,* 1939, pp. 11, 14, ill.; New York, Durlacher Brothers, *Exposition Nicolas Poussin,* 1940, no. 10; New York, Wildenstein and Co., *Jubilee Loan Exhibition History: Masterpieces from Museums and Private Collections,* 1951, no. 15; Richmond, Virginia Museum of Fine Arts, *Treasures in America,* 1961, p. 66; New York 1968–69, no. 31; Paris 1994–95, no. 209 (Paris only).

REFERENCES: Bellori 1672, pp. 445–46; *Catalogue des tableaux, dessins, terre-cuites, marbres . . . aprés le décés de S.A.S. Monseigneur le Prince de Conty* (Paris, 1777), pp. 169–70, no. 531; *The distinguished and interesting collection of paintings of John Knight esq. Portland Place: a catalogue of the celebrated collection of valuable pictures . . .* (1819), p. 6, no. 100; M. Graham, *Memoir of the Life of Poussin* (London, 1820), p. 205, no. 1; Smith 1837, p. 86, no. 162; H. Mireur, *Dictionnaire des ventes d'art faites en France et à l'étranger* (Paris, 1912), vol. 6, pp. 59–60; Grautoff 1914, vol. 2, p. 257; W. Friedlaender, *Nicolas Poussin: Die Entwicklung seiner Kunst* (Munich, 1914), p. 123; W. Friedlaender, review of A. Moschetti, "Dell'influsso del Marino sulla formazione artistica di Nicola Poussin," *Reportorium für Kunstwissenschaft* 37 (1915), p. 234; Friedlaender 1926–27, pp. 141–43; W. Friedlaender, "Nicolas Poussin," *Thieme and Becker* 1933, vol. 27, p. 326; Friedlaender 1940, pp. 11 and 13, ill.; A. J. Philpott, "War-Hidden Paintings Find Way to U.S., Exhibited Here," *Boston Globe,* Nov. 3, 1946, p. 18; McLanathan 1947, pp. 2–11, figs. 1, 2, 7; T. Bertin-Mourot, "Addenda au catalogue de Grautoff," *Bulletin de la Société Poussin* 2 (1948), no. 29, pp. 51–52 and 92; Friedlaender 1949, vol. 2, pp. 3–5; G. Wildenstein, "Les Graveurs de Poussin au XVIIe siècle," *GBA* ser. 6, 46 (1955), pp. 241–42, no. 105; H. Bardon, "Poussin et la littérature latine," p. 127, no. 25; C. Sterling, "Quelques imitateurs de Poussin," p. 271,

no. 4; and J. Thuillier, "Pour un corpus Poussinianum," p. 222—all in *Actes* 1960; *Catalogue de l'exposition Poussin* (Paris, 1960), p. 137 (in connection with the Richmond version); W. Friedlaender, "Poussin's Old Age," *GBA* 60 (July–Aug. 1962), p. 252, fig. 4; Friedlaender 1964, pp. 72–73, 84, fig. 66; Vermeule 1964, pp. 113–14, fig. 91; D. Mahon, "A Plea for Poussin as a Painter," in *Walter Friedlaender zum 90. Geburtstag* (Berlin, 1965), p. 140; Blunt 1966, p. 88, no. 126; Blunt 1967, pp. 31, 257, 260, 306, pl. 175; J. Thuillier, *Poussin* (Novara, 1969), pp. 84–85; T. Kamenskaia, *Les Dessins de Poussin dans les collections de l'Ermitage* (Leningrad, 1971), pp. 20–21; Thuillier 1974, p. 108, no. 184; Takashina and Goto 1977, p. 117 and pl. 52; Bonfante and de Grummond 1980, pp. 75 and 78–80, fig. 9; Wild 1980, vol. 2, pp. 150 and 324, no. 163; C. Pace, *Félibien's Life of Poussin* (London, 1981), p. 160; Paris 1982, p. 369, fig. 1; Tsuji and Takashina 1984, pl. 34; Wright 1984, pp. 227–28, 267, 275, 277, 279, no. 183, pl. 199; Murphy 1985, p. 231; Wright 1985, p. 248; Del Bravo 1988, p. 165, no. 41; Léveque 1988, p. 228; N. Petrusevich, in *Nicolas Poussin, Paintings and Drawings in Soviet Museums*, ed. Y. Zolotov and N. Serebriannaya, trans. T. Crane and M. Latsinova (St. Petersburg, 1990), pp. 182–83, ill.; Mérot 1990, pp. 215 and 327, no. 178; D. Carrier, "Blindness . . . in Poussin's Paintings," *Res* 19–20 (1990–91), pp. 40–41, fig. 5; Carrier 1993, pp. 23 and 180; Paris 1994, p. 35; Rosenberg and Prat 1994, vol. 1, pp. 684–85, fig. 354a, pp. 686, 698–99, fig. 362a, and vol. 2, p. 912; Thuillier 1994, p. 251, no. 204; R. Verdi, "Poussin's Subject Matter: Themes as Types," in Paris 1994–95, pp. 25–6, fig. 7, and pp. 301, 302 under cat. 79; Y. Zolotov, N. Serebriannaïa et al., *Nicolas Poussin, The Master of Colours: Russian Museums Collections Paintings and Drawings* (Bournemouth and St. Petersburg, 1994), p. 154; Olivier Bonfait, "Un éloge de Poussin . . . ," in *Poussin et Rome: Actes du colloque à l'Académie de France en Rome, 1994* (Paris, 1996), pp. 49 and 61.

CONDITION: The fabric support has been wax-lined. The thick paint is over a red ground, and the layer has extensive age cracks. The paint has been abraded and there are numerous inpainted losses.

∽

Poussin drew on a number of literary and visual sources for this painting. Several ancient authors, including Hyginus, Statius, Homer, and Ovid, tell the story that an oracle prophesied to the sea goddess Thetis that her son Achilles would be a great military leader but would die young.[1] To protect him from this fate she immersed him in the river Styx, which left him vulnerable only at the heel by which she held him. With the outbreak of the Trojan War, she sought to avoid his participation by sending him, disguised as a girl, to the island of Skyros. Achilles resided there among the daughters of King Lycomedes, one of whom, Deidamia, fell in love with him and, according to some versions, bore him a child. Since the Greek forces could not triumph without Achilles, Ulysses and Diomedes were sent to find him. When they arrived at the court of Lycomedes, the wily Ulysses presented the king's daughters with a chest containing not only clothes and jewels but also a spear, shield, and helmet, in which the disguised Achilles displayed great interest. By handling them expertly he revealed himself as a man and was then convinced to join the Greek forces. The tale was retold by the sixteenth-century author Natale Conti in *Mythologiae* with the added detail that Ulysses and Diomedes themselves went disguised as merchants from the East with goods to sell.[2] The seventeenth-century poet Cavaliere Marino also included the story in *Adone*, where he made the sword the means of Achilles' identification.[3]

In the Museum's painting, the three foreground figures are the major players in this drama of discovery. From left to right, they are the beturbaned Ulysses, who looks eagerly at the successful out-

come of his ploy. Deidamia is undoubtedly the young woman at the center, who turns from the jewels with a horrified expression of fear. At the right Achilles himself half-rises, enraptured by the sword he pulls from its scabbard. His face, hair, and costume appear convincingly female; only his muscular arm and his action betray his true sex. In fact, all three men are in disguise, and in a painting that deals with the theme of deception and reality, it is certainly not by chance that Poussin places the mirror at the very center of the composition.

Giovanni Pietro Bellori, who knew Poussin, and who in 1672 wrote the first biography of the artist, recorded that Poussin painted two versions of *Achilles on Skyros*. His description of one of

Fig. 9a. Nicolas Poussin, *Achilles among the Daughters of Lycomedes*, 1656. Richmond, Virginia Museum of Fine Arts, The Arthur and Margaret Glasgow Fund, 1957. (Photo: Katherine Wetzel, ©1996 Virginia Museum of Fine Arts)

these matches the painting now in Boston: "Achilles with one knee on the ground, drawing the sword from its scabbard. A little in front of him a daughter of Lycomedes, leaning forward toward the traveling merchants to extend her hand into the chest, which lies on the ground, turns backward astonished at the flash of the weapon; terrified, she raises her other hand in wonder at the bare steel. But Ulysses, kneeling opposite with Diomedes, watches intently and recognizes the youthful warrior, while his companion gives a mirror to one of the girls who stands with another of the sisters and points at the precious jewels in the chest."[4]

The other painting of the subject by Poussin is most likely a later work in the Museum of Fine Arts, Richmond (fig. 9a). A note by Poussin on the verso of a drawing now at Chantilly is his receipt stating that it was painted in 1656 for the duc de Crequi (Charles III).[5] Known through both the Richmond painting and an engraving after it attributed to Pietro del Po,[6] this later treatment adds the figure of a standing old woman and a much more extensive landscape. The three daughters busy themselves with the jewels while Achilles, wearing the helmet and holding the sword in his hand, kneels above a shield and vainly gazes at himself in the mirror.[7]

The early history of Poussin's two paintings is rather confused.

Dézallier d'Argenville recorded in 1757 that paintings titled *La Re-connaissance d'Achille* were in the collections of both the Fermier-Général Etienne-Michel Bouret and at the Hôtel de Lassay.[8] As Anthony Blunt has noted, the first collection is unknown, but the marquis de Lassay (d. 1738) formed a significant collection, most of which was dispersed privately.[9] In 1777 both versions appeared in public sales: The Richmond painting was most likely the one in a sale of pictures "consigned from abroad" at Christie's, London; and the earlier Boston treatment was in the prince de Conti's sale in Paris, as is confirmed by a sketch after it by Gabriel de Saint-Aubin in his copy of the Conti sale catalogue (fig. 9b).[10]

Both Pliny and Pausanias record that the story of the discovery of Achilles among the daughters of Lycomedes was a favorite subject of ancient painters.[11] Poussin may well have sought to emulate their accomplishments. Through drawings belonging to Cassiano dal Pozzo, he also knew classical reliefs depicting the subject.[12] The classical elements in the Boston painting have been well delineated by Cornelius Vermeule: "Here Poussin demonstrates his subjective communion with the colors of ancient costume and with the textures of chitons and himations. Grecian heads are used as models for the three daughters of Lycomedes, but by way of contrast, Achilles has been arrayed in a wig of the Capitoline Aphrodite type replete with Hellenistic topknot! Odysseus wears the turban of a peddler from the Ottoman East, and in this splendid example of tight, controlled painting Diomedes' Antonine head of the Lucius Verus type stands out against the Jovian Grove at the left and the sober architecture at the right."[13] Larissa Bonfante and Nancy Thomson de Gummond have noted that the oval mirror with bronze handles is also based on an Etruscan prototype.[14]

Poussin was probably familiar with a depiction of the Achilles subject by Primaticcio and Niccolò dell'Abbate in the Pavillon de St-Louis at Fontainebleau.[15] According to Richard B. K. McLanathan, a now-lost painting by Annibale Carracci, known through an engraving by Gérard Audran, may have influenced Poussin.[16] The subject was treated by other French seventeenth-century artists. One who spent time in Rome was Jean Le Maire. The architectural setting of his painting (now in the Los Angeles County Museum of Art) dominates the dramatic action.[17] A rendering of the theme in an interior setting (deposited by the Louvre at the Musée des Beaux-Arts, Reims), formerly attributed to Poussin, has been attributed by Blunt to Nicolas Colombel and more recently by Gilles Chomer and Sylvain Laveissière to Charles-Alphonse Dufresnoy.[18]

As was his established method of working, Poussin prepared a number of preliminary studies and probably even constructed a three-dimensional model of the composition. Several drawings related to the composition are at the Hermitage. In the first of these (fig. 9c) the black-chalk underdrawing is probably by Poussin, but the schematic pen-and-ink overdrawing is possibly by a later hand. On the verso is the draft of a letter in Poussin's handwriting.[19] This drawing seems to show an earlier stage in the composition's development. Ulysses, Deidamia, and Achilles all stand at the back; in front of them kneel Diomedes and the other two sisters. A trace of

Fig. 9b. Gabriel de Saint-Aubin, drawing from the Conti collection sale catalogue. (Reproduced from Paris 1994–95, fig. 209a)

Fig. 9c. Nicolas Poussin, *Discovery of Achilles*. Black chalk with later additions in pen and bistre. St. Petersburg, Hermitage, Brühl collection, inv. no. 5136. (Reproduced from Friedlaender 1949, vol. 2, no. 104)

Achilles' plumed helmet is on his head instead of on the ground, where there is a shield that does not appear in the painting. Two other drawings of the subject in the Hermitage were believed by Walter Friedlaender and Blunt to be copies of a lost original, but Pierre Rosenberg and Louis-Antoine Prat have accepted the one from the Brühl collection as original (fig. 9d).[20] In this there is a further development: Achilles still stands to the right but the Deidamia figure now kneels at the center. In yet another original drawing from the Brühl collection at the Hermitage (fig. 9e), the compositional grouping begins to foretell the later Richmond painting, although it still maintains the kneeling, sword-pulling Achilles (now on the left side) and the startled woman at the right.[21] A drawing in Chantilly of a group of young women was related to the Boston painting by Friedlaender but, as Blunt pointed out, is not for this composition.[22] This elaborate process of creation, as Friedlaender wrote, "exempli-

Fig. 9d. Nicolas Poussin, *Discovery of Achilles*. Pen and bistre. St. Petersburg, Hermitage, Brühl collection, inv. no. 5141. (Reproduced from Friedlaender 1949, vol. 2, no. A24)

Fig. 9e. Nicolas Poussin, *Discovery of Achilles*. Pen and bistre over black chalk. St. Petersburg, Hermitage, Brühl collection, inv. no. 5140. (Reproduced from Friedlaender 1949, vol. 2, no. 106)

fies the manner in which Poussin disciplined an original idea until the frozen essence of it emerged in the final painting."[23]

On the verso of the first Hermitage drawing is a text, recognized by Blunt as a draft for a lost letter from Poussin to Roland Fréart de Chambray, which accompanied a manuscript for a treatise on Leonardo published in 1651.[24] This would seem to indicate that the painting dates about 1648–50, during the mature phase of Poussin's career. Both Jacques Thuillier and Rosenberg prefer a slightly later dating, to after 1651. Stylistically and in its clear didactic arrangement of the figures, it is comparable to a number of the artist's works of the late 1640s, such as *The Finding of Moses, Death of Sapphira, Eleazer and Rebecca*, and *The Judgment of Solomon* (all Paris, Louvre). These are characterized by a strong narrative content, clearly delineated figures endowed with expressive gestures and facial expressions, and great strength of coloring. As Friedlaender so tellingly observed in his article published on the reappearance of the Boston painting, it reveals "gorgeous brilliant colors as only found in the most beautiful of Poussin's paintings. Very characteristic for Poussin is the strong red, that is used to emphasize the action and the foreground. Thus the cloak of Achilles, the clothing of the kneeling figures, and the crest of the helmet are a brilliant red while Achilles wears also a violet and warm yellow color."[25]

1. Hyginus *Fabulae* 96; Statius *Achilles* 1.841-72; Homer *Iliad* 19.332.

2. On Conti's *Mythologiae*, see McLanathan 1947, p. 10.

3. Marino *Adone* 19, stanzas 310–12.

4. Bellori 1672, p. 446, translated in McLanathan 1947, p. 2. The Boston painting was engraved in reverse by Pietro del Po (Wildenstein 1957, p. 241, no. 105; Andresen 1863, no. 303; and Davies and Blunt 1962, p. 213, nos. 104–105). A copy of the Boston painting is in the Musée d'Art of Coutances. See Blunt 1966, p. 88, and Thuillier, "Tableaux 'Poussinesques' dans les musées de Provence français," *Actes* 1960, vol. 2, p. 290.

5. Friedlaender 1949, vol. 1, p. 31, and Blunt 1966, p. 895, no. 127. A. Félibien, *Entretiens sur les vies et sur les ouvrages des plus excellens peintres anciens et modernes* (Trevoux, 1725), vol. 4, p. 65. See also Paris 1994–95, p. 491, no. 225, and Rosenberg and Prat 1994, vol. 2, pp. 696–97, no. 361.

6. The print is Andresen 1863, no. 302, and Wildenstein 1957, no. 104; for the painting see Paris 1994–95, no. 225.

7. A poor copy of this painting is in the Musée d'Art et d'Histoire, Geneva. Blunt 1966, p. 89.

8. A. N. Dézallier d'Argenville, *Voyage pittoresque de Paris*, 3d ed. (Paris, 1757), pp. 186, 415.

9. Blunt 1966, p. 88.

10. Blunt had believed it to be the other way around, but the identification of Saint-Aubin's sketch in the Conti sale catalogue by Rosenberg, in Paris 1994–95, p. 462, confirms the provenance, as does the list of works acquired by P. Remy at the prince de Conti's sale for Nicolas Beaujon published in A. Masson, *Un Mécene bordelais, Nicolas Beaujon, 1718–1786* (Bordeaux, 1937), p. 200, no. 531. The other version was sold at Christie's, April 18, 1777, no. 34.

11. See McLanathan 1947, p. 8, and Blunt 1966, p. 88.

12. McLanathan 1947, figs. 8, 9.

13. Vermeule 1964, p. 114.

14. Bonfante and de Grummond 1980, pp. 75–78.

15. As pointed out by Blunt 1967, p. 31.

16. For the engraving by Audran after Carracci see McLanathan 1947, p. 8, fig. 10.

17. Paris 1982, pp. 261–63, no. 43.

18. See Blunt 1966, no. R61; Paris 1994, p. 35, no. 3; and Thuillier 1994, p. 274, no. R.97.

19. See Friedlaender 1949, vol. 2, p. 3, no. 104, and Rosenberg and Prat 1994, vol. 1, p. 684, no. 354.

20. See Friedlaender 1949, vol. 2, p. 3, pl. 118, nos. A23 and A24, and Rosenberg and Prat 1994, vol. 1, pp. 686–87, no. 355, and fig. 355a.

21. Friedlaender 1949, vol. 2, p. 4, pl. 84, no. 106. See also Paris 1994–95, p. 490, no. 224, and Rosenberg and Prat 1994, vol. 1, pp. 698–99, no. 362.

22. Friedlaender 1949, vol. 2, p. 4, no. 105, and Blunt 1966, p. 88. See Rosenberg and Prat 1994, vol. 1, no. 376.

23. Friedlaender 1940, p. 11.

24. See Friedlaender 1949, vol. 2, p. 3, and Blunt 1966, p. 88. Also see Rosenberg, Prat, and Damian 1994, p. 143, no. 41.

25. Friedlaender 1926–27, p. 142.

CLAUDE GELLÉE, CALLED CLAUDE LORRAIN

1600–1682

Born at Chamagne in Lorraine, Claude was first an apprentice to a pastry cook, but after he was orphaned at age twelve, he went to Freiburg, where his brother was a woodcarver. The following year he was in Rome as an assistant to the painter Agostino Tassi. The young artist, who was interested in landscape, was influenced by a variety of painters who had visited Rome, including Adam Elsheimer, Bartholomeus Breenbergh, and the Carracci. Aside from a possible period spent in Naples (1618–22) with the painter Goffredo Wals and a return to Lorraine to work with Claude Deruet on frescoes at Nancy in 1625–26, Claude spent his remaining career solely in Rome. Having established himself by the early 1630s, commissions from Pope Urban VII and the king of Spain assured his fame at the end of the decade. Inspired by the Roman countryside, where he often sketched with the painter and future artists' biographer Joachim von Sandrart, Claude perfected his atmospheric depictions of landscape. These he used for mythological, biblical, and imaginary subjects, often with figures painted by collaborators. A valuable record of Claude's oeuvre, begun perhaps to discourage forgeries, was the *Liber Veritatis* now in the British Museum, which includes a sketch of all his paintings from about 1635 until his death in Rome at the age of eighty-two.

10. *Mill on a River*, 1631 (?)

Oil on canvas
24 1/4 × 33 1/4 in. (61.5 × 84.5 cm)
Signed and dated lower left: *CLAUDE I.V. 163(?)*
Seth K. Sweetser Fund
44.72

PROVENANCE: duc de Bouillon collection, Sedan (?); Woodburn, London, by 1837; Thomas Wright, Upton Hall, Newark; sale Christie's, London, June 7, 1845, no. 44; Moore; Wynn Ellis, London; sale Christie's, London, June 17, 1876, no. 4; Partington; Sir Berkeley Sheffield, Normanby Park, Scunthorpe, Lincolnshire; sale Christie's, London, July 16, 1943, no. 40 (as Cornelius van Everdingen); Sandor; David M. Koetser Gallery, London and New York, 1943.

EXHIBITION HISTORY: New York 1946, no. 11; Northampton, Mass., Smith College, *Commencement Exhibition*, 1952; Newcastle upon Tyne 1969, no. 3; Washington 1982, no. 6 (traveled to Paris, Grand Palais).

REFERENCES: Smith 1837, p. 378, no. 409; Waagen 1854, p. 294, no. 4; Pattison 1884, p. 210; "Boston's Claude," *Art News* 43, no. 6 (May 1–14, 1944), p. 6, ill.; W. G. Constable, "The Early Work of Claude Lorrain," *BMFA* 42 (Dec. 1944), pp. 68–72; idem 1944, pp. 308–10, 312–14; W. Sypher, "Baroque Afterpiece: The Picturesque," *GBA* 27 (1945), pp. 42, 45, fig. 5; A. Blunt, *Art and Architecture of France, 1500 to 1700* (London, 1953), pp. 179, 182, pl. 139; M. Roethlisberger and M. Kitson, "Claude Lorrain and the Liber Veritatis I," *TBM* 101, no. 670 (Jan. 1959), p. 23; E. Knab, "Die Anfänge des Claude Lorrain," *Jahrbuch der Kunsthistorischen Sammlungen in Wien* 56 (1960), pp. 63, 79, 108, 124, 128, 138, 140–44, fig. 177; Roethlisberger 1961, vol. 1, pp. 140–42, and vol. 2, fig. 66; M. Dobroklonsky, "The Drawings of Claude Lorrain in the Hermitage," *TBM* 103, no. 702 (September 1961), p. 395; W. Stechow, *Dutch Landscape Painting of the Seventeenth Century* (London, 1966), p. 154, fig. 299; M. Kitson, "Claude Lorrain: Two Unpublished Paintings and the Problems of Variants," in *Studies in Renaissance and Baroque Art Presented to Anthony Blunt on His Sixtieth Birthday* (London and New York, 1967), p. 147; Roethlisberger 1968, vol. 1, pp. 91–92, under no. 48 and p. 126 under no. 160; Roethlisberger 1975, p. 94, no. 81; L. Salerno, *Pittori di paesaggio del Seicento a Roma (Landscape Painters of the Seventeenth Century in Rome)* (Rome, 1977–78), vol. 1, p. 377, pl. 64.2; Kitson 1978, p. 65; M. Chiarini, "The Importance of Filippo Napoletano for Claude's Early Formation," in *Claude Lorrain 1600–1682: A Symposium*, Studies in the History of Art, no. 14 (Washington, D.C., 1984), p. 17; Paris 1982, p. 358, no. 1; M. G.

Roethlisberger, review of "Claude Gellée dit le Lorrain," *Kunstchronik* 36, no. 4 (April 1983), p. 200; Murphy 1985, p. 113; Wright 1985, p. 159; Langdon 1989, p. 28, pl. 15; R. R. Brettell, *Pissarro and Pontoise* (New Haven and London, 1990), p. 124, fig. 117.

CONDITION: The plain woven fabric support has been glue-lined. The paint is applied over a gray ground, and slightly raised brushmarks are visible in the trees and figures. The paint layer is in good condition, with very few losses.

∾

This painting of a mill was fully described by John Smith in his 1837 catalogue of Claude's works:

> The Mill. Peasant milking a goat. The view exhibits on the left a river, on the bank of which is an overshot mill, backed by a grove of trees which extend along the bank of the stream to the opposite side, and there unites with a cluster of trees, growing amidst bushes on a rocky hill, under which is an excavation, forming shelter for cattle, and from whence a herd of cows and goats, and a few sheep are coming: various fragments of architecture lie scattered on the foreground, on one of which is seated the artist, drawing, while two persons stand by, looking on: numerous goats are browsing around, one of which a man is milking; in addition to these may be noticed some men loading a vessel with timber, and at some distance off is a ferry-boat passing the river.[1]

According to Smith, the painting was then in the possession of the London dealer Woodburn; it had a pendant called *Hunting Party near a Waterfall.*[2] They were "stated to have formerly adorned the country mansion of the Count de Bouillon,"[3] who W. G. Constable proposed was most likely one of Claude's patrons, the duc de Bouil-

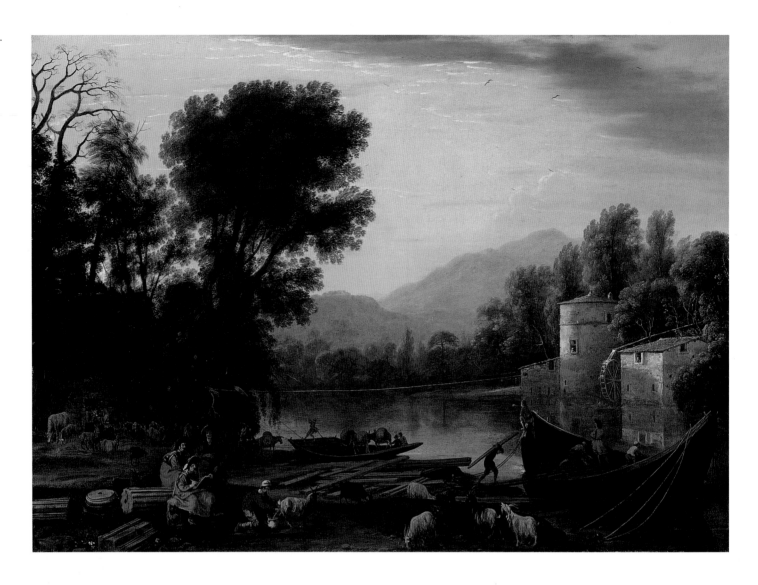

lon, although Marcel Roethlisberger has doubted this.[4] Perhaps because the history of the work was unknown, the signature was misread at the time of its sale in 1943 as Cornelius van Everdingen. However, when the old varnish was removed at the Museum, Claude's signature and the date, which is best read as 1631, were revealed.[5] This painting is therefore one of the artist's earliest known works.

Smith also noted that "the view was evidently taken from the same place as no. 22,"[6] referring to number 22 in Claude's *Liber Veritatis* (fig. 10a). Begun in the mid-1630s, this book records not only the appearance of the artist's paintings, but often the names of his clients as well. Number 22 is of a landscape with a river and a peasant milking a goat and is inscribed *Napoli*.[7] It differs most notably from the Boston painting in the absence of most of the goats in the foreground as well as the figures of the painter and the other two men with him. Michael Kitson has observed that "there must be a large gap between the execution of the painting and the drawing, which certainly dates from 1637–8 because of its position in the *Liber Veritatis*." He goes on to point out that Claude, following his brief visit to Naples in 1636, dispatched a group of his works to that city the following year. Possibly the artist then recorded the composition in the *Liber* from memory, or, to account for the dif-

ferences, Kitson proposes that the drawing might actually record a lost variant executed at a later date.[8]

On the verso of a Roman drawing by Claude dated 1632 is a pen-and-ink study of the seated artist sketching and observed by a standing gentleman while a peasant nearby is milking a goat (fig. 10b), but reversed from the painting.[9] It is certainly possible that the artist made use of this and a variety of other goat studies[10] to enliven the composition recorded in the *Liber Veritatis*.

The balanced and glowing treatment of the natural scene inhabited by modest figures was a type of painting that had been popularized by Paul Bril and Filippo Napoletano. The type was further developed by Agostino Tassi, whose work provides the most specific prototype for Claude's early works such as *The Mill*.[11] Among Claude's surviving paintings, those closest to the present example are *Landscape with Merchants* (Washington, D.C., National Gallery of Art), *Pastoral Landscape* also dated 1631 (The Detroit Institute of Arts), and *River Scene* (Copenhagen, Royal Museum of Arts).[12] The view across the watery vista to the brick mill probably records a real site on the Tiber that the artist could have seen. Constable pointed out that Claude employed the motif on a number of other occasions as well, such as in *Pastoral Landscape* of 1650 now at Kansas City (Nelson-Atkins Museum of Art)[13] and in his etching

La Danse au bord de l'eau.[14] Some of the same elements recur in Claude's *Landscape with River,* although in rearranged form, particularly the boat.[15] All these works share compositional elements but, as has been observed, the Boston painting is "one of the most exquisitely finished of Claude's early works."[16]

1. Smith 1837, p. 378.

2. Ibid., p. 379. This painting described by Smith as a deer hunt is unknown today; Roethlisberger 1961, p. 141, notes that the closest approximation may be *Landscape with an Artist Drawing and Two Men Shooting Ducks,* which is number 24 in the *Liber Veritatis.* See Kitson 1978, p. 68.

3. Smith 1837, p. 879.

4. Constable 1944, p. 308, and Roethlisberger 1961, p. 142.

5. Roethlisberger maintains that a reading of the date as 1637 is more convincing (see Roethlisberger 1968, p. 126, no. 60), but Kitson 1978 and H. D. Russell (in Washington 1982, p. 109) accept the 1631 reading.

6. Smith 1837, p. 378.

7. Kitson 1978, p. 65, no. 22.

8. Ibid.

9. Roethlisberger 1968, pp. 91–92, no. 48 verso.

10. Ibid., nos. 145, 257–59.

11. On Tassi and his influence on Claude see M. R. Waddingham, "Alla ricerca di Agostino Tassi," *Paragone* 12, no. 139 (July 1961), pp. 9–17, especially fig. 16. Also M. Chiarini, "Agostino Tassi: Some New Attributions," *TBM* 121, no. 919 (Oct. 1979), pp. 613–18.

12. See Washington 1982, pp. 107–8.

13. Number 123 in the *Liber Veritatis;* see Roethlisberger 1961, p. 303, no. 123, fig. 212.

14. Constable 1944, figs. 5 and 6.

15. The painting was with Wildenstein. Number 21 in the *Liber Veritatis;* see Roethlisberger 1961, p. 139, who dates it 1637.

16. Kitson, in Newcastle upon Tyne 1969, p. 14.

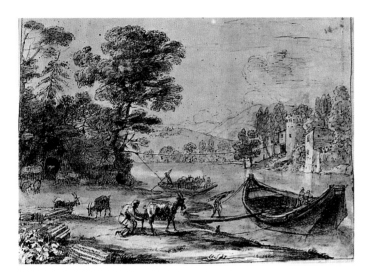

Fig. 10a. Claude Lorrain, *Liber Veritatis,* no. 22: *Landscape with a River and a Peasant Milking a Goat.* White paper, with pen and gray-brown wash. London, British Museum, inv. no. 28.

Fig. 10b. Claude Lorrain, *Drawing of Men and Animals.* Pen. St. Petersburg, Hermitage, inv. no. 7,134. (Reproduced from Roethlisberger 1968, no. 48v)

11. *Apollo and the Muses on Mount Helicon,* 1680

Oil on canvas
39 1/4 × 53 3/4 in. (99.7 × 136.5 cm)
Signed and dated lower center: *CLAUDIO IV fecit 168(?)*
Picture Fund
12.1050

PROVENANCE: Prince Lorenzo Onofrio Colonna, Rome, about 1680–d. 1689; by descent in the Colonna family to 1787; probably sold in 1798; purchased in Rome in 1802 by Robert Sloane; to his widow and son, Alexander Sloane, London, 1802; to his son; sale London, June 2, 1804, no. 71 (bought in); W. Buchanan, London; private contract sale, 18 Oxendon St., London, May 24, 1808, no. 7; Walsh Porter, d. 1809 or 1810; the Reverend Holvell Carr; sale Christie's, London, April 6, 1816, no. 92; B. Pinney; sold to Aynard in Paris by 1824; Smith collection, England; sale Stanley's, London, 1827; sometime between 1827 and 1854 to Edward Gray; by private sale to Wynn Ellis, London; sale Christie's, London, June 17, 1876, no. 6; Waters; William Graham; sale Christie's, London, April 9, 1886, no. 376; W. Grindlay; sale Christie's, London, April 23, 1887, no. 99; Thomas Humphrey Ward, London, by 1889; sale Christie's, London, June 28, 1890, no. 95; William Lockett Agnew; Sir William James Farrer, 1890 (?); sale Christie's, London, March 23, 1912, no. 5; Agnew's, London, and Trotti et Cie., Paris.

EXHIBITION HISTORY: London, British Institution, *Pictures by Italian . . . and English Masters,* June 1854, no. 53; Whitechapel, St. Jude's, 1889, no. 97; Washington, D.C., National Gallery of Art, *The Splendid Century: French Art, 1600–1715,* 1960, no. 83 (traveled to Toledo Museum of Art; New York, Metropolitan Museum of Art); Amherst, Mass., Amherst College, Mead Art Gallery, *Roman Baroque Festival,* 1974, no. 19; Paris 1982, no. 64; Boston 1984, no. 14; Boston 1992–93.

REFERENCES: *Catalogo . . . Colona* (1783), no. 152; W. Buchanan, *Memoires of Painting with a Chronological History of the Importation of Pictures by the Great-Masters into England* (London, 1824), vol. 2, pp. 112, 117, 389; Smith 1837, p. 302, no. 193; Hazlitt 1844, pp. 138–39; Waagen 1854, vol. 2, p. 294; Pattison 1884, pp. 110, 115, 224; Redford 1888, vol. 2, p. 275; J. Guiffrey, "The Parnassus of Claude Gellée," *BMFA* 11 (Feb. 1913), p. 9; Guiffrey 1913, p. 537; Boston 1921, p. 80; Roethlisberger 1961, vol. 1, pp. 451–54, no. 193, and vol. 2, fig. 314; Roethlisberger 1968, vol.1, pp. 393–95 and 404–10; vol. 2, nos. 1070–74 and 1113–14; R. H. Wilenski, *French Painting* 3d. ed. (New York, 1973), p. 55; Cavallo et al. 1974, p. 206, pl. 137; Roethlisberger 1975, pp. 123–24, no. 271; Kitson 1978, pp. 173–74; B. Holme, *Bulfinch's Mythology: The Greek and Roman Fables Illustrated* (New York, 1979), ill. pp. 14–15; L. J. Feinberg, "Claude's Patrons," in Washington 1982, p. 455; Bayerische Staatsgemäldesammlungen, *Im Licht von Claude Lorrain. Landschaftsmalerei aus drei Jahrhunderten* (Munich, 1983), p. 271; Murphy 1985, p. 113; Wright 1985, pp. 89, 159 165–66, pl. 23; Roethlisberger 1986, pp. 49–51, fig. 25; Städtische Galerie im Städelschen Kunstinstitut, *Nicolas Poussin—Claude Lorrain: Zu den Bildern im Städel* (Frankfurt am Main, 1988), p. 84, fig. 56; Langdon 1989, pp. 150–53, pl. 121; M. R. Lagerlöf, *Ideal Landscape*

(New Haven and London, 1990), p. 91, fig. 70; K. S. Champa, in *Currier Gallery of Art, The Rise of Landscape Painting in France: Corot to Monet* (Manchester, N.H., 1991), p. 29, fig. 3; Wine 1994, p. 111.

CONDITION: The support, a medium-weight, plain woven fabric, has been glue-lined. The tacking margins were flattened at the time of the lining, extending the original dimensions on all sides by approximately three centimeters. The paint is applied smoothly over a reddish-brown ground. An additional figure, painted out by the artist, can be seen among the group of Muses. Infrared examination reveals several additional changes in the contours of the architectural elements and trees. The paint is moderately abraded.

In 1652 Claude painted a *Parnassus* (now Edinburgh, National Gallery of Scotland), which showed Apollo playing his lyre surrounded by the nine Muses in a broad landscape, with a temple in the background and a lake with swans in the foreground.[1] Then, beginning in 1674, he produced a number of drawings on the theme.[2] These sketches resulted in this large painting commissioned by Claude's great Roman patron, Lorenzo Onofrio Colonna. Seemingly it was dated 1680. As was his custom, Claude recorded the composition in his *Liber Veritatis* (fig. 11a).[3]

In composing this painting, Claude, who clearly was still influenced by Raphael's painting in the Vatican, combined two different vistas. On the right is the rocky hillside inhabited by Apollo, the Muses, and Pegasus, and topped by a temple framed by trees, which is based on the well-known Temple of the Sibyl at Tivoli. Claude, who used this idyllic classical motif on other occasions,[4] here embellished it by adding a roof, an entablature with sculpture, a console cornice, and smooth-shafted Corinthian columns for ones that canonically should be fluted. Most notably, a ring of sculpted deities is placed on pedestals between the columns, among whom we can recognize Diana and Venus with Cupid. One cannot see the ocean from Tivoli, and the vista that Claude presents at the left of the painting, with a fortress and battlements extending far out into the sea, is reminiscent of the view from Delphi out to the Gulf of Corinth. However, the effect of the distant mountains could also have been inspired by the view of Capri from the Neapolitan coast.

Claude seamlessly joins these two disparate halves into a unified whole through the subtle coloration of the vegetation and the atmospheric painting of clouds and sky. The whole is bound together by the miraculous water flowing through the composition. This begins at the upper right, where the tiny Pegasus, born from the blood of the slain Medusa, kicks the side of a rock causing Hippocrene, the fountain of the Muses, to spring forth; it meanders down the rock face about which the Muses loll. The suggestion of its burbling purity serves as a natural counterpart to Apollo's divine song. The stream then enters the placid pool in the foreground,

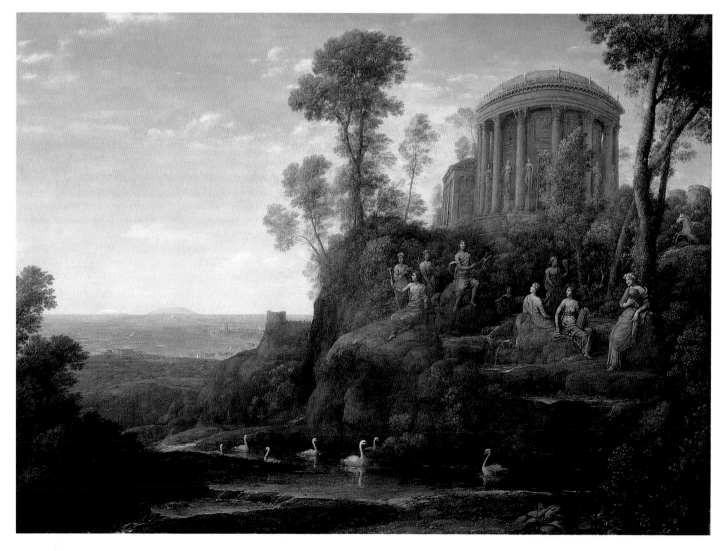

where the swans, birds sacred to Apollo, float gracefully. The water continues on its way to tumble down at the left edge and into the background, eventually to reach the sea.

The final appearance of the composition derives from the wishes of its patron, Prince Colonna, as recorded in a letter to him from Claude, which has been published by Marcel Roethlisberger.[5] Written on December 25, 1679, this reveals that the painting was intended to serve as a pendant to one done by Gaspard Dughet (q.v.) and Carlo Maratta. Claude also states that he has complied with his patron's wishes by adding the woods in the front plane and the temple and Pegasus on the mountain. Roethlisberger has identified this pendant as a *Judgment of Paris*, now in a Roman private collection,[6] in which the grandiose landscape is by Dughet and the figures by Maratta. Claude's last-minute alterations in the composition, which also clearly included changing the position of the Muses, have led to some modern-day confusion in identifying not only the Muses themselves but also the location of the subject. Originally the scene could be described as being the Temple of Apollo on Mount Parnassus, but the addition of Pegasus striking the rock shifted the locale to Mount Helicon. Depiction of a specific place was obviously less important to the artist and his era than the overall meditative effect the work created.[7]

One of Claude's preliminary drawings is unusual, however, for its depiction of the nine Muses, each identified with a text taken from Cesare Ripa describing their individual attributes, indicates that Claude was concerned about accurately detailing them.[8] The changes he made within these figures in the painting and the abrasion of the surface have now made it difficult to determine the identity of these figures from their attributes, although, as Roethlisberger has pointed out, both Clio and Calliope are borrowed directly from Raphael's *Parnassus*.[9] The following seems to be the best identification of them from left to right: Clio, muse of history, seated and robed in red and green, holds a long, thin trumpet and wears a garland of laurel. Standing behind her and slightly to the left is Melpomene, muse of tragedy, holding a crown and wearing an elaborate headdress. Standing next to her, looking at Apollo as he plays his lute, is most likely Erato, the muse of lyric and love poetry, whose own attribute, the lute, is seen behind her; her headdress is a crown of myrtle. (Terpsichore, the muse of dance and song, also has the attribute of a lyre and is usually shown in the act of dancing while wearing a garland of multicolored feathers.) Clutching the previously described Muse and also intently watching Apollo is a figure in blue who wears no specific headdress. She holds an attribute that, judging from its top, again appears to be a lyre. This is either Erato or Terpsichore. (The latter is most likely the figure painted out who now appears as a ghostly pentimento, for she had the most active, dancelike pose.) To the right of Apollo, seated below his rock in a recess, is another figure in blue, who by process of elimination should be Polyhymnia, muse of heroic hymns; in each hand she holds what appear to be wreaths or rings, rather than her usual attribute of a book. Next, seated in back view, wearing a green robe, and holding an object that is probably a wind instrument of some sort, is Euterpe, muse of music and lyric poetry, whose garland is composed of various flowers. Standing behind her is Thalia, the muse of comedy and pastoral poetry, who holds a mask and also wears a garland of flowers. Seated next and facing left toward Apollo is Calliope, muse of epic poetry, identified by a circlet of gold around her forehead and the large book in her lap. Finally, leaning against the tree at the right, wearing a garland of stars and holding a globe, is Urania, muse of astronomy.

By associating the Muses and Pegasus, Claude makes the winged horse into a symbol of inspiration, and that indeed seems to be the theme of this idyllic painting. The English critic William Hazlitt saw the work, most likely at the sale of the Carr collection in 1816, and he made the following observations: "The public in general merely know by tradition that this painter was a pastry-cook. Had this delectable composition to which we now allude been brought forward, they would have had the evidence of his practice to confirm it. It is said to represent 'Mount Parnassus;' and no one, who for a moment has seen the picture, can entertain the smallest doubt of its having been taken from one of his own *plateaux*. The figures have all the character and drawing which they might be expected to derive from a species of twelfth-cake casts. The swans are of the truest wax-shapes, while the water bears every mark of being done from something as right earnest as that at Sadlers' Wells, and the Prince's Fete of 1814."[10] The composition was nevertheless a popular one. A copy after the Boston painting appeared in a sale of 1987,[11] and a miniature version of it was formerly in the collection of Lady Dyne.[12]

Already in 1888 George Redford described this painting as "much rubbed and repainted."[13] This may be the reason, as Roethlisberger has pointed out, that the birds seen in the sky of the *Liber Veritatis* drawing do not now appear.[14] This is a shame, for it destroys a harmony that obviously existed between the various realms—that of water with the swans, the earth with the Muses, and

11a. Claude Lorrain, *Liber Veritatis*, no. 193: *Mount Parnassus or Mount Helicon with Apollo and the Muses.* Pen and brown ink with gray and gray-brown washes on blue paper. London, British Museum, inv. no. 199.

the air or sky with the birds. Nevertheless, a relationship between the calm swans and the elegant Muses still remains. The harmony evoked by Apollo's music is evident in the perfection of the natural elements. As in all of Claude's best works, there is an enrapturing balance between the vista and the light that filters through it.

1. Roethlisberger 1961, no. 126.

2. Roethlisberger 1968, vol. 1, pp. 393–94, 404–10; vol. 2, nos. 1070–74, 1113–14.

3. Kitson 1978, p. 173, no. 193.

4. See Wine 1994, pl. 32; Kitson 1978, p. 150; and Roethlisberger 1968, vol. 2, nos. 87, 119, 460, 553, 883, 938–39, 1050–51, 1124.

5. Roethlisberger 1986, pp. 49–50.

6. Ibid., fig. 24.

7. On seventeenth-century painters altering the attributes of the Muses see Paris 1994, p. 104.

8. The drawing was last with Agnew's of London. See Roethlisberger 1968, no. 1070, and Wine 1994, no. 75.

9. Roethlisberger 1968, vol. 1, p. 410.

10. Hazlitt 1844, pp. 138–39.

11. Sale Christie's, New York, October 16, 1987, no. 160.

12. Photograph from Paul Drey, New York, in the Paintings Department files, attributed to Blarenberghe.

13. Redford 1888, vol. 2, p. 275.

14. Roethlisberger 1961, p. 451.

LOUIS LE NAIN
1602/10–1648

MATHIEU LE NAIN
about 1607–1677

The three Le Nain brothers—Antoine, Louis, and Mathieu—were all born in Laon, and although they often collaborated, the works each produced fall into distinct groups. The brothers were in Paris by 1627. In 1632 they obtained a commission for a now-lost group portrait of the magistrates of Paris. In addition to portraiture they also executed religious paintings for Parisian churches. The three brothers attended the first meeting of the Académie royale de peinture et de sculpture in March 1648, but the two older brothers, Antoine and Louis, both died later that year. Traditionally, Louis is thought to be the greatest, a master primarily of melancholy peasant scenes. To the youngest brother, Mathieu, who eventually gave up painting and who lived until 1677, are attributed a number of religious works, allegories, and mythological scenes, as well as portraits.

After Louis Le Nain, 17th century

12. *Peasants in Front of a House*

Oil on canvas
22 1/4 × 26 in. (57 × 66 cm)
Clara Bertram Kimball Fund
22.611

PROVENANCE: possibly Michalon collection; sale Paris, Hôtel de Bullion, March 30–April 4, 1818, no. 351; earl of Carlisle; Rosalind, countess of Carlisle, London; sale Sotheby's, London, May 10, 1922, no. 88 (as Le Nain).

EXHIBITION HISTORY: London, Burlington Fine Arts Club, *The Brothers Le Nain* 1910, no. 12; Cambridge, Mass., Fogg Art Museum, 1931–35; New York, M. Knoedler and Co., *Georges de la Tour, the Brothers Le Nain*, 1936, no. 15; Boston, The Institute of Modern Art, *The Sources of Modern Painting*, 1939, no. 36 (also traveled to New York, Wildenstein and Co.); New York, 1946, no. 4; The First National Bank of Boston, 1958–59; Paris 1978, *hors catalogue*.

REFERENCES: Waagen 1854, vol. 2, p. 280; R. C. Witt, *Illustrated Catalogue of Pictures by the Brothers Le Nain* (London, 1910), p. 14; P. Jamot, "Sur quelques oeuvres de Louis et de Mathieu Le Nain," *GBA* 7 (1923), p. 32; P. Jamot, *Les Le Nain* (Paris, 1929), p. 40; P. Fierens, *Les Le Nain* (Paris, 1933), pp. 28, 62, pl. XXVII; W. Weisbach, *Französische Malerei des XVIIten Jahrhunderts* (Berlin, 1932), pp. 105–106, fig. 35; A. Sambon, "Les Le Nain," *Bulletin Trimestriel de la Chambre internationale des experts d'Art* (April–June 1936), under "Louis Le Nain," no. 6; Musée des Beaux-Arts, *Les Le Nain* (Reims, 1953), p. 26, under no. 7; Montreal Museum of Art, *Heritage de France, 1610–1760* (Montreal, 1961), p. 46, under no. 42; J. Thuillier, in Paris 1978, p. 206, under no. 35, and p. 297; Paris 1978, pp. 160, 169; Paris 1982, p. 356, no. 3; Murphy 1985, p. 164 (as Copy after); Wright 1985, p. 106, fig. 58; Rosenberg and Stewart 1987, p. 67, fig. 1; Rosenberg 1993, p. 81, fig. 36A.

CONDITION: The original plain woven fabric support has been glue-lined with the tacking margins trimmed. The paint is applied flatly and smoothly over a gray ground. There is an all-over pattern of age cracks in the paint layer. The painting is in good condition.

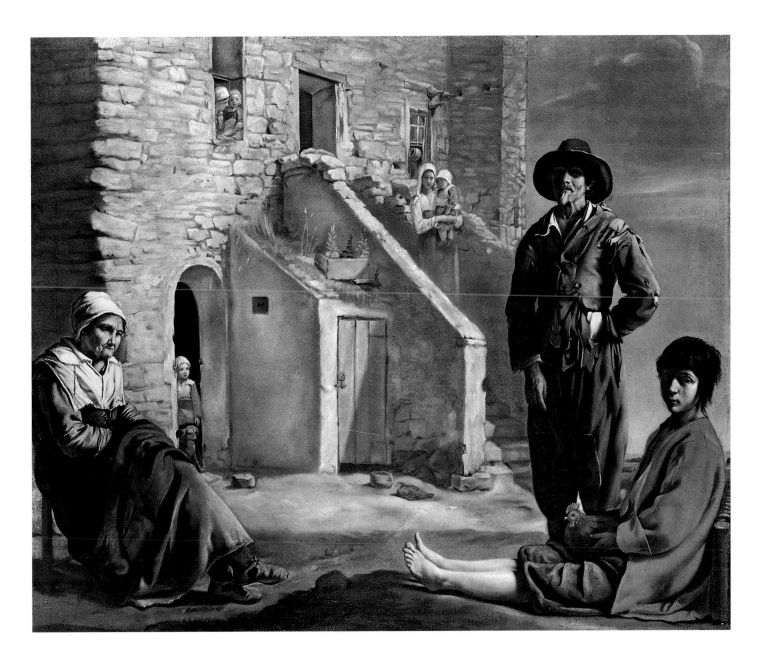

This painting is a copy of one attributed to Louis Le Nain, which is now in the Fine Arts Museums of San Francisco (fig. 12a).[1] The Boston version is not as powerful in the presentation of the figures nor as rich in texture and atmosphere as the original, but it does have some additional details that are lacking or obscured in the San Francisco painting. According to Pierre Rosenberg, it provides "a better idea of the San Francisco picture's probable appearance before its borders were extended slightly at either side." As seen in the Boston copy, the old woman seated at the left "had her back against the picture's frame; the boy with the rooster who sits on the ground at the right was originally shown leaning against a chair."[2] This is one of several cases where very close period copies of a Le Nain composition exist, and Jacques Thuillier was originally not willing to rule out the possibility that the Le Nains produced these copies themselves.[3] However, at the 1978 Le Nain exhibition in Paris, the two versions were exhibited together, and he had to conclude that the Boston painting was "nothing more than a copy of a great chef-d'oeuvre."[4]

Fig. 12a. Louis Le Nain, *Peasants before Their House*. Oil on canvas. Fine Arts Museums of San Francisco, Mildred Anna Williams Collection, 1941.17

1. Rosenberg and Stewart 1987, p. 67, and Rosenberg 1993, p. 81, no. 36.

2. Rosenberg and Stewart 1987, p. 67, where they unfortunately reproduce the Boston painting cropped.

3. Thuillier, in Paris 1978, p. 297.

4. Ibid., p. 160. Rosenberg 1993, p. 81, confirms this.

Mathieu Le Nain

13. *The Entombment of Christ*

Oil on canvas
32 × 41 3/4 in. (81.3 × 105.2 cm)
Gift of John Goelet in Memory of George Peabody Gardner
1978.225

PROVENANCE: Mme. Lenglier; sale Lebrun, Paris, March 10, 1788, no. 214; Chantreau; Vincent Donjeux; sale Lebrun, Paris, April 29, 1793, no. 309; Bonnemaison collection; sale Paris, July 15, 1802, no. 113; A. Delahante (?), London; sale Phillips, London, June 3, 1814, no. 50; Emerson (?); sale Christie's, London, March 29, 1819, no. 24; John Knapp, Balcomb Place, near Bradford; sold to William Rhodes in 1863; by descent to his grandson, Captain R. H. Rhodes, Saint Bride's Farm, Martin, Fordingbridge, Hampshire; to his widow, Mrs. Dorothy Rhodes; sale Christie's, London, July 15, 1960, no. 37; Wildenstein and Co., New York; private collection, New York.

EXHIBITION HISTORY: Paris 1978, no. 59.

REFERENCES: "Pictures at Christies, June and July," *Apollo* 71, no. 424 (June 1960), p. 219, ill.; "Berichte," *Pantheon* 18 (Sept.–Oct. 1960), pp. LXXVII–LXXXVIII, ill.; J. Thuillier, "Les Frères Le Nain: Une Nouvelle Oeuvre religieuse," *Art de France* 1 (1961), pp. 327–28; J. Thuillier, "Documents pour servir à l'étude des frères des Le Nain," *BSHAF* (1963), p. 157; J. Thuillier, "Le Nain: La Déploration sur le Christ mort," *RdA*, nos. 1–2 (1968), p. 98 n. 14; *The Museum Year, 1977–1978*, Museum of Fine Arts, Boston (Boston, 1978), p. 30; J. Thuillier, in Paris 1978, pp. 282–89; Blunt 1978, pp. 870, 873; Cuzin 1978, p. 876; Rosenberg 1979, p. 97, ill. p. 98; Thuillier 1979, p. 163; Paris 1982, p. 356, no. 5; Murphy 1985, p. 164; Wright 1985, p. 212; Rosenberg 1993, pp. 7, 87, 88, 118, 120, no. 60.

CONDITION: The plain woven fabric support has been glue-lined with the tacking margins trimmed. The paint is applied thickly over a gray ground. There is extensive retouching throughout the composition.

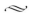

In the inventory of Mathieu Le Nain's works made after his death in 1677, a number of religious works are listed, several of which are called *Descent from the Cross* but none specifically an *Entombment*.[1] The earliest known mention of such a work is in the collection of Mme. Lenglier, sold in 1788, where it was described as by Le Nain: "Our Lord who will be put in the tomb; a composition of nine figures. The painting, which combines several beautiful passages, may take its place in the most beautiful collections and is a credit to our school. H. 30 inches. L. 43 inches."[2] Seemingly the same painting

with the same measurements appeared again in the Donjeux sale of 1793 described as "Christ in the tomb, where one can see the Holy Women and Joseph of Arimathea presiding over the funerary ceremonies; a nine-figured composition of a noble style, and correct design, and an extraordinary type in the manner of this master."[3]

The composition is indeed noble and grave, the figures grouped like a sculptural relief in front of the rock cave. In the far-left distance is an enormously tall cross with a ladder leaning against it. A procession of horsemen makes its way along the road observed by two onlookers. The lower right corner contains elements of the Passion—a basket with the hammer and a bowl as well as the skull of Adam, a traditional indication of the triumph over death. The subject is not specifically the Entombment but, as the French title *Mise au tombeau* suggests, a symbolic gathering before the burial. This allows the viewer—like the family and followers of Christ—to contemplate the Savior's dead body at its most pathetic and tragic, in an uncomfortable and awkward position. The figures from left to right are the Virgin Mary, kneeling and reaching out to touch the body; Mary Magdalen holding his hand; the bearded and turbaned Joseph of Arimathea standing behind them and gesturing to the cross; the third Mary; and the young Saint John the Evangelist, who actually supports the body of Christ. Three other men are seen farther back in the cave preparing the winding cloth on top of the tomb.

The early sales catalogues listed the painting simply as by "Le Nain," but when sold at Christie's in 1960, it was assigned to Mathieu Le Nain. In the first scholarly study of the work, Jacques Thuillier maintained that it was painted before 1648 and thus most likely is a collaboration of the brothers, as it seemed to him that different hands produced it.[4] At the time of the great 1978 Le Nain exhibition, Thuillier grouped it among "Le Nain problems," categorizing it as a work from the brothers' youthful period.[5] Reviewing the exhibition, Jean-Pierre Cuzin placed *The Entombment* among the works he believed to be by Mathieu.[6] Likewise, Anthony Blunt, in his review, decided that three distinct artists must have produced the Le Nain *oeuvre* and argued for identifying the one responsible for the group that included *The Entombment* as Mathieu, "till a painting can be found that can certainly be attributed to one brother."[7] Pierre Rosenberg, in his thoughtful review of the exhibition, although dividing the *oeuvre* in a somewhat different manner, also concluded that the Boston painting is by Mathieu.[8] More recently, he has restated this view and assigned the canvas to the 1640s.[9]

1. For Mathieu Le Nain's inventory see *BSHAF* (1963), pp. 235–50, and Rosenberg 1993, pp. 106–107.

2. Lenglier sale, March 10, 1788, quoted in Rosenberg 1993, p. 118.

3. Donjeux sale, April 29, 1793, quoted in Rosenberg 1993, p. 120.

4. Thuillier 1961, pp. 327–28.

5. Thuillier, in Paris 1978, pp. 282–89.

6. Cuzin 1978, p. 876.

7. Blunt 1978, p. 873.

8. Rosenberg 1979, p. 97.

9. Rosenberg 1993, p. 88, no. 60.

School of Mathieu Le Nain, 17th Century

14. *The Crucifixion with the Virgin, Saint John the Evangelist, and Mary Magdalen*

Oil on canvas
60 1/4 × 41 3/4 in. (154.5 × 105.5 cm)
M. Theresa B. Hopkins Fund
58.1197

PROVENANCE: D. Campbell Smith, Glasgow, 1952; London art market; Mrs. Robert Frank, London, by 1958.

EXHIBITION HISTORY: Poughkeepsie, N.Y., Vassar College Art Gallery, *Problem Pictures: Paintings without Authors*, 1965, no. 10 (as Dutch [?] XVII Century).

REFERENCES: "Accessions of American and Canadian Museums, October–December, 1958," *Art Quarterly* 22, no. 1 (Spring 1959), pp. 82, 85, ill. (as Abraham Janssens); Paris 1982, pp. 135, 356, no. 6; Murphy 1985, p. 165 (as Attributed to); Rosenberg 1993, p. 96, no. R2.

CONDITION: The plain woven fabric support, which has been glue-lined with the tacking margins trimmed, has a small, repaired, vertical tear at the bottom right in the Virgin's robe. The paint is applied thinly over a gray ground. Although some areas in the picture appear intact, the paint layer is generally in poor condition. There is extensive abrasion and damage. Retouching exists throughout, especially in the background and the upper-right quarter of the picture.

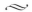

When acquired by the Museum, this impressive painting was identified as by the Flemish painter Abraham Janssens.[1] This attribution has been rejected, and several other artists, primarily of Dutch origin, were subsequently suggested.[2] Horst Gerson, when he saw the picture in 1964, however, expressed the opinion that it was perhaps French rather than Dutch or Flemish.[3] In 1975, Justus Müller Hofstede also believed it probably to be French.[4] In 1977 Pierre Rosenberg, while organizing the large Le Nain exhibition of 1978, first suggested the connection with this family of artists,[5] but it was not mentioned in the exhibition's catalogue. In 1982, however, Rosenberg listed it among the seventeenth-century French paintings in American collections as "Mathieu Le Nain (?)."[6] In a letter of 1990 he further described it as one of the most intriguing paintings among all those of the "entourage des Le Nain," but noted that certain elements of it are very Flemish.[7] Then in his 1993 catalogue of all the Le Nains' works, Rosenberg included it among the rejected works but with the caveat that it is very tempting to attribute the work to Le Nain and identify it with a now-lost *Crucifixion* painted for Nôtre Dame of Paris in 1646.[8]

There are indeed a number of Le Nain traits about the painting, such as the low, flat plane of ground and the striated clouds with patches of open sky. Most specifically, the head of the Magdalen is extremely close to that in Le Nain's *Lamentation over the Dead Christ* in the Hessisches Landesmuseum, Darmstadt.[9]

Although the operatic gestures of grief given to her and Saint John seem less characteristic of the Le Nains, the wind-blown garment, in this case Christ's loincloth, is something found in other works by them such as *Bacchus and Ariadne* (Orléans, Musée des Beaux-Arts) and *Allegory of Victory* (Paris, Louvre). The strikingly large Christ on the cross recalls other seventeenth-century French examples, notably those by Philippe de Champaigne (q.v.), and particularly that in Ottawa,[10] which also employs a nighttime setting and depicts the tower of a walled city at the lower right. In the case of the Boston painting, the strange *mélange* of buildings in the distance may be derived from an old French and Netherlandish tradition of representing in this way the three religious eras of history—pagan, Jewish, and Christian.[11]

1. Based on compositional similarities to a *Crucifixion* by Janssens in the museum at Valenciennes. The Flemish heritage of such a Crucifixion scene is reflected in a number of paintings by the schools of Rubens and Jordaens.

2. Michael Jaffé in 1961 and Kurt Bauch in 1962 (verbal opinions recorded in Paintings Department file) both rejected the attribution to Abraham Janssens. Marvin Sadik, in correspondence of 1961, proposed Jan Janssens; and Egbert Haverkamp-Begemann, in correspondence of 1966, named

Reyer Jacobs van Blommendal; while Richard Judson noted similarities to the work of Thomas de Keyser. In 1963 Horst Gerson, working from a photograph, first suggested Salomon de Bray and later Jacob Pynas. In a letter of 1969, Jacques Foucart proposed Karel du Jardin, by whom there is a somewhat similar heroic *Crucifixion* in the Musée d'Art et d'Histoire of Geneva. An equally emphatic *Saint Paul Healing the Sick of Lystra* attributed to du Jardin was sold at Christie's, London, December 11, 1987, no. 29. Frans Baudouin in 1974 and Otto Naumann in 1977 both proposed Pieter de Grebber.

3. On March 2, 1964, according to a note in the Paintings Department files.

4. On February 13, 1975, according to a note in the Paintings Department files.

5. Correspondence in the Paintings Department files of September 1, 1977.

6. Paris 1982, p. 356.

7. Letter, December 27, 1990, Paintings Department files.

8. Rosenberg 1993, p. 96. Another possibility is the *Crucifixion* recently in a New York private collection, ibid., no. 53.

9. See Thuillier, in Paris 1978, no. 14.

10. See M. Laskin and M. Pantazzi, *European and American Painting . . . Catalogue of the National Gallery of Canada* (Ottawa, 1987), vol. 1, pp. 68–69, fig. 169; for one in Kansas City see Paris 1982, no. 17.

11. For example, the fifteenth-century painting in the Frick Collection. See *The Frick Collection: An Illustrated Catalogue* (New York, 1968), vol. 2, pp. 124–29.

PHILIPPE DE CHAMPAIGNE

1602–1674

Born in Brussels on May 26, 1602, Philippe de Champaigne first studied with the little-known Jean Bouillon and Michel de Bordeaux as well as with the better-known landscape painter Jacques Fouquière, who had been an assistant to Rubens. In 1621 Champaigne moved to Paris, where he worked for the painter Georges Lallemond, and later for Nicholas Duchesne (active 1599–1627). Champaigne met Nicolas Poussin (q.v.), and both worked as Duchesne's assistants on the decorations of Marie de' Medici's Palais du Luxembourg. Champaigne succeeded Duchesne as court painter on the latter's death and, on November 29, 1628, married his daughter Charlotte. In 1629 he became a naturalized French citizen. Through the queen mother he received commissions for religious work for Parisian Carmelite cloisters. Following Marie's flight from Paris, he was favored with commissions by Louis XIII and Cardinal Richelieu, whose palace (later the Palais-Royal) he decorated and whose portrait he painted repeatedly. In

1638 his wife died. Two of their three children also died young, and the surviving daughter became a nun, whose miraculous recovery from illness he recorded in an *Ex voto* of 1662. By the early 1640s, Champaigne was increasingly involved with the strict reformist sect of the Jansenists in Port-Royal. However, he also remained the official painter to the magistrates of Paris and an official painter to the Church and its several factions (Carthusians, among others). In 1648 he was one of the founding members of the Académie royale de peinture et de sculpture. Subsequently he served as a professor at, and later as rector to, the Académie. Champaigne died in Paris in 1674.

Although best known as a portraitist, Champaigne was also active as a history painter and executed many large altar paintings depicting monumental religious subjects. His style is usually scrupulously polished and often austere but also psychologically probing.

15. *Portrait of the Reverend Father Giovanni Antonio Philippini*, 1651

Oil on canvas
28 1/2 × 23 1/4 in. (72.3 × 59 cm)
Signed and dated lower right: *Ph De Champaigne Pinxit 1651*
Inscribed at the bottom: *R[everendus]. P[ater]. Joan. Antoni Philippin. Roma. Prior Generalis / totius ordinis Carmelitar. anno aetatis. 52 / Domini 1651. quo in Galliam venit.*
Bequest of William A. Coolidge
1993.35

PROVENANCE: the artist's estate, 1674; Nicolas de Plattemontagne; sale Laneuville collection, Paris, sold at his residence 15, rue Saint Marc, June 5–7, 1826, no. 70 (?); Knoedler & Co., New York, by 1952; purchased by William A. Coolidge, Topsfield, Mass., 1958.

EXHIBITION HISTORY: Paris 1952, no. 39.

REFERENCES: Guiffrey 1892, p. 183, no. 35; C. Sterling, "Les Ducs de Bourgogne et la civilisation franco-flamande," in *Les Arts plastiques* (Brussels, 1951), p. 175, no. 3, ill.; A. Mabille de Poncheville, *Philippe de Champaigne* (n.p., n.d. [1953]), frontispiece; A. Mabille de Poncheville, "Philippe de Champaigne," *Bulletin de la classe des beaux-arts de l'Académie royale de Belgique* 38 (1956), p. 61; *Connaissance des arts* 68 (Oct. 1957), advertisement, p. 22; M. Rambaud, *Documents du minutier central concernant l'histoire de l'art* (Paris, 1964), vol. 1, p. 516; Dorival 1976, vol. 2, pp. 82, 111–12, 257, no. 201, pl. 201; Zafran, in Sutton 1995, no. 8.

CONDITION: The painting is in excellent condition. The original coarse canvas has been glue-lined, and the reverse of the lining fabric covered with lead paint. The surface paint is smoothly applied over a warm ground, and a slight weave imprint exists in the paint layer, which may have occurred during lining. There are no major losses or damages, and the original glazes are intact. A pentimento is visible, indicating changes in the position of the sitter's hand. It was mounted on a new stretcher, detectable from old stretcher creases, especially at the top edge.

Viewed bust-length, turned three-quarters to the viewer's left, and wearing the white robes of the Carmelite friars, the sitter appears behind a marble balustrade bearing a Latin inscription: "The Reverend Father Giovanni Antonio Filippini, a Roman, General Prior of the entire Carmelite order, in his 52d year in the year of our Lord 1651, in which he came to France."[1] Philippini, as his name is more generally spelled, was born in Rome in 1599 and entered the Carmelite order in Florence. After traveling to Spain, he studied in Naples and Rome, then became a doctor of theology. As prior of the convent of S. Martino ai Monti in Rome, he was responsible for restoring the church. Philippini was a protégé of Urban VII, and became an associate of the General Priors in 1642. From 1648 to 1654, he served as prior general, during which time he worked on reforming the order in Germany, Flanders, and France. He died on August 7, 1657.[2]

The sitter owned an identical portrait, which he left to S. Martino ai Monti, Rome, where it remains.[3] Both versions were presumably painted by Philippe de Champaigne when Philippini visited Paris in July 1651. The Boston example remained in the artist's possession, figuring in the posthumous inventory of his estate, dated August 17, 1674.[4] Bernard Dorival noted that the portrait formula of a bust-length format, that omits the hands and turns the sitter, who retains eye contact, was employed by the artist at least five years earlier in *Portrait of Martin de Barcos* (two versions of 1646, both in private collections, one including a balustrade)[5] and somewhat later in *Portrait of Abbé de Saint-Cyran*.[6] The motif of the balustrade was popularized by sixteenth-century Italian painters such as Bellini and Titian. It serves to set the figure in a removed

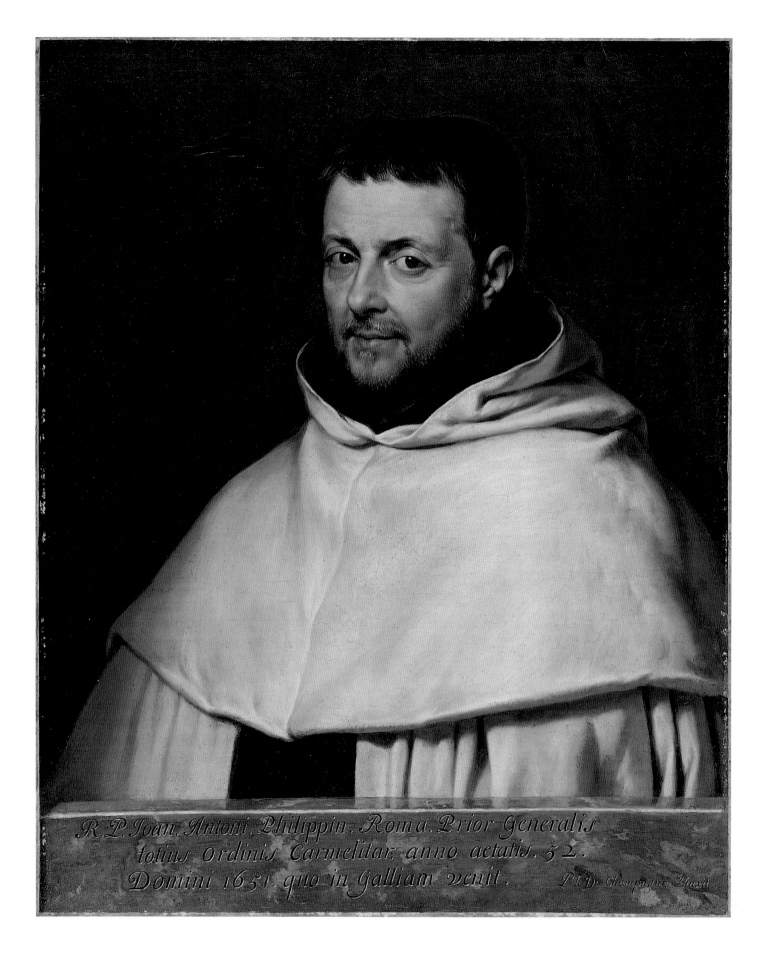

R.P. Joan. Antoni. Philippin. Roma. Prior Generalis
totius Ordinis Carmelitar. anno aetatis. 52.
Domini 1651 quo in Galliam venit. Phil De Champaigne Pinxit

but real space, enhancing the sitter's strong personality. The absence of the hands creates a monumental effect, and the sculptural robe supports a head of tremendous presence. As with the best of Philippe de Champaigne's works, an intense spirituality radiates from the prior, who seems about to deliver a sermon to the viewer.

1. Translation of the Latin kindly provided by Annewies van der Hock.

2. Dorival 1976, vol. 2, p. 534.

3. Ibid., p. 111, no. 200, fig. 200, inscribed in the same way.

4. Guiffrey 1892, p. 183. It was item no. 35, valued at 45 livres.

5. See Dorival 1976, vol. 2, nos. 145, 146, pls. 145–46.

6. Ibid., no. 215 (datable 1647–48) at Grenoble, Musée de Peinture et de Sculpture.

Attributed to Philippe de Champaigne

16. *Portrait of Valentin Valleron de Perrochel*, 1647

Oil on canvas
29 × 23 1/2 in. (74 × 60 cm)
Dated on the ledge: *A⁰· 1647.*
Denman Waldo Ross Collection
06.119

PROVENANCE: Comte Despinoy, Paris; sale 5, rue du Regard, Paris, January 14–19, 1850, no. 327 (as of Arnauld-Robert d'Andilly); marquis de Biencourt, Château Azay-le-Rideau; sale Galerie Georges Petit, Paris, May 13–14, 1901, no. 92; Alfred de Chaignon, Paris; Pierre de Chaignon la Rose, Cambridge, Mass.; sold February 23, 1905, to Denman W. Ross.

EXHIBITION HISTORY: Cambridge, Mass., Fogg Art Museum, Loan Exhibition, 1909 (as *Portrait of Arnaud D'Andilly*).

REFERENCES: *BMFA* 4 (April 1906), p. 11; *BMFA* 4 (Oct. 1906), pp. 34–37, ill.; Thieme and Becker 1912, vol. 6, p. 354; Addison 1910, p. 88; Guiffrey 1913, pp. 536–37; Boston 1921, p. 78, no. 189; Hendy 1927, p. 172; Boston 1932, ill.; Blunt 1952, p. 175; B. Dorival, in Paris 1952, p. 57; Boston 1955, p. 11; Dorival 1958, p. 132; Dorival 1976, vol. 2, pp. 329, 498, ill. no. 1778; Paris 1982, p. 348, no. 9 (as a copy); Murphy 1985, p. 49 (as Philippe de Champaigne); Wright 1985, p. 153.

CONDITION: The plain woven fabric support has been glue-lined with the tacking margins trimmed; the lower edge has been cropped into the composition. The paint is thinly applied over a granular red ground. In general, the painting is in very good condition. A pentimento is revealed in the sitter's hat. In-painting is confined to small areas in the shadows.

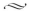

Seen in three-quarter bust-length, behind a balustrade and before a gray curtain, the sitter is dressed in a black robe and cap. At the time the painting entered the Museum, the figure was identified as Robert-Arnauld d'Andilly. However, another version of the painting in a private collection, also dated 1647, bears an old inscription identifying the sitter as Valentin Valleron de Perrochel, General Treasurer of France in Tours, born in 1574.[1] That work's provenance goes back to the Perrochel family, making the identification quite convincing. Furthermore, a definite portrait of d'Andilly, now in the Louvre, shows a quite different individual.[2]

In 1927 Philip Hendy suggested that the Boston painting was possibly by an assistant.[3] In the 1952 catalogue by Bernard Dorival for the Philippe de Champaigne exhibition at the Orangerie, where the other version was exhibited, the Boston painting was called a replica. Anthony Blunt wrote in his review of this exhibition that this was one of the cases in which "the works exhibited appear to be studio replicas of which better versions exist elsewhere."[4] In his monograph on the artist, Dorival again referred to the Museum's painting as a "replique" but added, "The possibility is not excluded that this painting may be a second version of the original one."[5] In his listing of seventeenth-century French paintings in American collections, Pierre Rosenberg describes it as a copy.[6]

The problem of replicas is frequently encountered in the works of Philippe de Champaigne, as with the portrait of Philippini (cat. 15). In that case the provenance tracing its ownership back to the artist enhances the work's claim to authenticity. One may note a certain bland quality in the present example. If the artist painted such replicas, he showed less interest in them and they tend to be more routinely executed. Still, in this case the pentimento in the hat indicates a willingness to change details.

1. Dorival 1976, vol. 2, p. 111, no. 199.

2. Dorival 1958, p. 132.

3. Hendy 1927, p. 172.

4. Blunt 1952, p. 175.

5. "Il n'est pas exclut que ce tableaux puisse être un deuxième exemplare de l'original." Dorival 1976, vol. 2, p. 329.

6. Paris 1982, p. 348, no. 9.

GASPARD DUGHET (ALSO CALLED GASPARD POUSSIN)

1613 or 1615–1675

Gaspard Dughet was born in Rome, the son of a French cook and an Italian mother, and he was raised amid the French colony in Rome. In 1630 his sister married the distinguished painter Nicolas Poussin (q.v.). Gaspard studied with that French master from about 1630 to 1635, but they do not seem to have been on close terms. He worked in both fresco and oil as a specialist in landscape, often with the figures painted by other artists. In his landscapes, the natural settings overwhelm the religious or classical figures and are usually dark and broodingly poetic. These landscapes are based on his study of the Roman Campagna, although he also traveled to Naples and Florence for his patrons. Unfortunately, Dughet seldom signed or dated his easel paintings, with the result that his development has been difficult to reconstruct.

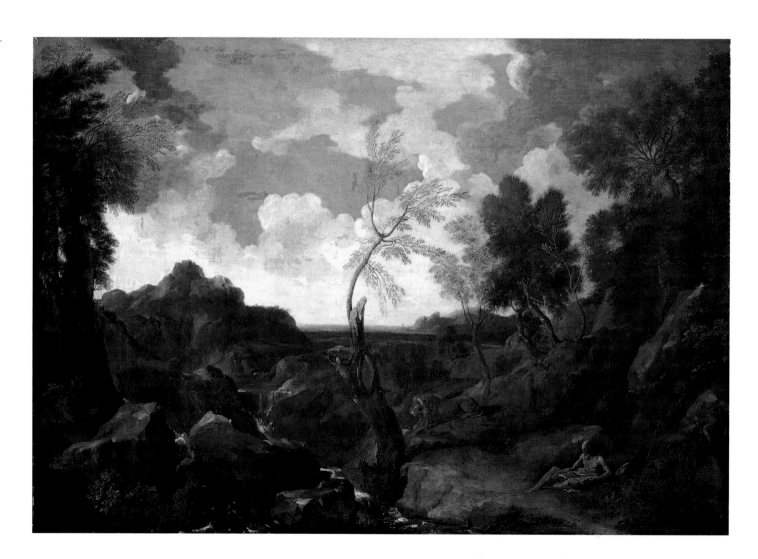

17. *Landscape with Saint Jerome and the Lion,* about 1638

Oil on canvas
48 × 70 3/4 in. (122 × 179.5 cm)
Seth K. Sweetser Fund
52.393

PROVENANCE: Charles Jennens, London, 1761; inherited by Penn Asheton Curzon, 1773; to his son, Richard William Penn, first count of Howe; by descent in the Howe family at Gopsall House; F. Stambois; P. and D. Colnaghi, London, by 1951.

EXHIBITION HISTORY: London, British Institution, 1858, no. 113 (as Poussin); London, Royal Academy, *Exhibition of Works of Old Masters*, Winter 1885, no. 167 (as Poussin); Paris 1982, no. 27; Tokyo 1983–84, no. 10.

REFERENCES: R. Dodsley and J. Dodsley, *London and Its Environs Described* (London, 1767) vol. 5, p. 77; T. Martyn, *The English Connoisseur* (London, 1766), vol. 1, p. 117; Boston 1955, p. 44; M. Roethlisberger, in New York and London 1975, p. 32; Boisclair 1978, vol. 2, p. 25, no. 58; P. Rosenberg, "La Peinture française du XVIIe siècle dans les collections des Etats-Unis," *RdL* 1 (1982), p. 72, fig. 2; H. Brigstocke, "France in the Golden Age," *Apollo* 116, no. 245 (July 1982), p. 13; Murphy 1985, p. 86; Wright 1985, p. 179; Boisclair 1986, pp. 43–44, 189–90, no. 72, fig. 97; *Colnaghi in America*, ed. N. H. J. Hall (New York and London, 1992), p. 127.

CONDITION: The painting is in fair condition. The central figures are largely intact and the sky, although worn, is preserved better than in many paintings of this type. There are small discrete losses throughout the composition. Many of the shadows in the landscape are sunken and have been damaged. Two compound tears in the left side of the painting have been repaired. There are several minor artist's changes: the profile of the hills and buildings at the left were changed and a tree trunk to the left of the lion was painted out in the final version.

~

As with many works from the Dughet-Poussin circle, the attribution history of this painting is rather tangled. A notably large and impressive canvas, it was identified in English collections and exhibitions of the nineteenth century as by Poussin. When acquired in 1952, both Colnaghi's James Byam Shaw and the Museum's W. G. Constable agreed to downgrade it to the Antwerp-born painter Francisque Millet.[1] In a letter of April 1952, however, Anthony Blunt suggested to Constable:

[T]he picture [is] almost certainly by a man whom I invented and called the Silver Birch Master. . . . It has in part his treatment of the foliage, with its very marked contrasts between delicate and clearly defined leaves, and much coarser woolly trees in other parts. It also has the rugged stones, which he particularly likes, and the general arrangement of space which is not so lucid as Poussin's nor quite so picturesque as Gaspar's. Two paintings which come very close to it are the *St. Jerome* in the Prado attributed to Poussin and its pair and another, which is perhaps even nearer, is a picture which was sold at Christie's on 24/7/1936, lot 82. . . . The picture is altogether closer to the Silver Birch Master than to Millet. On the whole, however, he is more closely Poussinesque than the author of your picture.[2]

Subsequently most of the works attributed by Blunt to the Silver Birch Master have been reassigned to the young Dughet or to Poussin (q.v.),[3] although neither Blunt nor others seem to have ever published the Museum's painting in this context. In March 1957, Ellis Waterhouse was apparently the first to express the opinion that the work was not by Millet but by Gaspard Poussin.[4] This idea was confirmed in a letter from Marie-Nicole Boisclair of 1975 (and she included it as such in her thesis and later publication);[5] then in September 1979, Pierre Rosenberg verbally also attributed it to Dughet[6] and published it in the 1982 catalogue accompanying the exhibition of seventeenth-century French paintings in American collections.

Boisclair dated the work to between 1638 and 1640,[7] which Rosenberg considered too early for "a work of such monumental character."[8] Boisclair, however, countered that the work was comparable to other large paintings of this period at Kassel (Staatliche Gemäldegalerie), and Kiel (Wanderndes Museum Universität Kiel).[9] Marcel Roethlisberger also noted its similarity to a stormy landscape that he dated to the early 1640s.[10]

Like Blunt, Rosenberg also compared the Museum's painting to Poussin's *Saint Jerome* in the Prado, noting that "Dughet had Poussin's canvas in mind when he executed this work." The Poussin was painted in the mid-1630s for the palace of the Buen Retiro and, according to Rosenberg, is "one of the rare paintings of the period in which he emphasized landscape."[11] Poussin's work was one of several depicting Anchorites that were commissioned by Philip IV from French artists in Rome including Claude (q.v.) and Dughet. Although both the Poussin and Dughet works emphasize landscape, as Boisclair has written, the paintings are quite different.[12] This is especially true of the treatment of the religious personages. In Poussin's painting St. Jerome is prominently placed at the center, engaged in self-mortification as he contemplates a spindly cross with a skull at its base. In the Boston Dughet the saint is more fully and harmoniously enmeshed in the landscape. He is placed off-center, to the right, and shown in the more passive act of reading. His lion also rests peacefully on the ground in the right background. At the center of Dughet's composition is a detail he may have borrowed from Poussin's composition, although by giving it such prominence he imbues it with greater symbolic meaning. This is the blasted tree stump out of which grows a leafy new branch. This symbol of renewal is silhouetted against the much broader expanse of open sky, a motif often found in Dughet's painting. The whole has a contemplative and serene mood appropriate to one of the few religious subjects treated by Gaspard.[13]

1. Correspondence and notes in the Paintings Department files of December 21, 1951, January 15, 1952, and March 21, 1952. For Millet see M. Davie, "A Note on Francisque Millet," *Bulletin de la Société Poussin*, 2d cahier (Dec. 1948), pp. 13–27.

2. Letter of April 7, 1952, in the Paintings Department files.

3. Blunt's original article appeared as "Poussin Studies V: 'The Silver Birch Master,'" *TBM* 92, no. 562 (Jan. 1950), pp. 69–73. For subsequent reappraisals of the Silver Birch Master, see Blunt's articles "Poussin Studies VIII: A Series of Anchorite Subjects Commissioned by Philip IV from Poussin,

Claude, and Others," *TBM* 101, no. 680 (Nov. 1959), pp. 389–90; and "The Silver Birch Master, Nicolas Poussin, Gaspard Dughet, and Others," *TBM* 122, no. 929 (Aug. 1980), pp. 577–82; J. Shearman, "Gaspard, Not Nicolas," *TBM* 102, no. 688 (July 1960), pp. 326–29; C. Whitfield, "Poussin's Early Landscapes," *TBM* 121, no. 838 (Jan. 1979), pp. 16–19; and Wright 1984, p. 64.

4. Note in the Paintings Department files of March 25, 1957.

5. Letters of August 5, 1974, and March 7, 1975, in the Paintings Department files.

6. Note of September 1979 in the Paintings Department files.

7. Boisclair in her letters of 1975 and 1978.

8. Rosenberg, in Paris 1982, p. 244.

9. Boisclair 1986, p. 190.

10. Roethlisberger, in New York and London 1975, p. 32, n. 2; and Boisclair 1986, no. 61.

11. Rosenberg, in Paris 1982, pp. 244–45. For the Poussin see Blunt 1966, p. 71, no. 103, also Thuillier 1994, p. 254, no. 114.

12. Boisclair 1986, p. 189.

13. *A Landscape with Saint John the Baptist* by Dughet is in the duke of Buccleuch's collection. See The Iveagh Bequest, Kenwood, *Gaspard Dughet* (London, 1980), p. 39, no. 8.

SÉBASTIEN BOURDON

1616–1671

Sébastien Bourdon was born to a Calvinist family of Montpellier in 1616. His father, also a painter, sent his young son to Paris in 1622 to escape the region's religious strife. Bourdon studied for seven years with the little-known artist Jean Barthálemy, and in 1630 he left Paris. For the next four years, Bourdon led an adventurous life, traveling throughout France. At the age of eighteen, he arrived in Rome without a patron and was forced to work for an art dealer named Escarpinelli, who had him "copy" paintings by popular artists, such as Claude, Andrea Sacchi, Michelangelo Cerquozzi, Pieter van Laer, and Giovanni Benedetto Castiglione. After two and a half years, Bourdon left Rome with the art collector Louis Hesselin and returned to Paris, where Hesselin introduced Bourdon to Simon Vouet with the hope that Bourdon would continue his education with this master. Bourdon, however, preferred to establish himself as an independent artist.

At first he produced genre paintings, particularly peasant scenes of the type that had been popular in Rome. In 1641 Bourdon married Suzanne du Guernier, a member of a well-known family of miniaturists. Her connections provided Bourdon with a new group of wealthier patrons. His first major success came in 1643 when he was commissioned to produce a *Martyrdom of Saint Peter* for the cathedral of Nôtre Dame, which is still in the church. In 1648 Bourdon became one of the twelve founding members of the Académie royale de peinture et de sculpture. Bourdon left Paris in 1652 for Sweden, where he had received a commission from Queen Christina for several royal portraits to decorate a memorial for her father. Due to lack of time, the project was abandoned, and within a year Bourdon returned to Paris, where he was named one of the four rectors of the Académie. On the death of Eustache Le Sueur (q.v.) in 1655, Bourdon received the commission for a tapestry cartoon for the church of St-Gervais.

After a year-long stay in Montpellier (1657–58), Bourdon spent the rest of his life in Paris. His final decade was his most prosperous and successful. His last major completed project was the decoration of the gallery of the Hôtel de Bretonvilliers. He also received the prestigious commission for the decoration of the Tuileries, but unfortunately, after having completed only one room in the lower apartments, Bourdon died at the age of fifty-five.

Sébastien Bourdon and Workshop

18. *Rebecca and Eleazer*, 1664–69

Oil on canvas
56 3/4 × 78 3/8 in. (144 × 199 cm)

19. *Christ and the Samaritan Woman*, 1664–69

Oil on canvas
56 7/8 × 78 3/8 in. (144.5 × 199.2 cm)
Juliana Cheney Edwards Collection
68.24 and 68.23

PROVENANCE: abbé de Saint-Georges, Montpellier (?), about 1658; prince de Conti, Paris; sale Paris, April 8–June 6, 1777, no. 2087; private collection, Paris; Wildenstein and Co., New York, by 1962.

EXHIBITION HISTORY: London, Wildenstein and Co., *Religious Themes in Painting from the Fourteenth Century Onwards*, 1962, nos. 39, 40; Boston 1970, nos. 47, 48; The Denver Art Museum, *Baroque Art: Era of Elegance*, 1971; Boston 1972, no. 89; Tokyo 1983–84, no. 11.

REFERENCES: G. de Saint-Georges, "Mémoire historique des principaux ouvrages de M. Bourdon," in Dussieux et al. 1854, vol. 1, p. 94; A. Jameson, *The History of Our Lord* (London, 1864), vol. 1, pp. 337–39; E. Bonnaffé, *Dictionnaire des amateurs français au XVIIe siècle* (Paris, 1884), p. 281; K. Künstle, *Ikonographie der christlichen Kunst* (Freiburg, 1928), vol. 1, pp. 393–94; A. Brookner, "Current and Forthcoming Exhibitions," *TBM* 104, no. 709 (April 1962), p. 173; A. Bury,

"Round about the Galleries," *Connoisseur* 149, no. 602 (April 1962), p. 270; A. Bury, "In the Galleries," *Connoisseur* 152 (March, 1963), p. 188; Fowle 1970, vol. 1, pp. 96–100, 107, nos. 25, 26, vol. 2, pp. 78–83; Fowle 1973; Vermeule 1976, pp. 97, 99, and 101, figs. 4, 5; Paris 1982, p. 346, nos. 5, 6; J.-P. Cuzin, "New York French Seventeenth-Century Paintings from American Collections," *TBM* 214, no. 953 (Aug. 1982), p. 530, no. 93; Murphy 1985, p. 31 (as Sébastien Bourdon); Wright 1985, p. 147.

CONDITION: (Cat. 18) The plain woven fabric support has been glue-lined with the original tacking edges intact. The artist applied a gray ground in thin, opaque layers. There is all-over cracking in the paint layers. Besides a small repaired damage in the white drapery at the right, the painting is in very good condition. In-painting is confined to the damaged area, scattered losses, and the edges. (Cat. 19) The plain woven fabric support has been glue-lined with the original tacking edges intact. The paint layer is applied over an artist-applied gray ground in thin, opaque layers and has a crack pattern. The picture is in very good condition, with in-painting confined to small scattered losses in and around the edges.

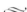

These pendants depict two biblical stories—one from the Old Testament and one from the New—that, on first glance, seem unrelated. In fact, the Museum's pendants may be the only known example of a pairing of a Rebecca and Eleazer and a Christ and the Samaritan woman in Western painting.[1] In the Old Testament episode, Abraham's servant Eleazer is sent to Mesopotamia to find a wife for Abraham's son Isaac. On entering the city of Nahor, Eleazer encounters Rebecca, a young woman, who offers the weary traveler water for himself and his camels. This act of kindness is a sign to Eleazer that Rebecca is the woman for whom he has been searching, and in recognition he places a gold bracelet in her hand. It is this moment that Bourdon depicts, and it was a subject frequently represented in paintings, most notably in Poussin's (q.v.) work of 1648 now in the Louvre.[2]

In the New Testament painting, *Christ and the Samaritan Woman*, Bourdon has chosen another episode in which revelation is the main theme. Christ, traveling in Samaria, stopped at a well outside Sychar, while his disciples continued into the town. A woman came to the well to draw water for herself, and Christ asked her for some. Since she did not recognize him, the woman hesitated and questioned him instead, but he soon revealed himself as Christ, and in response, the woman called to the other townspeople to come see him at the well. Bourdon has depicted the final moment of the episode, when the disciples and the Samaritans meet. Unlike the familiar iconography of the *Rebecca and Eleazer*, this moment is rarely depicted. More often represented is the meeting of the woman and Christ.[3] Despite the unusual subject matter of these pendants, their narratives are linked by the fact that both are set at wells and by their emphasis on personal revelation.[4]

The two works are intended to be seen together, with the Old Testament painting on the left and the New Testament one on the

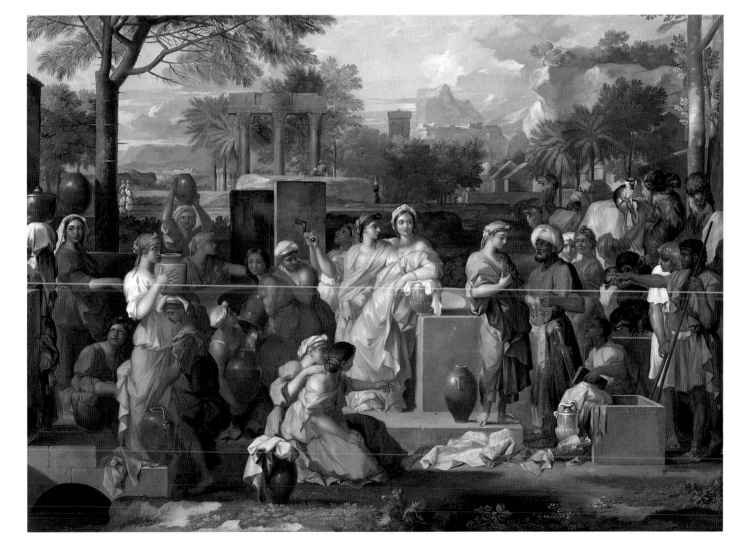

right. In both compositions, the main figures are slightly off-center, but when the pendants are hung together, they become the focal points. The full composition of the two works is framed at each side with a woman carrying a jug on her head, who looks directly out at the viewer.[5] Despite the complexity of the multifigured compositions, Bourdon highlights the principal figures through his use of color.[6] Instead of making Rebecca, Eleazer, Christ, and the Samaritan woman easy to identify by clothing them in bright and obvious colors, such as red or yellow, Bourdon employed more subtle, quiet shades of blue and purple for the main characters, surrounding them with other figures who are brightly dressed.

A comparison of the Museum's *Rebecca and Eleazer* to Poussin's 1648 painting of the same subject reveals that Bourdon was inspired by the older master. In fact, Anthony Blunt has attributed a drawing in the Nationalmuseum, Stockholm, after Poussin's painting to Bourdon.[7] Bourdon's painting incorporates many of Poussin's motifs, particularly the female figures carrying jugs of water on their heads.[8] In addition, the general compositional arrangement, which is horizontal, multifigured, and combines city and landscapes in the background, certainly is a trademark of Poussin's style. However, Bourdon's work does differ from that of his chief rival. According to Geraldine Fowle, Poussin's *Rebecca and Eleazer* was criticized during discussions at the Académie in 1668 for not including all the details

of the biblical story within the composition.[9] By contrast, Bourdon depicts the episodes in rich detail. He carefully incorporates elements and characters mentioned in the Bible, most notably all six camels in the *Rebecca and Eleazer* and all twelve disciples in *Christ and the Samaritan Woman*.

Bourdon had painted another version of *Rebecca and Eleazer* about twenty years earlier (Château Blois).[10] That composition differs substantially from the Museum's painting, with the depiction of only six main figures in a smaller and more intimate format. The larger scale of the Boston painting shows how fully he had absorbed the lessons of Poussin to create works that are at once grand and spiritual.

With their representations of nobly draped figures amid stone pedestals set in landscapes with distant towers and mountains,[11] the Museum's paintings are examples of Bourdon's mature classical period and can be dated to about 1664–69.[12] Commissioned by the abbé de Saint-Georges, they were completed by Bourdon after he returned to Paris from his last visit to Montpellier, his birthplace, in 1657–58. Bourdon's early biographer, André Georges Guillet de Saint-Georges, wrote in 1692: "After that [Bourdon's return to Paris], he worked on two cabinet paintings for M. the abbot of Saint-Georges, one representing Rebecca's story and the other one a Samaritan woman who brings several inhabitants of Samaria to

see the Savior. Each painting is seven to eight feet and of the same height."[13] Despite this reference, these biblical paintings were not mentioned in Charles Ponsonhaile's monograph of 1883, which was, until 1970, the most thorough catalogue of Bourdon's work.[14] The attribution of the pendants has been questioned by Pierre Rosenberg (1982) and Christopher Wright (1985), who both suggest that they might be copies. Jean-Pierre Cuzin (1982) disagreed with this assertion and concluded that the paintings were original. Geraldine Fowle has also confirmed the attribution, noting that "despite the breaks in provenance, there is no doubt that the pendants are the two works to which Guillet referred."[15] There is, nevertheless, a notable blandness, even crudeness, in the painting of the figures, as contrasted to the refined landscape, suggesting that these works were a collaboration of the master and his workshop.

1. Fowle 1970, vol. 2, p. 79.

2. See Paris 1994–95, no. 166; Thuillier 1994, no. 173; and Montreal 1993, no. 70.

3. Fowle 1970, vol. 2, p. 80.

4. Fowle 1973, pp. 84-86.

5. Fowle 1970, vol. 1, pp. 99–100.

6. Fowle 1973, pp. 78–79.

7. Blunt 1966, p. 10.

8. Fowle 1970, vol. 2, pp. 82–83.

9. Ibid., vol. 1, p. 99. Fowle cites a lecture given on January 8, 1668, by either Philippe or Jean-Baptiste de Champaigne, which criticized Poussin's composition.

10. Ibid., vol. 2, pp. 27–31. A copy of this earlier *Rebecca and Eleazer* also exists (formerly in the Staatsgalerie, Stuttgart, and sold, Sotheby's, New York, June 11, 1981, no. 77) and was probably painted by one of Bourdon's students.

11. Compare, for example, the *Christ with Children* in the Louvre; see Paris 1994, no. 25; and *Christ and the Centurion* in Caen. See Montreal 1993, no. 101.

12. Fowle 1973, p. 75.

13. "Après cela [Bourdon's return to Paris] il travailla à deux tableaux de cabinet pour M. l'abbé de Saint-Georges, l'un représentant l'histoire de Rébecca et l'autre une Samaritaine qui amène plusieurs habitants de Samarie pour voir le Sauveur. Chaque tableau est de sept à huit pieds et de la même grandeur." See Dussieux et al. 1854, vol. 1, p. 94, cited in Fowle 1973, p. 89 n. 2.

14. C. Ponsonhaile, *Sébastien Bourdon, sa vie et son oeuvre* (Paris, 1883).

15. Fowle 1970, vol. 2, p. 79.

EUSTACHE LE SUEUR
1616–1655

Unlike most French artists of his era, Eustache Le Sueur never went to Italy. The son of a woodworker, he trained in his native city of Paris until about 1644, with Simon Vouet, with whom his paintings have often been confused. In 1637, when Vouet received the commission for a series of compositions on "Le Songe de Polyphile" (The Dream of Polyphilus), he entrusted it to Le Sueur, who completed the works in 1645, having evolved his own distinctive style in the process. The other influences on him were prints and drawings of the Raphael school and works by Poussin (q.v.), who returned to Paris from 1640 to 1642. Le Sueur's paintings—some portraits but mainly religious and historical subjects—are distinguished by a sweetness and elegance that becomes more classical and cool in his late phase. From 1645 to 1648 he produced twenty-two paintings on the life of Saint Bruno for the Charterhouse of Paris. These brought him great fame, and in 1648 Le Sueur was invited to be one of the founding members of the Académie royale de peinture et de sculpture. He also received a number of royal commissions for decorations within the Louvre.

20. *Bacchus and Ariadne*, about 1640

Oil on canvas
69 × 49 1/2 in. (175.3 × 125.7 cm)
Ernest Wadsworth Longfellow Fund and Grant Walker Fund
68.764

PROVENANCE: comtesse Du Barry (?); sale Paris, February 17, 1777, no. 20 (as Vouet?); Parizeau collection; sale Paris, Hôtel de Bullion, March 26, 1789, no. 32 (?); bought in and sold again May 24–26, 1792, no. 63; private collection in South America; François Heim, Paris, by 1968.

EXHIBITION HISTORY: London, Heim Gallery, *French Paintings and Sculptures of the Seventeenth Century, Part I*, 1968, no. 4 (as Vouet); Boston 1970, no. 46; College Park, University of Maryland, *Simon Vouet*, 1971; Frankfurt, Schirn Kunsthalle, *Guido Reni und Europa*, 1988–89, no. D71.

REFERENCES: B. Scott, "Madame du Barry, a Royal Favorite with Taste," *Apollo* 97, no. 131 (Jan. 1973), pp. 69, 71; A. Pigler, *Barockthemen: Eine Auswahl von Verzeichnissen zur Ikonographie des 17. und 18. Jahrhunderts* (Budapest, 1974), vol. 2, p. 49; Vermeule 1976, p. 94, fig. 1, p. 95; Lee 1980, p. 214; Paris 1982, p. 356, no. 122; Rosenberg 1982, p. 41; Murphy 1985, p. 167; Wright 1985, p. 218; Sapin 1984, no. 4, fig. 4; Mérot 1987, pp. 179 and 181, no. 31, fig. 37.

CONDITION: The painting is in good condition. It may have been cut from a larger composition. It is glue-lined. Several artist's changes can be seen clearly with the aid of an infrared vidicon. Bacchus's right hand was turned palm up. Neither the crown of stars nor the staff and grapevine held by Bacchus was in the

original composition. His wreath was smaller and perhaps not made of grapevine. The left hand of the god was more open with his middle finger shown between the index finger and his thumb. The sky was visible to the left and right of this hand. The ship was smaller and did not have the classical ornament. The drapery of Ariadne and Bacchus have been changed. The white fabric at Ariadne's feet was blue and her bracelet added. The branches of the foliage in the background are also changed.

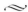

When acquired from the Heim Gallery in 1968, this painting was attributed to Vouet, who had treated the subject at least twice before.[1] Another version by him was engraved in 1644 by Michel Dorigny,[2] and the figure of Bacchus rushing in from the right holding out the crown with his drapery billowing is quite similar, if not as elegant in the present work, but the figure of Ariadne is quite different, shown crouching with her back to Bacchus. Although the young Le Sueur may have taken his inspiration from his master, he was already able to invest the subject with his own distinctive cool color harmonies, a trait recognized by a succession of scholars. Alistair Dunlop, in a letter of 1971, was the first to identify the painting as an early work by Le Sueur of about 1639–41, shortly after the Polyphilus scenes.[3] Marie Cabane, following a visit to the Museum in 1973, also made this attribution, later writing in a letter that she dated it to the mid-1640s and compared the Ariadne to the Diana in a *Diana and Callisto* in Dijon (Musée Magin), which also had previously been attributed to Vouet.[4] She was the first to suggest that the painting may be identical with a *Bacchus and Ariadne* identified as by Le Sueur that appeared in the Parizeau sale of 1789.[5] Pierre Rosenberg confirmed the Le Sueur attribution on a visit to the Museum in September 1979 and published it as such in 1982. The first to have done this, however, was Thomas P. Lee in 1980. He compared it to the somewhat earlier *Cupid and Venus at the Forge of Vulcan* in San Francisco.[6] Alain Mérot's definitive catalogue of Le Sueur, which includes this painting, appeared in 1987.

The ancient myth of Ariadne, daughter of King Minos of Crete, tells how she was abandoned on the island of Naxos by the hero Theseus, whom she had helped escape the labyrinth. According to Ovid, she was lamenting her fate when rescued by Bacchus, the god of wine, who took the crown from her head and threw it to the heavens, where it became a constellation in the form of a ring of stars. Here the artist directly and forcefully illustrates the encounter of the two principal figures. Bacchus rushes in from the ship seen in the distance. He wears a wreath of grape leaves and holds in his left hand the thalmus, which is also entwined with vine leaves. In his other hand is the delicate crown of stars crafted by Hephaestus, which he seems to place on the head of his seated beloved, whose anxious lamenting is conveyed by her hands kneading her fallen garments. As Cornelius Vermeule observed: "The only other relieving feature in this tour de force of staged baroque courtship in the Roman vein is the love knot on Ariadne's arm, perhaps a souvenir of her adventures with Theseus." This same writer has also brilliantly delineated the source of the "sculptural" figures that were undoubtedly known to Le Sueur through prints or drawings brought from Italy: "Ariadne comes from the lower part of any number of Roman mythological sarcophagi of the second and third centuries AD. Bacchus is a free, mirror reversal of Bernini's Apollo in his Apollo and Daphne [and] is easy to trace . . . to the famous, oft-copied Graeco-Roman marble statue of Apollo in the Belvedere of the Vatican [that] presents a lighthearted quality of tripping grace combined with smoothly chiseled classical face and polished limbs."[7] Le Sueur has fleshed out in form and tonality these marble sources to bring them glowingly alive.

1. See W. Crelly, *The Painting of Simon Vouet* (New Haven and London, 1962), p. 204, no. 116. Dimier believed the painting had been part of the destroyed gallery of the château at Chilly. See L. Dimier, "Un Tableau de Vouet présumé de la Galerie de Chilly," *BSHAF* (1924), pp. 15–19.

2. Crelly, *The Painting of Simon Vouet*, p. 204 and fig. 188. Dorigny's own painting of the subject in the same direction as the print was sold at Sotheby's, New York, October 13, 1989, no. 42.

3. In a letter of April 5, 1971, in the Paintings Department files.

4. Her visit was recorded August 1973, and the letter is dated November 21, 1973.

5. In the catalogue of M. Parizeau, painter and engraver of Paris, the work is described as "A painting composed of two life-size figures, representing Bacchus crowning Ariadne. This painting of a firm and bold brush has the character of Le Sueur's works when he was studying in Vouet's studio. Height 68 inches, width 48 inches." Both the description and the size (183 × 130 cm) correspond to the Boston painting, allowing for some slight trimming of the canvas at the top and right side as suggested by Mérot. It may also be identical to a *Bacchus and Ariadne* catalogued as by Vouet that was sold from the collection of the comtesse du Barry, Paris, on February 17, 1777, no. 20, which measured "5 feet 4 inches × 4 feet (5 pieds 4 pouces × 4 pieds)" and in which "the background is a landscape." Yet another *Bacchus Crowning Ariadne* appeared in the Mauméjan sale in Paris, June 29–July 2, 1825, no. 45, characterized as "relating strongly to the first manner of Le Sueur." Unfortunately the exact dimensions were not given.

6. Lee 1980, p. 214.

7. Vermeule 1976, p. 94.

21. *Camma Offers the Poisoned Wedding Cup to Synorix in the Temple of Diana,* about 1644

Oil on canvas
67 5/8 × 49 1/2 in. (171.8 × 125.7 cm)
M. Theresa B. Hopkins Fund
48.16

PROVENANCE: Le Doux, Paris; sale Paris, April 24, 1775, no. 51 (?);[1] sale Paillet, Paris, April 26, 1793, no. 32 (?); Samuel Pawson, London; sale London, December 1795, no. 37; Major Eric A. Knight, Wolverley House, near Kidderminster, England, d. 1944; P. and D. Colnaghi and Co., London, by 1947.

EXHIBITION HISTORY: London, Wildenstein, *A Loan Exhibition of French Paintings of the Seventeenth Century,* 1947, no. 25; New York 1968–69, no. 23.

REFERENCES: Boston 1955, p. 37; Sapin 1978, pp. 244, 250, fig. 4; F. Haskell and N. Penny, *Taste and the Antique* (New Haven and London, 1981), pp. 196, 198; Paris 1982, p. 357, no. 1; E. Foucart-Walter, *Le Mans: Musée de Tesse, peintures françaises du XVIIe siècle* (Paris, 1982), pp. 98, 99; Rosenberg 1982, pp. 24, 41; Cooper 1983, p. 26; Sapin 1984, p. 57, no. 6; Brejon de Lavergnée and Mérot

1984, under no. 44; Wright 1985, p. 218; Murphy 1985, p. 167; Mérot 1987, pp. 93, 180–81, 422, no. 32, pl. VI; Goldfarb, in Cleveland 1989, p. 186, fig. 94a; M. Hilaire, in Montreal 1993, p. 184, fig. 1.

CONDITION: The painting is in good condition. Although the glazes are worn, the paint layer is intact. The canvas has been glue-lined. There are later inserts at both top corners indicating the painting may have originally been in an architectural setting. The Doric capitals at the top of the composition were added at the time the inserts were attached. There are several important artist's changes: The old priest originally faced out, and the black servant with his pitcher was added over the existing steps. Two onlookers on the right were painted out. The ornate ewer on the steps had originally been very plain.

≈

Set inside a classical temple is a large statue of Diana, the goddess of the hunt, derived from a famous ancient marble then in the Louvre.[2] The baldacchino that shelters her is bedecked with her traditional attributes: a bow, quiver, and the sacred herb dittany. In the foreground is a large, elaborately decorated ewer. On the steps behind it is a tightly clustered group of celebrants. A bearded young man dressed as a warrior faces a young woman and receives from her a cup, above a tripod with a flaming brazier. A priest, aged and with a wreath of ivy in his hair, invokes the goddess. Surrounding the main figures are a child at the left, a kneeling black youth holding another plain ewer at the lower right, and a row of onlookers behind.

Alain Mérot has identified the subject, noting that when a work that seems to be this painting was sold in Paris in 1793, it was catalogued as "the queen Camma who poisons the wedding cup so that she does not have to marry the murderer of her husband." He points out that the same subject was also treated by another Vouet student, Charles Poërson (Musée de Metz),[3] and Michel Hilaire further noted that the story also inspired a print by Pietro Testa.[4] It is derived from one of the tales told by Plutarch in the section of his *Moralia* devoted to the Brave Deeds of Women. This was translated into French by Amyot in the sixteenth century.[5] Further renown was achieved by its inclusion in the *Galerie des femmes fortes* by Father Pierre Le Moyne of 1647.[6] Camma, who was a priestess of Diana and princess of Galatia, sought revenge on the tetrarch Synorix, the murderer of her husband, Sinatus. She pretended to accept the villain's amorous advances and agreed to marry him. Plutarch's text, followed closely by Amyot, relates that Camma requested the ceremony take place "in the presence of the goddess." When Synorix arrived,

[s]he received him kindly and, having led him to the altar, poured a libation from a bowl, then drank a portion herself and bade him drink the rest; it was a poisoned mixture of milk and honey. When she saw that he had drunk, she uttered a clear cry of joy, and, prostrating herself before the goddess, said, "I call you to witness, goddess most revered, that for the sake of this day I have lived on after the murder of Sinatus, and during all that time I have derived no comfort from life save only the hope of justice; and now that justice is mine, I go

down to my husband. But as for you, wickedest of all men, let your relatives make ready a tomb instead of a bridal chamber and a wedding."

When the Galatian heard these words, and felt the poison already working and creating a disturbance in his body, he mounted a chariot as if to try shaking and jolting as a relief, but he got out almost immediately and changed over into a litter, and in the evening he died. Camma endured through the night and when she learned that he had come to his end, she died cheerful and happy.[7]

A black-chalk drawing of the *Diana of Versailles* by Le Sueur is at the Art Museum, Princeton University.[8] It includes the stag that accompanies her and an architectural background of an arch flanked by pilasters. The same viewpoint, but not the stag, was incorporated into the painting. This drawing may also have helped Le Sueur in composing the background detail of another painting, *Saint Peter Preaching at Ephesus*, now in the Louvre.[9] A drawing at Besançon in pen and wash shows a fuller version of the Camma subject.[10] The statue is not present and the old priest is at the center and seen from the front. Another bearded man rather than the boy holds the ewer at the lower right. Marguerite Sapin suggested that this was a preliminary study by Le Sueur for the Boston painting,[11] but Mérot believes it to be a later pastiche or by another artist.[12] However, the recent discovery that the painter altered the direction in which the priest faces and made other pentimenti in the Boston canvas lends greater authority to the drawing's authenticity. These changes indicate how, as in the *Bacchus and Ariadne* (cat. 20), Le Sueur freely recomposed his compositions as he painted them.

The Le Doux sale catalogue of 1775 describes this painting as being in "the early manner of the painter coming out of the school of Vouet,"[13] and the Vouet influence is indeed quite evident. Sapin dates the painting to the period 1642–45, and Jacques Thuillier and Mérot agree on a date a little before 1645. Marie Cabane also noted that Le Sueur's taste for very classical and balanced architecture evidenced here is comparable to his 1645 painting *Polyphilus Kneeling before Queen Eleutherilide* at Rouen.[14]

As with the *Bacchus and Ariadne*, the monumental, frozen attitudes of the figures are again derived from sculptural models. The complex overlapping of archaeological and architectural details does not obviate the sense of order and purpose that are the dominant moods. By isolating the profile heads of the two chief protagonists, the painter creates an intense dramatic tension across the space. Knowing the story, one senses a horrible air of impending doom as Camma, having already imbibed the poison, stoically offers it to her victim, whose lustful nature is manifested by the orange glow of the altar flames reflected on his lips. As the sale catalogue of M. Le Doux observed, "this painting by the nobility of the characters, the elegance of the drawing, and the beauty of the color, is worthy of the one who justly merited being called the French Raphael."[15]

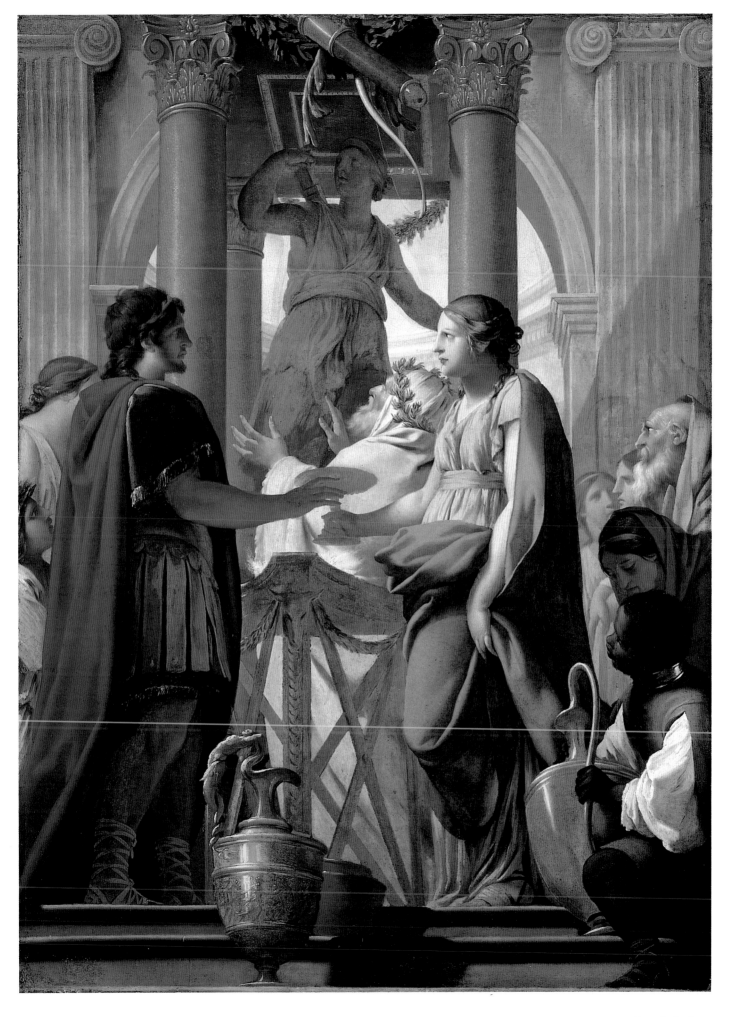

1. Marie Cabane, in a letter of November 21, 1973, first suggested this was the work from the Le Doux sale described as "[a] painting depicting a *Sacrifice in the Temple of Diana.* One sees a High Priest offering his prayer to the goddess for the alliance which is celebrated in his presence by a Prince and Princess, who hold a gold cup over an altar. . . . It is painted on canvas 6 pieds 3 pouces high by 3 pieds 10 pouces wide [2.030 × 1.245m]."

2. The statue *Diana the Huntress,* known as the *Diana of Versailles,* was taken to Fontainebleau around 1540 for François I and then moved to the Louvre by Henri IV in 1602 only to be taken to Versailles during the reign of Louis XIV. It was returned to the Louvre in 1798.

3. See J. Lejeaux, "Charles Poërson," *BSHAF* (1939), p. 38; and Hilaire, in Montreal 1993, no. 58.

4. See E. Cropper, *Pietro Testa, 1612–1650* (Philadelphia, 1988), pp. 104–116, no. 53.

5. J. Amyot, *Plutarchus, Les oeuvres morales & meslées de Plutarque.* I was able to consult editions printed at Paris in 1572 and 1575 at the Houghton Library, Harvard University.

6. Mérot 1987, p. 180; and Hilaire, in Montreal 1993, p. 184.

7. *Plutarch's Moralia,* trans. F. C. Babbitt (Cambridge, Mass., 1968), vol. 3, pp. 551–55.

8. Acc. no. 1964-40. See Cooper 1983, pp. 26–27; and Goldfarb, in Cleveland 1989, no. 94.

9. Musée du Louvre, no. 8020; see Mérot 1987, no. 85, fig. 296. Sapin 1978, p. 250.

10. Brejon de Lavergnée and Mérot 1984, no. 44.

11. Sapin 1978, p. 244.

12. Mérot 1987, p. 422.

13. Le Doux sale catalogue, Paris, April 24, 1775.

14. Cabane correspondence of 1974.

15. Le Doux sale catalogue, 1775. It was Brosses who in 1739 coined this appellation. See Michel, in Montreal 1993, p. 211.

French School, 17th century

22. *Portrait of a Woman Wearing a Pearl Necklace,* 1638

Oil on panel
13 1/2 × 10 in. (34.4 × 25.5 cm)
Inscribed upper left: *M. laduocat;* on verso in pen: *Marg. Roullier / feme de M. l'Aduoc / fait par du Gryer (?) / en l'anne 1638.*
The Forsyth Wickes Collection
65.2646

PROVENANCE: André J. Seligmann, Paris; purchased October 16, 1935, by Forsyth Wickes.

REFERENCES: Murphy 1985, p. 158 (as Ladvocat); Zafran, in Munger et al. 1992, p. 72, no. 11.

CONDITION: The support is a wood panel. The paint layer appears severely abraded and heavily overpainted.

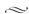

The discovery of an inscription on the verso of this painting not only provides a date but also allows us to recognize the name "L'Aduocat" as that of the sitter and not the painter.[1] The latter's name, du Gryer (?), is difficult to decipher and does not accord with one known at the period. In style, however, the work resembles some of the portraits of women attributed to Claude Deruet.[2]

1. The one painter with a similar name, listed in Bénézit 1976, vol. 6, p. 267, is Gérôme Ladvocat, a seventeenth-century "peintre verrier."

2. See, for example, one with the Groupe Gersaint, *Tableaux anciens* (Paris, 1989). A portrait of Mlle de Montpensier exhibited at the Cummer Gallery of Art, Jacksonville, and Museum of Fine Arts, St. Petersburg, Florida, *The Age of Louis XIII,* 1969–70, no. 21 (photograph in the Witt photo archives); and another of Julie d'Angennes signed and dated 1641 at the Musée des Beaux-Arts, Strasbourg; see H. Haug, *Musée des Beaux-Arts de la ville de Strasbourg: Catalogue des peintures anciennes* (Strasbourg, 1938), p. 167, no. 311.

French School, 17th century

23. *Portrait of Laurent Drelincourt*

Oil on canvas
5 5/16 × 3 5/8 in. (15.1 × 9.2 cm)
Inscribed below the portrait: *Laurent Drelincourt. / Ministre a Niort.*
Gift of Gladys E. Rossiter
1979.555

CAT.
23

PROVENANCE: Henry P. Rossiter, Boston and Surrey, about 1920–76; inherited by his wife, Gladys E. Rossiter, Surrey, England.

REFERENCE: Murphy 1985, p. 104.

CONDITION: The wooden support consists of a single-member panel with horizontal cross-grain. A monochrome paint layer is thinly and directly applied over the white ground. There is a slightly yellowed, natural-resin surface coating.

The subject was born in Paris in 1626. Following in his father's footsteps, he entered the Protestant church as a minister, first at La Rochelle and then, as the inscription indicates, at Niort. A prolific writer and poet as well as a scholar of French, he was regarded as an excellent preacher and knowledgeable theologian. Drelincourt died at fifty-five in 1681.[1] This painting may have served as model for a printed frontispiece to one of Drelincourt's books of sermons or sonnets. The style and format of the work with *trompe l'oeil* inscription are not unlike those found in the works of Robert Nanteuil.

1. Michaud, *Biographie Universelle* (Paris, n.d.), vol. 2, p. 310.

P. Nichon after Sebastian Stoskopff
French, 17th century

24. *Still Life with Carp*

Oil on canvas
19 3/8 × 23 1/4 in. (49 × 59 cm)
Signed lower left: *P Nichon F*
Francis Welch Fund
63.1628

PROVENANCE: R. Payelle, Paris, by 1951; Heim Gallery, Paris, by 1963.

EXHIBITION HISTORY: Paris, Galerie Charpentier, *Natures mortes françaises du XVIIe siècle à nos jours*, 1951, no. 129; Miami Art Center, *The Artist and the Sea*, 1969, no. 29; Boston 1978; Paris 1982, no. 75; Chiba 1994, no. 22; Boston 1994, no. 26.

REFERENCES: M. Faré, "La Nature morte française," *Arts*, no. 339 (Dec. 28, 1951), p. 10, ill.; "L'Epoque archaïque de la nature morte," *Connaissance des arts* 23, no. 23 (Jan. 15, 1954), ill. p. 19; P. Jouffroy, "Un Farceur nommé Nichon," *Connaissance des arts* 26, no. 26 (April 15, 1954), p. 19; P. Jouffroy, "Les Carpes de Nichon," *Connaissance des arts* 27, no. 28 (June 15, 1954), p. 17; Kunsthaus, *Unbekannte Schönheit* (Zurich, 1956), pp. 41–42; H. Haug, "Sébastien Stoskopff," *L'Oeil*, no. 76 (April 1961), p. 30; Faré 1962, vol. 1, pp. 46, 104; "Accessions . . .

October–December 1963," *The Art Quarterly* 27, no. 1 (1964), p. 107; H. Haug, "Une Nature morte de Sébastien Stoskopff," *Bulletin des musées et monuments lyonnais* 3, no. 4 (Nov. 4, 1965), p. 313; Hannema 1967, p. 23; Faré 1974, pp. 134–35, ill.; Paris 1982, pp. 293–94, 365, ill. p. 200; Laveissière, 1982, p. 704; Rosenberg 1982, p. 32, no. 75; Murphy 1985, p. 271; Wright 1985, p. 237; Rotterdam 1992, p. 154; Esielonis 1993, pp. 81–82, no. 29, pl. 25; C. Grimm, *Stilleben* (Stuttgart, 1995), p. 167, ill. 113; B. Hahn-Woernle, *Sebastian Stoskopff* (Stuttgart, 1996), pp. 223, 234–36, no. 54, and p. 287; Heck 1997, pp. 40–41, figs. 9b, 56, 158.

CONDITION: The support, a plain woven, glue-lined fabric, has been cut down, and there is a repaired tear above the fish. The paint is applied flatly over a double-ground composed of a red, granular layer, followed by a gray, possibly discontinuous layer. In addition to the tear, in-painted areas include the shadows on the lower-right side of the pitcher, scattered losses in the background, and reinforced lines around the fish and in the wall at left. The signature is contemporary with the paint layer.

The original rendering of this composition is a signed painting by the Strasbourg-born artist Sebastian Stoskopff.[1] A number of versions and variants of it exist, some by Stoskopff himself and some seemingly by other painters.[2] The Boston painting and another also on canvas, which most recently was sold in Paris in 1989, both bear the signature Nichon.[3] There are some slight differences between the Boston Nichon and the original Stoskopff. The wall at the left in the Museum's painting does not have the indication of a ledge, and instead of being a smooth wall it is composed of stone blocks. In addition, the composition is more tightly cropped at the lower edge and at the right to the side of the jug.

The previously mysterious Nichon was identified by Sylvain Laveissière as Pierre Nichon, a painter active in Dijon between 1645 and 1655 who produced a large, signed altarpiece that is preserved in that city.[4] Although the few still life elements—skull and ointment jar—in that painting are rendered in a heavy manner, there is not enough in common between this figural religious subject and the more archaic Boston still life composition copied with great skill to conclude absolutely that they are the same Nichon. Recently the Stoskopff expert, Birgit Hahn-Woernle, has stated that the Boston painting, despite the Nichon inscription, is by the Strasbourg master[5] but this has been disputed by Heck.[6]

The popularity of this still life composition may derive from its religious symbolism. As Pierre Rosenberg has written, the box "alludes to the holy casket, the carp symbolizes Christ and the extinguished candle signifies the evanescence of temporal life."[7] By the same token, the large tankard could serve as a eucharistic symbol of Christ's sacrifice. The haunting power of this Stoskopff-Nichon painting derives, however, not only from the symbolic nature of the objects but also from the juxtaposition of their odd shapes: The fish is too large for the bowl, which projects over the edge of the box, which in turn extends beyond the table's edge. This precarious balancing act is illuminated by a mysterious glowing light—a divine radiance—emanating from the fish, which highlights both its scaley texture and distinctly mournful expression.

1. Collection of Pierre Jouffroy, Montbéliard. See Faré 1974, p. 126.

2. One in the Hannema-De Stuers Foundation, Heino (see Hannema 1967, p. 23, no. 90), is on panel, 52 × 64.5 cm, and most recently has been also tentatively assigned to Nichon. See Rotterdam 1992, no. 33. Another was with Silvano Lodi, Campione; see S. Lodi, *Austellung Alter Meister* (Campione, 1969) no. 7. Another version at Nièvre, Musée de Clamécy, adds a citrus fruit; see, Kulturring Idstein, *Sebastian Stoskopff: Sein Leben, sein Werk, seine Zeit* (Idstein, 1987), no. 11; and a private collection, Stockholm. Another was sold first at Christie's, London, July 9, 1982, no. 9, then Christie's, New York, January 18, 1983, no. 151, and more recently, Sotheby's, London, December 11, 1996, no. 312.

3. Sale Hôtel Drouot, Paris, June 27, 1989, no. 27; previously sold Paris, Palais Galliera, November 23, 1972, no. 46. It is given the same (Payelle) provenance as the Boston painting and is signed, *Nichon fec.* and measures 46.5 × 60 cm.

4. Laveissière 1982, p. 704.

5. In a letter of February 1995, in the Paintings Department files, and in B. Hahn-Woernle, *Sebastian Stoskopff* (Stuttgart, 1996), pp. 234–35.

6. Heck 1997, pp. 56 and 158.

7. Paris 1982, p. 294.

French School, 17th century

25. *Flowers, Butterfly, and Book*

Oil on panel
10 1/2 × 14 1/4 in. (26.6 × 36.2 cm)
Gift of Mrs. Maxim Karolik for the Karolik Collection of American Paintings
47.1252

PROVENANCE: private collection, Philadelphia; Victor Spark, New York; Maxim Karolik, Newport, R.I.

REFERENCES: L. H. Giese and L. C. Luckey, *Selections from the M. and M. Karolik Collection of American Paintings, 1815–1865*, Museum of Fine Arts, Boston (Boston, 1976), pl. 35 (as Anonymous, American); *American Paintings in the Museum of Fine Arts, Boston* (Boston, 1969), no. 24, fig. 281 (as Anonymous, American).

CONDITION: The wood panel support with beveled edges has several small, filled cracks. The paint is applied smoothly over a pale ground, with small areas of impasto describing the design edges. The painting is in relatively good condition, although there are some areas of abrasion. There is overpaint in the background, flower petals, left ribbon, and covering a crack beside the box.

Although this painting entered the Museum with the Karolik Collection of American Paintings, it is clearly a product of the French seventeenth century. In 1985 Peter Sutton suggested as possibilities the still life painters Augustin Bouquet, Jean-Michel Picart, and Jacques Linard.[1] Subsequently both Pierre Rosenberg[2] and Jean-Max Tassel[3] have attributed it to Picart. It has to be admitted that French still lifes of this period have a familial resemblance, with different artists often employing the same motifs. Thus the droplets of water, showing the artist's mastery of realistic effects, occur in works by both Bouquet and Picart.[4] Likewise, the precisely fashioned, little wood boxes with round edges are seen in paintings by

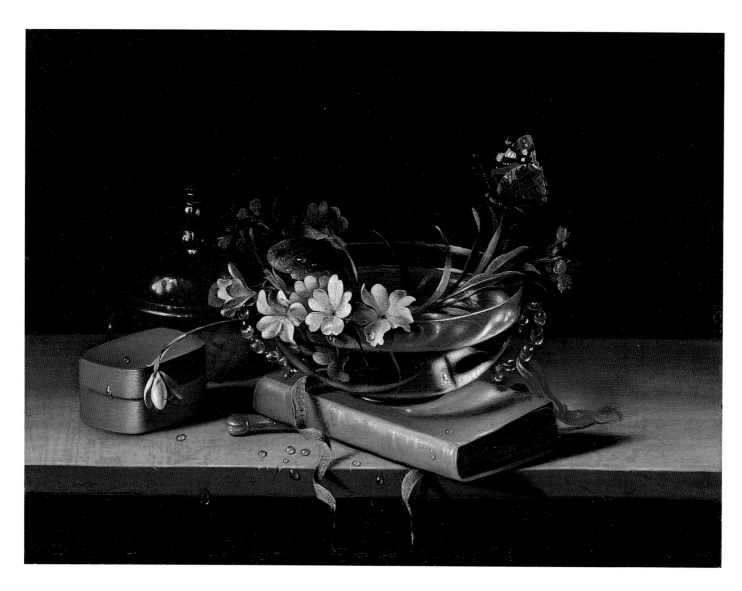

both Linard and Picart.[5] Picart is also the master of water in clear-glass vessels.[6] Despite the presence of these details in this painting, the majority of works attributed to Picart appear to be grander in conception and more vertical in format. The intimate nature of this work seems closer to a still life signed *F. Hubert* (fig. 25a).[7] The flowers, butterfly, droplets, and treatment of the table edge are all elements they share. As this mysterious artist is otherwise unknown, a definitive attribution is not possible, but the humble, self-contained quality and the similar size of the two works make an attribution of the Boston painting to Hubert a distinct possibility.

1. In a 1985 note in the Paintings Department files.

2. Undated verbal opinion recorded in the Paintings Department files.

3. Verbally, on April 11, 1991.

4. For Bouquet, see especially Faré 1974, p. 83. Louise Moillon also employed this motif, but usually in fruit pieces. See Faré 1974, p. 61.

5. For examples by Linard, see Faré 1974, pp. 32–35, and for Picart, see also Faré 1974, pp. 89, 92.

6. Faré 1974, pp. 86–87, 90–91.

7. It is difficult to believe that this painter is identical to the monogrammist FH, whose fish still lifes Faré groups with it; see Faré 1974, pp. 272–74.

Fig. 25a. F. Hubert, *Flowers in a Vase*. 27 × 35 cm. Private collection, Switzerland. (Reproduced from Faré 1974, p. 271)

JEAN-BAPTISTE SANTERRE

1651–1717

Santerre, who was a well-known artist in his day, had studied with Bon Boulogne and was *agréé* at the Académie royale de peinture et de sculpture in June 1698. At first active as a portraitist of famous men, he later devoted himself to imaginary figures, several of which were exhibited at the Salon of 1704.

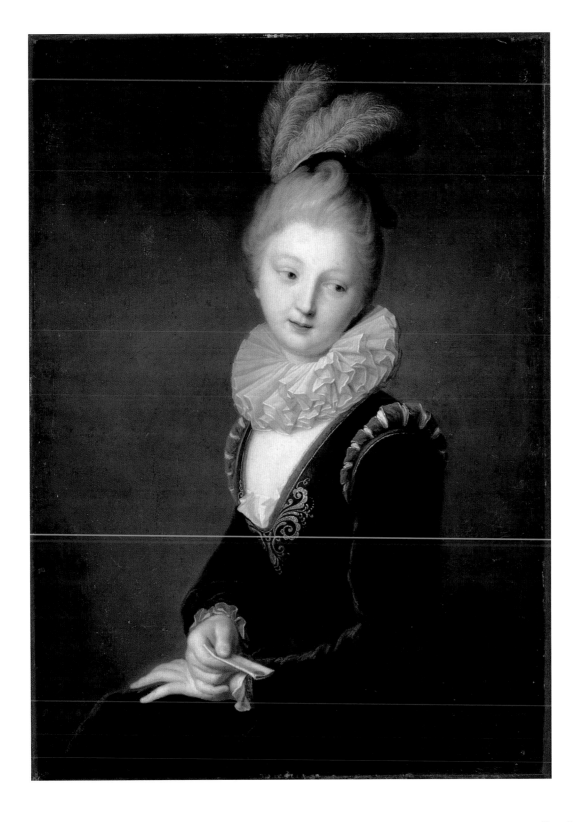

After Jean-Baptiste Santerre

26. *Young Woman with a Love Letter*

Oil on canvas
34 1/8 × 24 5/8 in. (86.8 × 62.6 cm)
Gift of Mrs. Albert J. Beveridge in Memory of Delia Spencer Field
47.245

PROVENANCE: Balletta collection, Paris; sale Hôtel Drouot, Paris, May 8–11, 1912, no. 65; Charles Hour, Paris; sold to Delia Spencer Field, 1912–45; to her niece Catherine Beveridge, Indianapolis and Beverly Farms, Mass., by 1945.

REFERENCES: Murphy 1985, p. 259; Lesné 1988, p. 106, under no. 58 (as a copy).

CONDITION: The original fabric support has been glue-lined with the tacking margins trimmed. The paint is applied smoothly over a red ground. The painting is in fair condition with many areas of abrasion and losses.

The reputed subject of this painting is the famous comic actress Charlotte Desmares (1682–1752), but as Claude Lesné has shown, it does not at all resemble her certain portrait by Charles-Antoine Coypel.[1] Instead, this is one of Santerre's typical imaginary figures in fancy dress, and is entitled by Lesné *Young Girl with a Love Letter*. The original version belonged to Conseiller Tronchin and descended in his family at Bessinge, near Geneva, until 1928; it was last recorded with a Parisian dealer in 1958. It was engraved by N. Chateau in 1708, and a great many copies are known, including this one and another at the Comédie Française, Paris.[2]

1. Lesné 1988, p. 107.

2. Paris 1984, p. 521, fig. 63.

NICOLAS DE LARGILLIÈRE
1656–1746

Nicolas de Largillière was born in Paris. His training, more varied than that of most French artists of the period, included studies in still life with Antoon Goubau in Antwerp and portraiture with Sir Peter Lely in London. After Largillière returned to Paris in 1682, he achieved his first success with large history paintings such as *The Delivery of Paris from Drought by Saint Geneviève* and the *Reception of Louis XIV at the Hôtel de Ville*. In 1686 Largillière was *reçu* by the Académie royale de peinture et de sculp-ture, where more than forty years later he served as director. Although he continued to paint landscapes and still lifes throughout his long career, he was most renowned for his portraits. Whereas his only serious rival as a portraitist, Hyacinthe Rigaud (q.v.), worked primarily for the court at Versailles, Largillière often found his clientele among the bourgeoisie, city councilors, financiers, and artists who resided in Paris.

27. *François-Armand de Gontaut, Duc de Biron,* 1714

Oil on canvas
54 5/8 × 42 in. (138.8 × 106.6 cm)
Signed and dated on the verso of the original canvas: *peint par N de Largillière / 1714*
Juliana Cheney Edwards Collection
1981.283

PROVENANCE: probably the collection of the marquis de Sourches; duc des Cars by 1922; Paul Cailleux, Paris, by 1935; Albert Buisson, Paris; descendants of Buisson; sale Sotheby's, Monaco, February 8, 1981, no. 73; Cailleux, Paris.

EXHIBITION HISTORY: Paris, Musée de la Légion d'Honneur, *Maréchaux de France*, 1922, no. 195; Copenhagen 1935, no. 118; Amsterdam, Rijksmuseum, *Exposition internationale de tableaux et objets d'art ancien*, 1936, no. 93; Montreal 1981, no. 51; Tokyo 1983, no. 23.

REFERENCES: G. Sortais, dossier DA 58, vol. II, in the Cabinet des Estampes, Bibliothèque Nationale, Paris, about 1912; G. Pascal, *Largillière* (Paris, 1928), p. 58, no. 28; L. Hourticq, "L'Exposition des Maréchaux," *RdA* 41, no. 237 (1922), p. 347, ill.; M. N. Rosenfeld, in Montreal 1981, pp. 256–58, 292; Museum of Fine Arts, Boston, *The Museum Year, 1981–1982* (Boston, 1982), p. 35, ill.; "La Chronique des arts," supplement *GBA* 101, no. 1370 (March 1983), p. 35, ill. no. 193; Murphy 1985, p. 160; Stebbins and Sutton 1986, p. 52, ill.; *Art for Boston* (Boston, 1987), p. 144, ill.

CONDITION: The painting is in excellent condition. The darks show normal wear, and the impasto has been slightly deformed by an old relining. There are several small local losses throughout the composition, which have been repaired. There are a few minor changes such as the positioning of the fingers and thumb on the staff and the outline of the tent.

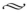

The authenticity of this portrait is evidenced both by its quality and the signature, now obscured. Scholars writing in the early part of this century identified the sitter as Charles-Armand de Gontaut, duc de Biron and maréchal de France (1664–1756).[1] Based on his age, however, Marianne Roland Michel,[2] followed by Myra Nan Rosenfeld,[3] have made the more convincing identification of the

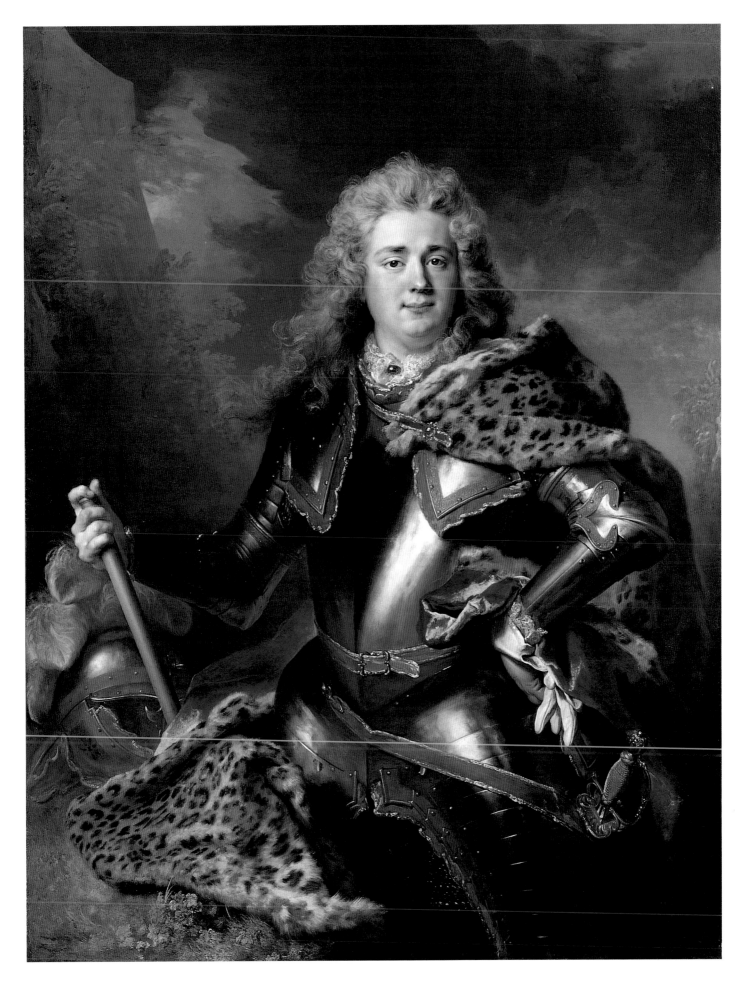

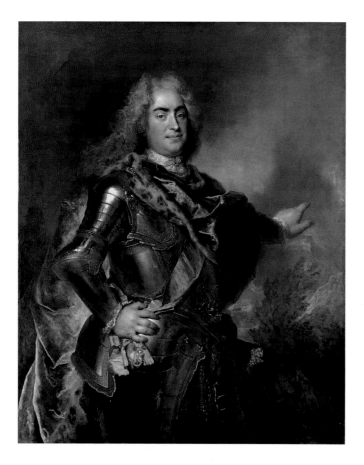

Fig. 27a. Nicolas de Largillière, *Augustus the Strong, Elector of Saxony and King of Poland*, about 1715. Oil on canvas. The Nelson-Atkins Museum of Art, Kansas City, Missouri (Purchase: Nelson Trust) 54-35

subject as his son, François-Armand de Gontaut (1689–1736). As Rosenfeld has written, the son began his military career in 1705 when he entered the Mousquetaires. At the time this portrait was painted (in 1714) he was Lieutenant de la Compagnie des Cent Gentilhommes de la Maison du Roi dits Bec de Corbin. Later, in 1719, he was made Brigadier des Armées du Roi, and in 1733, when his father relinquished the title, he became Pair de France. In 1715 he married Marie-Adélaïde de Gramont. They had no children, and the painting probably passed to his sister, who was married to the marquis de Sourches.

This type of elegant military portrait with the sitter shown three-quarter length and wearing armor was derived from prototypes by Anthony van Dyck and had been first employed by Largillière about 1710 in a presumed portrait of the comte de Bérulle,[4] and then in 1714 for both the Boston painting and the very similar portrait of Frederick Augustus II of Saxony, now in the Nelson-Atkins Museum of Art (fig. 27a).[5] These works are among the most grandiose of Largillière's male portraits and combine a voluptuous richness of materials and textures (especially the flowing hair and leopard-skin garments) with a forthright boldness characteristic of the shift in Largillière's portraiture from the baroque to the rococo.

1. A portrait of Charles-Armand, possibly by Rigaud, is in the Musées Royaux des Beaux-Arts, Brussels.

2. In the documents prepared for Cailleux Gallery in April 1981.

3. In Montreal 1981, p. 256.

4. Ibid., cat. 22.

5. Ibid., cat. 61.

HYACINTHE RIGAUD

1659–1743

Hyacinthe Rigaud was born into a family of artists at Perpignan, where his realistic style was probably formed before he went to Paris in 1681. Supported by Charles Le Brun, Rigaud entered the Académie royale de peinture et de sculpture. He won the Grand Prix in 1685 but never made the trip to Italy. Instead he developed his own impressive formal style, inspired in part by the

example of Anthony van Dyck. In 1700 he was *reçu* as a history painter by the Académie, but that same year he painted highly successful portraits of Louis XIV and Philip V, and his long career as a portraitist was set. Rigaud painted not only monarchs but also churchmen, courtiers, and aristocrats. In 1727 he himself was ennobled, and in 1733 he was appointed director of the Académie.

Hyacinthe Rigaud and Workshop

28. *A Magistrate*

Oil on canvas
27 1/4 × 21 3/4 in. (69.2 × 55.3 cm)
Gift of Mr. and Mrs. William Tudor Gardiner
50.188

PROVENANCE: private collection, France; W. Fairfax Murray, London; Thomas Agnew and Sons, London, by 1902; Washington B. Thomas, Boston; by descent to his daughter Mrs. William Tudor Gardiner.

REFERENCES: *BMFA* 48 (June 1950), p. 40; Boston 1955, p. 55; Murphy 1985, p. 246 (as Style of).

CONDITION: The support, a plain woven, glue-lined fabric, has been altered by extensions at the top and bottom, and examination suggests that the original

bottom edge was trimmed into the composition. The paint, applied thinly over a red ground, has darkened and become transparent with time. This has especially affected the background, cloak, and wig, whereas the relationships in the areas of the flesh and cravat have not changed as much. There is some damage in the lower right quadrant and minor in-painting throughout the composition.

Rigaud and his workshop produced numerous bust-length portraits of the magistrates of Paris. A similarly round-faced man in a nearly identical wig and collar by Rigaud is in the Musée de Besançon.[1] An even grander three-quarter-length portrait of a similar gentleman was sold in 1990.[2] In all these works the artist gave particular atten-

tion to the expression of the face—the eyes sparkle and the hint of a smile plays around the tightly drawn mouth. The results are portraits of intensity that suggest men of strong character. The accoutrements of wig and robe in the Museum's painting have less presence, suggesting that while the face may be by the master, the remainder was carried out by workshop assistants.

1. Inv. no. MPR3593. Other similar heads by Rigaud are one of François Giradon exhibited at Château de Versailles (*Deux Siècles de l'histoire de France [1589–1789]*, 1937, no. 86), and one of the marquis de Sillery in the collection of the earl of Duraven. Photographs in the Frick Art Reference Library, New York.

2. Orangerie du Château Cheverny, June 23, 1990, no. 101, photograph in the Service de la Documentation, Musée du Louvre, Paris.

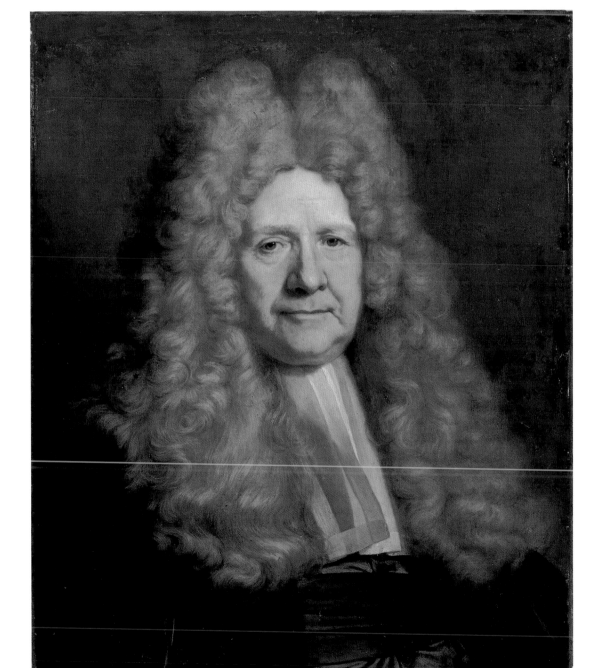

Jean van Loo

JEAN VAN LOO

active 1682–1694

The Dutch painter Jacob van Loo, a member of an extensive artistic family, fled from Amsterdam to Paris in 1660 to escape a charge of murder. Three years later he was admitted to the Académie royale. His two sons, Jean and Louis-Abraham, also became painters. Jean seems to have worked primarily in Toulon, and the Museum's signed portrait provides the first distinctive evidence of his style.[1]

1. Cathrin Klingsöhr-Leroy, "Van Loo," in *The Dictionary of Art* (London, 1996), vol. 19, p. 644.

29. *Portrait of a Man*

Oil on canvas
53 × 41 in. (134.5 × 104 cm)
Signed on the book at right: *Jean Van Loo*
Gift of Miss Amelia Peabody
37.1211

PROVENANCE: Baron Lazzaroni, Rome; sale The Ehrich Gallery, New York; sale The Fifth Avenue Art Galleries, New York, March 12, 1908, no. 16; bought in by Ehrich Galleries, New York; Vose Galleries, Boston, March 13, 1915; Miss Amelia Peabody, Boston, October 16, 1915.

EXHIBITION HISTORY: Boston 1939, no. 111 (as Rigaud).

REFERENCE: Murphy 1985, p. 288 (as Jean-Baptiste Van Loo).

CONDITION: The original support has been glue-lined, with the tacking margins trimmed. The paint layer is applied over a red ground. There are several damaged and repainted areas, and the painting has been abraded throughout.

This work, previously wrongly assigned to Rigaud (q.v.), was attributed by Alexandra Murphy to Jean-Baptiste van Loo, best known for his grand male portraits, such as that of the collector J.-P. Ricard in the Musée des Beaux-Arts, Nice.[1] However, in correspondence of 1988, Christine Buckingham Rolland observed, "I see no reason why the 'book title' in the painting (Jean van Loo) should not be read as his signature. If so, it would be the only known painting currently attributed to him."[2]

Jean van Loo was the uncle of the more famous Jean-Baptiste van Loo, and they both seem to exhibit a similar van Dyck influence. The emphasis on the wigs and the elegant gestures found in the latter's work are all evident here.[3] The identification of the Boston painting as by Jean may provide a basis for the attribution to him of the many anonymous works previously designated as "School of Jean-Baptiste van Loo."[4]

1. See J. Fornéris, *Musée des Beaux-Arts Jules Chéret, catalogue promenade* (Nice, 1986), p. 24, no. 7. Also see J. Boyer, "La Peinture et la gravure à Aix, 1530–1790," *GBA* 78 (July–Sept. 1971), pp. 178–80.

2. Letter of January 15, 1988, in the Paintings Department files.

3. See for example the portraits sold at Galerie Charpentier, Paris, May 30, 1956, no. 48; and Sotheby's, London, November 28, 1973, no. 29.

4. See for example the *Portrait of a Gentleman* sold at Sotheby Parke-Bernet, New York, June 7, 1978, no. 118.

JEAN-ANTOINE WATTEAU

1684–1721

Born in Valenciennes in 1684, Jean-Antoine Watteau studied there briefly with Jacques-Albert Gerin. With little money and few possessions, he went to Paris, making a meager living by copying the works of old masters. He became a pupil first of Claude Gillot and, by 1708, of Claude Audran. By the time Watteau finished second in the Académie's student competition for the Prix de Rome in 1709, he had already established his reputation. In 1712 Watteau presented a number of paintings to Charles de la Fosse and other senior members of the Académie for which he was *agréé*.

Watteau's greatest contribution to the history of French art was the invention of the *fête galante*, a category of genre painting the Académie created especially for him when it accepted his reception piece, *Pilgrimage to the Island of Cythera* (Paris, Louvre), in 1717. He painted a wide variety of genre scenes, however, including military subjects.

Audran, who was in charge of the collections in the Palais du Luxembourg, gave Watteau access to the works there, especially the Marie de' Medici series by Rubens. Though it is not certain if

Watteau ever visited Italy, he certainly studied the works in the royal collections of the Italian artists Titian, Veronese, Rosalba Carriera, and Sebastiano Ricci.

Plagued by poor health, Watteau traveled briefly to England in hopes of a cure. Slowly making his way back to Valenciennes, he died at Nogent. Despite his short career, Watteau's importance was singular and lasting; his style was perpetuated and disseminated through engravings and drawings by other artists and by a number of younger painters who specialized in *fêtes galantes*.

30. *La Perspective (View through the Trees in the Park of Pierre Crozat)*, about 1715

Oil on canvas
18 3/8 × 21 3/4 in. (46.7 × 55.3 cm)
Maria Antoinette Evans Fund
23.573

PROVENANCE: Guenon, Paris, by 1729; Daniel Saint, Paris; sale Hôtel des Ventes, Paris, May 4, 1846, no. 56; Richard, fourth marquis of Hertford, d. 1870; by inheritance to his illegitimate son, Sir Richard Wallace, d. 1890; to Lady Wallace, d. 1897; bequeathed to Sir Richard's secretary, Sir John Murray Scott, d. 1912; sale Christie's, London, June 27, 1913, no. 138; Thomas Agnew and Sons, London; Walter Burns, March 4, 1919; Durlacher Brothers, New York and London.

EXHIBITION HISTORY: London, *The Collection of Paintings . . . and Other Works of Art, Lent for Exhibition in the Bethnal Green Branch of the South Kensington Museum by Sir Richard Wallace*, 1872–75, no. 440 (?); New York, Metropolitan Museum of Art, *Landscape Paintings*, 1934, no. 32; on loan to Williamstown, Mass., Williams College, Lawrence Museum, 1941–44; Museum of Fine Arts, Boston, *A Thousand Years of Landscape East and West*, 1945; Houston, Museum of Fine Arts, *The Human Image*, 1958; New York 1970, no. 39; Providence 1975, no. 45; Toledo Museum of Art, *The Age of Louis XV: French Painting, 1710–1774*, 1975, no. 119 (traveled to the Art Institute of Chicago; Ottawa, National Gallery of Canada); Bordeaux, Galerie des Beaux-Arts, *L'Art européen à la cour d'Espagne au XVIIIème siècle*, 1979, no. 93 (also traveled to Paris, Grand Palais; Madrid, Prado); Washington 1984–85, no. 25; New York 1990, no. 20; Boston 1993.

REFERENCES: P. Hédouin, "Watteau," *L'Artiste* 100 (Nov. 30, 1845), p. 80; P. Hédouin, "Watteau," *Mosaïque* 101 (Paris, 1856), p. 113; Waagen 1857, p. 83; E. de Goncourt and J. de Goncourt, *L'Art du dix-huitième siècle* (Paris, 1860), p. 152; P. J. Mariette, *Abécédario* (Paris, 1862), p. 110; J. Cousin, *Le Tombeau de Watteau . . .* (Nogent-sur-Marne, 1865), p. 31; A. Sensier, *Journal de Rosalba Carriera . . .* (Paris, 1865), p. 232; E. de Goncourt, *Catalogue raisonné de l'oeuvre peint, dessiné d'Antoine Watteau* (Paris, 1875), p. 136, no. 152; R. Dohme, *Die Austellung von Gemälden älterer Meister . . .* (Berlin, 1883), p. 99; J. W. Mollett, *Watteau* (London, 1883), p. 69; P. Mantz, *Cent Dessins de Watteau gravés par Boucher* (Paris, 1892), p. 88; E. F. S. Dilke, *French Painters of the Eighteenth Century* (London, 1899), p. 88; V. Josz, *Watteau, moeurs du XVIIIe siècle* (Paris, 1903), pp. 315–16; E. Pilon, *Watteau et son école* (Paris, 1912), p. 82; Dacier and Vuaflart 1929, vol. 1, pp. 48–49, 264, and 1922, vol. 3, pp. 83–84, no. 172; E. Dacier, "En étudiant l'oeuvre gravé de Watteau . . . ," *BSHAF* (1923), p. 88; C. H. Hawes, "La Perspective by Antoine Watteau," *BMFA* 22 (Feb. 1924), pp. 1–2, no. 129; A. Joubin, "Un Catalogue de vent . . . ," *Beaux-Arts* (Dec. 15, 1925), p. 336; E. Dacier, *Antoine Watteau, dessinateur de figures de différents caractères* (Paris, 1926), p. 49; Réau 1926, p. 151; *Eighty-five Years of Art Dealing: A Short Record of the House of Durlacher Brothers* (London, 1927), p. 11; G. Séailles, *Les Grands Artistes . . . Watteau* (Paris, 1927), p. 67; L. Réau, "Watteau," in A. Dimier, *Peintres français du XVIIIe siècle* (Paris, 1928), vol. 1, p. 48, no. 196; K. T. Parker, *The Drawings of Antoine Watteau* (London, 1931), p. 49; Boston 1932, ill.; Roux 1940, vol. 4, p. 140 under no. 486; *Handbook of the Museum of Fine Arts, Boston* (Boston, 1946), p. 66; Wilenski 1949, p. 104, pl. 45a; Adhémar and Huyghe 1950, no. 111, pl. 56; R. Cecil, "The Remainder of the Hertford and Wallace Collections," *TBM* 92, no. 567 (June 1950), p. 171; *Museum Catalogue, Museum of Fine Arts, Boston* (Boston, 1952), p. 66, ill.; Boston 1955, p. 68; K. T. Parker and J. Mathey, *Antoine Watteau—catalogue complet de son oeuvre dessiné* (Paris, 1957), under nos. 86, 538, 546, 627, 713, 830; M. Gauthier, *Watteau* (Paris, 1959), pl. XIII; J. Mathey, *Antoine Watteau, peintures réapparues . . .* (Paris, 1959), p. 68; Junecke 1960, pp. 66–73; A. Seilern, *Paintings and Drawings of Continental Schools . . . at 56 Princes Gate* (London, 1961), vol. 3, p. 74; J. L. Schefer, "Visible et thématique chez Watteau," *Médiations* 5 (1962), pp. 44–45, 48, 53–54, and 58; *Museum of Fine Arts, Boston, Illustrated Handbook* (Boston, 1964), pp. 252–53; J. Thuillier and A. Châtelet, *La peinture française de Le Nain à Fragonard* (Geneva, 1964), p. 159; *Catalogue of the Wallace Collection* (London, 1968), p. 368; Macchia and Montagni 1968, p. 106, no. 117; A. Brookner, *Watteau* (Paris and Verona, 1969), pl. 10; P. T. Rathbone, in *Great Museums of the World: Museum of Fine Arts, Boston* (Newsweek; Los Angeles, 1969), pp. 123–24, ill. and detail; E. Camesasca and P. Rosenberg, *Tout l'oeuvre peint de Watteau* (Paris, 1970), no. 117, pls. IV–V; *One Hundred Paintings from the Boston Museum of Fine Arts* (Boston, 1970), p. 63, no. 39; Museum of Fine Arts, Boston, *Western Art* (Greenwich, Conn., 1971), pp. 195–96, pl. 109; G. Macchia, *I Fantasmi dell'opera* (Rome, 1971), p. 14; Ferré 1972, vol. 1, pp. 218, 277, vol. 3, pp. 1000–1001, no. B52, and vol. 4, pp. 1100–1101; E. Souffrin-Le Breton, "Banville et la poétique du décor," in *French Nineteenth-Century Painting and Literature* (Manchester, 1972), p. 71, fig. 52; Y. Boerlin-Brodbeck, *Antoine Watteau und das Theater* (Basel, 1973), pp. 211–14; B. Scott, "Pierre Crozat, a Maecenas of the Régence," *Apollo* 97, no. 113 (Jan. 1973), pp. 13–14, fig. 5; I. Nemilova, "Watteau's Drawing *The Allée* and Pater's *Spring*," *Soobscenija Gos* 40 (1975), pp. 21–22; *Illustrated Handbook, Museum of Fine Arts* (Boston, 1976), pp. 278–79, ill.; K. Nakayama, *Watteau* (Tokyo, 1976), p. 102, pl. 12; M. Eidelberg, *Watteau's Drawings: Their Use and Significance* (New York, 1977), pp. 63–65, fig. 29; O. T. Banks, *Watteau and the North* (New York, 1977), p. 170, fig. 93; Jean-Richard 1978, p. 38, under no. 51; W. H. Adams, *The French Garden, 1500–1800* (New York, 1979), pp. 102, 104, 122, 139, fig. 122; D. Mallett, *The Greatest Collector* (London, 1979), pp. 188, 198–99; R. Butler, *Choiseul* (Oxford, 1980), vol. 1, p. 839; J. Clay, *Le Romanticisme* (Paris, 1980), p. 28, ill.; P. Hulton, *Watteau Drawings in the British Museum* (London, 1980), pp. 28–29, fig. 28; M. Roland Michel, *Tout Watteau* (Paris, 1982), cat. 149, pp. 20–21; Posner 1984, pp. 40, 111, 121, 148, 150, 173, 176, 285, 293, fig. 105, pl. 21; M. Roland Michel, *Lajoue et l'art rocaille* (Neuilly-sur-Seine, 1984), p. 261, under nos. D141–42; M. Ooka and C. Ikegami, *Watteau* (Tokyo, 1984), pl. 35; N. Parmantier, *Le Petit Journal des grandes expositions: Watteau, 1684–1721* 146 (Paris, 1984), p. 1; Roland Michel 1984, pp. 160–65; M. Morgan Grasselli and P. Rosenberg, in Washington 1984–85, pp. 160, 300–304; Whittingham 1985, pp. 12–14, fig. 15; S. Whittingham, "Pelerinage à Montmorency," *The Watteau Society Bulletin* (1985), pp. 22–27; M. Roland Michel, "Watteau: After the Exhibitions," *TBM* 127, no. 993 (Dec. 1985), p. 917; J. Baticle, "Inventaire aprés décés du chanoine Haranger, 17 mai 1735," *RdA* 69 (1985), p. 65, fig. 7; T. E. Crow, *Painters and Public Life in Eighteenth-Century Paris* (New Haven and London, 1985), p. 55, fig. 16; Murphy 1985, p. 298; Bean and Turčić 1986, p. 295; Stebbins and Sutton 1986, p. 50; J. de la Gorce, "Watteau à l'opéra (1702)?" p. 14; P. Rosenberg, "Répétitions et répliques dans l'oeuvre de Watteau," pp. 108–109, figs. 22 and 23; J.-R. Mantion, "Sites de Watteau: Watteau et la question de paysage," p. 149; Y. Boerlin-Brodbeck, "La Figure assise dans un paysage," p. 163; M. Vidal, "Conversation as Literary and Painted Form," p. 173; S. Whittingham, "Watteau and 'Watteaus' in Britain, c. 1780–1851," p. 277—all in *Watteau 1987*; J.-F. Méjanès, in Musée du Louvre, *Dessins français du XVIIIe siècle de Watteau à Lemoyne* (Paris, 1987), p. 82, under no. 108; The Phillips Collection and National Gallery of Art, *Places of Delight: The Pastoral Landscape* (Washington, D.C., 1988), pp. 149, 151–53, 163, fig. 141; J. Ingamells, *The Wallace Collection Catalogue of Pictures, III: French before 1815* (London, 1989), pp. 9, 13 n. 143, ill. p. 14; *Tableaux anciens*, Sotheby's, Monaco, June 16–17, 1989, p. 92, under no. 374; Lewis 1989, p. 91, fig. 41; P. Conisbee, "The Eighteenth Century: Watteau

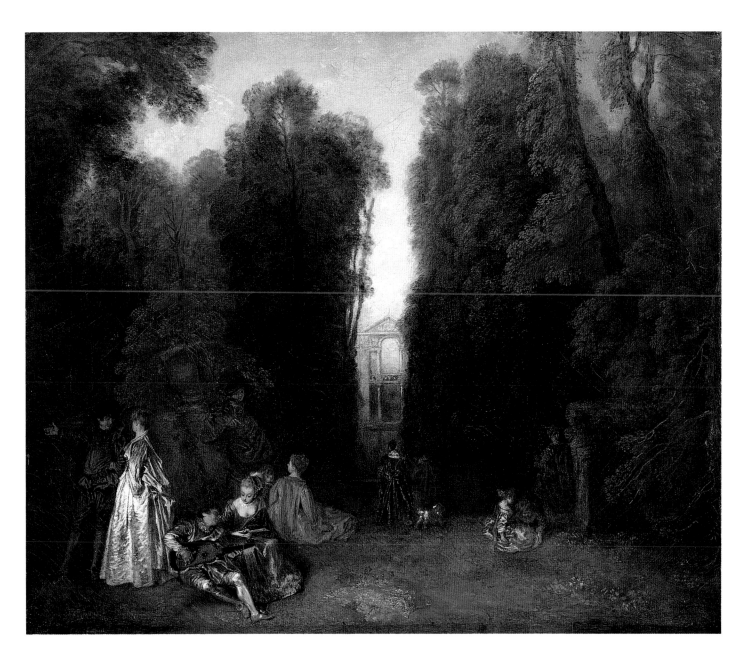

to Valenciennes," in New York 1990, p. 86; C. Riopelle, "New York, Colnaghi, French Landscape Painting," *TBM* 133, no. 1054 (Jan. 1991), p. 55; H. Wine, *Watteau* (London, 1992), pp. 31–33, pl. 19; M. Vidal, *Watteau's Painted Conversations* (New Haven and London, 1992), pp. 27 and 148, fig. 34; P. Rosenberg and L. A. Prat, *Antoine Watteau 1684–1721: Catalogue raisonné des dessins* (Milan, 1996), vol. 1, pp. 284, 316, 352, and 520; vol. 2, pp. 736, 800, 916, and 950.

CONDITION: The plain, loosely woven fabric support has been glue-lined, with the tacking margins trimmed. The paint has been applied over a double ground, consisting of a tan layer below a red layer. Infrared examination reveals, among several artist's changes, two reclining figures where the yellow skirt of the figure at left is now. Watteau's working methods have resulted in darkening and cracks in the paint. The painting is abraded. Damaged areas include the lower right area with the red-cloaked figure, the pair of figures at the right (now barely visible), and the standing red-capped man at the left.

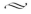

A great deal of the information concerning this painting, including its title, comes from an engraving in reverse of the subject made by Louis Crépy (fig. 30a), which was announced in the *Mercure de France* of December 1729.[1] The legend on the print states that the painting was from the cabinet of M. Guenon. This was the name of a family of cabinetmakers who worked for the king, but just which Guenon is meant has yet to be determined.[2] The print gives the measurements of the painting as "1 foot 9 inches × 1 foot 5 inches" (22³⁄₈ × 18¹⁄₈ in.), so it is likely that they had been reversed and that the work has been trimmed slightly to its present dimensions.

The engraving by Crépy is not identical to the Boston painting as we now know it. The print shows a man seated on the balustrade next to the standing women, his feet crossed and looking out at the viewer; two other figures, seen in back view, lean on the same balustrade. Further, the standing man leaning against the stone pedestal of the garden urn in the painting wears a beret and gestures toward the seated woman, while in the engraving he does not point and is bareheaded, as he also is in a seemingly preliminary drawing by Watteau.[3] A much later, poor copy of the composition (fig. 30b)[4] shows the background figures and the standing man as they appear in the print. Louis Réau attributed the absence of the three background figures in the Boston painting to repainting,[5] but

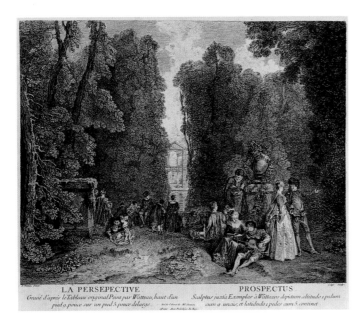

Fig. 30a. Louis Crépy, after Watteau, *La Perspective*. Engraving. New York, The Metropolitan Museum of Art. Gift of Mr. and Mrs. Herbert N. Straus, 1928 28.113.(1-67)

Fig. 30b. Eighteenth-century copy after cat. 30. Photograph courtesy Schaeffer Gallery, New York, 1949

in fact it is due to abrasion. The figures are gone; only the reddish ground of the canvas remains.[6] The presence of the beret and the pose of the standing man, clearly a weak and repainted figure, was, according to Pierre Rosenberg, the result of an "old, poorly understood restoration."[7]

X-rays and infrared reflectography unfortunately provide no record of the change in the figure, and color analysis indicates only that it is an old restoration.[8] Although X-rays did not reveal any change in the standing man, they did provide one noteworthy discovery (fig. 30c). Originally, to the right of the seated woman and guitar-playing man was another couple, a reclining man reaching toward a woman. Their poses are quite similar, as Rosenberg has observed, to those in Watteau's painting *The Family* (Switzerland, private collection).[9] Perhaps the artist decided that the more active

poses of these figures destroyed the quiet harmony of the present painting and therefore painted over them.

The Goncourts, in their seminal study of eighteenth-century French art, were inspired by this painting, or rather the print after it, to wax rhapsodic about Watteau's abilities as a landscape painter:

[I]t should be said that Watteau was a great landscape painter whose originality in this field has not yet been properly recognized. The painter who, while staying in the Crozat's country house at Montmorency, painted the picture engraved under the title "Perspective" was a creative artist who had invented a new genre. Academic landscape, that is to say, landscape that seeks to convey an impression of nobility, of a more than natural beauty, was achieved by Watteau without any of the tricks and eliminations of his predecessors and contemporaries. With his trees whose branches flow, like a cascade, down to the ground, his groves of hornbeam spreading like a fan behind the reposing forms of his lovers, his arches of foliage which seem to open between the supports of a stage-set, his forest clearings, trodden by the measures of a minute and illumined by a sunbeam, his tall woods like a half-drawn curtain behind the figures of his bathers; with the airy foliation that pervades his pictures, touched with his liquid colour, interspersed with balustrades, termae, statues of women and children, fountains enveloped in the mist of their waters, Watteau has conjured up a nature more beautiful than nature.[10]

While their appreciation of the artist's talents is still apt, their assumption concerning the setting remains open to question. The supposedly unique role of *La Perspective* as the only identifiable setting of any Watteau painting is based on a notation by the connoisseur Pierre Jean Mariette that the background of the painting represents "a view of the garden of M. Crozat at Montmorency,"[11] and an inscription by comte de Caylus on an engraving by him after a now-lost drawing by Watteau.[12] This shows an alley of trees at whose end is a building similar to that in the painting, but as Marianne Roland Michel observes, there are notable differences: "The painting in Boston does not show an alley of trees forming an arbour as in Caylus's engraving; here the trees arranged symmetrically to the right and left of the architectural background stop at the height of a low wall half-way between the foreground and the vaguely Palladian facade in the distance, a facade which in fact does not correspond to what we know of the building at Montmorency altered by Oppenard and Cartaud for Crozat."[13]

Pierre Crozat was a great patron of the arts, and Watteau resided for some time at his Paris residence, where he had the opportunity to study and copy Crozat's fine collection of Renaissance drawings. Crozat's suburban residence, acquired in 1709, was the château de Montmorency, north of Paris near Saint-Denis. Originally the home of the painter Charles LeBrun, it had gardens designed by André Le Nôtre. Crozat employed the architect Jean-Silvain Cartaud to adapt the property to his taste. A new château in

Fig. 30c. Infrared reflectograph detail of cat. 30 revealing artist's pentimento

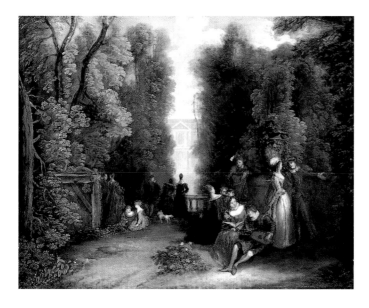

Fig. 30d. After Watteau, *Garden Scene*. Oil on canvas. Glasgow Museums, Art Gallery and Museum, Kelvingrove

the style of a sixteenth-century Roman palazzo was built as the main residence, and the older, two-storied mansion was, by the removal of the back wall, turned into an open-air *maison de plaisance*. It is the central part of this façade, known also from a print by Israel Silvestre, that most scholars believe can be seen in the painting.[14] In composing this unusual painting, Watteau most likely used his assembled collection of drawings of landscape with architecture. These included the now-lost example copied by Caylus as well as one in the Hermitage.[15] But Watteau freely embellished or changed them. The Caylus print, for example, shows a statue on one side of the vista, and this is missing in the painting. As Roland Michel has suggested, contemporary theatrical motifs may have been an influence, which "may also explain the title of 'perspective' evoking the theatre and decoration."[16]

The white marble façade of the château appears in the far distance set behind a pool of water, in which it is reflected. Towering, fluffy trees with flourishes of autumnal colors frame it on either side. In the foreground is the idyllic type of open-garden setting frequently employed by Watteau for his *fêtes galantes*. The figures wear the old-fashioned Flemish or Spanish fancy dress typical of these works, further indicating the imaginary or theatrical nature of the scene.[17] The activities of the figures—strolling, listening to music, making conversation—are also typical of these *fêtes galantes*, and attempts have been made to read them as meditations on love or a progress of love. For example, Donald Posner writes: "The figures at the left have become couples arranged so that their actions together shape a larger content. The man leaning on the pedestal begins a conversation with the seated woman. In front of them a relationship deepens as a guitarist serenades his belle. To the left, completing the circle of forms, a gentleman invites a lady to accompany him into the privacy of the woods. And this is the culmination of an everyday and age-old episode that is seen to begin, at the right, with children playing innocently, and to pass by people who take in the beauty of the place and of the moment, but are not ready to engage one another."[18]

This programmatic description ignores some elements of the composition. Most notably, between the man leaning on the pedestal and the seated lady in back view there is also a seated child, a boy, who turns his head so that he is the only figure in the composition actually to look out at the viewer and make us, as it were, party to the foibles of the adult world depicted here. Such a device is found in other works by Watteau,[19] and the presence of children amid these very adult scenes is a constant motif in his work.[20] The two seated children at the right occur again almost identically, for example, in *The Champs Elysées* (London, Wallace Collection).

If the overriding subject is an invocation of love, it derives in great part from one of Watteau's chief sources of inspiration: Rubens's famous *Garden of Love* (Madrid, Prado). Watteau would have known that composition through several sources—a studio copy then in Paris (now in Dresden, Gemäldegalerie), Rubens's drawings for the woodcut, which were in the collections of Mariette and Crozat, and the woodcut by Christoffel Jegher.[21] While Watteau borrowed the basic theme of couples strolling and seated in a garden with an architectural backdrop, he eschewed the baroque buoyancy of Rubens for a more delicate, balletic arrangement. To this he also added a Venetian element, most specifically the pastoral motif of the seated guitar player inspired by a figure in Titian's *Concert Champêtre* (Paris, Louvre).[22]

The dating of *La Perspective* within Watteau's short career has produced a number of conflicting theories. Dates have ranged from 1712 to 1717. According to Rosenberg, the painting stems from "the time when Watteau began his contact with Crozat, seeking to gain favor by painting his newly remodeled château. That would place the painting relatively early, before Crozat's departure for Italy in November 1714."[23] Margaret Morgan Graselli and Alan Wintermute both commented on the similarity of *La Perspective* to

Assembly in the Park (Paris, Louvre), and the former has suggested a date of 1716–17.[24]

In addition to the drawing of the man leaning on the pedestal, a number of other Watteau drawings have been related to the painting. A study for the standing woman at the left is in a private French collection;[25] in the British Museum is a study for the seated guitarist;[26] one for the seated woman with a fan listening to the guitarist is in the Metropolitan Museum of Art;[27] a study for the men on the back balustrade seen in the print is in the Seilern collection, Courtauld Institute, London;[28] and one for the head of the child looking out is in Bayonne (Musée Bonnat).[29]

Watteau's *La Perspective* became quite famous. It was apparently copied by Pater,[30] and remembrances of its composition appear in works by Turner,[31] Ingres,[32] and Cézanne.[33] Despite the painting's somewhat damaged state, it remains, as Paul Sachs observed, "a superb example by the greatest master of French painting in the eighteenth century."[34]

1. Dacier and Vuaflart 1922, vol. 3, p. 83.

2. It was Mariette who identified Guenon as "Menuisier du Roy." There were two possibilities, Jean-Antoine and Jean-François.

3. Parker and Mathey 1957, no. 671.

4. Belonging to the Schaeffer Gallery, New York, in 1969. Another copy but in reverse is at the Art Gallery and Museum, Glasgow (fig. 30d). In it, the leaning figure is wearing a hat and at least one cross-legged man is seated on the back balustrade.

5. Réau 1926, p. 151.

6. It should be noted that in the Saint sale of 1846 the work is still described thus: "[I]n the background, one can see several characters leaning on a balustrade."

7. Rosenberg, in Washington 1984–85, p. 301.

8. Rosenberg, in Washington 1984–85, p. 300, recorded that Martin Eidelberg, who noted that the printmakers seldom altered Watteau's compositions, had speculated "that the print does not reproduce the Boston painting, but rather a second [lost] version of the work." But after a recent careful examination of the painting, Eidelberg has rejected this notion. Jean Ferré puts forward an even more extreme but unlikely proposition: The Boston painting is a good replica of a lost original. See Ferré 1972, p. 218.

9. Rosenberg, in *Watteau* 1987, pp. 108–10, fig. 24.

10. E. de Goncourt, *French XVIII Century Painters: Watteau, Boucher, Chardin, La Tour, Greuze, Fragonard* (London, 1948), pp. 39–40.

11. Mariette's observation is in *Notes manuscrites* vol. 9, fol. 193 [58], reference in Dacier and Vuaflart 1929, vol. 1, p. 83.

12. The print is titled *A Montmorency*, and an impression in the Bibliothèque Nationale is inscribed *Maison de M. Le Brun, P.P. du Roi L. XIV.* See Roux 1940, p. 140, no. 486.

13. Roland Michel 1984, p. 160.

14. Discussed most thoroughly in Junecke 1960.

15. Another may have been etched by Boucher; see Jean-Richard 1978, no. 122.

16. Roland Michel 1984, p. 148.

17. Posner 1984, p. 148, suggested that the women and children are in contemporary clothing and that the men wear essentially seventeenth-century costume, but Wintermute, based on information from Edward Meader (Los Angeles County Museum of Art), disputed this. See New York 1990, p. 135. Eidelberg, in conversation of March 1993, also agreed that all the figures are

in fanciful dress. In the catalogue of the Saint sale in 1876, the guitar-playing man was wrongly described as "in the costume of Mezettin."

18. Posner 1984, p. 150.

19. Other examples are found in *The Expected Declaration* (Angers, Musée des Beaux-Arts). See Rosenberg, in Washington 1984–85, no. 45.

20. Children are also present, for example, in *The Charms of Life* (London, Wallace Collection), *The Pleasures of the Ball* (London, Dulwich College Picture Gallery), *The Concert* (Berlin, Charlottenberg Palace), and *Meeting in a Park* (Paris, Louvre). See Posner 1984, pls. 24, 29, and figs. 115, 141.

21. See Providence 1975, p. 142.

22. Pointed out first by Wilenski 1949.

23. Rosenberg, in Washington 1984–85, p. 302.

24. See New York 1990, p. 134, and Morgan Grasselli, in Washington 1984–85, p. 161.

25. Parker and Mathey 1957, no. 538.

26. Ibid., no. 830.

27. Ibid., no. 546. See also Bean and Turčić 1986, p. 295, fig. 331.

28. Ibid., no. 86.

29. Ibid., no. 713.

30. In the E. Barre sale, Paris, 1894. See F. Ingersoll-Smouse, *Pater* (Paris, 1928), no. 599.

31. Whittingham 1985, p. 13.

32. A drawing by Ingres after the Crépy print is at the Musée de Montauban, according to Adhémar and Huyghe 1950, p. 214.

33. See Lewis 1989, p. 91.

34. Letter, November 30, 1923, in the Paintings Department files.

NICOLAS LANCRET

1690–1745

Nicolas Lancret was born in Paris to a family of artisans, but the source of his earliest training is unknown. He did, however, work for a time in the atelier of Pierre Dulin, a painter of history subjects and a teacher at the Académie royale. In 1708 the young Lancret was expelled from the Académie for quarreling. He then worked in the studio of Claude Gillot, whose popular theatrical subjects had already influenced Watteau (q.v.). Lancret developed a similar taste and was befriended by Watteau, who encouraged him to leave Gillot and work in a more naturalistic manner. In 1711 Lancret competed for the Grand Prix of the Académie, in the category of history painting, but failed. He was finally admitted in 1719, but as a painter of *fêtes galantes*—imaginary subjects in the style of Watteau. Following Watteau's death in 1721, Lancret's clientele came to include such great amateurs of the period as Pierre Crozat, the duc d'Antin, comte de Tessin, and Frederick II of Prussia. He also received royal commissions for Versailles. He exhibited at the Exposition de la jeunesse in 1722 and 1723, at the Salon of 1725, and the Salons in the later part of his life. Lancret was made a *conseiller* of the Académie in 1735. Although he achieved fame with his theatrical and *galant* subjects, Lancret also painted historical scenes, illustrated La Fontaine's *Fables*, and did some portraits.

31. *Le Déjeuner de jambon*
(Luncheon Party in a Park), about 1735

Oil on canvas
25 5/16 × 18 1/8 in. (55.7 × 46 cm)
The Forsyth Wickes Collection
65.2649

PROVENANCE: Ange-Laurent de La Live de Jully, by 1756; sale Paris, March 5, 1770, no. 79; Sevin (?); Eveillard de Livois, by 1791; marquis de la Rochefoucauld-Bayers, by 1925; David David-Weill, Paris, by 1926; Wildenstein and Co., New York, by 1937; Jacques Helft & Co., New York, purchased February 1, 1945, by Forsyth Wickes.

EXHIBITION HISTORY: Nantes, Musée des Beaux-Arts, *Peinture française*, 1924, no. 899; Paris, Musée du Petit Palais, *Paysage français de Poussin à Corot*, 1925, no. 162; Paris, Pavillon de Marsan, *Orfèvrerie française civile* (1926), *hors catalogue*; London 1932, no. 246; New York 1935–36, no. 12; New Orleans, Isaac Delgado Museum of Art, *Masterpieces of French Painting through Five Centuries, 1400–1900*, 1954, no. 31; Hartford, Wadsworth Atheneum, *Harvest of Plenty*, 1963, no. 26; Boston 1972, no. 90; New York 1991, no. 10.

REFERENCES: *Catalogue historique du cabinet . . . de M. de La Live de Jully* (Paris, 1764), p. 37; M. Herbert, *Dictionnaire pittoresque et historique* (Paris, 1766), vol. 1, p. 122; E. Bocher, *Catalogue raisonné . . . Nicolas Lancret* (Paris, 1877), p. 94; F.-A. Gruyer, *Chantilly, notice des peintures, école française* (Paris, 1900), p. 300; Wildenstein 1924, p. 76, no. 74; L. Réau, *Histoire de la peinture française au XVIIIe siècle* (Paris, 1925), vol. 1, p. 24; Henriot 1928, vol. 1, pp. 223–25; G. Wildenstein, "L'Exposition de l'art français à Londres, 1932," *GBA* 6 (1932), p. 62, fig. 9; H. B. Wehle, "French Painting of the Eighteenth Century," in New York 1935–36, pp. 5–6; A. Bonnard, "La Vigne et le vin dans l'art," *Plaisir de France* (Dec. 1936), p. 17; Musée de l'Orangerie, *De Clouet à Matisse: Dessins français des collections américaines* (French Drawings from American Collections: Clouet to Matisse) (Paris, 1958), under no. 62 (traveled to Rotterdam, Boymans Museum; New York, Metropolitan Museum of Art, 1958–59); Mongan 1963, p. 151; Rathbone 1968b, p. 738, fig. 6; Watson 1969, pp. 216–17, fig. 43; Museum of Fine Arts, Boston, *Illustrated Handbook* (Boston, 1984), p. 280; Christie's, London, *Old Master Drawings*, Dec. 13, 1984, under no. 154; M. T. Holmes, "Nicolas Lancret and Genre Themes of the Eighteenth Century" (Ph.D. diss., New York University, 1985), p. 40, and under cat. 8; Murphy 1985, p. 160; Stebbins and Sutton 1986, p. 51; C. B. Bailey, introduction to *Ange-Laurent de La Live de Jully* (New York, 1988), pp. vi–vii, XXII–XXIII; Zafran, in Munger et al. 1992, pp. 74–77, no. 15; A. Wintermute, "The Art of Nicolas Lancret," *Apollo* 135, no. 361 (March 1992), p. 191.

CONDITION: The original plain woven fabric support has been glue-lined, with the tacking margins cut. The granular paint is applied over a beige ground that is visible in parts of the composition. Examination reveals the jacket of the figure standing on the table was originally painted lighter, which could be underpainting or an artist's change. Infrared examination reveals curved forms at all corners, suggesting that the painting had once been in a different format. Besides some very minor retouched losses and abrasion in the background, the paint is in remarkably good condition.

In 1735 Louis XV ordered a pair of festive scenes to decorate the dining room of the *petits appartements* at Versailles. These works, to give their common names, were *The Luncheon of Oysters* by Jean-François de Troy and *The Luncheon of Ham* by Lancret, for which the artists were paid in January 1738. Both of these paintings are now in the Musée Condé at Chantilly.[1] In a contemporary listing of the works painted for the king between 1722 and 1737, the painting by Lancret is more fully described as "representing a party with young men at table, becoming debauched, one is laughing, all on a background of landscape."[2] Very shortly thereafter, descriptions of Versailles remarked on the quality of the paintings and also their elaborate framing amid ornaments of the hunt.[3] These chambers were used for private feasting and revelry by Louis XV and his intimates and called for rather special works; Lancret and de Troy must have conferred to produce such similar, yet effectively contrasted, compositions. De Troy's (fig. 31a) is set in an interior and presents a gathering of gentlemen and their servants, gorging on oysters, washed down with white wine, under the watchful gaze of a sculpted Venus. The open space in the foreground is covered by empty silver trays and discarded shells. Lancret's painting, by

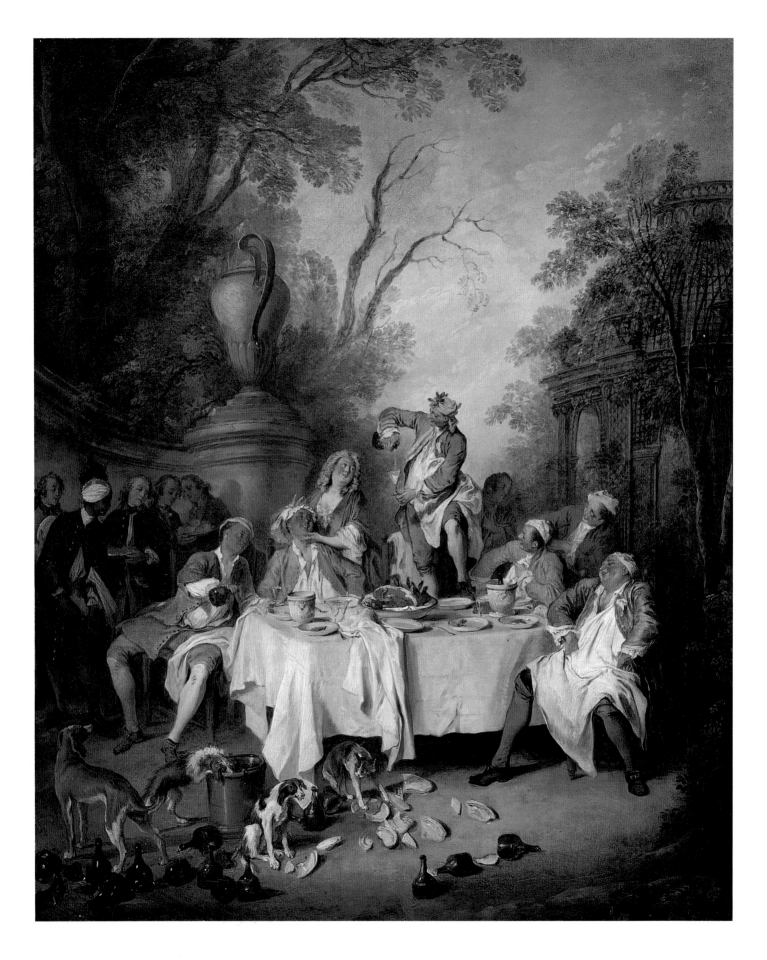

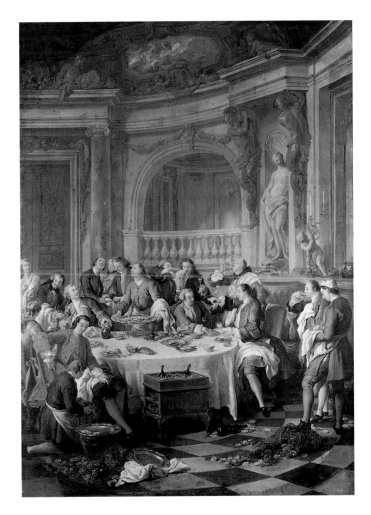

Fig. 31a. Jean-François de Troy, *Le Déjeuner d'huitres*, 1735. Chantilly, Musée Condé. © Giraudon

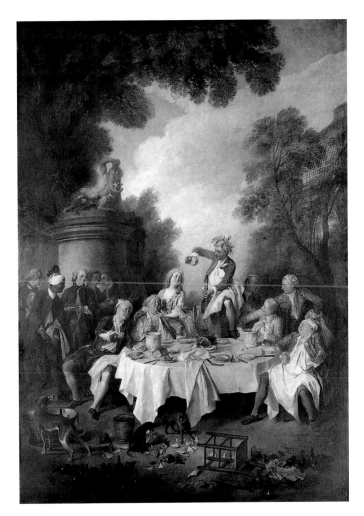

Fig. 31b. Nicolas Lancret, *Le Déjeuner de jambon*, 1735. Chantilly, Musée Condé. © Giraudon

contrast (fig. 31b), is set outdoors with a statue of the youthful, drunken Bacchus or a satyr dominating the background; the centerpiece of the meal is a ham, and here it is red wine that is served. The inebriated gentlemen, who wear large napkins, have removed their wigs and also smashed a great deal of the crockery. One man crowned with laurel pours out yet another glass, while turning as if to propose a toast to his seated neighbor, who is embraced by a voluptuous, well-dressed, rosy-cheeked woman. The servants holding platters of food converse at the left, and two dogs and a cat forage amid the debris.

The objects on the table include the precious Saint-Cloud porcelains, and the effect of white on white *à la* Oudry is a tour de force of still life painting. Between them, de Troy and Lancret succeeded in capturing a robust *joie de vivre*, presenting a celebration of overindulgence and sensuality that seems neither effete nor decadent, but sophisticated and universal. These works with their picturesque dissolution provided the inspiration for many later festive banqueting scenes.[4]

As there were not many precedents for his composition,[5] to achieve the seemingly haphazard look Lancret must have made a number of preliminary drawings, but only one is known.[6] This small version of Lancret's painting does not appear to be a prelimi-

nary study but rather a reduced replica with many notable differences made for more private, intimate viewing. The overturned chair in the foreground, needed to establish depth in the large-scale painting, is removed, as is the large, copper cooler at the left. An additional dog lapping at the bucket is included. The perhaps too-obvious statue has also been replaced by a large, tankardlike urn. But most striking of all, the standing woman now cradles the head of a much younger and laughing host in one hand while with her other she makes the traditional sign of the cuckold behind his head. This provides a focal point for the general merriment, which, for all its brilliance, the larger painting lacks. The Boston canvas is painted with a spontaneity of touch and freshness of color that mark it as a truly inspired original creation.

This revised version of a work belonging to the king was most likely specifically commissioned from Lancret, but the painting's first known owner, the famous and eccentric collector La Live de Jully, was of a later generation. It was already engraved in 1765 by P.-E. Moitte as *A Pleasure Party*, with a dedication to La Live de Jully (fig. 31c).[7] The catalogue of La Live de Jully's collection describes it simply as "a rural meal."[8] As the provenance reveals, a succession of distinguished collectors later owned this refined gem of eighteenth-century artistry.

Fig. 31c. Pierre-Etienne Moitte, after Lancret, *Partie de plaisirs*, 1765. Engraving, Paris, Bibliothèque Nationale

1. See F.-A. Gruyer, *Chantilly, Musée Condé: Notice des peintures* (Paris, 1899), pp. 337–38, 364–67, nos. 366, 383; A. Lefébure, *Chantilly, Musée Condé* (Rennes, 1986), p. 78, ill.

2. "un tableau representant une partie de jeunes gens à table, faisant le débauche, dont il y en a un qui rit, sur un fond de paysage." Grasselli 1985–86, p. 386, fig. 14.

3. Piganiol de la Force, *Nouvelle Description des châteaux et parcs de Versaille et de Marly* (Paris, 1764), vol. 1, p. 318, describes Lancret's painting as "a light meal served in a garden." See M. T. Holmes, "Lancret décorateur des 'petits cabinets' de Louis XV à Versailles," *L'Oeil* 356 (1985), p. 27.

4. See, for example, Boucher's painting and oil sketch for *The Hunting Luncheon*; Ananoff and Wildenstein 1976, vol. 1, p. 351, no. 263; Lancret's own *Luncheon in a Park* at Orléans; and Atlanta 1983, no. 46, now in the Metropolitan Museum of Art, New York.

5. A much stiffer indoor *Luncheon of Ham*, attributed to Levrac-Tournières, is at the Musée Lambinet, Versailles.

6. In the Pierpont Morgan Library, New York; see Grasselli 1985–86, p. 386, fig. 14.

7. Reproduced in *La Revue de l'art ancien et moderne* 3, no. 4 (April 10, 1898), p. 339. C. Le Blanc, *Manuel de l'amateur d'estampes* (Paris, 1858–88), vol. 3, p. 35, no. 40.

8. *Catalogue historique du cabinet* (Paris, 1764), p. 37.

32. *The Escaped Bird*

Oil on canvas
18 1/4 × 21 3/4 in. (47 × 56 cm)
Martin Brimmer Fund, Ernest Wadsworth Longfellow Fund, and Mrs. Edward Wheelwright Fund
40.478

PROVENANCE: Hannah Mathilde von Rothschild, Frankfurt; to her daughter Minna Caroline (Minka) Goldschmidt, Frankfurt; André Weil, Paris, by 1939.

EXHIBITION HISTORY: Frankfurt, Städelsches Kunstinstitut, *Austellung von Meisterwerken alter Malerei aus Privatbesitz*, 1925, no. 117; London 1932, no. 185; London, University of Western Ontario, McIntosh Art Gallery, *Loan Exhibition: Seventeenth–Eighteenth Century French Masters*, 1953; Richmond, Virginia Museum of Fine Arts, *Fêtes Galantes*, 1956.

REFERENCES: Constable 1940, pp. 86–89; Boston 1955, p. 36; Murphy 1985, p. 159; Boime 1987, p. 19, fig. 1.15.

CONDITION: The support, a plain woven unlined fabric, has a patched, vertical tear at left (through the servant's leg and the cloud). A double ground, composed of a lower dark-red layer followed by a warm grayish pink layer, is visible in areas through the granular, opaque paint. Pentimenti show changes in the boy's arm, which was initially placed higher. Discrete areas of in-painting cover minor losses to the paint layer, which is in very good condition.

The imagery of caged birds and birds escaping from their cages was popular in eighteenth-century French painting[1] and was treated often by Lancret. As Mary Taverner Holmes has observed of these works, "A bird that has escaped from a cage or is about to is a recurring symbol of the loss, or potential loss, of virginity."[2] The present painting may have had as its pendant one called *The Caged Bird* (fig. 32a),[3] in which, according to W. G. Constable, "the melancholy air of a woman regarding a bird in a cage, is an appropriate contrast to the comparative elation of the lady in the Museum's picture."[4] The sense of elation and freedom is heightened by the woman's balletic pose, a frequent one for Lancret, the trumpeting fountain figure, and the delightfully devoted attitude of the little black servant. The liveliness of his expression derives from a life study, and Lancret's drawing of the beturbaned boy's head (fig. 32b) was formerly in the Haseltine collection.[5] The influence of Watteau (q.v.) is evident, and one almost feels this little tableau should be accompanied by music.

1. See J.-L. Bordeaux, "The Epitome of the Pastoral Genre in Boucher's Oeuvre: *The Fountain of Love* and *The Bird Catcher* from *The Noble Pastoral*," *The J. Paul Getty Museum Journal* 3 (1976), pp. 88–89.

2. M. T. Holmes, in New York 1991, p. 98. See also E. M. Bukdahl, *Diderot: Critique d'art* (Copenhagen, 1980), pp. 313–14.

3. Of nearly the same size (43 × 54 cm), it was sold Hôtel Drouot, Paris, May 14–16, 1914, no. 282, ill., and again at Sotheby's, New York, January 12, 1989, no. 152.

4. Constable 1940, p. 87.

5. Ibid., p. 88, fig. 2. According to a letter of February 6, 1941, from Constable to Felix Wildenstein. The latter supplied the information that this drawing, once attributed to Watteau, was then either in Mr. Cognaqc's own collection or in the Cognaqc Jay Museum.

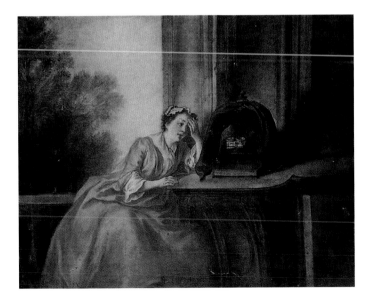

Fig. 32a. *(far left)* Nicolas Lancret, *L'Oiseau prisonnier.* Oil on canvas. (Photograph reproduced from sale Sotheby's, New York, January 12, 1989, no. 152)

Fig. 32b. *(left)* Nicolas Lancret, Study for cat. 32. Ex-Haseltine collection, present location unknown

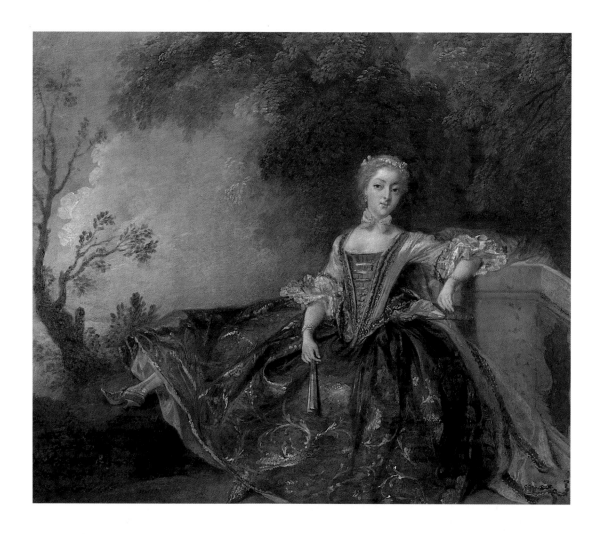

33. *An Actress Seated out of Doors*

Oil on paper mounted on panel
11 × 13 in. (27.7 × 32.8 cm)
The Forsyth Wickes Collection
65.2647

PROVENANCE: de Poismenu; sale Paris, August 26, 1779, no. 151 (?); S. R. Bertron, New York; Mrs. S. Fahnestock (?); Mrs. W. Bouimistrow, Paris (?); Wildenstein and Co., New York, by 1937, purchased January 14, 1943, by Forsyth Wickes.

EXHIBITION HISTORY: Cincinnati Art Museum, *French Paintings of the Eighteenth and Early Nineteenth Centuries*, 1937, no. 12; Pittsburgh 1951, no. 80; Kansas City, Mo., Nelson Gallery and Atkins Museum, *The Century of Mozart*, 1956, no. 62; Hartford 1956, no. 29.

REFERENCES: Wildenstein 1924, p. 112, no. 613; Rathbone 1968a, p. 18; Rathbone 1968b, pp. 738–39, fig. 7; Murphy 1985, p. 159; Zafran, in Munger et al. 1992, p. 78, no. 16.

CONDITION: The painting is on a paper support later mounted to a cradled panel. There is no evidence of a ground preparation. The paint layer is in good condition, with retouched areas confined to small areas at the edges. There is a slight change, which is visible under infrared light, in the position of the left hand holding the book.

In his 1924 catalogue of Lancret's works, Georges Wildenstein included this portrait in his section of "unknowns," identifying it as the "portrait of a woman" included in the de Poismenu collection sale in the eighteenth century. When the firm of Wildenstein and Co. sold the painting to Mr. Wickes in 1945, the subject was identified as the well-known dancer Marie-Anne de Cupis de Camargo. There exist a number of portraits of her by Lancret and others,[1] in which she bears little resemblance to the woman in this painting, who assumes a seated pose quite different from La Camargo's active ones. This elaborately dressed woman, closing a book with one hand and holding a provocatively placed fan in the other,[2] however, does make a point of revealing (albeit somewhat stiffly) her well-turned ankle. In this as well as her coquettish regard, she resembles another portrait of a woman by Lancret[3] that has been identified as that of an actress.[4] The settings in both works could indeed be theatrical backdrops.

1. See Atlanta 1983, pp. 111–12, no. 43.

2. Hers definitely is not one of the six polite ways of holding a fan codified in 1770 by Matthew Toule in his *Young Gentleman and Lady's Private Tutor*. As Addison rightly observed, "a Fan is either a Prude or a Coquet according to the nature of the person who bears it." See *The Language of the Fan* (Fairfax House, York, 1989), pp. 28–32.

3. Wildenstein 1924, p. 107, no. 567.

4. See Bordeaux 1980, p. 84, no. 37.

34. *The Serenade*

Oil on panel
10 5/8 × 7 7/8 in. (27 × 20 cm)
The Forsyth Wickes Collection
65.2648

PROVENANCE: Kraemer collection by 1912 (?); Wildenstein and Co., New York; purchased August 12, 1946, by Forsyth Wickes.

EXHIBITION HISTORY: Paris, Société Nationale des Beaux-Arts, *La Musique et la danse*, 1912, no. 70.

REFERENCES: Wildenstein 1924, p. 79, under no. 119; Murphy 1985, p. 160; Zafran, in Munger et al. 1992, p. 79, no. 17.

CONDITION: The wood support has been thinned and attached to a cradled panel. The paint is applied over gesso and a layer of gold leaf. Aside from various colors, especially the browns, which have darkened with time, the painting is in very good condition.

This small panel, probably part of a now-dispersed decorative wall scheme in an intimate boudoir, reveals Lancret's ability to distill motifs from the works of Watteau (q.v.),[1] such as the standing guitarist serenading a lady.

1. See, for example, Macchia and Montagni 1968, nos. 88, 153.

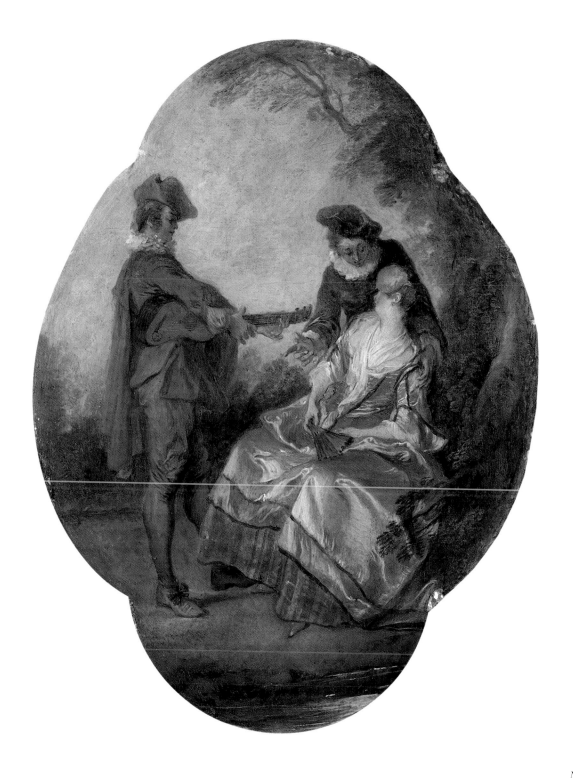

JEAN-SIMÉON CHARDIN

1699-1779

Jean-Siméon Chardin, the son of a carpenter, was born in Paris. In 1718 he was apprenticed to Pierre-Jacques Cazes, and in 1720 he began working with Noël-Nicolas Coypel. He entered the Académie de Saint Luc in 1724 and absorbed its standards of conscientious craftsmanship. Chardin painted humble still lifes, which, when shown at an exhibition in the Place Dauphine in 1728, attracted considerable attention, notably from the painter Nicolas de Largillière (q.v.). That same year, Chardin had the unusual honor of being both *agréé* and *reçu* by the Académie royale de peinture et de sculpture on the same day. He was received as a "painter of animals and fruits," and his reception pieces were two large still lifes now in the Louvre: *The Skate* and *The Buffet.*

Chardin became a regular contributor to the Salon. About 1733 he enlarged his repertoire to include figural subjects—portraits and genre scenes of bourgeois life, often influenced by seventeenth-century Dutch works. Though never able to attain a higher rank in the categories of painting, Chardin was a dedicated *académicien.* He was elected *conseiller* to the Académie royale in 1743 and *trésorier* in 1755. From then until 1774 he held the often difficult post of *tapissier*, or official hanger, in the Salons.

After 1751 Chardin again limited his output primarily to still lifes. These had become extremely popular, and, though he was a slow painter, he often had to make several replicas. In 1752 the king gave him a royal pension and in 1757 provided lodgings for the painter and his family in the Louvre. In 1766 Empress Catherine the Great of Russia commissioned an impressive still life, *Les Attributs des Arts*, to grace the Academy of Fine Arts in St. Petersburg. Between 1771 and 1775, because of failing eyesight, Chardin began producing portraits in pastel, a medium easier for him to control than oils. Despite his poor health, he continued working and exhibiting until his death.

35. *The Kitchen Table*

Oil on canvas
15 5/8 × 18 in. (39.8 × 47.5 cm)
Signed and dated lower right: *chardin / 17[55?]*
Gift of Mrs. Peter Chardon Brooks
80.512

PROVENANCE: Ange-Laurent de La Live de Jully, by 1757; Johann Anton de Peters, Paris and Cologne, 1779; estate sale of Mme Johann Anton de Peters, Basan, Paris, March 9, 1779, no. 104 (bought in); J. A. Peters; sale Paris, November 5, 1787, no. 165 (bought in); M. du Charteaux et Salavet; sale Rémy and Le Brun, Paris, May 2, 1791, no. 146; Peter Chardon Brooks, Boston; inherited by Mrs. Peter Chardon Brooks, Boston.

EXHIBITION HISTORY: Paris, Salon, 1757, no. 33; Paris, *Salon de la Correspondance*, 1783, no. 80; Cambridge, Mass., Fogg Art Museum, Still Life: *Loan Exhibition Arranged by Students*, 1931, no. 9; Toronto, Art Gallery of Ontario, *Loan Exhibition of Paintings Celebrating the Opening of the Margaret Eaton Gallery and the East Gallery*, 1935, no. 6; New York, Marie Harriman Gallery, *Chardin and the Modern Still Life*, 1936, no. 7; Cambridge, Mass., Fogg Art Museum, French paintings, teaching exhibition, 1938; Milwaukee Art Institute, *Still Life Painting since 1470*, 1956, no. 13 (traveled to Cincinnati Art Museum); Paris 1979, no. 102; Boston 1984, no. 12; Chiba 1994, no. 25; Boston 1994, no. 29.

REFERENCES: Museum of Fine Arts, *Fifth Annual Report* (Boston, 1881), p. 8; Downes 1888, p. 501; Furst 1911, p. 134; Guiffrey 1913, pp. 540–41; Boston 1921, p. 79, no. 190; Boston 1932, ill.; Wildenstein 1933, p. 228, no. 949; R. H. Ives Gammell, *Twilight of Painting* (New York, 1946), pl. 45; B. Denvir, *Chardin* (Paris, 1950), pl. 5; Boston 1955, p. 11; H. Fussiner, "Organic Integration in Cézanne's Painting," *College Art Journal* 4, no. 4 (Summer 1956), pp. 303–304, 310; Faré 1962, vol. 1, p. 164; Wildenstein 1963, p. 158, no. 120, fig. 53; Whitehill 1970, vol. 1, p. 77, ill.; Scott 1973, p. 75; M. Faré and F. Faré, *La Vie silencieuse en France* (Fribourg, 1976), p. 158; M. Fried, "Anthony Caro's Table Sculptures," *Arts Magazine* 7 (March 1977), p. 97; Rosenberg, in Paris 1979, pp. 305–307, no. 102; Rosenberg 1983, p. 105, no. 146; P. Rosenberg, *Chardin: New Thoughts* (Lawrence, Kans., 1983), pp. 31, 64, fig. 13; Conisbee 1985, p. 195, ill.; R. Lack, ed., *Realism in Revolution: The Art of the Boston School* (Dallas, 1985); Murphy 1985, p. 49; Bailey 1988, p. xxiii; N. Bryson, in Memorial Art Gallery of the University of Rochester, *In Medusa's Gaze* (Rochester, N.Y., 1991), pp. 19–20, fig. 10; M. Roland Michel, *Chardin* (Paris, 1994), pp. 171, 173, ill.

CONDITION: The plain woven fabric support has been glue-lined, with the tacking margins extended, slightly increasing the original dimensions. The paint is applied in layers over a double ground composed of a rough, red layer below a warm gray layer. The paint layer has been flattened during lining, and the browns in the background on the left have sunk, causing some tonal imbalance and making it difficult to see the ladle on top of the copper pot. Glazes are absent in the light areas of the design, possibly due to previous cleaning. There are some areas of disfiguring shrinking cracks. A number of pentimenti are evident to the naked eye.

The notable eighteenth-century collector Ange-Laurent de La Live de Jully[1] owned a number of works by Chardin. To the Salon of 1757 he lent a pair of still lifes that the accompanying *livret* described as follows: "One represents some dishes on a kitchen table and the other a dessert course on a butler's pantry table."[2] This pair of paintings did not, however, appear in La Live de Jully's collection catalogue of 1764 or in his sale of 1770.[3] He must have sold or traded them at an earlier date to a painter from Cologne, Johann Anton de Peters. Two sales were held of works from his collection. In the first, in 1779, the pair of still lifes is more fully described: "A kitchen and pantry; in one we see a chicken, loin of

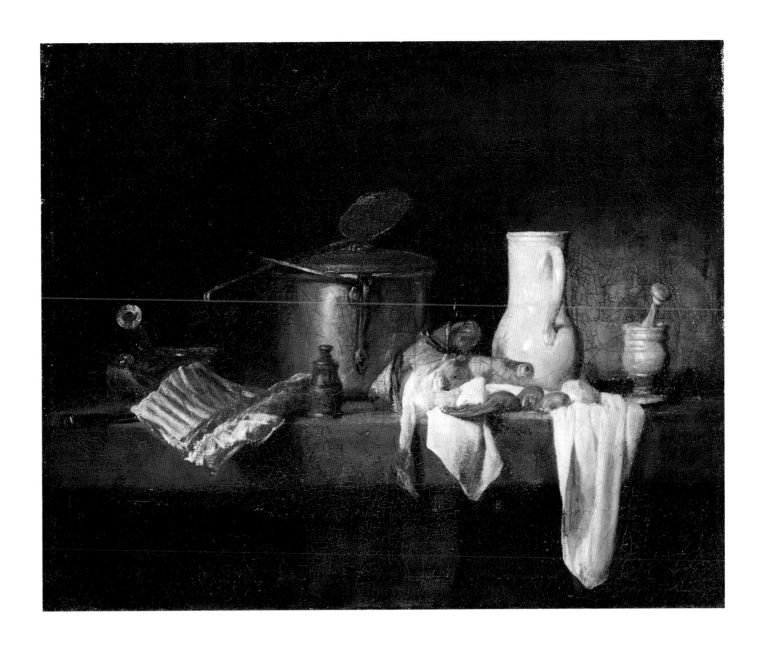

mutton, copper pot, faience pitcher, and other necessary utensils; in the other, a pâté, some fruit, a tureen, an oil and vinegar cruet, etc. These two paintings, admirable for brushwork and color, are on canvas; each measures 13 *pouces* 6 *lignes* high by 16 *pouces* 6 *lignes* wide [14³⁄₈ × 17¹⁄₂ in.]."[4]

The pair did not sell but were bought in for de Peters, probably through the intercession of the dealer Basan, for 130 livres. Then at the *Salon de la Correspondance* of 1783, de Peters exhibited only one of them, described as "kitchen utensils with meat,"[5] and it was this same painting that was included in the estate sale of de Peters's widow in 1787, where a yet fuller account was given, including the La Live de Jully provenance: "A kitchen where one sees a chicken, a loin of mutton, copper pot, faience pitcher, and other necessary utensils. . . . It comes from the collection of the late M. La Live. 14 × 17 *pouces* [15 × 18¹⁄₈ in.]."[6] Once again the work was bought in. The pair next appeared in 1791 in the sale of M. du Charteaux et Savalet where they were again described in detail and warmly

praised: "Tables on which are a pâté, a tureen, an oil and vinegar cruet, a loin of mutton, a fowl, and kitchen and pantry utensils; these two richly composed paintings are beautifully painted; they were made with care for M. de Juli de La Live [*sic*] patron of the arts."[7]

The Kitchen Table was given to the Museum of Fine Arts by Mrs. Peter Chardon Brooks in 1880. David Carritt, in correspondence of 1975, first suggested that the date on the painting be read as 1755 and not, as was previously believed, 1733.[8] Then, in correspondence of 1977, he definitely identified it as La Live de Jully's painting and named its pendant as *The Butler's Pantry Table* (fig. 35a),[9] dated 1756, in the Musée des Beaux-Arts of Carcassonne since 1846.[10] The two paintings are nearly identical in size (the one in Carcassonne is 38 × 46 cm). The date when the works were separated and the intervening history of the Boston painting are not known, although a note of 1880 from Mrs. Brooks's niece Elizabeth (?) Hooker to the Museum's director states that Mr. Brooks had purchased it "some years ago."[11]

Fig. 35a. Jean-Siméon Chardin, *The Butler's Pantry Table*. Oil on canvas. Carcassonne, Musée des Beaux-Arts

Fig. 35b. X-ray of cat. 35

As Pierre Rosenberg has observed, the seven paintings exhibited by Chardin at the Salon of 1757 all "had been completed several years earlier. . . . The two paintings now in Boston and Carcassonne were hardly noticed. Nothing was said about them specifically, even though criticism of Chardin's entries was, generally speaking, favorable. These two paintings, however, are the most important and sure evidence of Chardin's return to still life after an interval of almost twenty years."[12]

Philip Conisbee has noted that La Live de Jully's pair of paintings contrast "the basic foodstuffs of the kitchen" with "more sophisticated preparations and finer utensils for serving and more public display. . . . Even the tables are different in form, function, and 'meaning'—the kitchen table is a thick, solid, working surface, set four-square and parallel with the picture-plane, while the

serving-table is curved in shape, creating a more sophisticated spatial effect. Further enhancing the contrast is the overall and specific coloration. Those of the butler's table are 'more positive.' "[13]

Examinations with the naked eye, X-ray (fig. 35b), and infrared reflectography reveal that Chardin made extensive changes both in his choice of objects and in their placement. Beginning at the left side of the painting, the handle of the casserole has been altered, the ladle that now rests on the top of the large copper pot was placed where the meat is presently located. The lid of the pot was at an angle and a box was to the left of the pot. The pepper mill was more to the left of its present location, and the meat was at the very center, as was the cloth hanging over the edge of the table. The placement of the mortar and pestle to the left of their present location is evident, as the image has come through as a ghostly shadow; another bowl and standing dish completed the composition. This considerable amount of reorganization evidences the care Chardin took in arranging his compositions. Substantial repainting was needed to move the meat and the white cloth, but the end result achieves a subtle progression of vertical elements precariously poised at the table's edge.

1. On La Live de Jully see Scott 1973 and Bailey 1988.

2. Rosenberg, in Paris 1979, p. 385.

3. On La Live de Jully's catalogue of 1764 and sale of 1770, see Bailey 1988.

4. De Peters sale, March 9, 1779, no. 104.

5. Rosenberg, in Paris 1979, p. 305.

6. De Peters sale, November 5, 1787, no. 10.

7. M. du Chartreaux et Salavet sale, April 30–May 2, 1791, no. 146.

8. D. Carritt in correspondence, September 1975, in the Paintings Department files.

9. Idem, January 1977.

10. For the Carcassonne painting see Wildenstein 1963, p. 194, no. 258, fig. 122, and Paris 1979, no. 103.

11. Ms. Hooker to General Loring, October 16, 1880, in the Paintings Department files.

12. Rosenberg, in Paris 1979, p. 306.

13. Conisbee 1985, p. 195.

36. *Still Life with Teapot, Grapes, Chestnuts, and a Pear*

Oil on canvas
12 5/8 × 15 3/4 in. (32 × 40 cm)
Signed and dated lower left: *chardin / 17[64?]*
Gift of Martin Brimmer
83.177

PROVENANCE: Signol collection; sale Paris, Hôtel Drouot, April 1–3, 1878, no. 45; Etienne Martin, baron de Beurnonville, Paris; sale Paris, Hôtel Drouot, May 21, 1883, no. 7; Martin Brimmer, Boston.

EXHIBITION HISTORY: New York 1935–36, no. 23; New York, Arnold Seligmann-Helft Galleries, *French Still Life from Chardin to Cézanne*, 1947, no. 11; Paris 1979, no. 119; Tokyo 1983–84, no. 24; Boston 1984, no. 13; Chiba 1994, no. 26; Boston 1994, no. 30.

REFERENCES: P. Eudel, *L'Hôtel Drouot et la curiosité* (1884), p. 334; Downes 1888, p. 501; Furst 1911, p. 134; Guiffrey 1913, pp. 540–41; Boston 1921, p. 79, no. 191; Boston 1932, ill.; Wildenstein 1933, p. 221, no. 870; Boston 1955, p. 11; Faré 1962, vol. 1, p. 164; Wildenstein 1963, pp. 208–209, no. 335; New York 1970, no. 37; Whitehill 1970, vol. 1, pp. 77–78, ill.; Cavallo et al. 1974, pl. 138, p. 206; Rosenberg, in Paris 1979, pp. 330–31, no. 119; Rosenberg 1983, p. 108, no. 168; Conisbee 1985, pp. 67–68, pl. 58; Murphy 1985, p. 49; R. Arnheim, "For Your Eyes Only," in *To the Rescue of Art* (Berkeley, 1992), pp. 69–70, fig. 10; Roland Michel 1994, pp. 175, 178, ill.

CONDITION: The plain woven fabric support has been glue-lined, with the tacking margins trimmed. The paint is applied in layers over a double ground composed of a granular, red layer below a warm gray layer. The painting has been abraded, and retouch defines the contours of the fruit and strengthens the reds in the pear.

∾

Although very abraded, the date on this painting is most likely 1764. At this point in his career, Chardin was creating modest masterpieces with ever more-simplified means. The elements here, as given in the title, are arranged seemingly at random on a ledge. Yet all are clearly thought out, so that the rounded contours of the teapot are balanced by those of the pear. The latter was an object

Chardin had painted in some of his earliest still lifes, but this white teapot (probably of English earthenware) first appears only about 1750, as for example in a still life with fruit and a bottle in a private collection.[1] The particular juxtaposition then occurs in more simplified fashion in the Museum of Fine Arts' painting and another version in the Musée National des Beaux-Arts d'Algérie, Algiers.[2] The latter had as a pendant a still life of faience and apples now in the National Gallery of Art, Washington.[3]

The Boston painting has no pentimenti, suggesting that it is a replica of the Algiers version instead of the other way around, as has usually been proposed. Also, the original tacking edges of the Boston painting have been trimmed, so that it is now about half an inch (1 cm) smaller in each dimension than the one in Algiers; originally it may have been a bit larger.

1. See Paris 1979, no. 106. A dark teapot was, however, a major feature in the *Woman Taking Tea*, in Glasgow, Hunterian Museum and Art Gallery. See Paris 1979, no. 64.

2. Wildenstein 1963, no. 247.

3. Ibid., no. 248.

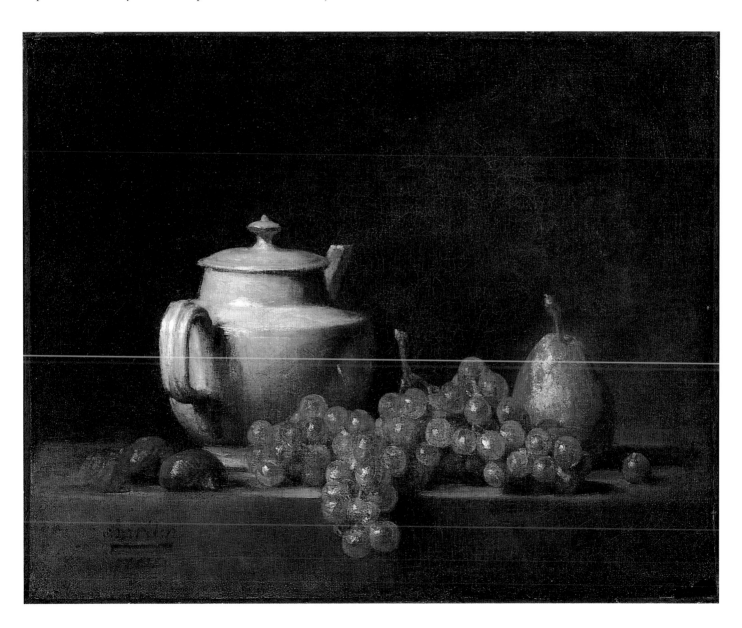

Follower of Jean-Siméon Chardin, 18th or 19th century

37. *Goblet and Fruit*

Oil on canvas
13 × 17 in. (33 × 43 cm)
Bequest of John T. Spaulding
48.526

PROVENANCE: marquis de Biron, Paris; Wildenstein, New York, 1926; John T. Spaulding, Boston.

EXHIBITION HISTORY: New York, Wildenstein Galleries, *Exhibition of Paintings by Chardin, 1699–1779*, 1926, no. 13; Cambridge, Mass., Fogg Art Museum, *Exhibition of French Painting of the Nineteenth and Twentieth Centuries*, 1929, no. 10; Museum of Fine Arts, Boston, 1931–32; Boston 1939, no. 16; Museum of Fine Arts, Boston, *The Collection of John Taylor Spaulding, 1870–1948*, 1948, no. 10; Pittsburgh 1951, no. 83; Montreal, Museum of Fine Arts, *Héritage de France*, 1961–62, no. 83 (traveled to the Art Gallery of Toronto; Ottawa, National Gallery of Canada).

REFERENCES: A. Pope, "French Paintings in the Collection of John T. Spaulding," *Art News* 28 (April 26, 1930), pp. 97, 104, ill.; P. Hendy, "The Collection of Mr. John T. Spaulding," *BMFA* 29 (Dec. 1931), p. 112; Wildenstein 1933, no. 853;

Boston 1955, p. 11; Wildenstein 1963, no. 288; Rosenberg 1983, p. 74, no. 25, ill; Murphy 1985, p. 50; Boime 1987, p. 25, ill. 1.23.

CONDITION: The composition, on three fabric sections, has been glue-lined to a secondary support. The tacking edges on the central section were flattened and canvas strips added, extending the composition by approximately four inches (10 cm) at the top and bottom. The paint is applied over a red ground, which is slightly different in color and texture on the extensions. The paint layers on the additions overlap the center section. Radiography reveals a second composition, a male portrait in a vertical orientation, on the original center section.

This is a problematic painting.[1] An X-ray (fig. 37a) has revealed that the horizontal still life composition was painted over a vertical portrait of a man of the seventeenth or eighteenth century.[2] This in itself would not rule it out as by Chardin, although very few of his works are known to have been painted over other paintings. Certain elements of this composition are comparable to those found in early works by Chardin, most notably the grouping of plums and the goblet, but here it is gilded rather than silvered, as is usually the case. In general, the touch seems less delicate and the color bolder than that of authentic Chardins, but as Pierre Rosenberg has specu-

Fig. 37a.
X-ray of cat. 37

lated, it may be "a question of an original painting modified and 'arranged' due to its state of preservation in the nineteenth century."[3] In this regard it is worth noting that it is this type of composition, with the goblet and grapes, that was often employed by nineteenth-century French painters inspired by Chardin. See, for example, a comparable Bonvin in Glasgow and an anonymous nineteenth-century French still life with artichokes in the National Gallery, London.[4] Gabriel Weisberg has suggested that the Museum of Fine Arts' painting might be by another nineteenth-century Chardiniste, Philippe Rousseau.[5]

1. In a letter of November 9, 1978, the dealer and scholar David Carritt wrote, "It is a puzzling picture, but I cannot dismiss it altogether, at least until I have had a good look at it. Sadly I did not have the time to study it further." Paintings Department files.

2. Rosenberg describes the portrait as "seventeenth century," but Joseph Baillio, in conversation, has stated that it could be eighteenth century.

3. Rosenberg 1983, p. 74.

4. See Gabriel P. Weisberg and William S. Talbot, in Cleveland Museum of Art, *Chardin and the Still-Life Tradition in France* (Cleveland, 1979), p. 37, ill. 33.

5. Verbal opinion of 1979, in the Paintings Department files.

PIERRE-HUBERT SUBLEYRAS
1699–1749

Pierre-Hubert Subleyras's father, a painter at Uzès, sent his son to be trained in the studio of Antoine Rivalz at Toulouse. Subleyras soon became a collaborator with Rivalz on various works, including a depiction of the coronation of Louis XV. Having mastered the painting of religious subjects as well as portraiture, in 1726 Subleyras was ready to move to Paris. The next year, at the age of twenty-eight, he won the Grand Prix for his *Brazen Serpent* (Paris, Louvre). This allowed him to go to Rome, where he was to live the rest of his life. His first residence was at the French Academy in the Palazzo Mancini. The painter Nicolas Vleughels set Subleyras to copying works by Raphael, the Carracci, and Pietro da Cortona. Through the intercession of the Princess Pamphili and the duchess of Uzès, Subleyras received an extension of his stay. Settling in Rome, he received several important commissions, including a *Descent of the Holy Spirit* for the duc de Saint-Aignan now in the Musée de la Légion d'Honneur, Paris, and, for the refectory of the Ordine di San Giovanni Laterano, an enormous *Christ in the House of Simon* (Paris, Louvre) in 1735, which won him great fame.

In 1739 he married the miniature painter Felice Maria Tibaldi, the daughter of a well-known musician and sister-in-law of the painter Pierre-Charles Tremolière, who had gone to Rome in 1728. Presumed portraits of his wife are in the Worcester Art Museum and the Walters Art Gallery. Cardinal Valenti Gonzaga, a counselor of the pope, became Subleyras's protector and was the first in a line of important sitters—culminating with the pope—who made Subleyras one of the most fashionable portrait painters in Rome.

Commissions for religious paintings continued to come from both France and Italy. In 1741 he painted a *Holy Family* for the church of Saint-Etienne in Toulouse. Probably his most famous works were two 1744 altarpieces for the Olivetan church of Monte Morcino Nuovo in Perugia: *Saint Benedict Reviving a Peasant* (Rome, Sta. Francesca Romana) and *Saint Ambrose Absolving Theodosius* (Perugia, Galleria Nazionale dell'Umbria). In his final year, he was most occupied with the completion of a *Mass of Saint Basil* for St. Peter's, which was executed in mosaic. Subleyras painted a self-portrait (Vienna, Akademie) of disarming directness, and, although a master of the classical tradition, he could also create genre compositions of great vitality and humor.

38. *Brother Philippe's Geese*

39. *Brother Luce, the Hermit, with the Widow and Her Daughter*

Oil on canvas
Each 11 1/2 × 8 3/4 in. (29.5 × 22 cm)
Gifts of Colnaghi USA, Ltd.
1983.593 and 1983.592

PROVENANCE: Baron Beyens, Brussels, by about 1920; (Cat. 38): sale Sotheby's, London, July 8, 1981, no. 4; (Cat. 39): sale Sotheby's, London, December 10, 1980, no. 6; both acquired by Colnaghi's, London and New York, and presented to the Museum in 1983.

EXHIBITION HISTORY: Paris 1987, nos. 20 and 24 (traveled to Rome, Villa Medici).

REFERENCES: Murphy 1985, p. 272; P. Rosenberg and Michel, in Paris 1987, pp. 173, 177, 179–81.

CONDITION: (Cat. 38) The plain woven fabric support is unlined on its original stretcher and has a repaired tear at the proper left elbow of the standing figure. The paint is fluidly applied over a yellow ground. The picture is in very good condition, although the pigments have faded over time, which obscures the definition of the figures painted over the dark background. (Cat. 39) The plain woven fabric support is unlined on its original stretcher. The paint is fluidly applied over a red ground and is in very good condition.

Fig. 38a. Pierre Subleyras, *Brother Philippe's Geese*. Oil on canvas. Paris, Musée du Louvre, inv. no. 8009. (© Photo R.M.N.)

Subleyras painted a number of scenes based on the fables compiled by the seventeenth-century writer La Fontaine. One set of four of these *Fables* was apparently commissioned in 1732 by the duc de Saint-Aignan, the French ambassador in Rome from 1723 to 1741.[1] Of these works, recorded in prints by Jean-Baptiste-Marie Pierre, *The Geese of Brother Philippe*, *The Hermit, or Brother Luce*, and *The Falcon* are now in the Louvre, and the fourth of this set, *The Amorous Courtesan*, is in a private collection and promised to the Louvre. Two other La Fontaine fables by Subleyras, *The Pack Saddle* and *The Mare of Godfather Pierre*, are in the Hermitage, St. Petersburg.[2] The intimate scale of these racy subjects undoubtedly contributed to their popularity, and Subleyras seems to have produced not only individual replicas but also a variant set, of which the Boston pair forms a part. This set, with its variations, is probably a bit later than 1745.

The story "The Geese of Brother Philippe" was taken by La Fontaine from Boccaccio's *Decameron*.[3] Brother Philippe, a widower, became a hermit to raise his only son in isolation from the evils of civilization. Eventually, however, the young man was taken by his father to a nearby town and was immensely curious about everything he saw, especially a group of finely dressed young women. Never having seen one before, he asked his father what they were and was told, "It's a bird—called a goose." To this the son, who was strangely attracted to these novel creatures, replied, "Couldn't we take one home and fatten it up?" There are a great many differences between the Louvre's version (fig. 38a) and Boston's. The former's is set before monumental fragments of a city

with arches and columns, while the buildings in the Boston work are distinctly more humble. Although the poses of the father and son remain the same, the types are somewhat changed. In the Louvre's painting the boy looks quite simple-minded. In the Boston version he is more attractive, and the father is more sympathetic— bareheaded, bent, and carrying a large straw basket on his arm.

The most notable difference, however, is the look of the "geese." The gaggle of four ladies in the Louvre painting are generalized types, whereas the three in the Boston painting seem much more specific, especially the standing woman in an elaborate white dress, who looks directly out at the viewer. This figure has indeed been identified as a portrait of Virginia Parker Hunt, the wife of the painter Joseph Vernet. She was also depicted on other occasions by Subleyras.[4]

The other painting in Boston is devoted to La Fontaine's fable "Brother Luce," the tale of a lecherous hermit who became enamored of a poor maiden, the daughter of a widow. In order to possess her, the hermit pretended to speak with the voice of God, encouraging the mother and daughter to give the girl to him so that their union would produce a future pope. The young woman became pregnant but, because she enjoyed her encounters with the hermit, concealed the fact for seven months; when the child was finally born, however, it proved the falsity of her mother's hopes—for it was a girl.

Pierre-Hubert Subleyras

When Boucher treated the subject he chose to show the figures of the mother and daughter making their way to the hermit through a broad landscape.[5] Subleyras instead depicts a moment from early in the story, when the hermit in his cell reacts with feigned shock at the mother's proposal that he become intimate with her daughter. Again the Boston and Louvre treatments differ. Other versions of the Louvre composition (fig. 39a) are at Nantes (Musée des Beaux-Arts), Zurich (Kunsthaus), and one formerly on the art market. The Boston version has greater psychological impact. The position of the mother's hand has been changed so that it looks less like a curse and more like a welcome. The pile of books at the lower right corner of the Louvre painting is eliminated and to the rock ledge above has been added the evilly smiling skull that adds a macabre tone. The evidence for the two versions being created about the same time—but with the Boston one later—is a drawing in the Louvre. Although it shows the two women in the poses they assume in the Louvre version, it also includes in the lower corner a sketch showing the alternative gesture given to the mother in the Boston version.[6] Another drawing at Montpellier is a study of the hermit as he appears in the Boston painting.[7] Such attention to detail indicates that, although small, these were certainly important commissions that the artist carefully refined to please his patrons.

Fig. 39a. Pierre Subleyras, *The Hermit, or Brother Luce.* Oil on canvas. Paris, Musée du Louvre, inv. no. 8011 (© Photo R.M.N.)

1. Rosenberg and Michel, in Paris 1987, pp. 173–74.

2. Ibid.

3. The subject was also depicted by Fragonard, Vleughels, Lancret, and Boucher; ibid., p. 175. See New York 1986, pp. 105–108, no. 7, and also Musée du Petit Palais, *Fragonard et le dessin français au XVIIIe siècle* (Paris, 1992), pp. 195–96, and 228.

4. Rosenberg and Michel, in Paris 1987, p. 185.

5. New York 1986, pp. 208–10, no. 45.

6. Rosenberg and Michel, in Paris 1987, p. 180, no. 21.

7. Ibid., p. 181, no. 22.

FRANÇOIS BOUCHER

1703–1770

Beginning in 1728, François Boucher spent three years in Italy, in and out of the company of Carle, François, and Louis van Loo, Charles Natoire, and Nicolas Vleughels. He also studied the works of the Italian baroque artists Castiglione and Pietro da Cortona. Boucher returned to Paris in 1731 and was *agréé* by the Académie royale de peinture et de sculpture. He was *reçu* as a history painter in 1734 for his *Rinaldo and Armida* (Paris, Louvre) and was appointed professor in 1737. He exhibited in all genres at the Salons from the mid-1730s until 1769. After 1735, under the pa-

tronage of Madame de Pompadour, Boucher became the leading decorator of royal palaces and private residences. He enjoyed immediate success with the first of his many designs for tapestries, the *Fêtes italiennes*, produced by the Beauvais manufactory in 1736. In 1755 he was appointed director of the tapestry works at Gobelins. Boucher also contributed designs to the Sèvres and Vincennes porcelain factories, created book illustrations, and designed theatre and opera sets. In 1765 Boucher was appointed director of the Académie and *Premier peintre du Roi*.

CAT.
40

40. *Young Woman with Flowers in Her Hair*

Oil on canvas
22 3/8 × 18 1/8 in. (57 × 46 cm)
The Forsyth Wickes Collection
65.2637

PROVENANCE: Bacqua, Nantes; sale Hôtel Drouot, Paris, February 18, 1873, no. 23 (as *Portrait de la femme de l'artiste*); Baron Nathaniel de Rothschild, Vienna; château La Joutenir, Charente (?); Wildenstein and Co., New York, by 1936; purchased December 4, 1944, by Forsyth Wickes.

EXHIBITION HISTORY: Paris, Galerie Cailleux, 1964, *François Boucher*, no. 31; Tokyo 1982, no. 10.

REFERENCES: Michel 1906, p. 56, no. 1019; "Masterpieces in the Art Market, Part I, the Old Masters," *Art News* 35, no. 11 (Dec. 19, 1936), p. 14, ill., pp. 24–25; Ananoff and Wildenstein 1976, vol. 1, p. 240, no. 109, fig. 428; Murphy 1985, p. 28 (as *Portrait of a Woman* [Madame Boucher?]); A. P. Wintermute, in New York 1985–86, p. 127, no. 6; Zafran, in Munger et al. 1992, pp. 64–65, no. 1.

CONDITION: The oval fabric support has been glue-lined, with the tacking margins trimmed. The paint layer is over a cool gray ground and is in excellent condition. Discrete areas of in-painting are confined to small spots in the figure's hair, cheeks, and breast.

Although in the past the sitter has been identified as the painter's wife,[1] such a claim is difficult to verify.[2] This figure may be an idealized type based on the artist's wife, but it is not a portrait. As Denys Sutton has pointed out,[3] a similar woman is depicted in the *Lady with a Fan* (Buenos Aires, private collection),[4] and there are other examples of oval paintings depicting young girls, often with flowers and more than a hint of eroticism, attributed to Boucher.[5] This work, with its rich, painterly touch, was dated to the mid-1730s by Alexandre Ananoff; Donald Posner has suggested it is from the 1740s,[6] but Alastair Laing, writing that he finds the work "borderline" Boucher, believes it "is probably a work of his old age."[7]

1. In both the Bacqua sale catalogue and in Ananoff and Wildenstein 1976.

2. The only certain existing portrait of Madame Boucher is that of 1761 by Alexandre Roslin in the Musée de Versailles (see Ananoff and Wildenstein 1976, vol. 1, p. 91). The reclining woman in the Frick Collection was long believed to be a portrait of Madame Boucher. See *The Frick Collection: An Illustrated Catalogue. Vol. II, Paintings* (New York, 1968), pp. 3–6. For discussions of this problem, none of which mention the Boston painting, see R. Shoolman Slatkin, in Stair Sainty Matthiesen, *François Boucher: His Circle and Influence* (New York, 1987), pp. 10–13; A. Laing, in New York 1986, pp. 216–20; J. Cailleux, "Who Was Boucher's Best Beloved?" adv. suppl. in *TBM* 108, no. 755 (1966), pp. i–vi.

3. In Tokyo 1982, p. 225.

4. Ananoff and Wildenstein 1976, vol. 1, no. 110.

5. See those sold from the Lehmann collection, Galerie Georges Petit, Paris, June 8, 1925, no. 190, and one from the Stern collection, American Art Association, New York, April 4–7, 1934, no. 838. Drawings of the theme were sold at the Hôtel Drouot, Paris, April 20–21, 1883, no. 9, and March 18–23, 1901, no. 170.

6. In a letter of May 15, 1990, in the Paintings Department files.

7. In a letter of August 16, 1992, in the Paintings Department files.

41. *Shepherd Boy Playing Bagpipes*, about 1754

Oil on canvas
21 3/4 × 19 5/8 in. (55.2 × 49.8 cm)
Given in Memory of Governor Alvan T. Fuller by the Fuller Foundation
61.958

PROVENANCE: Baron Adolphe de Rothschild, Paris, d. 1900; Vicomte Jacques de Causon, Paris; S. J. Frank, New York; William Salomon, New York, d. 1919; Mrs. William Salomon, New York; sale American Art Association, New York, April 5, 1923, no. 381; Otto Bernet, agent, possibly for Governor Fuller; Alvan T. Fuller, Boston, d. 1958; Fuller Foundation, Boston, 1958–61.

EXHIBITION HISTORY: Boston, The Boston Art Club, *Fuller Collection*, 1928, no. 1; Boston, Museum of Fine Arts, *Memorial Exhibition of the Collection of the Honorable Alvan T. Fuller*, 1959, no. 12; Palm Beach, Fla., The Society of the Four Arts, *Paintings from the Collection of Alvan T. Fuller*, 1961, no. 8; Springfield, Mass., Museum of Fine Arts, *Masterpieces by François Boucher from New England Museums*, 1984; Tokyo 1990, no. 21.

REFERENCES: Michel 1906, p. 87, no. 1558; Ananoff and Wildenstein 1976, vol. 2, p. 125, under no. 437 (as a copy of a lost original); Slatkin 1979, pp. 122–23, fig. 85; Standen 1981, pp. 18–19, ill.; E. A. Standen, *European Post-Medieval Tapestries and Related Hangings in the Metropolitan Museum of Art* (New York, 1985), vol. 1, pp. 406–407; A. P. Wintermute, "Inventory," in New York 1985–86, p. 127, no. 7; Murphy 1985, p. 28; A. Faÿ-Hallé, "The Influence of Boucher's Art in the Production of the Vincennes-Sèvres Porcelain Manufactory," in New York 1986, p. 354; Standen 1994, pp. 120 and 131.

CONDITION: The plain woven fabric support has been lined and the tacking margins trimmed, and there are indications that it is now slightly smaller than the original size. The paint layer is applied thinly over an extremely grainy, warm-gray ground and has all-over pinpoint losses.

Boucher painted a number of playful, young shepherd or peasant figures that served as the basis for decorative schemes in tapestry, porcelain, and prints. Such is the case of this work, of which at least one other painted version exists.[1] Two prints that reverse the composition are also known. Boucher himself, according to the inscription on one of the prints, had begun the etching of one of these, and the work, which was completed by Antoine Aveline, was published with the title *Innocence*.[2] The other, engraved by Demarteau l'Aîné, with the date 1770, gives the information that it was done after a drawing by Boucher in the collection of Monsieur de Grandcourt.[3] A drawing in the same direction as the Boston painting but probably by a follower of Boucher was recently sold at auction.[4] The dog alone appears in a drawing at the Courtauld Institute. The image also served for one of the series of small Gobelins tapestries known as *Boucher's Children*;[5] surviving examples of these in screen form are in the Dodge collection at the Detroit Institute of Arts and the Carnegie Institute.[6] Others, with the design reversed, in the form of a chair back include one sold at auction and one in the collection of the Metropolitan Museum of Art.[7] Related to the latter is a gouache drawing, which is also in the Metropolitan.[8] Cotton textiles from Nantes that use this design are known.[9] Finally, it also served as the basis for a porcelain figurine[10] and an enameled design on a snuffbox, which transfers the scene to an interior.[11]

Alexandre Ananoff classified the Boston painting as a copy (os-
tensibly after a lost original).[12] However, Regina Slatkin countered
that there was "no valid reason for labelling the *Shepherd Boy* a copy
and claiming that the original engraved by Aveline and Demarteau
has disappeared."[13] J. Patrice Marandel concurs, writing, "There is
indeed no reason to reject this painting from Boucher's oeuvre of
the mid-1750s."[14] A certain lack of brilliance in the painting may in

fact be due to its condition. When cleaned, it was found that the
surface was pitted and had suffered greatly. Perhaps this was the
result of its heavy service in the artist's studio. In correspondence
and a recent article, Edith A. Standen has indeed suggested that the
painting might be an actual *modèle*, or cartoon, like Ananoff num-
bers 438–43.[15] Alastair Laing, in correspondence, has pointed out,
however, that, "the weaving of tapestries from the designs by no

means presupposes that it was Boucher who worked up the painting that the cartoon was made from—rather the opposite."[16]

The simple charm of the painting remains evident. The young shepherd calms and delights the animals by playing on the bagpipe, or musette, an instrument that had a long pastoral connotation in French and Dutch art.[17] The motif of the dog dancing on its hind legs was adapted by Boucher's student, the young Fragonard (q.v.), for one of his series of youthful professionals: *The Little Teacher* (Cholet, Musée des Beaux-Arts).[18]

1. Ananoff and Wildenstein 1976, vol. 2, p. 125, lists three, which sold in 1889, 1891, and 1892 respectively. One wonders if this was not the same painting reappearing and may even be the Boston painting before it entered the Rothschild collection. The fifth version given by Ananoff was one on the Paris art market at the time of his writing. A copy was incorporated into a set of screens sold at Christie's, London, July 10, 1987, no. 144.

2. Jean-Richard 1978, p. 77, no. 196.

3. Ibid., pp. 207–208, no. 780. Gilles Demarteau also produced a version in horizontal format with the boy seated; Jean-Richard 1978, p. 215, no. 813.

4. Sale Christie's, London, April 16, 1991, no. 61.

5. See M. Fenaille, *Etat général des tapisseries de la manufacture des Gobelins* (Paris, 1907), vol. 4, p. 405, and J. Badin, *La Manufacture de tapisseries de Beauvais . . .* (Paris, 1909), pp. 68–70.

6. Detroit Institute of Arts, acc. no. 71.181. For the Carnegie version (acc. no. 71.44), see Standen 1981, p. 18.

7. Christie's, London, December 1, 1966, no. 95; F. Little, "Textiles from the Elsberg Collection," *Bulletin of the Metropolitan Museum of Art* 34, no. 6 (June 1939), p. 142.

8. Acc. no. 28.104.

9. H. R. d'Allemagne, *La Toile imprimée* (Paris, 1942), vol. 2, pl. 82; also on a Beautiran piece at the Metropolitan, acc. no. 38.182.6.

10. *The Bagpipe Player*, for which see New York 1986, p. 353, no. 96.

11. See H. Nocq et C. Dreyfus, *Tabatières, boîtes et étuis . . . du Musée du Louvre* (Paris, 1930), pp. 18–19, no. 54, pl. xxxi.

12. Ananoff and Wildenstein 1976, vol. 2, p. 437.

13. Slatkin 1979, p. 123.

14. J. P. Marandel, in Tokyo 1990, p. 168.

15. In a letter of November 20, 1991, in the Paintings Department files, and Standen 1994, p. 120. The measurements of these other children compositions are quite close to the Boston painting.

16. In a letter of March 18, 1993, in the Paintings Department file.

17. See R. D. Leppert, *Arcadia at Versailles* (Amsterdam and Lisse, 1978), pp. 7–11, 35–37, 66–72.

18. See P. Rosenberg, *Tout l'oeuvre peint de Fragonard* (Paris, 1989), p. 75, no. 39.

42. *Halt at the Spring*, 1765

Oil on canvas
82 1/8 × 114 1/8 in. (208.5 × 290 cm)
Signed and dated center right, on pedestal of vase: *FBoucher 1765*
Gift of the Heirs of Peter Parker
71.2

43. *Return from Market*, 1767

Oil on canvas
81 1/4 × 113 in. (206.4 × 287 cm)
Signed and dated lower left, on stone: *F Boucher 1767*
Gift of the Heirs of Peter Parker
71.3

PROVENANCE: Bergeret de Grancourt, Paris, by 1769;[1] his estate sale, Hôtel de M. Bergeret, Paris, April 24, 1786, no. 47; sale Beurdley, Paris, December 21–22, 1846, nos. 1 and 2; Mr. and Mrs. Edward Preable Deacon, Boston; inherited by Mrs. Deacon's father, Peter Parker; sale Boston, February 1–3, 1871; Mr. Franklin, for the heirs of Peter Parker.

EXHIBITION HISTORY: (Cat. 42) Paris, Salon of 1761, as one of no. 9. (Cat. 43) Paris, Salon of 1769, no. 1; New York 1970, no. 41; Boston 1984, no. 15. (Cats. 42 and 43) Boston, Athenaeum, *Exhibitions of Paintings for the Benefit of the French*, 1871, no. 5; Boston, Athenaeum, *Forty-eighth Exhibition of Paintings*, 1871–72, no. 97; Boston 1993.

REFERENCES: *Catalogue of the Collection of Ancient and Modern Works of Art Given or Loaned to the Trustees of the Museum of Fine Arts, at Boston* (Boston, 1872), p. 31, nos. 353 and 354; *First Annual Report of the Committee on the Museum of Fine Arts* (Boston, 1873), p. 11, no. 5; E. de Goncourt and J. de Goncourt, *L'Art du dix-huitième siècle* (Paris, 1880), p. 184; Downes 1888, p. 501; G. Kahn, *Boucher* (Paris, 1904), p. 123; P. de Nolhac, *François Boucher* (Paris, 1907), p. 161; Guiffrey 1913, pp. 538–40; Boston 1921, pp. 75–76, nos. 179 and 180; Boston 1932, ill.; Boston 1955, p. 7; Randall 1961, p. 39; Watson 1966, vol. 1, p. XXVI; Seznec and Adhémar 1967, vol. 4, pp. 15–16, 67–69; Whitehill 1970, vol. 1, pp. 18–19; P. Rosenberg 1972, p. 139; R. S. Slatkin, in Washington 1973, pp. xv–xvii, 14; Cavallo et al. 1974, pp. 20, 196, pl. 110; Ananoff and Wildenstein 1976, vol. 1, pp. 93–96, 123–25, 128 and 133, vol. 2, pp. 283–88, nos. 660 and 661; Wildenstein Galleries, *François Boucher: A Loan Exhibition for the Benefit of the New York Botanical Gardens* (New York, 1980), p. 32; E. M. Bukdahl, *Diderot critique d'art: Théorie et pratique dans les Salons de Diderot* (Copenhagen, 1980), pp. 1, 52–53, 57–58, 187, 246, and 259, fig. 3; Virginia Museum of Fine Arts, *Three Masters of Landscape: Fragonard, Robert, and Boucher* (Richmond, Va., 1981), p. 52, fig. 10; Tokyo 1982, p. 27; G. Brunel, "Boucher neveu de Rameau," in Paris 1984, pp. 102–103, ill. pp. 104 and 105; Musée du Breuil de Saint-Germain, *Diderot et la critique de Salon, 1759–1781* (Langres, 1984), p. 42; Murphy 1985, p. 27; G. Brunel, *Boucher* (New York, 1986), pp. 273, 290–91, ill. p. 183, fig. 149; New York 1986, pp. 33, 36, 306, and 307, fig. 194–95; P. Rosenberg and M. Hilaire, Boucher: *60 chefs-d'oeuvre* (Bienne, 1986), no. 56; Stebbins and Sutton 1986, p. 53; Rosenberg and Stewart 1987, p. 112, figs. 3 and 4; W. M. Brady & Co., *Old Master Drawings* (New York, 1990), under no. 21, fig. 4; Neale 1994, p. 4.

CONDITION: (Cat. 42) Originally the painting was smaller, consisting of two vertical pieces of fabric joined at the center by a seam. Boucher later added the top and sides. The painting has been glue-lined. The flatly applied paint layer covers a light pinkish-tan ground. The extensions no longer match the central portion, being paler than the rest of the painting. Many artist's changes are visible with raking light and in X-radiographs. The painting is abraded and paint is lost throughout. A large damage is in the lower right on the log. Some of the damages along the seams have been in-painted. (Cat. 43) The original fabric support, composed of two pieces joined horizontally, has been glue-lined to a secondary fabric, with the tacking margins extended. There are several old, repaired tears in the canvas. The flatly applied paint layer covers a light-gray ground. Numerous changes in the arrangement of the figure are evident. The painting is in good condition with discrete in-painting covering minor scattered losses.

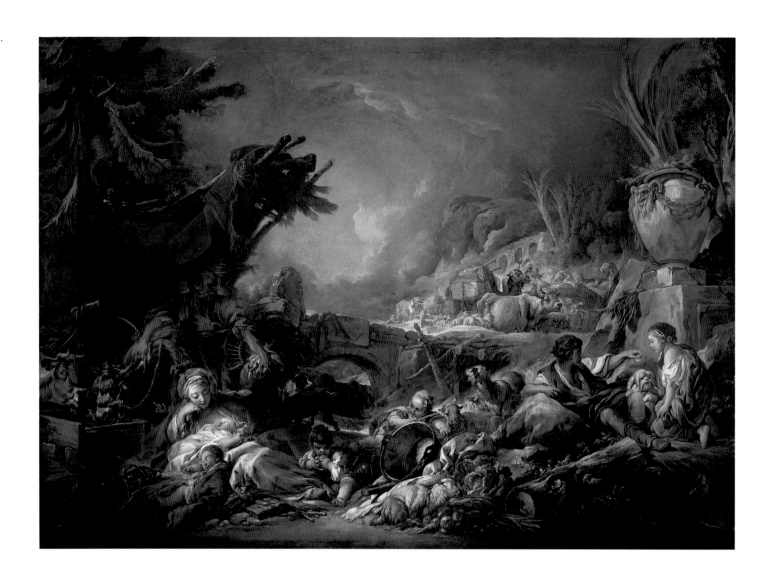

This grandiose pair of paintings represents the summit of Boucher's art in the depiction of peasants and shepherds, which had long been among his chief subjects. The two works were actually created over a period of several years, beginning with one painting of smaller dimensions devoted to a religious subject. Thus we can but marvel at Boucher's disregard for specific subject matter, his fertile imagination, and his stupendous bravado that allowed him, even in old age, to create such large and brilliant works.

At the Salon of 1761 Boucher exhibited six paintings identified simply as "Pastorals and Landscapes."[2] Fortunately, as Casimir Stryienski first pointed out, the appearance of these works was recorded by Gabriel de Saint-Aubin in the tiny sketches he made in his copy of the Salon *livret*.[3] It was Alexandre Ananoff, however, who brilliantly perceived that the large composition depicted by Saint-Aubin (fig. 42a), showing trees, a seated woman, and a bridge to the left, children and a tipped-up pot in the center, and a large cow at the right was the Boston painting in an earlier stage. This painting has had clearly visible strips added at the sides and the top, changing its proportions from those seen in Saint-Aubin's sketch. As Ananoff noted and as can be observed with the naked eye, the cow has been painted out and replaced with a selection of other animals and a peasant genre scene of a young man and woman

playing with a dog, quite similar to the grouping that appears in Boucher's 1768 painting *Obedience Rewarded*.[4] The added strip at the right edge contains not only the female peasant but a large urn on a pedestal, which bears Boucher's signature and the date 1765.

It is evident, therefore, that Boucher reworked his composition between 1761 and 1765, but X-ray examination, as well as detailed study of the surface, indicates that the painting had already been altered before being shown at the 1761 Salon. Most notably, a large palm can be seen in the sky at the right, and the seated woman, instead of looking down, looked across to her left (fig. 42b). Again, as Ananoff rightly suggested, the work had all the features of a Rest of the Holy Family in Egypt. In fact its original proportions and scale make it comparable to the *Rest in Egypt* now in the Hermitage, St. Petersburg, which was supposedly painted for Madame de Pompadour and shown *(hors catalogue)* in the Salon of 1757.[5] In that picture the Virgin and Child are seated at the left and the powerful figure of St. Joseph is at the center. One wonders if the Boston painting was not originally a larger alternative version done for the pleasure of La Pompadour. Since detailed contemporary descriptions are lacking, it is not clear which version was shown at the Salon. In any case, Boucher was not to let such a large canvas go for naught and made the conversion to the secular subject shown in 1761.

Among the other works identified as exhibited by Boucher in 1761 are *Sleeping Bacchantes Surprised by a Satyr* (London, Feather Collection) and a *Jupiter and Callisto* (Private collection).[6] But as Diderot's review makes clear, it was the large *Pastorale* that received the most attention:

What colors! what variety! what richness of objects and of ideas! This man has everything except truth. There is no part of his compositions which, separated from the others, will not please you; even the totality seduces you. One asks oneself: But where has one seen shepherds dressed with such elegance, such luxury? What subject has ever gathered together in the same place in the middle of the countryside, under the arches of a bridge, far from any habitation, women, men, children, oxen, cows, sheep, dogs, bundles of straw, water, fire, a lantern, chafing dishes, pitchers, cauldrons? What is this charming woman doing there, so well dressed, so neat, so voluptuous? and these children playing and sleeping, are they hers? and this man who carries some fire that he seems about to empty on her head, is he her husband? What does he wish to do with the lighted coals? Where did he find them? What an uproar of disparate objects! One senses how absurd it all is; but nevertheless one cannot leave the painting. It grips you. One returns to it. It is such an agreeable vice, it is an extravagance so inimitable and so rare. In it there is so much imagination, effect, magic, and fluency.

When one has studied for a long time a landscape such as that which we have described, one might think one has seen everything. But one would be mistaken; one finds here an infinity of things of such value! . . . No one understands like Boucher the art of light and of shade. He is destined to capture the attention of two sorts of people—men of the world and artists. His elegance, his delicacy, his romanesque galantry, his coquetry, his taste, his fluency, his variety, his brilliance, his

rouged complexions, his debauchery, ought to captivate young fops, little women, young people, men and women of the world, the mass of those who are strangers to true taste, to truth, to proper thinking, to the severity of art.[7]

A published Salon review, the *Observations d'une Société d'amateurs*, described the painting in the following manner: "This piece, whose background is a landscape in which almost all possible sites are combined without too much of a sense of strangeness, also contains a multitude of figures of every age, every sex, every character, and an infinity of fruits and utensils. As unfortunately the result of this assemblage is no specific subject, this painting can only have a mediocre interest for the public. It is nevertheless, in the opinion of all connoisseurs, a rich representation of all the best principles of art. One can therefore regard it as an admirable Guide to Painting, enriched by the best examples of all the parts of which it is composed."[8]

Two other reviews made telling observations on the work. The *Avant-Coureur* noted "the great pastorale placed near the staircase where all the richness of his [Boucher's] color is deployed, but one finds in the foreground a woman holding a baby who looks too much like his Virgin. Great men ought to repeat themselves less than others, otherwise this piece is of the greatest beauty and is not at all beneath the reputation of this master."[9] The similarity of the woman and sleeping child to the Virgin and slumbering baby Jesus in the *Sleep of the Infant Jesus* shown at the Salon of 1759 is quite evident.[10] The *Mercure de France* commented that "with regard to his [Boucher's] great landscape, it is treated in the manner of Benedette [Castiglione]."[11] This similarity to the Italian painter Castiglione will prove a telling comparison when it comes to the later pendant.

Despite the generally favorable reception of his painting, Boucher, as we have seen, decided to alter and expand the composition. The role of the large man, ostensibly the former Saint Joseph,

Fig. 42a. Gabriele de Saint-Aubin, sketch in 1761 Salon *livret* of a *Pastorale*. Paris, Bibliothèque Nationale, Cabinet des Estampes (Reproduced from Ananoff 1966, vol. 1, fig. 132)

Fig. 42b. X-ray detail of cat. 42

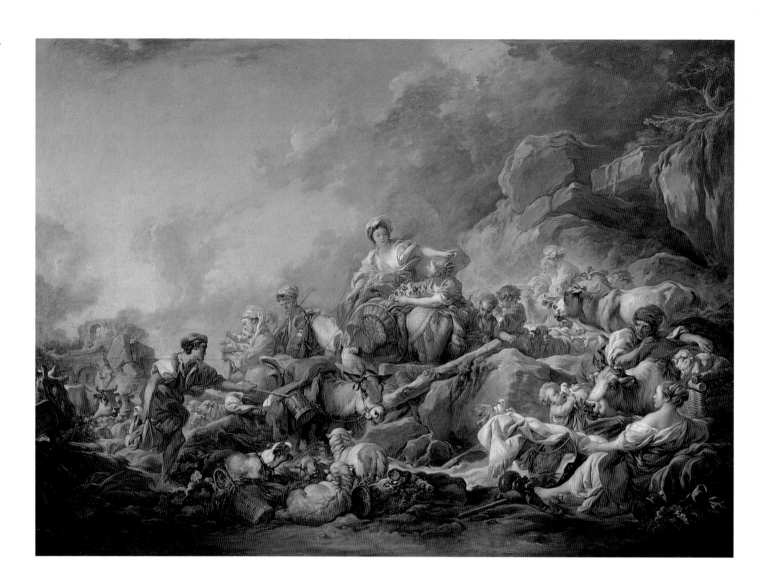

carrying hot coals that so puzzled Diderot, was changed. Now he holds the donkey with one hand and grasps the bundles with the other, in fact recalling the Saint Joseph in the Hermitage painting. The finished work of 1765 also shares many elements found in paintings, drawings, and prints of Boucher's later years. The children playing with a dog, as seen in his 1768 painting, have already been mentioned. The dancing dog also appeared in *The Puppy's Dance* of 1758.[12] The copper pot turned upward is a detail frequently found in the painter's pastoral scenes.[13] The large urn in the added strip at the right appears several times in both drawings and paintings, often with additional decoration.[14] The rough-hewn tent with a large projecting beam and draped blankets that seems to act as a shelter behind the woman and children is seen in a print, *Rest in the Countryside*, after a drawing that was in the Bergeret collection.[15] The slumbering child, a charming detail that Boucher used variously for peasant children and for the infant Jesus, is, according to Regina Slatkin, based on studies Boucher made of his own sleeping children; one of the most notable is in the Museum of Art, University of Michigan.[16]

In 1767, two years after completing the alterations on this large painting, Boucher signed and dated a pendant of equal size.[17] This in turn was exhibited at the Salon of 1769 and was Boucher's only showing that year, the last he was ever to make. In the Salon *livret* it was titled *Bohemians Walking, or a Caravan in the Manner of Benedetto di Castiglione*. Once again a sketch of the composition was made at the Salon by Saint-Aubin (fig. 43a), who also noted the name of the owner.[18] It was owned by the immensely rich *receveur général des finances* Bergeret de Grancourt, who formed a remarkable collection.[19] The catalogue of his estate sale clearly described both large paintings that sold together as one lot. It would seem likely that it was Bergeret for whom the earlier composition was enlarged and who later commissioned the pendant. He had been to Italy for the first time in 1762[20] and may well have developed there a taste for large-scale decorative works in the style of Castiglione. Paintings by or in the manner of this Italian master were already very popular in eighteenth-century France.[21] Boucher in particular had long found inspiration in Castiglione,[22] and many elements in this large homage clearly derive from this Italian precursor. Most notable are the woman on horseback near the center of the composition, the *mélange* of animals—goats, cows, and sheep—arranged in a zigzag pattern, and the sweeping landscape backdrop. The bit of a cavern or ledge at the right, however, reminds one more of Salvator Rosa, another Italian seicento painter popular in France.[23]

Boucher prepared for this major painting with a number of

preliminary studies. The most elaborate is a chalk drawing now in the Nelson-Atkins Museum of Art, Kansas City (fig. 43b).[24] Another study without the cow or parasol, but with a donkey, is closer to the painting and was in Bergeret's collection (fig. 43c).[25] As in the earlier pendant, a number of typical Boucher figures appear. The mother and child seated on the donkey at the left are similar to figures in an oval painting in San Francisco,[26] and the woman in profile at the lower right corner is found in a *Saint John Preaching*.[27]

In his review of the 1769 Salon, Diderot wrote at length on this painting. He had not always been sympathetic to Boucher, but now the philosopher-critic, who may actually have written his comments in 1770, when the painter was dying or deceased, praised him effusively, perhaps recognizing that they were both relics of a disappearing age:

> The old athlete has not wished to die without showing himself one last time in the arena; I mean Boucher. Exhibited by this artist was a *Marche de Bohémiens*. . . . In it one still remarked fecundity, facility, and energy; I was even surprised that there wasn't more, for the old age of sensible men degenerates into babbling, platitudes and imbecility; and the old age of madmen tends increasingly towards violence, extravagance, and delirium. Oh what an insufferable old man I will be if God grants me life!
>
> One could have placed beneath this painting one of those scamps that one sees at the entrance to fairground games; he would have cried, "Come near gentlemen, it is here that you will see the great showman. . . ." Do you like figures? They were there in profusion, there were also horses, donkeys, mules, dogs, birds, flocks, mountains, buildings, a multitude of accessories, a prodigious variety of actions, draperies and accouterments. It was the greatest crush that you have ever seen in your life.
>
> But this disorderly crowd formed a fine, picturesque composition. The groups were linked and distributed with intelligence; between them a well-conceived chain of light prevailed; the accessories were skillfully arranged and rendered with good taste, nothing felt forced, the brushstrokes were bold and lively; one sensed everywhere the great master; the sky above all warm, light, true, was full of enthusiasm and sublimity.[28]

When this pair of paintings was sold with Bergeret de Grancourt's collection in 1786, they were described as possessing "a choice and a taste to which one cannot refuse one's admiration, with contours full of grace; a suave color and a perfect harmony are the brilliant qualities which will cause them always to be regarded as two of the finest works by the master."[29] At this sale the works were bought in and, having fortunately survived the Revolution, do not appear again until a Parisian sale in 1846. Again praise was lavished on them:

> We do not know any works by Boucher superior to these and we have not yet seen any that may be compared to them, care-

Fig. 43a. Gabriele de Saint-Aubin, sketch in 1769 Salon *livret* after cat. 43. Paris, Bibliothèque Nationale, Cabinet des Dessins. (Reproduced from Ananoff and Wildenstein 1976, fig. 1727)

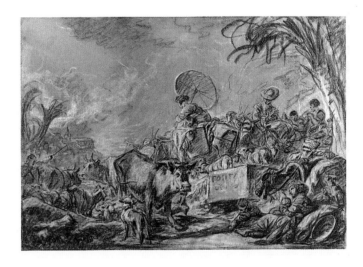

Fig. 43b. François Boucher, *Landscape*. Black and white chalks on blue paper. The Nelson-Atkins Museum of Art, Kansas City, Missouri. (Gift of Milton McGreevy), F59-64/10

Fig. 43c. François Boucher, *Drawing of a Caravan*. Sanguine. (Reproduced from Ananoff and Wildenstein 1976, fig. 1729)

fully painted in all their parts, truly capital, moreover, to this abundance they add the liveliness of the figures, a multitude of well-depicted animals and fresh and dewy landscapes. The

richness of composition and the beauty of color evidently place these two paintings in the ranks of the master's chefs d'oeuvres. They are framed in rich borders of carved wood in the best style of the period. Everything leads one to presume that these paintings are related to those by the same master in the Grand Trianon at Versailles. They are signed and dated 1765 and 1767.[30]

It may have been at this sale or shortly thereafter that the pair of paintings was acquired by Edward Preable Deacon, who in 1841 had married Sarahann Parker, daughter of Peter Parker, one of Boston's wealthiest merchants. For the couple, Parker built a lavish house in the French style on Washington Street. He had purchased a number of pieces in Paris in 1840, and Deacon made two trips to Paris in 1846–47 and 1848 to accumulate the furnishings for the house, which was completed in 1848. The Bouchers were placed in the dining room. When Deacon died young of consumption in 1851 and his unstable widow and their children went to live abroad in 1861, the ownership of the Deacon House, as it had become known, reverted to Peter Parker.[31] It was apparently closed up in 1865, and after Parker's death in 1871 the contents of the house were auctioned. The Bouchers were bought in by Parker's heirs,[32] and then given, as the first European paintings, to the recently founded Museum of Fine Arts.[33]

1. Although Ananoff and Wildenstein 1976, vol. 2, p. 283, suggest that Bergeret was the owner, possibly by 1761 and definitely by 1765, the first identified reference to his ownership is in 1769. See note 18 below.

2. Salon de 1761, no. 9.

3. C. Stryienski, "Le Salon de 1761, d'après le catalogue illustré par Gabriel de Saint-Aubin," *GBA* 29 (April 1903), pp. 287–89. See also E. Dacier, *Catalogues de ventes et livrets de Salons illustrés par Gabriel de Saint-Aubin* (Paris, 1911), vol. 6, p. 54.

4. In the Musée de Nîmes. See Ananoff and Wildenstein 1976, no. 656.

5. See A. Laing, in New York 1986, no. 68; Ananoff and Wildenstein 1976, no. 477; and I. S. Nemilova, *The Hermitage Catalogue . . . French Painting, Eighteenth Century* (Moscow and Florence, 1986), pp. 53–54, no. 13.

6. See Seznec and Adhémar 1967, vol. 1, p. 83.

7. Ibid., p. 112.

8. *Observations d'une Société d'amateurs sur les tableaux exposés au salon cette année 1761* (Paris, 1761), pp. 17–18.

9. *Avant-Coureur* 35 (Aug. 31, 1761), pp. 555–56, quoted in Ananoff and Wildenstein 1976, vol. 1, p. 96.

10. In the Pushkin Museum. See Ananoff and Wildenstein 1976, no. 498.

11. *Mercure de France*, Oct. 1761, p. 147, quoted in Ananoff and Wildenstein 1976, vol. 1, p. 96.

12. Ananoff and Wildenstein 1976, no. 500.

13. For example, this pot is seen in *Two Peasants near a Rustic Fountain* of 1765 (Ananoff and Wildenstein 1976, no. 616), where one also sees similar details such as the sleeping sheep and the laden donkey.

14. See Ananoff 1966, vol. 1, nos. 374–76, fig. 158.

15. Jean-Richard 1978, no. 1544.

16. Slatkin, in Washington 1973, p. 14, no. 10; see also M. Sharp Young,

"Pastorales et paysages," *Apollo* 99, no. 148 (June 1974), p. 471, fig. 4; and Ananoff 1966, nos. 303–13, fig. 60.

17. The date has sometimes erroneously been given as 1769, but it is clearly 1767.

18. See E. Dacier, *Catalogues de ventes et livrets de Salons illustrés par Gabriel de Saint-Aubin* (Paris, 1909), vol. 2, p. 72. The sketch appears on the page of the Avertissement and the inscription on the first page of the *Explication*.

19. See G. Wildenstein, "Un Amateur de Boucher et de Fragonard, Jacques-Onesyme Bergeret (1715–1785)," *GBA* 58 (July–Aug. 1961), pp. 42ff.; Wildenstein also publishes an inventory of Bergeret's collection, made after his death in 1785, and mistakenly identifies no. 72, described as "two small landscapes by Boucher," with lot 47 of the Bergeret sale. More likely that lot (the two Boston paintings) was no. 31 of the inventory, "two landscapes by Boucher," which had the very high valuation of 721 livres.

20. Ibid., pp. 43–44.

21. See Wildenstein 1982, p. 20; Paris, Grand Palais, *Seicento: Le Siècle de Caravage dans les collections françaises* (Paris, 1988), pp. 166–68; and A. Brejon de Lavergnée and N. Volle, *Musées de France: Répertoire des peintures italiennes du XVIIe siècle* (Paris, 1988), pp. 93–97.

22. See New York 1986, pp. 32–33 and 58–59.

23. Wildenstein 1982, p. 45.

24. Acc. no. 33-668. See Rosenberg 1972, p. 138, no. 15, pl. IX; and R. Ward and M. S. Weil, in Washington University Gallery of Art, *Master Drawings from the Nelson-Atkins Museum of Art* (St. Louis, 1989), p. 44.

25. It was later in the Bureau sale, May 20, 1927, no. 3. See Ananoff and Wildenstein 1976, vol. 2, p. 287, fig. 1729.

26. Acc. no. 57.2. See Rosenberg and Stewart 1987, pp. 110–12.

27. Ananoff and Wildenstein 1976, no. 562.

28. Seznec and Adhémar 1967, vol. 4, pp. 67–68.

29. Bergeret sale catalogue, Paris, April 24, 1786, no. 47.

30. Sale catalogue, Dec. 21–22, 1846.

31. On the Deacon House, see M. C. Crawford, "The Edward Preable Deacon House," *New England Magazine* (April 7, 1901), pp. 15–18; Whitehill 1959, pp. 125–26; also H. Vickers, *Gladys, Duchess of Marlborough* (London, 1979), pp. 13–15; Neale 1994, pp. 2–5.

32. The *Boston Evening Transcript* of February 1, 1871, reported on the Deacon House sale: "In the dining-room the two large paintings by Boucher, 'Going to Market' and 'Returning from Market,' were sold to Mr. Franklin for $1500 each, it being the first bid."

33. The handwritten minutes from the trustees' meeting of March 10, 1871, record that "the President also read a letter from Charles F. Shummin (?) Esq., one of the executors of the will of the late Peter Parker, presenting to the Museum on the behalf of the heirs, the pictures by Boucher, called Night and Morning. On motion of Mr. Gray, it was voted: That the pictures be accepted and that the thanks of the corporation be presented to the donors by the President, for their valuable gift to the Museum." In the Museum's first catalogue published in 1873 the paintings were titled *L'Aller et Le Retour du Marché*. At some later point the mistaken idea that the paintings had been bought at the 1852 sale of the Hôtel Richelieu in Paris became part of Museum lore. See Guiffrey 1913, p. 539, Whitehill 1970, vol. 1, p. 18; Randall 1961, p. 39; Watson 1966, vol. 1, p. XXVI.

MAURICE QUENTIN DE LA TOUR

1704–1788

If it was Rosalba Carriera who popularized pastel portraiture in France, it was Maurice Quentin de La Tour, from the town of Saint-Quentin, who took the art to its peak of perfection. As a young man he went to Paris, where he followed the advice of the engraver Nicolas Tardieu and entered the studio of the Flemish painter Jacques-Jean Spoëde. He may then have gone to England for a time before settling again in Paris.

La Tour was made *agréé* by the Académie royale de peinture et de sculpture in 1737 and elected a full member in September 1746 as a *peintre de portraits au pastel*. In 1750 he was appointed portraitist to the king. He exhibited at the Salon frequently, and his work was extremely well received, both for its technical proficiency and for the insight into the sitters' personalities. La Tour attempted to penetrate their superficial exteriors, as he described it, to "descend to their very depths and bring them back whole."[1]

1. Quoted and translated in Arts Council of Great Britain, *French Drawings from Fouquet to Gauguin* (London, 1952), p. 62.

44. *Portrait of a Woman in a Rose Gown (La Dame en Rose)*, about 1755

Pastel on paper
25 × 21 in. (63.5 × 53.3 cm)
The Forsyth Wickes Collection
65.2661

PROVENANCE: private collection, Paris; Camille Groult, Paris; Galerie Charpentier, Paris, March 21, 1952, no. 66; where acquired by Georges de Batz and Co., New York, for Forsyth Wickes.

REFERENCES: Besnard and Wildenstein 1928, p. 177, no. 612, fig. 119, pl. XXXII; Rathbone 1968a, pp. 21–22, cover ill.; Rathbone 1968b, pp. 738, 741, fig. 11; Murphy 1985, p. 160; Zafran, in Munger et al. 1992, p. 86, no. 28.

CONDITION: The pastel is in good condition except for some water damage in the lower half of the figure.

La Tour produced many pastel portraits of fashionable ladies such as this.[1] The sitters often hold a prop, in this case probably a musical score, and regard the viewer with a knowing look. Very similar in this regard is the *Portrait of Baronne de Tuyll* of 1753, in which the sitter holds a mask.[2] As Champfleury wrote, these works are not only lifelike but have a particular charm that is conveyed by the trace of a smile.[3] Here the intelligent head is complemented by a brilliant display of luxuriant fabrics rendered with the utmost mastery and subtlety of the pastelist's art.

1. Others are the portraits of Madame Masse, Madame His, Marguerite le Comte, and Madame Grimod de la Reynière. See Besnard and Wildenstein 1928, nos. 176, 179, 264, and 336.

2. See C. Debrie, *Maurice-Quentin de la Tour au Musée Saint-Quentin* (Saint-Quentin, 1991), pp. 180–82.

3. J. Champfleury, *La Tour* (Paris, 1886), p. 41.

French School, 18th century

45. *Head of a Young Woman*

Oil on canvas
16 1/2 × 13 5/8 in. (42 × 34.5 cm)
The Forsyth Wickes Collection
65.2651

PROVENANCE: comte d'Armagnac, Paris (?); private collection, England (?); Wildenstein and Co., New York; purchased May 16, 1945, by Forsyth Wickes.

REFERENCES: Murphy 1985, p. 296 (as Attributed to Nicolas Vleughels); Zafran, in Munger et al. 1992, pp. 72–73, no. 13.

CONDITION: The original plain woven fabric support has been glue-lined. The smooth, resinous paint layer is applied over a pale ground. The paint layer has been abraded from cleaning, especially in the background and shadows.

When acquired by Forsyth Wickes, this painting was attributed to Jean-Baptiste Joseph Pater. The head betrays a stylistic debt to Watteau (q.v.) and Lancret (q.v.) but is not by any of these major masters. Margaret Morgan Grasselli suggested that it might be by Antoine Pesne or Nicolas Vleughels.[1] Eunice Williams found the latter the more promising attribution, noting that the "idealized oval face[,] . . . dimples at corners of the mouth and bow-shaped lips"[2] are similar to those features in works by Vleughels. The unusually large scale of the work and its fragmentary nature, however, are unlike anything else found in the artist's *oeuvre*[3] and may indicate that it was produced later in the eighteenth century in emulation of this Watteau-inspired style.

1. In a letter of October 4, 1982, in the Paintings Department files.

2. In notes of December 1982, in the Paintings Department files.

3. See B. Hercenberg, *Nicolas Vleughels* (Paris, 1975).

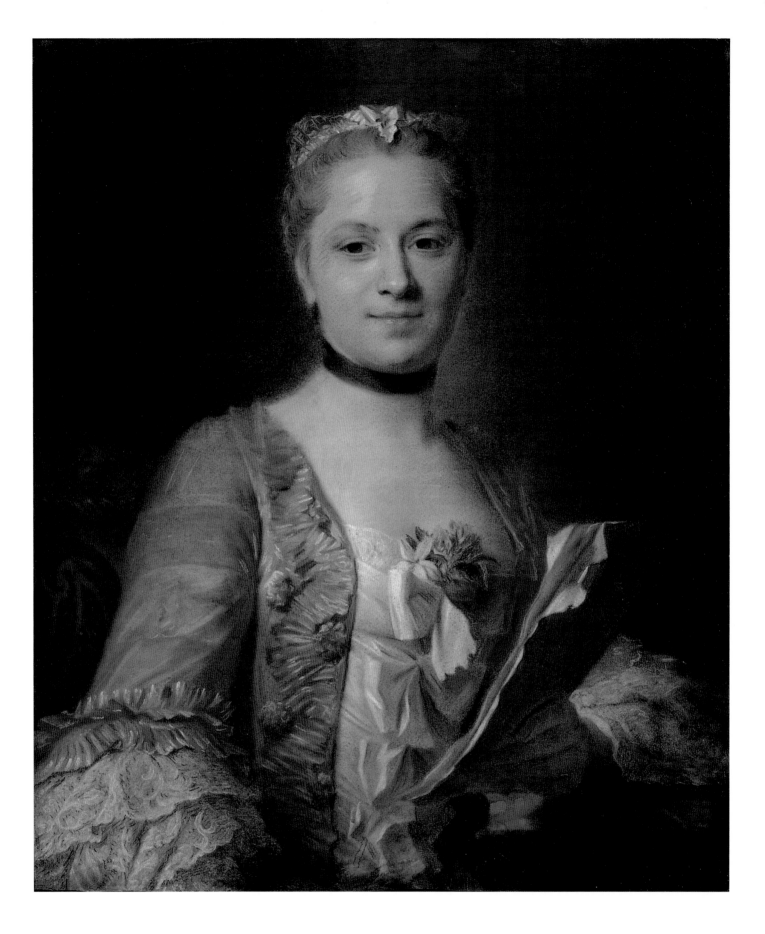

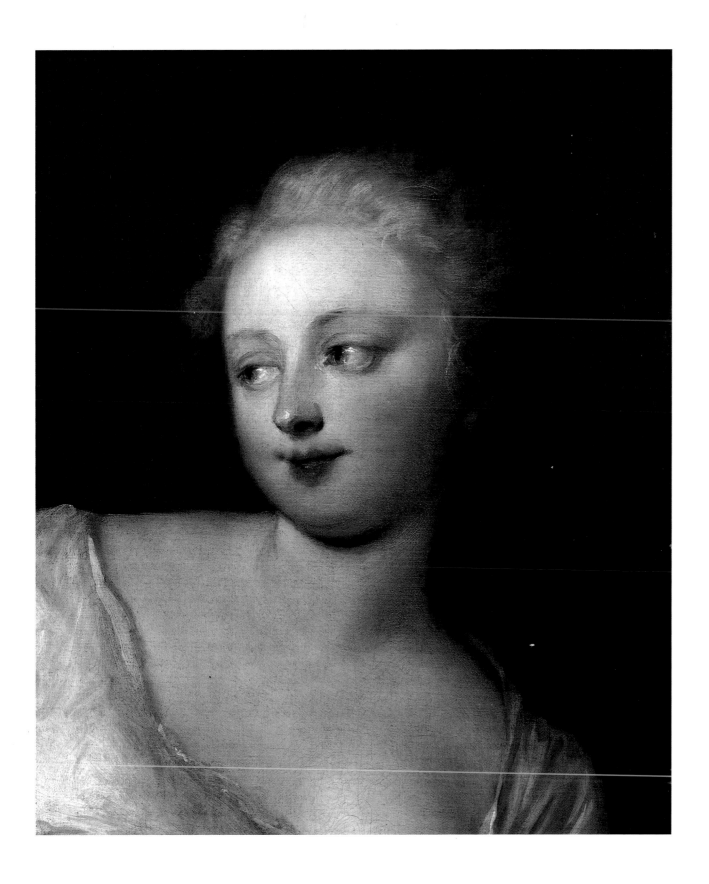

JEAN-MARTIAL FRÉDOU

1710–1795

Born in Fontenay-Saint-Père, Jean-Martial Frédou settled at Versailles in 1752. There he had an important role as a copyist of royal portraits and he also created original pastel portraits of the nobility and the royal family, especially the children of the dauphin.

In 1775 he was appointed *peintre du cabinet du roi* and in 1776 *premier peintre de monsieur*—that is, to Louis XVI's brother.[1]

1. Comte Doria, "Le Portraitiste Frédou," *BSHAF* (1950), pp. 150-66.

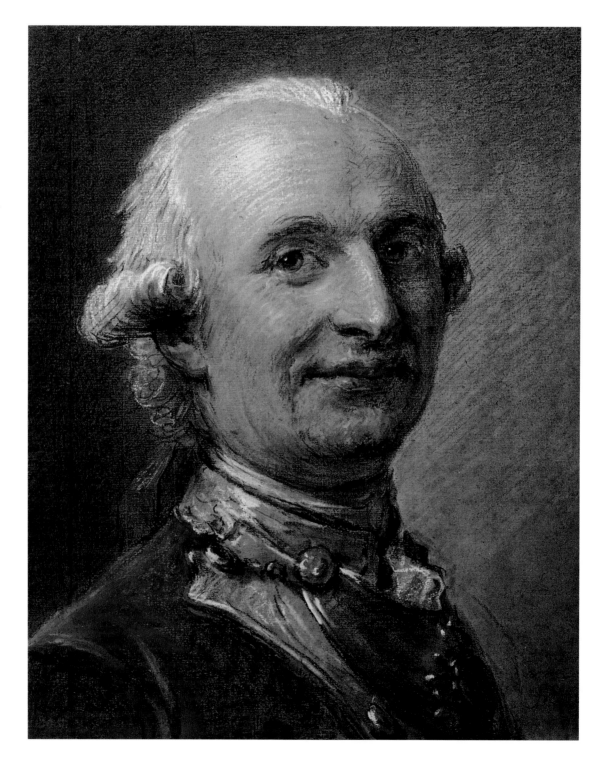

46. *Portrait of a Man*
(Monsieur de Praroman)

Pastel on tan paper
11 3/4 × 9 1/4 in. (29.8 × 23.5 cm)
Signed at the lower right: *Frédou*
The Forsyth Wickes Collection
65.2658

PROVENANCE: Adolphe le Goupy, Paris; purchased October 16, 1935, by Forsyth Wickes.

REFERENCES: Murphy 1985, p. 102; Zafran, in Munger et al. 1992, p. 83, no. 23.

CONDITION: The pastel is in generally good condition, but the paper has darkened. There is an indication of pentimenti at the lower right.

Frédou's portraits, as evident here, show a sound command of pastel technique and a liking for sweet, bright colors, but they could occasionally, as in this case, reveal a sense of individual character reminiscent of La Tour (q.v.). At the time of its sale to Wickes, this pastel was identified as a "Portrait of Monsieur de Praroman," an officer in the Swiss guards.

Attributed to Jean-Martial Frédou

47. *Portrait of a Young Woman*
with a Blue Ribbon at Her Throat

Pastel on paper
18 3/16 × 14 3/4 in. (46.5 × 37.5 cm)
The Forsyth Wickes Collection
65.2664

PROVENANCE: sale Georges Bourgarel, Hôtel Drouot, Paris, June 15–16, 1922, no. 79 (as "Portrait de jeune fille . . . Atelier de Drouais?") ; Cailleux, Paris; purchased November 12, 1927, by Forsyth Wickes.

EXHIBITION HISTORY: Paris, *Exposition de pastels français du XVIIe et du XVIIIe siècle*, 1927, no. 91; Copenhagen 1935, no. 281.

REFERENCES: Dacier and Ratouis de Limay 1927, p. 49, no. 24, pl. XVII; Rathbone 1968b, p. 740, fig. 12; Murphy 1985, p. 216 (as Attributed to Nattier); Zafran, in Munger et al. 1992, p. 84, no. 24.

CONDITION: The pastel is in good condition, but there are a slight loss on the left cheek, blistering at the lower edge, and lifting from the support.

Although published previously as by Jean-Marc Nattier, this extremely charming portrait of an unknown young woman does not seem capable of bearing the weight of such an attribution. In 1988 Joseph Baillio[1] pointed out the similarity of this work to a signed and dated pastel of 1760 by Frédou, which is also a depiction in bust length of a young girl wearing a neck ribbon and flowers in her hair.[2] It also recalls Frédou's *Portrait of Maria Josepha of Saxony*, in oil, in which the sitter has similar sparkling eyes and a blue bowtie.[3] Thus, Frédou seems a most convincing attribution for this pastel.

1. In correspondence in the Paintings Department files.

2. *Portrait de jeune femme* was sold at Sotheby's, Monte Carlo, February 22, 1986, no. 302.

3. For this work of 1760, now in the Museum Boymans-van Beuningen, Rotterdam, see Rotterdam 1992, p. 99, no. 15.

French, 18th century

48. *Portrait of a Woman*
(Madame de Praroman née d'Affry?)

Pastel on paper
22 1/2 × 19 in. (57.2 × 48.3 cm)
The Forsyth Wickes Collection
65.2657

PROVENANCE: Adolphe le Goupy, Paris; purchased October 16, 1935, by Forsyth Wickes.

REFERENCES: Murphy 1985, p. 105; Zafran, in Munger et al. 1992, p. 84, no. 25.

CONDITION: The pastel is in fairly good condition.

This pastel was identified at the time of its purchase as Frédou's *Portrait of Madame de Praroman née d'Affry*, said to be the sister-in-law of the gentleman represented in the *Portrait of a Man* (cat. 46). It was further claimed that the work is executed on "a bluish paper glued to canvas and mounted on a support," a configuration claimed by the artist's descendant Jean-Paul Mariage to be typical of other works by Frédou.[1] The identification of the sitter may be correct, but the quality of the work is not consistent with other pastels by Frédou.

1. "un papier bleuté collé sur toile et monté sur un châssis." On the receipt of sale from le Goupy.

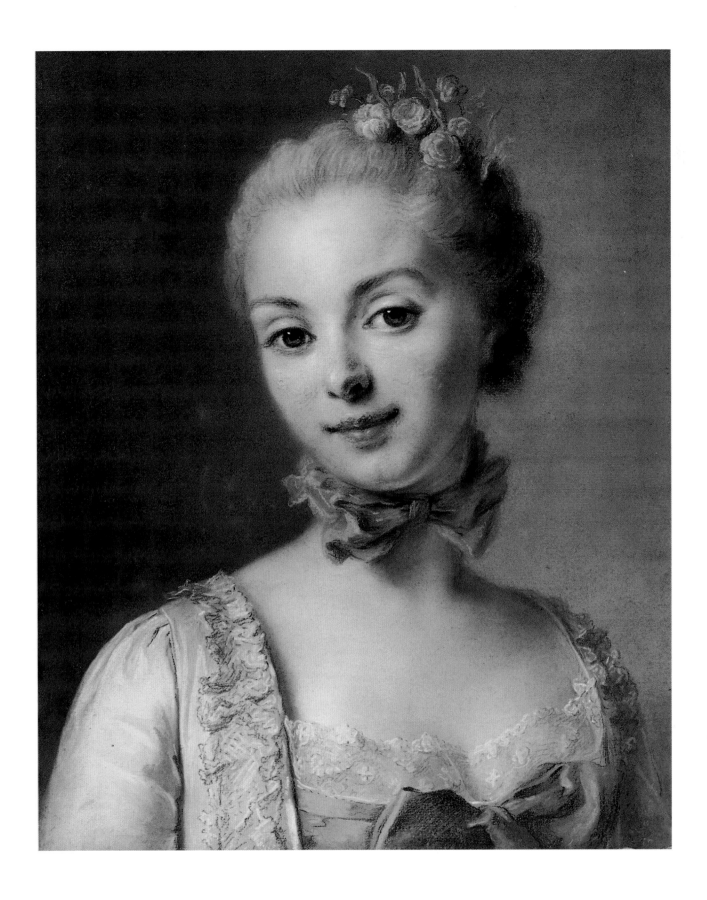

Attributed to Jean-Martial Frédou

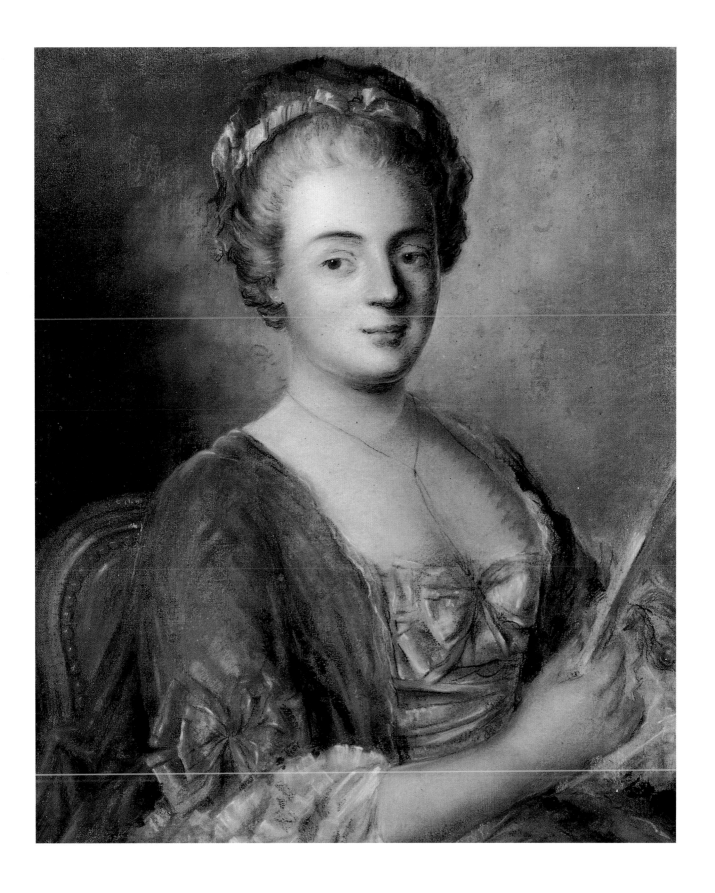

NOËL HALLÉ

1711–1781

Both Noël Hallé's father and grandfather were painters, and although he first studied architecture, he eventually followed in their footsteps. An important influence on him was the history painter Jean Restout, who became his brother-in-law in 1729. Hallé competed unsuccessfully for the Prix de Rome in 1734 but won it in 1736, departing for Italy late in 1737. Supervised by the Académie's director, Jean-François de Troy, he copied frescoes by Raphael in the Stanze and painted his own historical and biblical compositions before returning to France in 1744. He had a distinguished career as a dedicated *académicien*, being *agréé* in 1746 and *reçu* as a history painter in 1748 with his *Dispute of Minerva and Neptune over the Naming of the City of Athens* (Paris, Louvre). He was appointed a *surinspecteur* of the Gobelins manufactory, then professor at the Académie, and was sent to Rome to reorganize the Académie there. He was awarded the Ordre de Saint-Michel by the king and in 1781 became *recteur* of the Académie. In addition to the history paintings that made his reputation, Hallé also painted portraits and genre subjects.

49. *The Death of Seneca*, 1750

Oil on canvas
60 1/2 × 48 1/16 in. (153.7 × 122 cm)
Juliana Cheney Edwards Collection
1978.123

PROVENANCE: the artist; Jean-Noël Hallé, Paris, 1783;[1] his descendants until about 1970; Heim Gallery, London, by 1975; purchased 1978.

EXHIBITION HISTORY: Paris, Salon of 1750, no. 71; Paris, Salon de la Correspondance, 1783, no. 91; London, Heim Gallery, *Aspects of French Academic Art, 1680–1780*, 1977, no. 16; Boston 1978; Tokyo 1983–84, no. 25; Cologne 1987–88, no. 36.

REFERENCES: Baillet de Saint-Julien 1750, pp. 34–35; Pahin-Champlain de La Blancherie, *Catalogue du Salon de la Correspondance* (Paris, 1783), p. 237, no. 91; E. Bellier de la Chavignerie and L. Auvray, *Dictionnaire général des artistes de l'école française* (Paris, 1882), vol. 1, p. 735; Estournet 1905, pp. 154, 218, no. 129; J. Locquin, *La Peinture d'histoire en France* (Paris, 1912; reprint, 1978), pp. 188, 245 n. 13, fig. 24; T. Crombie, "Mid-Winter Medley," *Apollo* 101, no. 156 (Feb. 1975), pp. 130–31, fig. 8; "Notable Works of Art Now on the Market," *TBM* 117, no. 873 (Dec. 1975), suppl., p. 875, pl. 18; *TBM* 119, no. 891 (June 1977), no. 891, adv., p. cxxv; Museum of Fine Arts, Boston, *The Museum Year, 1977–1978* (Boston, 1978), p. 31; A. Brookner, *David* (New York, 1980), p. 29, fig. 2; Lomax 1983, pp. 107–109, fig. 7; Murphy 1985, p. 128; Willk-Brocard 1995, pp. 120, 168, and 376, no. 38.

CONDITION: The original fabric support has been wax-lined. It is difficult to determine the original construction of the ground and paint layers because of the extensive abrasion and in-painting.

≈

As related by Tacitus, the Stoic philosopher Seneca was condemned to death in 65 C.E. by the profligate emperor Nero, who had been his student.[2] In adherence to his beliefs, Seneca announced his decision to take his own life. His loyal wife, Paulina, insisted on joining him in this act, but after Seneca, who was emaciated with age, had the veins in his legs opened, he ordered her taken away to spare her the pain of witnessing his death. She was removed to another room and her own death was averted. Seneca, continuing to dictate his final words to his followers, was placed in a hot bath to alleviate his suffering. Thus, although Hallé's painting was exhibited at the Salon of 1750 as *The Death of Seneca*, it does not—as does Rubens's famous example,[3] or that of a French predecessor, Claude Vignon[4]—depict the scene of the philosopher's succumbing in the bath, but rather the much more affecting moment of separation between husband and wife. This scene had also figured in the tragedy *The Death of Seneca* written by the seventeenth-century dramatist Tristan l'Hermitte.[5] In Hallé's painting the distraught woman is shown being led away by her attendants as an already weakened Seneca gazes at her lovingly. Only the subtlest traces of blood are evident on his right leg and on the white cloth to the right of his left leg. The pathos of this last encounter produces in Seneca's three followers attitudes that suggest a secular lamentation. For Anke Repp-Eckert, the intensity of Paulina's expression and gestures recall representations of the Virgin Mary mourning over the dead Christ.[6]

In its representation of a virtuous death for the sake of personal principles, the subject foreshadows many of the high-minded subjects that Jacques-Louis David and his followers were to produce on Roman themes during the Revolution. Hallé, although seeking to inspire edifying thoughts in the viewer, still invests the work with a rococo rather than a neoclassical flavor, with fluid technique, rich color, and an element of voluptuous sensuality.

At the Salon of 1750 Hallé exhibited four paintings including the present work, and Diderot, who later was not to have the highest opinion of the artist,[7] supposedly wrote: "Hallé is a good history painter; he has been in Rome for some time and draws well, although a little incorrectly. There is more good than bad to say about his color; his brushwork is light and witty."[8] The one critic who wrote that year specifically about the painting, Baillet de Saint-Julien, liked it the best of Hallé's exhibited works but still had some reservations:

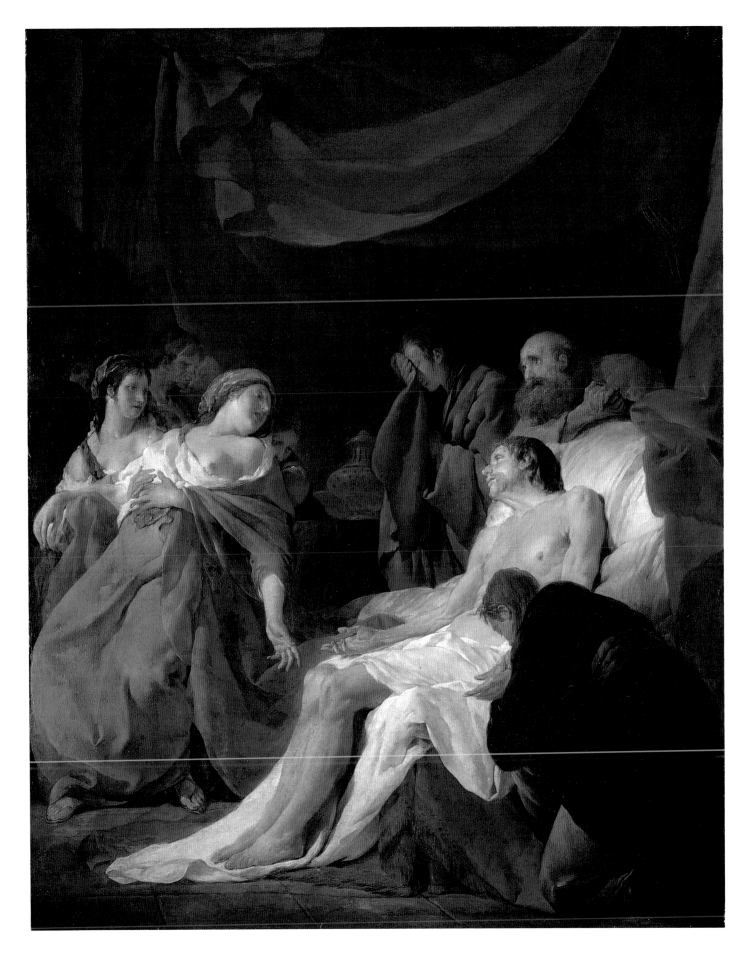

This subject seems to me both felt and reasoned by a painter and a clever man. One notes much understanding, character, and intention; and the color in general is in very good taste. I very much like that figure compressed in the foreground of the painting, which cleverly separates itself from the whole subject, the others contrasted to him in the background, who seem to approach him; his simple and naive attitude and the elegant sadness which appears in his expression. I do not admire any less the tearful women occupied in supporting the wife of Seneca, who seems so distraught by his death. Seneca himself, who like a true philosopher, awaits it without impatience neither desiring or fearing it. But I do not admire in the same way the color that has been given to the figure, which is less that of a dying man than that of a cold and inanimate corpse. I am equally unmoved by the base and ignoble character that has been given to Seneca in this painting; it is not at all what has been transmitted to us by antiquity through marbles and medals and even less accords with the idea that is generally conveyed by his works; it would seem that M. Hallé has only read him in some bad translation.[9]

David Lomax believed that the painting, although exhibited in 1750, was actually done when Hallé was still in Rome. He pointed out that the swooning figure of Paulina derives from de Troy's *Death of Lucretia*, which was painted in Rome and etched by Le Lorrain in 1742.[10] Another fainting female figure, also by de Troy, as pointed out by Nicole Willk-Brocard, was another possible source.[11] For his overall conception Hallé may have relied on Italian prototypes such as the one by Luca Giordano,[12] which shows the philosopher seated at the right and, as in Hallé's painting, turned in profile to the left as he speaks to his disciples. Hallé characterizes the figures in his distinctive manner. Thus the young, standing disciple is quite close to his figure of Joseph in *Joseph Accused by Potiphar's Wife* of 1740–44[13] and, as noted by Willk-Brocard, *Joseph Interpreting Dreams* of 1744, while the model for Seneca also served as a beggar in Hallé's *Charity of Saint Martin* of 1747.[14] Hallé later reused the motif of the recumbent, seminude, male figure in his painting *The Scythian King Scilurus*.[15]

Hallé's painting of Seneca's death may have been influential in the choice of this subject for the Prix de Rome competition in 1773. Jean-François Pierre Peyron, whose painting is known only from an engraving and preliminary drawings, was the winner, but an important competitor was David.[16] Although both artists include the departure of Paulina, they also show the bloody footbath and a great deal of other architectural details and subsidiary figures, thus diffusing the noble clarity and solemnity of Hallé's painting.

1. According to the handwritten catalogue of the 1783 *Salon de la Correspondance*, p. 72, no. 91 (Frick Art Reference Library, New York), and the printed version in the Bibliothèque du Louvre. Also see Estournet 1905, p. 218.

2. See Tacitus, *The Annals*, trans. J. Jackson (Cambridge, 1951), vol. 4, book 15, pp. 315–19.

3. Munich, Alte Pinakothek, no. 305. The actual severing of the veins is shown in a painting by Matthias Stomer, sold at Christie's, London, November 30, 1979, no. 12.

4. The Vignon is in the Louvre. See A. Michel, *Histoire de l'art* (Paris, 1921), vol. 6, ill. p. 222.

5. See H. C. Lancaster, *A History of French Dramatic Literature in the Seventeenth Century, Part II* (New York, 1932; reprint, 1966), vol. 2, pp. 562–67; and C. K. Abraham et al., eds., *Le Théâtre complet de Tristan l'Hermitte* (Tuscaloosa, Ala., 1975), pp. 219–21, and act 5, scene 1, pp. 293–98.

6. A. Repp-Eckert, in Cologne 1987–88, p. 244.

7. See Paris 1984, pp. 268–69. Diderot's comment on Hallé in the Salon of 1761 reveals his low estimation: "I maintain that there is not one bit of Professor Hallé's work which is worth anything. . . . I don't know if Professor Hallé is a great draughtsman, but he is lacking in genius. He does not know nature; he has nothing in his head, and he's a bad painter." (Author's translation)

8. Quoted in Estournet 1905, p. 189, but without documentation.

9. Baillet de Saint-Julien 1750, pp. 34–35.

10. Lomax 1983, pp. 107–108.

11. In a letter of November 18, 1987, in the Paintings Department files.

12. Luca Giordano's *Death of Seneca* is in the Alte Pinakothek, Munich. See O. Ferrari and G. Scavizzi, *Luca Giordano* (Naples, 1966), vol. 2, p. 356, vol. 3, pl. 4.

13. Smart Gallery, University of Chicago. The photograph is in the Frick Art Reference Library.

14. Willk-Brocard, letter of 1987, and Willk-Brocard 1995, p. 376.

15. The painting is in the Museum Narodowe, Warsaw, and an oil sketch for it is in a private collection, Paris. See *Catalogue of Paintings: Foreign Schools, II* (Warsaw, 1969), no. 477, and Paris 1984, pp. 275–76, no. 78.

16. See C. Saunier, "La Mort de Sénèque par Louis David," *GBA* 33 (1905), p. 234; and P. Rosenberg and U. van de Sandt, *Pierre Peyron, 1744–1814* (Paris, 1983), pp. 71–73, figs. 3–7.

JEAN-BAPTISTE PERRONNEAU

1715–1783

Jean-Baptiste Perronneau was a master portraitist who worked in both pastel and oils. He studied with Charles Natoire and the engraver Laurent Cars. *Agréé* at the Académie royale de peinture et de sculpture in 1746, he exhibited at the Salon for the first time in that year. His work was invariably compared to that of Maurice Quentin de La Tour (q.v.), who created the vogue for pastel portraits and whose virtual monopoly of the field led Perronneau to seek patrons abroad. He visited Italy, Holland, Spain, England, Russia, and Poland; he died in Amsterdam.

50. *Portrait of a Man*

Oil on canvas
23 3/4 × 19 3/4 in. (60.3 × 50.2 cm)
The Forsyth Wickes Collection
65.2652

PROVENANCE: Mrs. Cragg, England (?); Wildenstein, Paris and New York; purchased January 23, 1937, by Forsyth Wickes.

EXHIBITION HISTORY: Paris, Salon of 1753, no. 123 (?); New York, Wildenstein and Co., *Jubilee Loan Exhibition 1901–1951*, 1951, no. 24; New Haven 1956, no. 20; New York, Wildenstein and Co., *Paris–New York: A Continuing Romance*, 1977, no. 48.

REFERENCES: Mongan 1963, p. 152; Rathbone 1968a, pp. 22–23, 63, ill.; Rathbone 1968b, pp. 740, 742, fig. 13; Watson 1969, pp. 216–17, fig. 42; M. Sharp Young, "The Last Time I Saw Paris," *Apollo* 106, no. 189 (Nov. 1977), p. 414, fig. 6; Murphy 1985, p. 226 (as *Francis Hastings, Earl of Huntingdon*); Zafran, in Munger et al. 1992, pp. 80–81, no. 19.

CONDITION: The fabric support has been glue-lined with the tacking margins trimmed. The paint layer covers a pale granular ground and is in good condition. Small areas of loss are confined to the background and the sitter's jacket.

~

In 1753, the year Perronneau was *reçu* by the Académie royale, he exhibited seven portraits at the Salon. One of these was listed as "The Portrait of Milord Hunlington" [*sic*].[1] This was Francis Hastings (1728–89), who became tenth earl of Huntingdon in 1746. Described by his contemporaries as a bright and attractive young man,[2] he frequently visited the Continent and had as his mistress in Paris Mademoiselle Lany, a dancer at the Paris Opéra. She lived on the same street as Perronneau, who showed a pastel portrait of her at the Salon of 1751, and it may have been through this connection that the painter received the commission for the earl's own portrait when he visited Paris in the summer of 1753.[3]

The present portrait was sold to Wickes as the Salon portrait of Lord Huntingdon and has continued to be identified as such until recently. There is, however, reason to doubt this identification, since in the following year, 1754, his portrait was also painted by Sir Joshua Reynolds, and that work, with a provenance back to the Hastings family, is now in the Huntington Library at San Marino, California.[4] It shows a man with a much longer face and sunken eyes, different from those in the Boston painting. Other depictions of Lord Huntingdon also emphasize the long, thin face,[5] making the traditional identification of this portrait yet more doubtful.

If doubt exists as to the identity of the sitter, there is none as to the quality of Perronneau's painting: This is one of his finest. It is comparable to the best of his bold, bust-length pastel portraits of gentlemen,[6] shown in the height of fashion with the hair gathered at the back into a black silk bag, the ends of which are tied around the front *en solitaire*.[7] As the *Mercure de France* aptly wrote of the painter's showing at the Salon of 1753, "M. Perronneau has merited congratulations thanks to the lightness of his manner and of his touch."[8]

1. *Explication des peintures . . . 1753* (Paris, 1753), p. 28, no. 123. P. Ratouis de Limay, *Le Pastel en France au XVIIIeme siècle* (Paris, 1946), p. 213.

2. See Dr. Doran, *'Mann' and Manners at the Court of Florence, 1740–1786* (London, 1876), vol. 1, pp. 370–71.

3. Vaillat and Ratouis de Limay 1923, p. 48.

4. *The Huntington Art Collection: A Handbook* (San Marino, Calif., 1986), p. 26, inv. no. 44.101; E. K. Waterhouse, *Reynolds* (London, 1941), p. 39.

5. See H. Ward and W. Roberts, *Romney* (London, 1904), vol. 2, p. 83; G. C. Williamson, *Life and Work of Ozias Humphrey* (London, 1918), opp. p. 84. Other likenesses include an anonymous portrait in the collection of D. Minlorg, London, and, according to information kindly supplied by Jonathan Franklin of the archives of the National Portrait Gallery, London, a portrait by Andrea Soldi, once at Donnington Park as well as a bust possibly by Joseph Wilton in the Government Art Collection.

6. Such as the *Portrait of Lorimier* from the Coty collection, sold Palais Galliera, Paris, June 3, 1970, no. 12.

7. As in the Perronneau portrait of Jacques Cazotte. See A. Ribeiro, *Dress in Eighteenth-Century Europe, 1715–1789* (New York, 1985), pp. 94–95.

8. "M. Perronneau a merité des applaudissements par la légèreté de sa manière et celle de sa touche." *Mercure de France*, October 1753 (reprint; Geneva, 1970), p. 163.

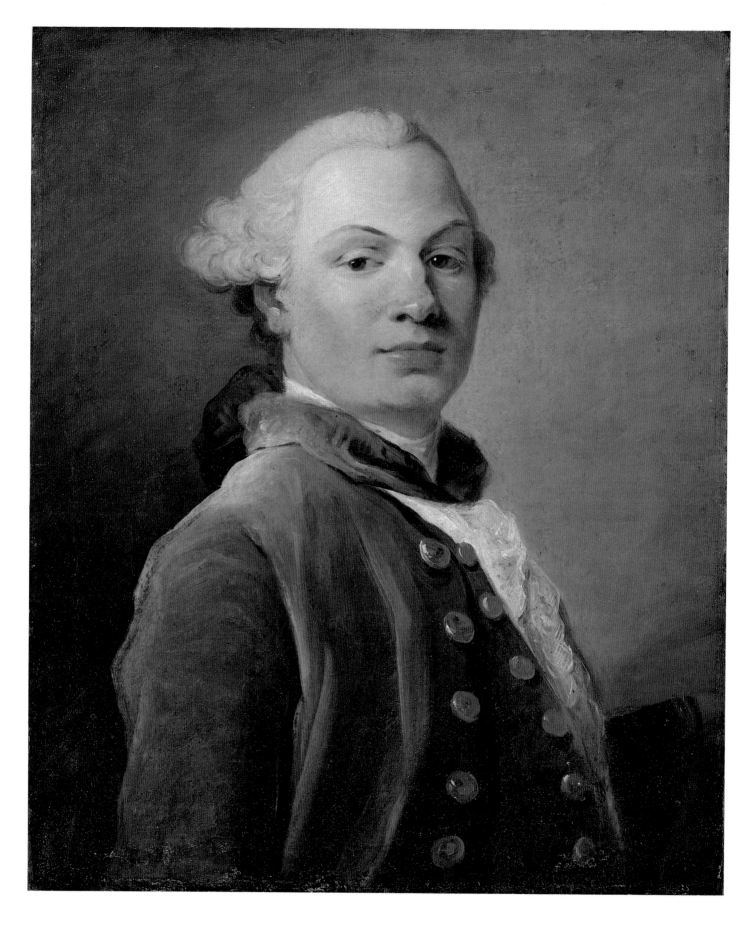

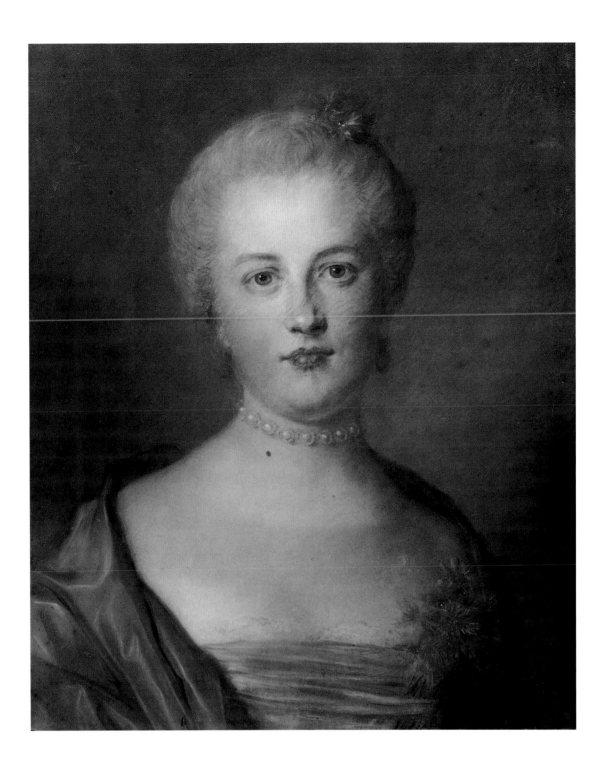

51. *Portrait of a Woman with a Corsage of Blue Flowers*

Pastel on paper
16 3/4 × 20 1/2 in. (54 × 45 cm)
Signed upper right: *Perronneau*
The Forsyth Wickes Collection
65.2665

PROVENANCE: Cailleux, Paris; purchased May 8, 1935, by Forsyth Wickes.

REFERENCES: Murphy 1985, p. 226; Zafran, in Munger et al. 1992, p. 88, no. 31.

CONDITION: The pastel is in fair condition. Some tearing at the lower left and some buckling are visible.

This straightforward type of pastel portrait of a woman is characteristic of Perronneau's work in the 1760s. The powdered hair, the pearl necklace, the off-the-shoulder dress, and similar facial type are all found, for example, in the *Portrait of Cornelia Straalman*,[1] a *Portrait of a Woman* sold from the Groult collection,[2] and another in oval format of 1768.[3]

1. See Vaillat and Ratouis de Limay 1923, pl. 32.

2. Galerie Georges Petit, Paris, June 21–22, 1920, no. 27.

3. Sold Palais Galliera, Paris, March 28, 1967, no. 131.

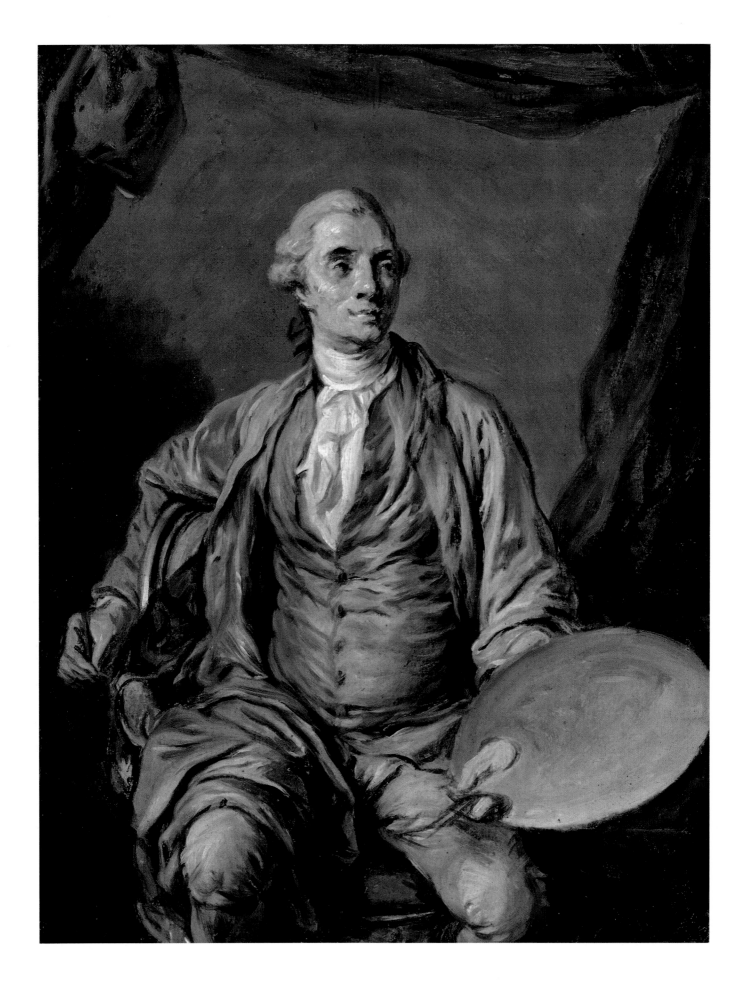

JOSEPH-SIFFRED DUPLESSIS

1725–1802

The son of a surgeon who became a painter, Joseph-Siffred Duplessis was born at Carpentras in Provence. After studying with another local painter, Duplessis journeyed to Rome and worked closely with Pierre Subleyras (q.v.) for four years. He then returned to France, working in Carpentras and Lyon before finally going to Paris in 1752. He first exhibited at the Académie royale de peinture et de sculpture in 1769, when his portraits were acclaimed at the Salon. He was only *reçu* as a portraitist in 1774, the year of Louis XVI's accession, and he became the favorite portraitist of the king, who appointed him director of the Galleries of Versailles.

Duplessis's skill in the presentation of character and the depiction of elaborate garments made his portraits popular not only with royalty (including Marie Antoinette) and aristocrats, such as the comte d'Angiviller, but also with the bourgeoisie. His two 1778 portraits of the visiting American statesman Benjamin Franklin found such favor that his studio was called upon to produce many replicas. Duplessis was also the portraitist of choice for many artists and musicians, including Christoph Willibald Gluck, Christophe Gabriel Allegrain, and Joseph-Marie Vien.

52. *Joseph-Marie Vien with a Palette*

Oil grisaille on paper mounted on canvas
12 3/8 × 9 3/8 in. (31.4 × 24.6 cm)
The Forsyth Wickes Collection
65.2643

PROVENANCE: Forsyth Wickes.

REFERENCES: A. Brejon de Lavergnée, in Washington 1976, p. 140; Murphy 1985, p. 87; Zafran, in Munger et al. 1992, p. 69, p. 70 ill., no. 9.

CONDITION: The paper support, which is mounted on canvas, has several creases. The paint is applied thinly over the pinkish yellow paper, which shows in many parts of the design, reducing the coolness of the grisaille colors. The paint layer is in very good condition, with a small amount of retouching at the edges.

~

Joseph-Marie Vien (1716–1809) was the director of the French Académie in Rome from 1775 to 1781. Later, in Paris, he was a professor at the Académie royale. Vien commissioned a portrait of himself in 1771 as one of the requirements for Duplessis's admission to the Académie, but because of Vien's departure for Rome, it was only carried out after he returned. The painting (fig. 52a), finally finished in 1785, was exhibited at the Salon in that year. This life-size depiction of the artist shows him framed by a curtain, seated, a brush in one hand, his palette and more brushes held in the other.

The small grisaille study in the Wickes collection is identical in almost all regards to the finished painting, lacking only such final touches as the paints on the palette and the buttons at the upper edge of the vest. There is also less sureness about the expression in the face, so that it is difficult to deduce if this is a preliminary study or a rapidly rendered replica.

Fig. 52a. Joseph-Siffred Duplessis, *The Painter Joseph-Marie Vien.* Oil on canvas. Paris, Musée du Louvre, inv. no. 4036

JEAN-BAPTISTE GREUZE
1725–1805

Jean-Baptiste Greuze played a pivotal role in the history of French painting. His work was immensely popular during the middle part of the eighteenth century, but his reputation went into eclipse at the end of his life and has only recently been reestablished. Born in Tournus to a merchant of masonry and tile, he studied first at Lyon under Charles Grandon, a specialist in portraiture. He went to Paris and enjoyed almost immediate success with his *Family Bible Reading*, which he may have begun in Lyon, and which was bought by an amateur who exhibited it privately before its public debut at the Salon of 1755. Having been *agréé* earlier that year, Greuze left for Rome with his first important patron, Louis Gougenot, abbé de Chezal-Benoît. In Italy he met Charles Natoire and studied the work of Guido Reni as well as his contemporaries Pierre Subleyras (q.v.), Jean-Honoré Fragonard (q.v.), and the Scotsman Gavin Hamilton. During his stay in Rome, Greuze executed a series of moralizing paintings of figures in Italian costume, which he exhibited at the Salon of 1757 following his return

to Paris that year. His next great success came at the Salon of 1761 with *The Marriage Contract* (Paris, Louvre). In this work the cult of *sensibilité* found ideal visual expression. Diderot hailed its "high principles" and, in 1765, called Greuze "the first who had endowed art with morality." Greuze, however, was conscious of the hierarchy of genres and wished to be accepted as a history painter by the Académie royale de peinture et de sculpture. He attempted to transfer the moralizing parable of filial piety into a more classical and severe setting for his reception piece of 1769, *Septimius Severus Reproaching Caracalla* (Paris, Louvre), but he was *reçu* only as a genre painter. This disappointment caused Greuze to break with the Académie, and he did not exhibit at the Salon again until after the Revolution. Working and exhibiting privately in his studio, he was able to achieve great financial reward and public notoriety for his many sentimental subjects. In the final decades of his life, he received the patronage of the Bonapartes.

53. *Presumed Portrait of the Chevalier de Damery*, about 1765

Oil on canvas
25 1/4 × 21 5/8 in. (64 × 55 cm)
Charles H. Bayley Picture and Paintings Fund
1982.140

PROVENANCE: Boittelle collection, Paris; sale Paris, April 24–25, 1866, no. 61; Princess Mathilde, Paris; sale Paris, May 17–21, 1904, no. 34; Mr. David Ames, Mr. Oliver F. Ames, and Mrs. Peter S. Thompson, Boston.

EXHIBITION HISTORY: Hartford 1976–77, no. 40.

REFERENCES: J. Martin and C. Masson, *Catalogue raisonné de l'oeuvre peint et dessiné de Jean-Baptiste Greuze* (Paris, 1908), no. 1278; Murphy 1985, p. 124.

CONDITION: The glue-lined, fine, loosely woven fabric support imparts a pebbly texture to the surface of the painting. The paint is applied over a pale red ground. The face is abraded, but the coat and vest appear intact.

Edgar Munhall has identified this bust-length portrait tentatively as the chevalier de Damery, "lieutenant-colonel of grenadiers of the French Guard,"[1] and a patron and close friend of Greuze. The identification is based on the fact that among the decorations so carefully painted on his jacket is the military Ordre de Saint-Louis, which Damery had received. Damery was also friendly with the artist Jean-Georges Wille, and this portrait as well as one of Wille

were probably painted by Greuze when all were in contact in 1765.[2]

As he typically did in his portraits, Greuze here combined a lively depiction of the sitter with a virtuoso rendering of the garments. Despite the clear delight he derived from the luxurious array of textures—the brilliant gold and silver buckle, the luminous blue velvet, the delicate gray lace—Greuze focuses attention on the face. Damery appears to turn, with a hint of a smile, to address the viewer. This intimacy of a speaking likeness is an indication of Greuze's debt to Dutch and Flemish prototypes.

1. "lieutenant-colonel des grenadiers aux gardes françaises." See Munhall in Hartford 1976–77, pp. 94–95, no. 39.

2. Ibid.

54. *The White Hat*

Oil on canvas
22 7/16 × 18 1/8 in. (57 × 46 cm)
Gift of Jessie H. Wilkinson Fund, Grant Walker Fund, Seth K. Sweetser Fund, and Abbot Lawrence Fund
1975.808

PROVENANCE: Thomas Dowse, Cambridge, Mass.; bequeathed to the Boston Athenaeum, 1859; on loan to the Museum of Fine Arts, 1876–1975.

EXHIBITION HISTORY: Boston Athenaeum, annual exhibitions, 1857–73; Boston Athenaeum, *Sanitary Fair Exhibition*, 1863, no. 107; Boston Athenaeum, *National Sailors Fair Exhibition*, 1864, no. 99; Paris 1937, no. 172; Hartford 1976–77, no. 91; Tokyo 1983–84, no. 26; Boston 1984, no. 23.

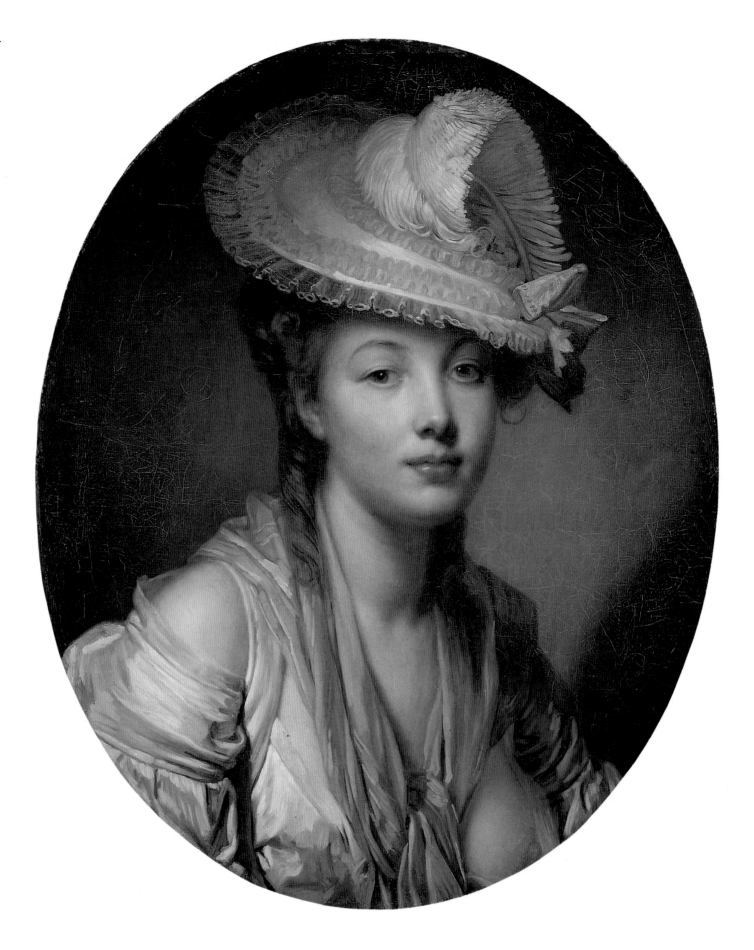

REFERENCES: Downes 1888, p. 501; "The Fine Arts," *Boston Evening Transcript*, Nov. 3, 1897; E. Pilon, *J. B. Greuze* (Paris, 1912), p. 52, ill. opp. p. 42; Guiffrey 1913, p. 542; Boston 1921, p. 102, no. 267; E. de Goncourt and J. de Goncourt, *French Eighteenth-Century Painters* (New York, 1958), fig. 70; Whitehill 1970, vol. 1, ill. p. 28; J. H. Hagstrum, *Sex and Sensibility* (Chicago and London, 1980), pp. 313–14, fig. 30; Murphy 1985, p. 124 (as *Young Woman in a White Hat*); Stebbins and Sutton 1986, p. 54.

CONDITION: The plain woven fabric support has been glue-lined. Physical evidence attests that the oval format is original, but old stretcher creases indicate that it has been trimmed down on all sides, slightly more at the top and right edge. The paint is applied over a pale granular ground containing lead. Infrared examination reveals changes in the placement of the eyes and mouth. The painting is in good condition, despite many small losses and some abrasion of the original glazes.

~

One of Greuze's most sensual images, the image of this young woman is a variety of genre painting that comes close to portraiture. In fact, the "eminent marine painter" Winslow Homer suggested in 1897 that the work depicted Madame Du Barry.[1] However, the enigmatic, expressionless face is clearly of a type rather than an individual. The dominant element in the painting is the remarkable white hat. The sinuous swirls of its organdy material and feather are mirrored in the oval format of the painting, which cunningly serves to highlight the woman's exposed left breast. Greuze often employed the oval shape, especially for suggestive or sensual female subjects.[2] As Edgar Munhall points out, it was Marie Antoinette who set the fashion for a "natural déshabillé mode" by wearing a plain white dress as early as 1775.[3]

The appeal of the painting derives, however, not only from the composition but also from the remarkable handling of paint. The limited, muted palette of white and purple for the garments is offset by the glowing pink in the flesh.

1. In the *Boston Evening Transcript*, Nov. 3, 1897.

2. See Musées d'Art de Ville de Clermont-Ferrand, *Greuze et Diderot* (Clermont-Ferrand, 1984), nos. 34 and 35.

3. Munhall, in Hartford 1976–77, p. 54.

55. *Portrait of a Child (Le Petit Frère)*

Oil on canvas
16 × 12 7/8 in. (40.7 × 32.6 cm)
Gift of Edwin H. Abbot, Jr., in memory of his mother, Martha T. Abbot
49.1145

PROVENANCE: J.-B. Pigalle, Paris, by 1771; Pushkin Museum, Moscow, to 1921, no. 524; purchased from the Soviet government by Mrs. Henry J. Pierce; on deposit at the Metropolitan Museum of Art, 1932–43; acquired by Edwin Hall Abbot, Jr., Cambridge, Mass., in 1943.

REFERENCE: Murphy 1985, p. 124 (as Follower of).

CONDITION: The plain loosely woven fabric support has been glue-lined, and the resinous paint has been applied over a pale ground. Infrared examination reveals a contour sketch of the child in a dry media. The paint layer is in fair condition, with scattered damage and abrasion, especially in the hand, and discolored inpainting.

Children were one of Greuze's chief subjects. He was able to make them sweet, even sentimental, yet real. This charming, rather serious, long-haired boy who rests his chubby arms on a table is, according to Edgar Munhall, the original of a composition that was engraved by Jean-Baptiste Lucien in 1771, when the painting was in the collection of the sculptor Jean-Baptiste Pigalle.[1] In the print (fig. 55a), the composition is converted into an illusionistic oval medallion.

1. Munhall in correspondence of April 29, 1991. See J. Martin, *Catalogue du Musée de Tournus* (Tournus, 1910), no. 254.

Fig. 55a. Jean-Baptiste Lucien, after Greuze, *The Little Brother*, 1771. Engraving. New York, The Metropolitan Museum of Art, Harris Brisbane Dick Fund, 1953 (53.600.221)

FRANÇOIS-HUBERT DROUAIS

1727–1806

François-Hubert Drouais was both the son and the father of a painter. He was trained by the leading artists of his youth—Carle van Loo, Charles Natoire, and François Boucher (q.v.)—from whom he learned the requisite style of elegance and high finish for his career as a fashionable portraitist at the court of Louis XV. Drouais, *agréé* by the Académie royale de peinture et de sculpture in 1754, began exhibiting at the Salon that same year and painting for the court in 1756. He was *reçu* in 1758 with two portraits. Despite harsh criticism from Diderot, he was an immensely popular artist, rivaling Jean-Marc Nattier, whose style of allegorical portraits he occasionally attempted. Drouais's talents, however, were better suited to straightforward representation, especially of

children. His figures, dressed in their most luxurious garments, were placed in richly decorated interiors. His quintessential works are his portraits of the royal mistresses including Madame de Pompadour and Madame Du Barry. Writing of one of his portraits of Madame de Pompadour, Baron Grimm observed that all the major artists had painted her, but Drouais was "the only man who knows how to paint women, because he knows how to capture that delicacy and grace which gives charm to their features."[1]

1. In a letter of August 15, 1764; see Le Baron de Grimm, *Correspondance littéraire de Grimm et de Diderot* (Paris, 1829), vol. 4, p. 37.

56. *Portrait of a Woman in Turkish Costume (Mademoiselle de Romans ?)*, 1762

Oil on canvas
23 3/4 × 19 9/16 in. (60.3 × 49.7 cm)
Signed and dated above sitter's right arm: *Drouais le / fils 1762*
The Forsyth Wickes Collection
65.2640

PROVENANCE: comte de Chabannes Lapalisse, château de Montmelas; comte de Tournon, château de Montmelas; Arthur Veil-Picard, Paris; Wildenstein and Co., New York; purchased February 14, 1930, by Forsyth Wickes.

EXHIBITION HISTORY: Copenhagen 1935, no. 58 (as Mademoiselle Hainaut); Hartford 1956, no. 11.

REFERENCES: Mongan 1963, p. 152; Rathbone 1968a, pp. 23, 61, ill.; Murphy 1985, p. 85; Zafran, in Munger et al. 1992, pp. 67–68, no. 6.

CONDITION: The plain woven fabric support has been glue-lined, with the original tacking margins trimmed. The paint layer is in excellent state and applied over a tan ground. The impasto is intact, and the glazes appear intact. Examination with infrared reveals a pentimento in the placement of the sitter's right arm.

This portrait is thought to depict one of the mistresses of Louis XV. When Forsyth Wickes acquired the painting from Wildenstein in 1930, the woman was identified as Mademoiselle de Romans, whose liaison with the king began in 1759 and lasted some three to five years, producing a child, Louis-Aimé, the only one of his natural children the king recognized. She later married the marquis de Cavanac. Strangely, the provenance given by Wildenstein for the painting traces it to comte de Chabannes Lapalisse at château

Montmelas; it was Mademoiselle Hainault (or Henaut), also briefly Louis's mistress, who afterward became marquise de Montmelas. It seems unlikely that her home would house two portraits of her rival, for in addition to this signed half-length of the sitter in Turkish costume with a musical score, a full-length painting showing her clipping Cupid's wings was also at the same château. It is signed and dated 1761.[1]

Despite the dubious provenance, this most likely is Madame de Romans, known as "la grande," for her looks certainly coincide with the description provided by Casanova in his *Mémoires:* "Her satin skin was of an amazing whiteness, emphasized more by magnificent black hair. The features of her face were of a perfect regularity; her complexion was slightly colored; her black well-shaped eyes had the most lively brightness and the highest sweetness; she had well-curved eyebrows, a little mouth, regular and well-placed teeth, with a pearl enamel; and lips of a soft pink on which rested the smile and the grace of modesty."[2]

1. It was last recorded in the collection of Eugène Kraemer, sold Paris, April 28–29, 1913, no. 10, and reproduced in L. Vaillat and R. Dell, *Maîtres des XVIIIe siècle, cent portraits de femmes des écoles anglaise et française* (Paris, 1910), pl. 60. In the photo collection of the Service de la Documentation, Musée du Louvre, the paintings are still identified as of Mademoiselle Hainaut. Another painting by Drouais, dated 1769, was also identified as Mademoiselle de Romans. See L. Réau et al., *Catalogue de la collection Philippe Wiener* (Paris, 1929), no. 15.

2. See Casanova, *Mémoires* (Paris, 1959), vol. 2, p. 582. Also quoted in Comte Fleury, *Louis XV intime et les petites Maîtresses* (Paris, 1899), p. 201. See also the *Mémoires du maréchal de Richelieu* (Paris, 1793), vol. 9, pp. 349–52, who notes, "Mademoiselle de Romans has the most beautiful hair we have ever seen. It goes down to her knees."

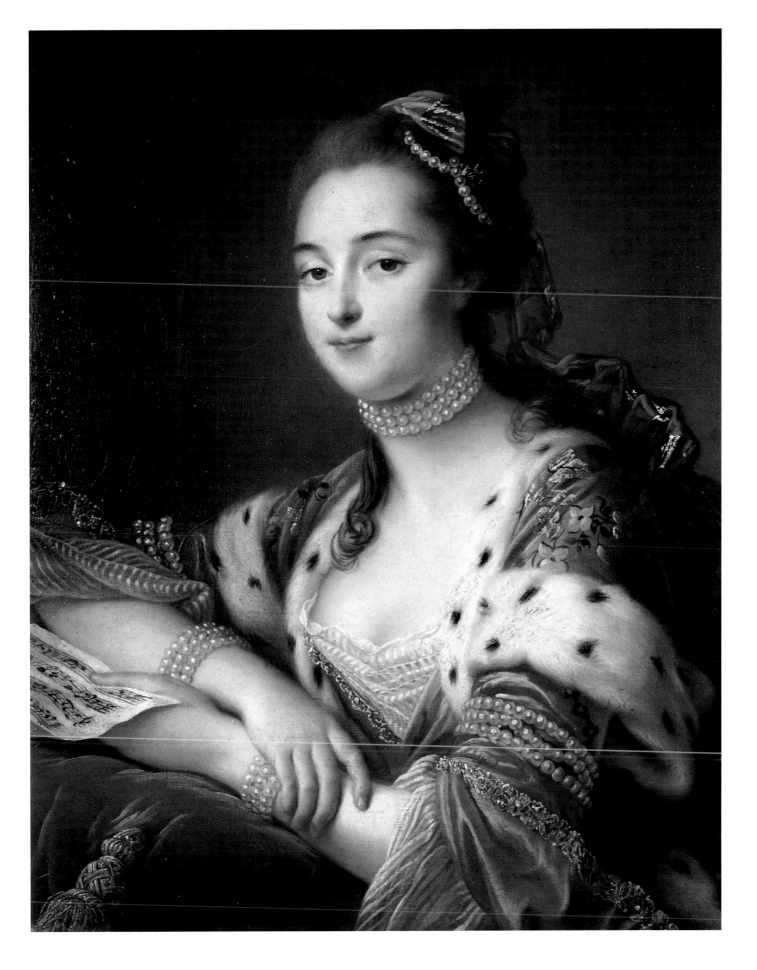

SIMON BERNARD LE NOIR

1729–1789

Simon Bernard Le Noir was a specialist in portraiture. He was granted membership in the Académie de Saint Luc in 1760 and exhibited his portraits in both pastel and oil at its Salons of 1762, 1764, and 1774. His masterpiece is the grand *Portrait of Robert-Joseph Pothier* in Orléans,[1] and he also captured such celebrities as Voltaire and the actor Henri Lekain,[2] as well as more ordinary individuals.[3]

1. See M. O'Neill, *Les Peintures de l'école française des XVIIe et XVIIIe Siècles: Catalogue critique du Musée d'Orléans* (Paris, 1980), pp. 93–94, no. 103.

2. See Bordeaux 1980, pp. 85–86, no. 40.

3. See Dacier and Ratouis de Limay 1927, nos. 104–106, and other examples sold at the Galerie Charpentier, Paris, June 24, 1960, nos. 210 and 211.

CAT.
57

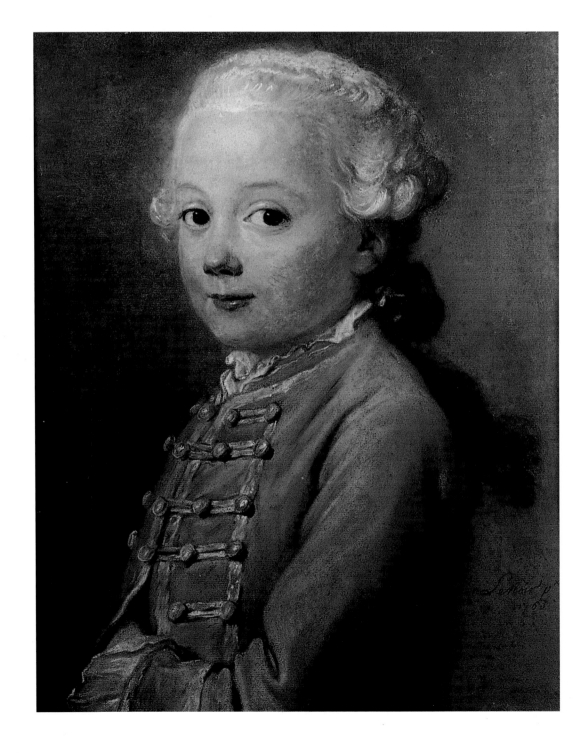

57. *Portrait of a Young Boy (Marc René de Heere?)*, 1760

Pastel on paper
18 3/16 × 15 3/8 in. (46.5 × 39 cm)
Signed and dated lower right: *LeNoir pxit / 1760*
The Forsyth Wickes Collection
65.2662

PROVENANCE: Vigna (?); Forsyth Wickes collection by 1933.

EXHIBITION HISTORY: Copenhagen 1935, no. 279.

REFERENCES: Murphy 1985, p. 165; Zafran, in Munger et al. 1992, pp. 86–87, no. 29.

CONDITION: The pastel is in good condition; some remnants of mold stains are visible.

The subject here has been traditionally identified as Marc René de Heere, born in 1753, who was married in 1783 to Anne Geneviève de l'Escalopier, and who died in 1810. The work displays the charming manner that made Le Noir popular as a portraitist of children.[1]

1. See, for example, one in the B. Lasquin sale, Paris, November 1932, no. 15.

JEAN-HONORÉ FRAGONARD
1732–1806

Born in Grasse in 1732, Jean-Honoré Fragonard went to Paris with his family at an early age. Though he was apprenticed to a notary, his parents recognized his inclinations toward art and arranged to have him enter the studio of Jean-Siméon Chardin (q.v.). Soon after, about 1747, he moved to the studio of François Boucher (q.v.), where he was to become the master's most promising protégé.

Boucher encouraged Fragonard toward a conventional academic career as a history painter. At his teacher's insistence, Fragonard competed for the Prix de Rome, which he won in 1752 with his *Jeroboam Sacrificing to the Idols* (Paris, Ecole des Beaux-Arts). He then spent three years in the Ecole royale des élèves protégés, where Carle van Loo was director and where he was influenced by Nicolas-Bernard Lépicié (q.v.). By late 1755, when Fragonard departed for Rome, he had received a thorough academic training and achieved a considerable reputation.

His years in Rome proved to be an especially fertile experience for Fragonard. Charles Natoire, director of the Académie in Rome, granted the artist two extensions beyond the normal three-year period. Fragonard copied the works of Tiepolo, Pietro da Cortona, Solimena, and Giordano and seems to have been particularly influenced by his contemporary Jean-Baptiste Greuze (q.v.) during that artist's trip to Italy. He spent a half-year traveling through the countryside and major cities of Italy in 1761. Particularly important was his association with the abbé de Saint-Non; on their visit to the Villa d'Este, Fragonard made many landscape and architectural studies that later would be incorporated into his paintings.

On his return to France, Fragonard sought official recognition. In 1761 he was *agréé* by the Académie royale with the presentation of the large *Coresus and Callirhoë* (Paris, Louvre), which was shown at the Salon of 1765. On the verge of success, Fragonard voluntarily withdrew from the official scene. He never submitted a reception piece to the Académie, nor did he exhibit at the Académie's Salons after 1767. He married the miniaturist Marie-Anne Gérard in 1769.

Following the success of the famous *Swing* (London, The Wallace Collection), which he painted for the baron de Saint-Julien, he concentrated on private commissions. These ranged from sensual *scènes galantes* to sentimental and moralistic genre pieces. As taste changed, Fragonard's popularity declined, most vividly evidenced by Madame Du Barry's rejection of his 1771–73 *Progress of Love* series (New York, The Frick Collection). Fragonard, however, was to enjoy considerable success among middle-class patrons until the Revolution, and afterward he served the new regime as an official on the museum commission and was appointed by Jacques-Louis David to be curator of the new Musée des Arts in 1793.

58. *The Good Mother*, about 1779

Oil on canvas
25 5/8 × 21 1/4 in. (65 × 54 cm)
Bequest of Robert Treat Paine II
44.777

PROVENANCE: La Fontaine sale, Paris, February 22, 1798, no. 146 (?); Aubert sale, Paris, April 17, 1806, no. 12 (?); sale Paris, August 1, 1812, no. 3 (?); sale Paris, January 18, 1813, no. 52 (?); Rolland sale, Paris, March 22, 1830, no. 385 (?); d'Houdan sale, Paris, May 6–8, 1858, no. 127 (?)]; M. . . . sale, Paris, December 14, 1875, no. 34 (?); F. Spitzer, Paris; Mme Pellegrin; Gimpel and Wildenstein, Paris and New York, 1913; Samuel Reading Bertron, New York, 1913; Robert Treat Paine 2d, Brookline, Mass.

EXHIBITION HISTORY: Paris, Galerie Georges Petit, *L'Art au XVIIIe siècle*, 1883–84, no. 60; Paris, *Maîtres anciens au profit des Inondées du Midi*, 1887, no. 45; Paris, Sedelmeyer, *Marie Antoinette et son temps*, 1894, no. 161; New York, Wildenstein Gallery, *Fragonard*, 1914, no. 7; New York, Wildenstein Gallery, *J. H. Fragonard*, 1926, no. 10; New York, *Dedication of the French Institute Building*, 1926, no. 18; Detroit Institute of Arts, *French Paintings of the Eighteenth Century*, 1926, no. 22; Boston, Museum of Fine Arts, *Masterpieces from Boston Collections*, 1938, no. 4; Boston 1939, no. 45; London 1968, no. 246; New York 1970, no. 38; Tokyo 1980, no. 71; St. Petersburg 1982–83, no. 9; Museum of Fine Arts, Boston, *Unlocking the Hidden Museum*, 1990.

REFERENCES: J. de Goncourt and E. de Goncourt, "Fragonard," in *L'Art du XVIII siècle*, 3 ed. (Paris, 1882), vol. 2, p. 376; H. Portalis, *Honoré Fragonard: Sa vie et son oeuvre* (Paris, 1889), p. 281; Thiébault-Sisson, *Le Temps*, Nov. 9, 1913, p. 3, and Nov. 27, 1913, p. 3; B. Alvin, "Jean-Honoré Fragonard: La Verité sur *La Bonne Mère*," *Le Pedigrée: Erreurs et vérités en art* (Paris, 1913), pp. 26–31; G. Grappe, *La Vie et l'oeuvre de J.-H. Fragonard* (Paris, 1929), pl. II; Boston 1955, p. 25; L. Réau, *Fragonard: Sa Vie et son oeuvre* (Brussels, 1956), p. 171; Munich, *The Residenz, The Age of Rococo Art and Culture in the Eighteenth Century*, trans. M. D. Senft-Howie and B. Sewell (Munich, 1958), p. 51, under no. 57; G. Wildenstein, *The Paintings of Fragonard* (London, 1960), p. 299, no. 451; Wildenstein and Mandel 1972, p. 106, no. 475; Grayson 1980, p. 26, fig. 1; Murphy 1985, p. 101; P. Rosenberg, in Paris 1987–88, p. 335, fig. 1; Cuzin 1988, p. 310, no. 262; M. D. Sheriff, *Fragonard: Art and Eroticism* (Chicago and London, 1990), p. 15.

CONDITION: The oval fabric support has been wax-lined. The paint layer is applied over a pink ground and has a heavy weave impression owing to pressure applied in lining. The paint layer has an all-over pattern of age crackle and has been extremely abraded. The picture is in poor condition.

~

In this oval composition the background is all foliage and sky. In the middle is a pot with bluish flowers growing out of it. The floral motif is continued in an abundance of pink and red flowers that tumble along the lower right edge, serving to frame the figural component. This consists of a young woman seated on a stone bench. She wears a red dress with a low-cut white blouse and a white cap. On her lap is a large white cloth; she places her left hand on the head of a standing child—a little girl—pulling back her hair as she appears to reach with the other hand for a cloth with which to wipe the child's face. The woman's attention as she turns seems to have been caught by a young boy behind a low wall at the left who, concealing his face with his hat, pours water into a dish. At the same time a furry and somewhat indistinct little white dog nuzzles at the lady's neck. Behind her on the stone step is an infant slumbering in a cradle.

Fig. 58a. Jean-Honoré Fragonard, *The Good Mother*. Oil on canvas. Switzerland, private collection

Fig. 58b. Nicolas Delauney, after Fragonard, *La Bonne Mère*, 1779. Etching and engraving, trial proof, state II. New York, The Metropolitan Museum of Art, Purchase, Roland L. Redmond Gift, Louis V. Bell and Rogers Fund, 1972 (1972.539.28)

Fig. 58c. Jean-Honoré Fragonard, *The Good Mother (La Bonne Mère)*, about 1773–77. Watercolor and gouache. St. Petersburg, Fla., Museum of Fine Arts. Gift of Margaret Acheson Stuart

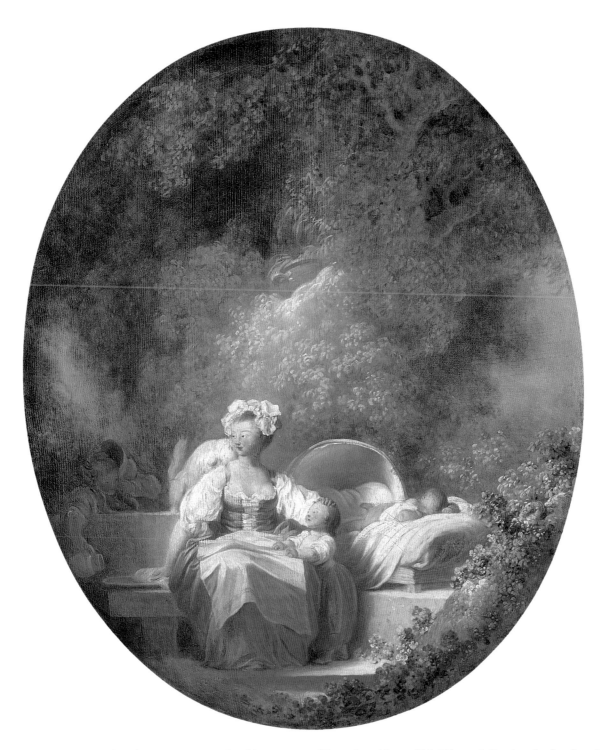

The connoisseurship related to this painting is confused by a number of different versions—painted, drawn, and printed. A second oil on canvas, somewhat smaller (48.9 × 39.2 cm) is in a Swiss private collection (fig. 58a).[1] Its tonality is much brighter, and it differs in certain details such as the woman's cap, which becomes a more elegant bonnet, and in the presence of a white lattice fence in the right background and a straw basket among the flowers in the lower-right foreground.

Nicolas Delauney made an etching after this composition, which was exhibited at the Salon of 1779. This was, of course, in reverse but follows the format of the Swiss painting with the bonnet, fence, and basket all evident. One state of the engraving (fig. 58b), which also is the source of the painting's title, was inscribed,

"from the cabinet of *M. Ménage de Pressigny*," a *fermier-général* to whom it was also dedicated. He was later arrested and executed; his painting was recorded as seized, and although the provenances of the two paintings have become tangled, his most likely is the one now in Switzerland. A watercolor described as "a young mother taking care of her children, a well-known subject thanks to the beautiful print by M. de Launay," was exhibited by the painter in the Salon de la Correspondance of 1781; this may be the work now in the Museum of Fine Arts, St. Petersburg, Florida (fig. 58c), which again follows the Swiss version.[2]

Since the early part of this century there has been a controversy as to which of the two paintings has primacy as the original. In 1913–14 a debate in pamphlets was waged between François

Thiébault-Sisson, who argued in favor of the Boston painting, and V. Alvin-Beaumont and Guillaume Apollinaire, who defended the other version, then in the Veil-Picard collection. According to Thiébault-Sisson, it was from the Boston original that Fragonard, at the urging of Delauney, produced the slightly modified gouache replica for the engraving. He further states that Fragonard was asked to repeat the composition, which led to the Veil-Picard replica.[3] More recently, David Carritt has stated that he does not believe the Boston painting to be by Fragonard.[4] Then, in the Paris and New York Fragonard exhibition of 1987–88, only the Swiss version was shown, and in the catalogue text Pierre Rosenberg dismissed the Boston version, observing, "It is difficult to study because of its poor state of preservation, but, at best, it seems to be no more than a mediocre replica."[5] Jean-Pierre Cuzin's Fragonard monograph of 1988, however, includes both paintings as authentic.[6]

In a special exhibition at the Museum of Fine Arts, Boston, in 1990, the two paintings were exhibited side by side. If the damaged state of the Boston painting was evident (layers of glazes removed by overcleaning and the canvas showing through), the recently restored Swiss version conveyed a cloying sweetness that was equally suspect, and one came away feeling that both works were indeed by Fragonard but had suffered in different ways. It was not unknown for Fragonard to do versions of his own popular compositions. For example, there are two versions of the painting *The Return Home*.[7] One is more sketchy than the other and reveals changes in the drapery of the baby's crib and the definition of the figures, similar to the discrepancies between the Boston and Swiss *Good Mother*.

The theme of the good mother had great resonance in the late eighteenth century. The writer-philosopher Jean-Jacques Rousseau dedicated his 1762 novel *Emile, or On Education* "to a good mother." And according to Marion Grayson, Fragonard's paintings and gouache were directly inspired by this controversial book, which advocated breast feeding, freedom for children to develop, and the assignment to them of small physical tasks,[8] all elements seen in this painting.

The themes of motherhood and child-rearing, of course, figure in many other works by Fragonard, including the other Fragonard in this collection (cat. 59). This concern was a personal one, as the artist observed his own family growing up. In fact, the figures in the Boston painting have on occasion been identified as Fragonard's wife, Marie-Anne Gérard, their daughter, and a nephew.[9]

1. See Paris 1987–88, pp. 335–36, no. 159.

2. See Paris 1987–88, no. 160, and Grayson in St. Petersburg 1982–83, pp. 11–12.

3. Thiébault-Sisson in *Le Temps*, Nov. 9 and 27, 1913, both p. 3.

4. In a letter of May 22, 1978.

5. Rosenberg in Paris 1987–88, p. 335.

6. Cuzin 1988, p. 310.

7. See Wildenstein 1960, nos. 453–54.

8. Grayson 1980, p. 24.

9. See New York 1970, p. 62.

59. *Mother and Children*

Oil on canvas
18 1/4 × 14 3/4 in. (46.4 × 37.5 cm)
The Forsyth Wickes Collection
65.2644

PROVENANCE: duc de La Rochefoucauld-Liancourt, Paris; sold at his home, 9, rue Royale, June 20, 1827, no. 19; Madame Corbin, Paris; Wildenstein and Co., New York; purchased February 20, 1945, by Forsyth Wickes.

REFERENCES: P. de Nolhac, *J. H. Fragonard* (Paris, 1906), p. 129; Wildenstein 1960, pp. 304–305, no. 466, ill.; Rathbone 1968b, pp. 738, 740, fig. 8; Wildenstein and Mandel 1972, p. 107, no. 490, ill.; Murphy 1985, p. 101; Cuzin 1988, p. 313, no. 281, ill.; Rosenberg 1989, p. 108, no. 328; Zafran, in Munger et al. 1992, p. 70, no. 10.

CONDITION: The original fabric support has been lined. The paint layer is applied over a pale-cream ground and is very worn, with much of the original subtlety of the transitions missing. The greenish underpainting in the flesh tones is now visible, and the browns have all become transparent. Only small areas, such as the yellow skirt of the sitter, give a sense of the way the painting must once have looked.

At the La Rochefoucauld-Liancourt sale of 1827, this painting was described as *A Mother Having her Child Play on a Large Book*, and it had as a pendant a now-lost work, "a mother making her child say 'please' before giving him some bread."[1] The theme of mothers and children, usually in the guise of the Virgin and Child, figured in Fragonard's earlier *oeuvre*,[2] but after the birth of his daughter in 1770 and son in 1780, secular treatments became more numerous. As an observer of his own family, he could draw on personal experience for humorous moralizing themes, as in this oval and its lost pendant. Other works in which similar didactic themes are seen, often with a large book present, are the drawing *Apologize to Grandfather* and a print by Nicolas Delauney after Fragonard, *Say Please*.[3] The Boston painting is similar to Fragonard's depiction of the *Education of the Virgin*, which Cuzin also dated to about 1775.[4] Stylistically, the sketchy application of paint (somewhat exaggerated by the work's overcleaned state) and the figure type with small head sitting on an attenuated neck are characteristic of Fragonard's work at this period.[5]

1. The compositions that have been suggested as recording this lost pendant are horizontal rather than upright ovals. See Rosenberg 1989, pp. 108 and 111, nos. 354 A and B.

2. Paris 1987–88, pp. 57–58, no. 10.

3. Ibid., p. 458, fig. 7, and pp. 460–61, no. 224.

4. Cuzin 1988, p. 312, nos. 273–75.

5. This type is seen particularly in the painter's various "sultanas" of this period. See Paris 1987–88, pp. 451–54.

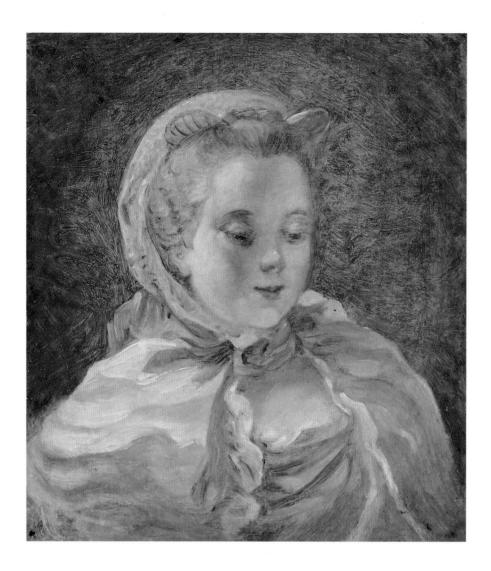

French School, 18th century

60. *Head of a Young Woman (Madame de Pompadour)*

Oil on panel
10 × 8 7/8 in. (25.4 × 22.55 cm)
The Forsyth Wickes Collection
65.2639

PROVENANCE: Howard Back Works of Art, New York; purchased March 15, 1945, by Forsyth Wickes.

REFERENCES: Murphy 1985, p. 104; Zafran, in Munger et al. 1992, p. 72, no. 12.

CONDITION: The support, a vertically grained wood panel, has a slight convex warp. The paint, applied loosely over a white ground, appears medium rich and is very smooth.

Alastair Laing[1] recognized that the head of the woman in this thinly painted oil is identical with that of Madame de Pompadour in a drawing in the Albertina, Vienna, that shows her reading with her daughter Alexandrine.[2] This and another drawing of Madame de Pompadour and her daughter, also in the Albertina, were, on the basis of an oil sketch of the same subject, attributed to François Guérin (active 1751–91).[3] Guérin was admitted to the Académie royale in 1761 and studied with Charles Natoire. He developed a refined manner, which he applied to drawings and paintings of small scale. Madame de Pompadour became his patroness, and in the Salon of 1761 he exhibited several genre paintings he had done for her. However, the few surviving paintings seemingly by Guérin[4] are neither as remarkable as the two Albertina drawings nor provide a basis for attributing this painting to him. In its application of paint and charming subject it is rather similar to the oval portrait of a young woman sold at Sotheby's, New York, in 1990 as attributed to Fragonard.[5]

1. In a letter of November 4, 1989, in the Paintings Department files.

2. O. Benesch, "Two Drawings Dedicated to Madame de Pompadour," *GBA* 37 (1950), pp. 125–29, figs. 1, 3; O. Benesch, *Master Drawings in the Albertina* (Greenwich, Conn., 1967), p. 373, pl. XXIII.

3. See M. N. Benisovich, "A Bust of Alexandrine d'Etoilles by Jully," *GBA* 28 (1945), pp. 31–42; and University Art Museum, *Master Drawings from California Collections* (Berkeley, Calif., 1968), pp. 21–22.

4. One sold at the Hôtel Rameau, Versailles (photo in the Service de la Documentation, Musée du Louvre), and another at the American Art Association, New York, March 7–8, 1929, no. 177.

5. Sale Sotheby's, New York, January 11, 1990, no. 9.

HUBERT ROBERT

1733–1808

The young Hubert Robert studied drawing with the sculptor Michel-Ange Slodtz. His interest in landscape painting may have been stimulated by a brief contact with Joseph Vernet in 1753. Because he had not trained at the Ecole royale des elèves protégés, it took the special intercession of the comte de Stainville, for whom his father was *valet de chambre*, to obtain Robert's admission to the Académie de France in Rome, where he arrived by November 9, 1754. He was particularly influenced by the professor of perspective, the Italian painter Giovanni Paolo Pannini, whose paintings of ruins provided a continual source of inspiration. Robert progressed rapidly, and in 1759 the marquis de Marigny commissioned a small picture by him and later that year designated him a *pensionnaire* at the Académie. In 1760 Robert went to Naples with the amateur engraver the abbé de Saint-Non. Although Robert's residency ended in October 1763, he was able to extend his Italian period to eleven years by working in Italy for Bailli de Breteuil. He finally returned to France in July 1765.

Already a heralded artist at the time of his return, Robert was both *agréé* and *reçu* by the Académie royale de peinture et de sculpture on July 26, 1766, for a *Port of Rome*, which was shown at the Salon the following year. His many paintings of ruins (both invented and based on antiquities in Italy and France), as well as charming pastoral subjects, brought him great renown. In the 1770s and 1780s Robert devoted much time to garden design and, in 1778, he was appointed *dessinateur des jardins du roi* and given lodging in the Louvre. Under Louis XVI he was also appointed a curator for the proposed national museum. Although imprisoned briefly during the Revolutionary period, he was able to resume his museum post. Many of his late paintings are depictions of the Grande Galerie of the Louvre, which he helped arrange.

61. *Staircase of the Washerwomen*, 1796

Oil on paper mounted on canvas
23 5/8 × 16 1/2 in. (60.3 × 41.6 cm)
Signed and dated lower right: *H. Robert / 1796*
The Forsyth Wickes Collection
65.2653

PROVENANCE: possibly Jules Burat; sale Galerie Georges Petit, Paris, April 28–29, 1885, no. 85 (as *Les Laveuses*); Robert Bonnel, Paris; Wildenstein and Co., Paris and New York; purchased February 14, 1930, by Forsyth Wickes.

EXHIBITION HISTORY: Copenhagen 1935, no. 193; New Haven 1956, no. 26.

REFERENCES: P. de Nolhac, *Hubert Robert* (Paris, 1910), p. 145 (as *Les Laveuses*); Raymond Lécuyer, "Les Expositions: lettre à une jeune fille qui veut être avertie," *Plaisir de France* 13 (Oct. 1935), p. 34. S. Rocheblave, *French Painting in the Eighteenth Century* (London and Paris, 1937), pl. 73; Mongan 1963, p. 152, ill. 154; Rathbone 1968a, p. 24, ill. 62; Watson 1969, p. 216; Murphy 1985, p. 246; Zafran, in Munger et al. 1992, p. 81, no. 20.

CONDITION: The paper support is attached to fabric. The paint layer is thinly applied over a pale gesso preparation layer, which is visible in many areas. The painting is in good condition, with retouch confined mostly to the dark areas and shadows.

〜

The idea for this late painting depends on compositional devices that Robert and Fragonard first developed in Rome during the 1760s in which a large light-filled arched structure or space is placed at the center.[1] The huge complex of interconnected buildings and bridges shown here also recalls examples of Roman structures found in other paintings by Robert.[2] This example, however, is without any classical motifs and may reflect a location actually observed in Paris to which the painter then applied his inventive imagination. Dwarfed by the building are the industrious washerwomen, who had also been a constant theme in the painter's work for many years.[3]

The painting's subject is similar to that in a painting sold by comte A. de Ganay in 1907 (Paris, Hôtel Drouot, April 16, no. 52) and might also be a version on paper of the painting the artist exhibited in the Salon of 1798 (no. 346), which was described as "a painting representing an old building used as a public bath."

1. See, for example, *Staircase in Ruins* of 1776 sold from the Seligmann collection, Galerie Georges Petit, Paris, March 9–12, 1914, no. 386; *The View of the Capital with Statue of Marcus Aurelius* in the Musée Gustave Crask, Valenciennes, no. 236; *An Architectural Caprice* in the Fribourg collection, sold Sotheby's, London, June 26, 1963, no. 120; and *View of the Octavian Gate and Fishmarket* at the Frances Lehman Loeb Art Center, Vassar College, Poughkeepsie, N.Y.

2. Most notably in the signed painting of 1798 that was with P. de Boer, Amsterdam, in 1956 (Witt Photo Archives, London).

3. They can be seen, for example, in *Ruins of Roman Baths with Laundresses* at the Philadelphia Museum of Art; and one sold at Parke-Bernet, New York, November 17–18, 1961, no. 198; *The Washerwomen* in the Bardac collection, sold at Galerie Georges Petit, Paris, May 11, 1920, no. 31; *Washerwomen near a Staircase* (Orléans, Musée des Beaux-Arts); and a rather similar treatment of laundresses in a Roman setting that was at Wildenstein in 1949 (Witt Photo Archives, London).

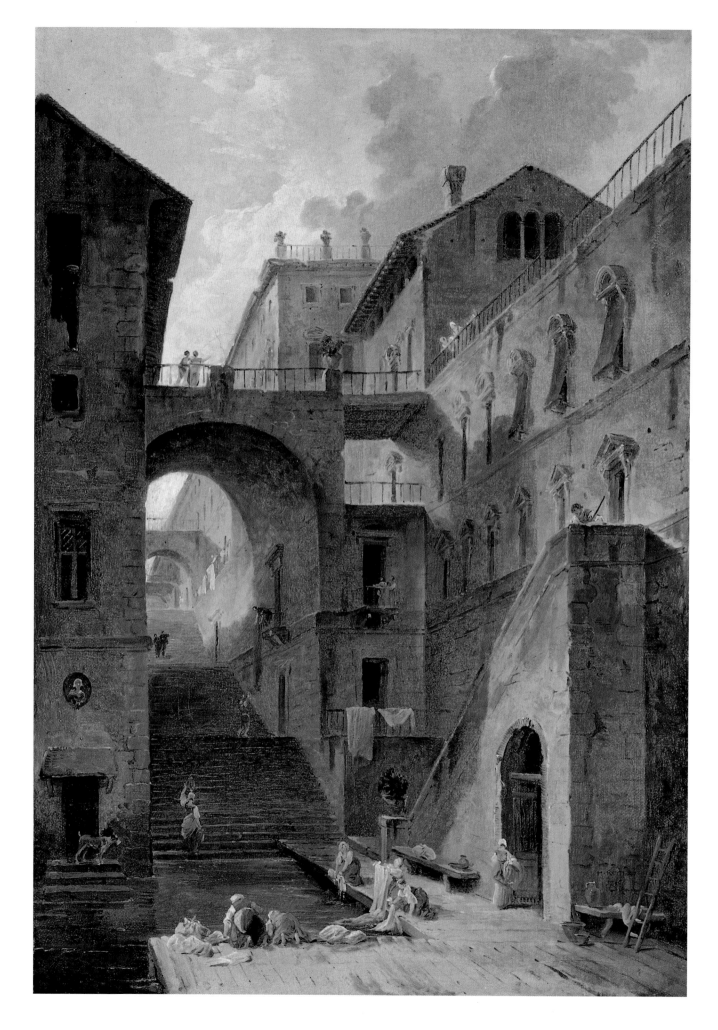

JOSEPH DUCREUX

1735–1802

The son of an artist, Joseph Ducreux from Nancy had the distinction of being the only pupil of Maurice Quentin de La Tour (q.v.), from whom he derived a lifelong interest in portraiture and facial expressions. Having entered the Académie de Saint Luc in 1764, Ducreux was entrusted by the duc de Choiseul with the delicate task of traveling to Vienna, in 1769, to paint the first official portrait of Archduchess Marie Antoinette, who later named him her first painter when she became queen. However, during the Revolu-tion he switched allegiances and recorded the features of, among others, Mirabeau and Robespierre, and he also sketched the last portrait of Louis XVI just before his death. Ducreux is perhaps best known for his self-portraits illustrating various emotions.[1]

1. See Colnaghi, *1789: French Art During the Revolution* (New York, 1989), pp. 158–59, no. 18.

After Joseph Ducreux, 18th century

62. *Portrait of Marie Antoinette*

Oil on canvas mounted on board
25 3/8 × 21 in. (64.8 × 55.3 cm)
Gift of Mrs. Charles Sumner Bird
1981.722

PROVENANCE: Mrs. Charles Sumner Bird, Ipswich, Mass.

REFERENCE: Murphy 1985, p. 86.

CONDITION: The original plain woven fabric support has been lined to a cradled board with the tacking edges trimmed. The paint is applied over a red ground and is in fair condition, except for a strip of in-painted damage at the right, confined to the background.

Ducreux was sent to the Hapsburg court at Vienna to paint the official portrait of Marie Antoinette on the occasion of her betrothal to the dauphin in 1769. She was fourteen years old at the time and easily tired of the many sittings. The portrait was damaged before shipment, and the artist had to complete a second one in three weeks. Sent to Paris, it was widely copied, so that even though the original is now lost the type is well known.[1] This example shows a somewhat wooden quality in the hair and face, but as Eunice Williams has

CAT.
62
(far left)

CAT.
63
(left)

observed, "there is still a trace of sweetness and formality appropriate for a princess who knows she will be queen of France."[2]

1. See P. de Nolhac, "Les Portraits de Marie-Antoinette par Ducreux," *GBA* 62, no. 711 (Dec. 1920), pp. 367–74.

2. Note of September 1982 in the Paintings Department files.

Follower of Joseph Ducreux, late-18th century

63. *Portrait of a Boy*

Oil on canvas
21 1/2 × 17 15/16 in. (54.6 × 45.6 cm)
The Forsyth Wickes Collection
65.2641

PROVENANCE: descended in the family of the artist, Villa Meguillel at Neuilly-sur-Seine (?); Cailleux, Paris; purchased May 8, 1936, by Forsyth Wickes.

REFERENCES: Murphy 1985, p. 86; Zafran, in Munger et al. 1992, p. 69, no. 7.

CONDITION: The oval fabric support has been glue-lined and has a repaired tear above the sitter's proper left eye. The paint layer is applied over a cream-colored ground and is slightly abraded in the shadows, the contour of the face, and in the central part of the jacket. Discolored and clumsy retouches exist at these areas.

If it were not for the presumed provenance of the painting, one would not particularly associate it with Ducreux, whose best-known works typically have much greater strength and vivacity. This rather bland depiction of a young man looking at the viewer is most likely by a minor artist of the late-eighteenth century who had some knowledge of Ducreux's portrait style.

NICOLAS-BERNARD LÉPICIÉ
1735–1784

Nicolas-Bernard's father was François-Bernard Lépicié, a *graveur du roi* and secretary of the Académie royale who was known for his reproductive prints, especially those after paintings by Jean-Siméon Chardin (q.v.). François-Bernard and his wife, who was also an artist, resided in the Louvre from 1748 and provided the first training for their son, who then went on to study with Carle van Loo. Nicolas-Bernard won several prizes at the Académie royale de peinture et de sculpture, including the second Grand Prix in the *concours* of 1759. He was *agréé* for his *William the Conqueror* in 1764, which was then exhibited at the Salon of 1765, and *reçu* as a history painter in 1769. In the early part of his career, he was primarily a painter of history and religious subjects.

In the early 1770s, Lépicié also began painting and exhibiting small genre scenes inspired by seventeenth-century Dutch paintings and the much-acclaimed works of Jean-Baptiste Greuze (q.v.). The critic Louis Petit de Bachaumont, writing in 1773, noted Lépicié's deficiencies as a history painter but found these genre subjects in the tradition of Teniers captivating, and praised their "truthfulness."

Toward the end of his life, Lépicié underwent a spiritual crisis and sought to eliminate what he felt were licentious elements from his work. In his will, made sometime before April 1783, he lamented having painted and engraved mythological works that might give rise to evil thoughts, and he also specified that some of the prints after his paintings be destroyed.[1]

1. P.-G. Dreyfus, "Une Dernière Volonté de N.-B. Lépicié," *BSHAF* (1910), pp. 18, 20; and Dreyfus 1923, p. 205, no. 179.

64. *Portrait of a Girl*

Oil on canvas
15 1/2 × 12 3/8 in. (39.4 × 31.6 cm)
Charles H. Bayley Picture and Painting Fund
1981.278

PROVENANCE: sale Christie's, London, April 10, 1981, no. 4; Somerville and Simpson Ltd., London, 1981.

REFERENCE: Murphy 1985, p. 165.

CONDITION: The plain woven fabric support has been glue-lined onto Fabrisil, with the tacking edges intact. The paint is applied over a double ground, composed of a red layer below a gray layer. The painting is in excellent condition.

A good number of head studies of young people, both in oil and pastel, have been attributed to Lépicié.[1] In contrast to the rather cheerful depictions of youthful boy artists (see cat. 65) are several

somber studies of young women. One of these oils relates to a
larger genre painting, *Le Lever de Fanchon*,[2] suggesting that Lépicié
may have done his bust-length studies from life and then incorpo-
rated them into more complex compositions. The intensity of the
present example is partly due to the excellent condition of the work,
which allows one to appreciate the rich impasto in the face and
bodice contrasted with the translucent glazes.

1. See Rosenberg and Stewart 1987, pp. 222–24.

2. See Galerie Heim, *Le Choix de l'Amateur* (Paris, 1974), no. 38.

followed by Hubert Drouais (q.v.), Jean-Baptiste Greuze (q.v.), Carle van Loo, and Elisabeth Vigée-Le Brun (q.v.).[1] Perhaps no one produced more variations on the theme, both in oil and pastel, than Nicolas-Bernard Lépicié, the son of the celebrated engraver of Chardin's works, François-Bernard Lépicié.[2] Although identified by Louis Dumas in 1920 only as French school, the present pastel was included in Lépicié's oeuvre by Phillipe-Gaston Dreyfus, who dated it about 1770 and, with reference to the inscription on the portfolio, wrote: "The child represented can be neither the engraver J. B. Delafosse, student of Fessard (1721–1775), nor J. Charles the architect (1734–1789). He is probably the child of either the engraver or the architect and a student of Lépicié."[3]

It is not certain, however, that the name "la Fosse" refers to the subject. It might instead be an identification of the young artist's master caricatured in the drawing on the portfolio. The boy's mischievous expression may be due, as Jean-Pierre Cuzin observed,[4] to his having hidden something in the portfolio, and indeed what is possibly the handle of a racquet is seen protruding from it.

1. J. Baillio, in Fort Worth 1982, pp. 30–32, no. 2, fig. 1. Also see Kunsthaus, *Handzeichnungen alter Meister aus schweizer Privatbesitz* (Zurich, 1967), no. 33. A similar painting is in the Baltimore Museum of Art (*The Young Draftsman*, oil on canvas, 32 1/2 × 26 in., attributed to François-Hubert Drouais, acc. no. 1970.2.1). A version after Drouais was sold at Phillips, London, December 11, 1990, no. 271.

2. Several examples were in the David-Weill collection. See Henriot 1928, vol. 1, pp. 239, 245, 249. See also F. Ingersoll-Smouse, "Trois Portraits des enfants . . . de N.-B. Lépicié," *RdA* 40 (Dec. 1921), pp. 323–29. Another is in San Francisco; see Rosenberg and Stewart 1987, pp. 222–23. Others are in the Louvre and the Mauritshuis, the Hague; see London 1968, no. 431, fig. 171; one was also formerly with the London dealer John Mitchell; and another sold at Christie's, New York, October 9, 1991, no. 9.

3. "L'enfant représenté ne peut être ni le graveur J.-B. Delafosse élève de Fessard (1721–1775) ni J. Charles l'architecte (1734–1789). Il s'agit probablement d'un enfant du graveur ou de l'architecte qui avait été élève de Lépicié." Dreyfus 1923, p. 112.

4. In conversation, January 1990.

School of Nicolas-Bernard Lépicié, late-18th century

65. *Portrait of a Boy Holding a Portfolio (Le Jeune Ecolier)*

Pastel
18 3/4 × 14 in. (47.6 × 35.6 cm)
Inscribed on the portfolio: *la fosse*
The Forsyth Wickes Collection
65.2663

PROVENANCE: Delafosse family (?); Georges Wildenstein by 1923; Wildenstein and Co., New York; purchased November 27, 1928, by Forsyth Wickes.

EXHIBITION HISTORY: New York, Wildenstein and Co., *Pastellistes français*, 1920; Copenhagen 1935, no. 279 (as by Nicholas-Bernard Lépicié).

REFERENCES: L. Dumas, "Aux pastellistes français," *La Renaissance* (1920), p. 230 ill. (as école française); Dreyfus 1923, p. 112, no. 377; Rathbone 1968a, pp. 21, 59 ill.; Rathbone 1968b, p. 738, fig. 10; Murphy 1985, p. 105 (as French, 3rd quarter, 18th century); Zafran, in Munger et al. 1992, pp. 87–88, no. 30.

CONDITION: The pastel is in good condition.

The subject of young boys as scholars and draftsmen, often holding their portfolios—a reflection of the early age at which artistic training began in the eighteenth century—was a popular one. The tradition, which was probably begun by Chardin (q.v.), was

Follower of Nicolas-Bernard Lépicié, French (?), late-18th century

66. *Servant Girl Plucking a Chicken*

Oil on canvas
35 × 28 in. (89 × 71 cm)
The Forsyth Wickes Collection
65.2650

PROVENANCE: comte de Houdetot (?); Hôtel des Ventes, Paris, December 19–20, 1859, no. 83 (?); Wildenstein and Co., New York; purchased November 13, 1945, by Forsyth Wickes.

REFERENCES: Dreyfus 1923, p. 90, no. 221 (as *Jeune cuisinière faisant son marché*); Rathbone 1968a, p. 21; Rathbone 1968b, p. 738, fig. 9; Murphy 1985, p. 115 (as German, 2d half, 18th century); Zafran, in Munger et al. 1992, p. 79, no. 18.

In the past, this work has been attributed to the genre painter Nicolas-Bernard Lépicié and was identified by Phillipe-Gaston Dreyfus as the work listed in the Houdetot sale of 1859. Since the sale catalogue is unillustrated and contains no further description or measurements, it is not possible to be absolutely certain of this. The painting's execution is less fine, and the finish harder, than those that can be seen in other works of Lépicié. It recalls to some extent the approach of other French genre masters—such as Jean-Georges Wille, Etienne Aubry, and Martin Drolling—all of whom were indebted to Lépicié to some extent. On the other hand, both Margaret Stuffmann[1] and Eunice Williams have suggested the painting may be by a German artist. The latter has tentatively attributed it to Georg Karl Urlaub (1749–1811).[2]

1. During a visit to the Museum in April 1990.

2. Note of June 24, 1982, in the Paintings Department files. Several examples of Urlaub's work that treat similar subjects were once in the Städelsches Kunstinstitut, Frankfurt. They are now in the historical museum of that city.

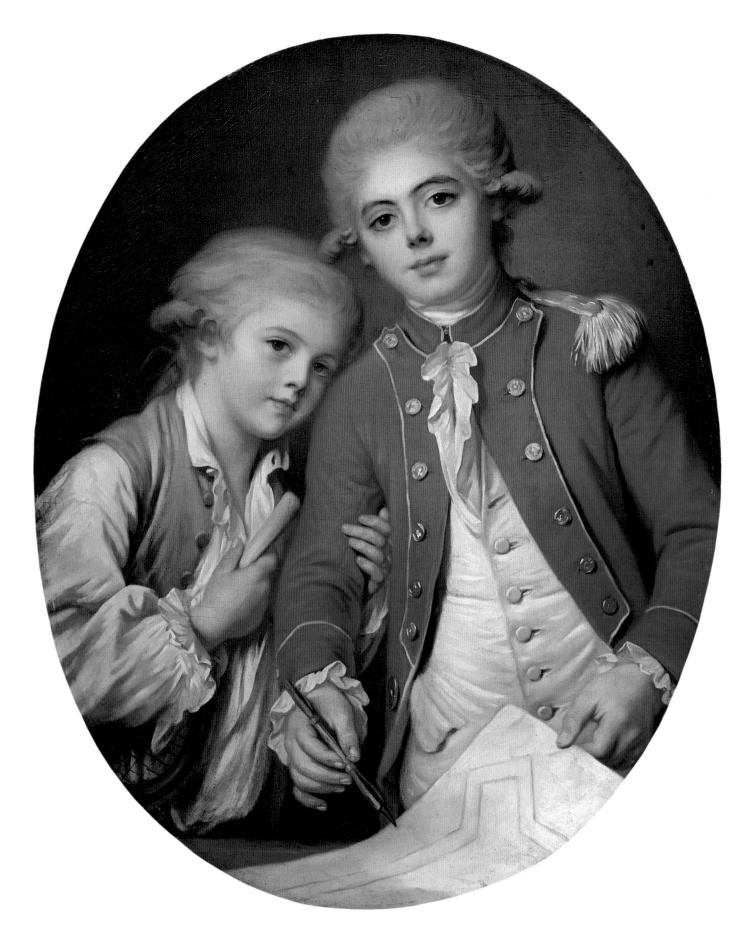

JOSEPH BOZE

1745–1826

Joseph Boze was the son of a sea captain who was later commandant of the West Indies and consul in Malta. Born in Martigues, Boze studied painting in Marseille, Nîmes, and Montpellier before going to Paris, where he probably trained with Maurice Quentin de La Tour (q.v.). He never gained admittance to the Académie royale de peinture et de sculpture but had a successful career as a court painter, preparing miniatures and oil and pastel portraits, often of the royal children. Implicated in the preparations for the royal family's flight to Varennes in 1791, he later testified on the queen's behalf during her trial and was himself imprisoned until the fall of Robespierre, after which he emigrated. Boze lived in Belgium, Holland, and England until he returned to France in the Napoleonic period. In 1816, after the Restoration, he was given the title of *comte*.[1]

1. See N. Herbin-Devedjian, "Un Artiste sous la Révolution: le peintre Joseph Boze," *BSHAF* (1981), pp. 155–64.

Attributed to Joseph Boze

67. *Portrait of Two Boys*
(The Autichamp Brothers?)

Oil on canvas
28 1/2 × 23 in. (72.4 × 58.4 cm)
The Forsyth Wickes Collection
65.2636

PROVENANCE: château du Blésois; sale Hôtel des Ventes, Orléans, July 23, 1930 (as attributed to Greuze); Paul Cailleux, Paris; purchased March 10, 1930,[1] by Forsyth Wickes.

EXHIBITION HISTORY: Copenhagen 1935, no. 24.

REFERENCES: *Gazette de l'Hôtel Drouot*, Paris, July 16, 1930, ill; Murphy 1985, p. 32; Zafran, in Munger et al. 1992, pp. 65–66, no. 3.

CONDITION: The oval plain woven fabric support has been lined, with the tacking margins trimmed. The thick paint layer is applied over a red ground and has age cracks and scattered losses throughout.

Boze often employed the oval format,[2] and his works tend to exhibit the somewhat smooth and sweet quality evident here.[3] This double portrait of two young boys with their sympathetic embrace probably derives, as Edgar Munhall pointed out,[4] from Greuze's *Portrait of the La Rochefoucauld Brothers* of about 1773.[5] It has traditionally been said to portray the Autichamp brothers. If so, the older boy must be Charles de Beaumont, later comte d'Autichamp, who was born in 1770 and early entered into military service.[6]

1. According to information from Galerie Cailleux, February 17, 1990.

2. See, for example, one in San Francisco; Rosenberg and Stewart 1987, pp. 132–33.

3. As Joseph Baillio has pointed out in conversation, to some extent this work's style also recalls the portraits painted by Johann Friedrich Tischbein.

4. In conversation, February 1, 1990.

5. See E. Munhall, "Quelques Découverts sur l'oeuvre de Greuze," *RdL* 16, no. 2 (1966), pp. 91–92, figs. 16 and 17.

6. Dr. Hoefer, *Nouvelle Biographie générale* (Paris, 1861), vol. 3, col. 788.

CLAUDE-JEAN-BAPTISTE HOIN

1750–1817

Claude-Jean-Baptiste Hoin, along with Pierre-Paul Prud'hon (q.v.), was a student of François Devosge at the drawing school at Dijon, where Hoin's family were doctors and jewelers. When he was about twenty, he went to Paris, where he was influenced by Jean-Baptiste Greuze (q.v.). A portraitist for both the court, specifically the king's brother, and the theater, he worked in oil, watercolor, and pastel. He returned to Dijon in 1780, where he became a professor and in 1811 curator of the local museum.[1]

1. See the series of articles by R. Portalis in *GBA* 22 (1899), pp. 441–61; and 23 (1900), pp. 10–24, 203–16, and 293–309.

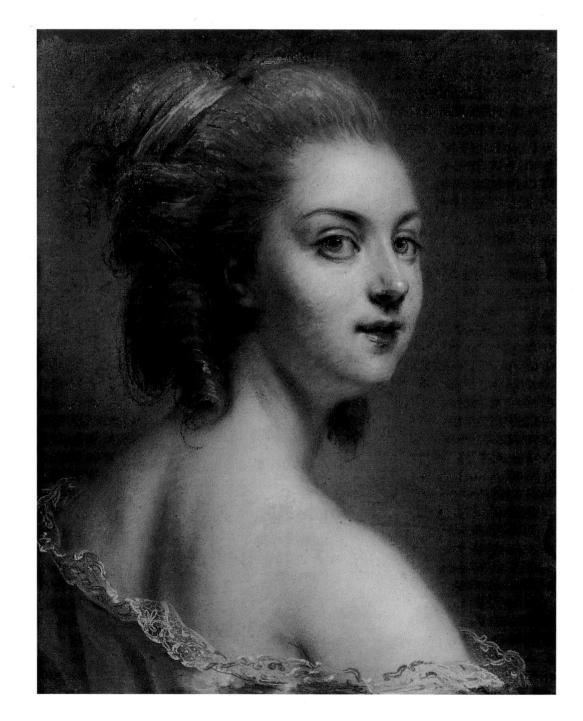

Attributed to Claude-Jean-Baptiste Hoin

68. *Presumed Portrait of Mademoiselle Rosalie Duthé*

Pastel on paper
18 × 14 1/2 in. (45.7 × 36.8 cm)
The Forsyth Wickes Collection
65.2660

PROVENANCE: Paul Cailleux, Paris; purchased in 1927 by Forsyth Wickes.

EXHIBITION HISTORY: Paris, Galerie Charpentier, *Les Arts au Théâtre*, 1925, no. 75; Paris, Musée Carnavalet, *Le Théâtre à Paris*, 1929, no. 158; Copenhagen 1935, no. 270.

REFERENCES: Murphy 1985, p. 132; Zafran, in Munger et al. 1992, pp. 85–86, no. 27.

CONDITION: The pastel is in fair condition, with water stains and some smudging.

This portrait is reputed to represent Catherine-Rosalie Gérard, called Mademoiselle Duthé (1748–1830), a singer and dancer in the corps de ballet of the Opéra, who, as a courtesan, had several notable liaisons with aristocrats, including the duc de Durfort, the marquis de Genlis, and the comte d'Artois, the future Charles X.

In the late 1780s she immigrated to London.[1] Other depictions of her are known by Jean-Honoré Fragonard (q.v.),[2] Lié-Louis Périn-Salbreux,[3] Antoine Vestier,[4] and in her English phase by Henry-Pierre Danloux.[5] In this pastel she coyly looks out over her bare shoulder at the viewer, with a direct sensuality displaying her evident pride in her blonde good looks. The technique of the drawing does not seem as strong as the best works by Hoin, but there are occasional bust-length studies by him of equally seductive female figures[6] that at least provide some support for the traditional attribution.

1. See Baron de E. L. Lamothe-Langon, *Souvenirs de Mlle Duthé de l'Opéra, 1748–1830* (Paris, 1909).

2. See Wildenstein 1960, p. 274, no. 345, fig. 150.

3. See B. Lossky, in Tours, Musée des Beaux-Arts, *Peintures du XVIIIe siècle* (Paris, 1962), no. 79.

4. See London 1968, fig. 309.

5. See R. Portalis, *Henry-Pierre Danloux* (Paris, 1910), p. 126; one sold at Palais Galliera, Paris, April 6, 1976, no. 22; and another now in the Staatliche Kunsthalle, Karlsruhe, sold at Sotheby's, Monte Carlo, March 5, 1984, no. 1087, and exhibited in Colnaghi, *Art, Commerce, Scholarship* (London, 1984), p. 176, no. 55, p. 92 ill.

6. For example, a bust of a young girl, also from Cailleux, of which a photograph is at the Frick Art Reference Library; one illustrated in Musée des Beaux-Arts de Dijon, *Claude Hoin, Dijon, 1750–1817* (Dijon, 1963), pl. XI, fig. 47; and for others at Toulouse and elsewhere, see R. Portalis in "Claude Hoin," *GBA* 22–23 (1899–1900), pp. 447, 213, and 301.

JEAN-JOSEPH TAILLASSON
1745–1809

Jean-Joseph Taillasson was born in Bordeaux, but in 1764 he entered the Paris atelier of Joseph-Marie Vien. There he was a fellow student with Jacques-Louis David, whose severe neoclassical style would come to dominate his generation's approach and also inspire Taillasson's taste for ancient subjects. After failing three times to win the Prix de Rome, Taillasson made his own way to Rome in 1773 and remained there for four years. In 1783 Taillasson, who became a full member of the Académie royale de peinture et de sculpture the following year, first exhibited at the Salon and continued to do so until 1806. In addition to his painting, Taillasson was known for his writing on art and his poetry.

69. *"Seigneur! Voyez ces yeux"* *(Cleopatra Discovered by Rodogune to Have Poisoned the Nuptial Cup)*, 1791

Oil on canvas
54 3/8 × 73 in. (138.1 × 185.4 cm)
Signed and dated lower right: *Taillasson 1791*
Charles H. Bayley Picture and Painting Fund
1981.79

PROVENANCE: Godefroy, Paris; private collection, Constance, by 1809; Norman Leitman, London, 1981.

EXHIBITION HISTORY: Paris, Salon of 1791, no. 3.

REFERENCES: Dezallier d'Argeville 1791, pp. 2–3, no. 3; P. Bordes, *Le Serment du Jeu de paume de Jacques-Louis David* (Paris, 1983), pp. 75, 116; Murphy 1985, p. 274; J.-P. Mouilleseaux, in Bordeaux 1989, pp. 255, 257, 268, 304–305, fig. 1; J.-F. Heim, C. Béraud, and P. Heim, *Les Salons de peinture de la Révolution française, 1789–1799* (Paris, 1989), p. 349; Grand Palais, *La Révolution française et l'Europe, 1789–1799* (Paris, 1989), vol. 3, p. 855.

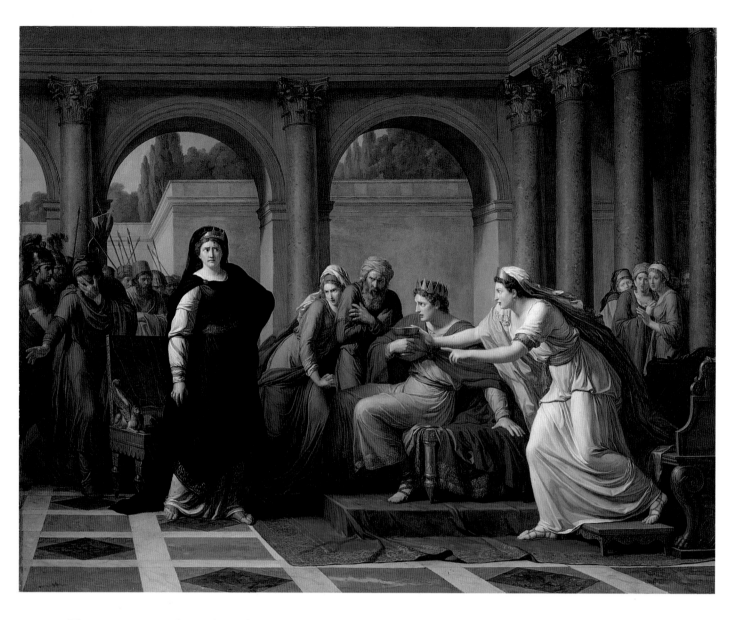

CONDITION: The painting is in outstanding condition. The original support, a plain woven medium-weight fabric, is unlined. A fine, light ground is visible in the interstices on the reverse of the ground support. Tacking margins suggest two priming layers: a gray top layer and a pink bottom layer. It is not certain whether both primings are present under all areas of the composition. Examination under infrared light reveals delicate freehand drawing under the faces of the primary figures and ruled lines for the architecture. There is little abrasion or loss in the thin, finely applied paint films.

This painting was exhibited at the Salon of 1791, and the *livret* contained the following text identifying the scene: "Cleopatra, pretending to cede her throne to her son Antiochus and to give him Rodogune as a bride, presents him with a poisoned wedding cup. Upon seeing that her crime will be discovered, she drinks and gives the cup to her son. But the poison has an effect on Cleopatra; Rodogune perceives this, stops Antiochus, and cries, 'My lord! . . . Look at her eyes!' "[1]

The subject and this key last line are taken from *Rodogune*, Pierre Corneille's tragedy of 1644. Based on a passage from Appian, it was considered by its author and others to be his greatest work.

The heroine is Rodogune, princess of Parthia, but it is the villainous character Cleopatra, queen of Syria, who has the juiciest role. To maintain her hold on the throne, she first murders her husband, who had become enamored of Rodogune. Then, as it is apparent her twin sons also love Rodogune, Cleopatra, in her efforts to prevent a marriage, slays one and offers the other, named Antiochus, a cup of poisoned wine. Forced to drink first from the vessel, Cleopatra imbibes and the results are immediately evident to Rodogune, whose impassioned outburst in act five, the climactic moment of the play, was chosen for illustration by Taillasson and several earlier French artists.

The first major painting of the subject was that by Charles-Antoine Coypel (fig. 69a) of 1747.[2] Coypel, who made something of a specialty of grandiose theatrical and biblical subjects, sets the scene in a huge, columned interior in which the empty throne looms over the participants as a silent reminder of the quest for power. The figures are divided into three major groups. Standing at the center are Rodogune and Antiochus. Her arms encircle him. With one hand she restrains him from lifting the poisoned cup and with the other gestures toward his mother at the left. Rushing in

from the middle left is Timagene, guardian of the two brothers, to report finding the dying brother, Selecus, in the garden. At the right is Oronte, Rodogune's brother and the ambassador to the king of Parthia. His gesture and gaze are also directed at Cleopatra, who clutches at her voluminous fur-lined robe and struggles to support herself as the poison begins to take effect. To her left is her confidant, Laonice. Coypel's depiction of Cleopatra has an operatic quality comparable to that given to other female figures in many of his works such as the *Athalie* (Musée de Brest).[3]

Coypel's painting undoubtedly served to inspire the next known depiction. This is in an edition of Corneille's play published in 1760 with an etched frontispiece (fig. 69b) inscribed with an impressive roster of creators: "Designed by F. Boucher. Etched by Mme. de Pompadour. Retouched by C. M. Cochin." The subject of the etching, as given by the inscription, is "Rodogune Act V, Scene IV," and again the full line quoted is "My lord, see her eyes, already distraught, blurred, and raging."[4] In preparation for the print, Boucher (q.v.) made two black-and-white chalk drawings, one of the figures of Cleopatra and her attendant and the other of Rodogune and Antiochus (figs. 69c and d).[5] Although the print is vertical in format, it condenses the scene to focus on the four major figures, which are clearly derived from Coypel's painting. Antiochus, in his huge, feathered helmet, is almost a direct borrowing. In the Morgan Library's preliminary drawing, Rodogune extends both hands toward the evil queen, but in the print she holds the cup with one and points accusingly with the other.

Boucher apparently could not bring himself to create an ugly figure, and thus his Queen Cleopatra, despite the similar gesture of gathering up her garment, remains a noble, even attractive, figure without the theatrical eye-rolling of Coypel's. The isolation of the queen with just the one servant also provides for a sharper focus.[6]

Looking at Taillasson's large painting, one sees clearly that the Revolution and the development of the neoclassical style of Vien, perfected by David, introduced a very different aesthetic. It is nevertheless reminiscent of Coypel, with a horizontal composition set in a large columned gallery—although now the columns are Corinthian instead of Solomonic. There is also a patterned stone floor, and Cleopatra is the dominant figure on the left side of the composition (fig. 69e). She dominates both in height and by her immense expanse of black robe (the mourning dress for her deceased husband). As in Coypel's conception, the action is frozen at the key moment, but here it reads much more like a frieze than a theater piece. Rodogune, observing the queen's rolling eyes, has leapt forth from her throne to place one hand on the poisoned cup while pointing with one extended finger (fig. 69f). Both the prince and the princess are in strict profile (fig. 69g). Cleopatra, framed by the archway, ominously rises up, one half of her face bathed in shadows. Her throne has been set tellingly at a lower level than her son's. In this case, the figures huddled together behind the prince (fig. 69h) are probably Oronte and Laonice. The former is truly shocked and the latter, accomplice to the attempted murder, is perhaps distressed over the unexpected outcome.

Fig. 69a. Charles-Antoine Coypel, *Rodogune Discovers the Nuptial Cup Poisoned by Cleopatra of Syria*. Oil on canvas. Paris, Musée du Louvre, inv. no. 3542

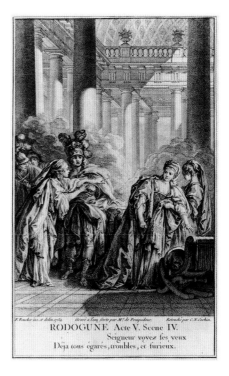

Fig. 69b. Engraved frontispiece by Mme de Pompadour and Cochin after Boucher for Pierre Corneille, *Rodogune, princesse des Parthes*. New York, The Pierpont Morgan Library

Figs. 69c and d. François Boucher, *Cleopatra and Her Attendant* and *Rodogune and Antiochus*. Black and white chalk. New York, The Pierpont Morgan Library, III, 104a

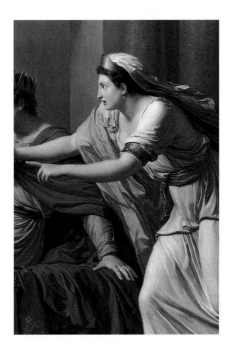

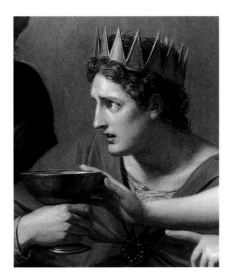

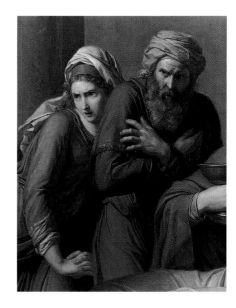

Fig. 69h. Oronte and
Laonice. Detail of cat. 69

The frozen neoclassical style that Taillasson displays in this subject from Corneille is evident in a great many of his works, such as *Virgil Reading the Aeneid to Augustus* (London, National Gallery) and *Hero and Leander* (Blaye, Musée des Beaux-Arts).[7] He had also previously evidenced a liking for dramatic, large-scale female figures in his *Mary Magdalen* of 1784 and *Electra* of 1785.[8]

Taillasson's preliminary drawing for the composition (fig. 69i) is in the Bibliothèque Nationale and differs notably from the painting in that Cleopatra is shown seated, her hands on her knees, looking directly out.[9] This is a much less-successful arrangement than that of the final painting, with the powerful standing queen. Such dramatic changes seem to be typical of Taillasson's way of working. For example, his preliminary drawing for *Berenice Reproaching Ptolemy* (Detroit Institute of Arts) showed the emperor, in an analogous position to the Boston Cleopatra, as an older, bearded man wearing a pointed hat. In the finished painting of 1802 (also Detroit Institute of Arts), however, he is a young man with a headband.[10]

At the Salon of 1791 Taillasson displayed three works. In addition to the finished painting of Rodogune, there was also an oil sketch of it, the present location of which is not known.[11] The other painting displayed was a dramatic *Suicide of Sappho* (fig. 69j) with the heroine given Taillasson's typical grandiose, anxiety-ridden face and angular body.[12] It was the Rodogune, however, that drew the most attention. The author of the *Sallon de peinture* described it thus: "[T]his well-composed picture is of the greatest interest for its noble and varied expressions," but the Sappho was found to be "much weaker."[13] For Dézallier d'Argenville, the purported author of the *Explication et critique impartiale*, the figure of Rodogune did not succeed in illustrating the text, but the expression of Cleopatra was well presented: "Her head has great character: One can see in it something dark and sinister." Likewise, Antiochus was thought to be gracefully posed and well drawn. In sum, "there is much of interest in this picture, but little effect. The draperies are shabby,

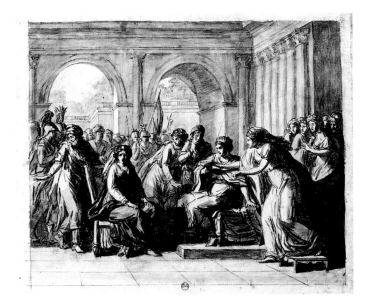

Fig. 69i. Jean-Joseph Taillasson, preliminary drawing for cat. 69. Paris, Bibliothèque Nationale

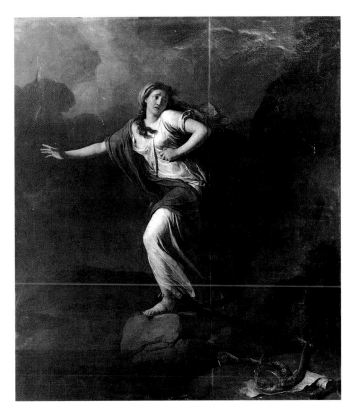

Fig. 69j. Jean-Joseph Taillasson, *Sapho*. Brest, Musée des Beaux-Arts. Photograph: Musée Nationaux, inv. no. RF 1973-43

rigid, and too uniform; the color is too gray and wooden."[14] The author of a review entitled *Lettres analitiques* was even more detailed, finding the painting one of the best that Taillasson had done since the *Philoctetes* that had gained him admittance to the Académie. Still, it was observed that the *Rodogune* "does not sparkle because of the composition, it is simply a scene from the theater copied as well as possible." While the expressions of Cleopatra and Antiochus are thought successful, that of Rodogune is again found lacking. The writer suggests that Taillasson should follow his own rules for art and that the painting should be self-explanatory.[15]

The popular success of Taillasson's *Rodogune*, despite such criticism, can be deduced from the facts that it won him a *prix d'encouragement* of four thousand livres, that it is mentioned in a letter from David as a *chef d'oeuvre* precisely for its "expression,"[16] and that it, in turn, inspired a small painting of about 1800–1805 by Girodet de Roucy-Trioson (fig. 69k).[17]

1. "Cléopâtre, feignant de céder le trône à Antiochus, son fils, & de lui donner Rodogune pour épouse, lui présente la coupe nuptiale empoisonnée; sur le point de voir son crime découvert, elle boit elle même, & donne la coupe à son fils, mais le poison agit sur Cléopâtre, Rodogune s'en aperçoit, arrête Antiochus, & s'écrie: . . . Seigneur! Voyez ces yeux." This is the text of the *livret* found in *Ouvrages de peinture, sculpture et architecture . . . exposés au Louvre par ordre de l'Assemblée nationale* (Paris, 1791), p. 4, no. 3, and as given in *Collection des livrets, Salon de 1791* (Paris, 1870), p. 10. A slightly fuller condensation of the story was given in the *Explication des peintures . . . de messieurs de l'Académie royale* (Paris, 1791), p. 18, no. 95.

2. The Coypel at the Louvre is inv. no. 3542. See Schnapper 1968, p. 257, fig. 3, and T. Lefrançois, *Charles Coypel, Peintre du roi* (Paris, 1994), pp. 362–64, nos. 265–66. A tapestry produced by the Gobelins factory after Coypel's painting is reproduced in Galerie des Beaux-Arts, *Les Arts du Théâtre de Watteau à Fragonard* (Bordeaux, 1980), pp. 200–202, no. 221.

3. See Schnapper 1968, fig. 4.

4. "Seigneur Voyez ses yeux / deja tous égarés, troublés, et furieux." For the etching by Boucher, see V. Carlson and J. Ittmann, in Baltimore Museum of

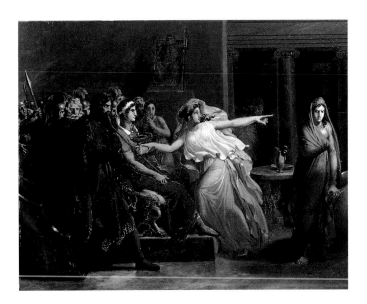

Fig. 69k. Anne-Louis Girodet de Roucy-Trioson, *Rodogune Prevents Antiochus from Drinking from the Poison Cup*. Oil on panel. Photograph courtesy Didier Aaron, New York

Art, *Regency to Empire: French Printmaking, 1715–1814* (Baltimore, 1984), pp. 128–29, no. 37.

5. For the drawings, see G. N. Ray, *The Art of the French Illustrated Book, 1700 to 1914* (Ithaca, N.Y., 1982), vol. 1, pp. 24–25, no. 7. These works are also discussed by R. Shoolman Slatkin, in Washington 1973, pp. 103–4, no. 80. L. Grigaut, "Madame de Pompadour and the Rodogune Frontispiece," *Art Quarterly* 11, no. 3 (Summer 1948), pp. 263–69; and P. Hunter-Stiebel, in Rosenberg and Stiebel, *Louis XV and Madame de Pompadour: A Love Affair*

with Style (New York, 1990), p. 61. Another drawing attributed to Boucher for the figure of Cleopatra alone was included in Hazlitt, Gooden, and Fox, *European Master Drawings* (London and New York, 1994), no. 31.

6. The painting is in the Musée des Beaux-Arts de Narbonne. A small painting of the subject with the queen shown seated was executed about 1780 by the Toulouse artist Jacques Gamelin (Narbonne, Musée des Beaux-Arts). See Musée des Augustins, *Toulouse et le néo-classicisme: Les Artistes toulousains de 1775 à 1830* (Toulouse, 1989), p. 16, no. 10.

7. See M. Wilson, in National Gallery, *French Paintings before 1800* (London, 1985), pp. 120–21, no. 50, and Grand Palais, *French Painting, 1774–1830: The Age of Revolution* (Paris, 1975), pp. 624–26, no. 172.

8. See Richard L. Feigen and Co., *Neo-Classicism and Romanticism in French Painting, 1774–1826* (New York and London, 1994), no. 55, and Washington 1976, no. 257.

9. See Mouilleseaux, in Bordeaux 1989, p. 305, no. 111.

10. The Detroit drawing is 1985.2 and the painting 75.87. See D. F. Mosby, in Detroit Institute of Arts, *The Figure in Nineteenth-Century French Painting* (Detroit, 1979), p. 17, no. 1.

11. Salon of 1791, no. 353.

12. See Mouilleseaux, in Bordeaux 1989 p. 302, no. 110.

13. *Sallon de peinture* (Paris, 1791), p. 4.

14. Dezallier d'Argeville 1791, pp. 2–3.

15. *Lettres analitiques, critiques et philosophiques sur les tableaux du Salon* (Paris, 1791), pp. 13–14.

16. See Mouilleseaux, in Bordeaux 1989, p. 305.

17. See Didier Aaron, *Catalogue Tableaux et Dessins* (Paris, London, New York, 1995), vol. 4, no. 16.

PIERRE-HENRI DE VALENCIENNES

1750–1819

Pierre-Henri de Valenciennes received his earliest training at the Académie royale in his hometown of Toulouse. There he studied with the history painter Jean-Baptiste Despax and the miniaturist Guillaume-Gabriel Bouton. He first traveled to Italy in 1769, then moved to Paris in 1771, where he entered the atelier of the history painter Gabriel-François Doyen through the influence of his patron, the duc de Choiseul, at whose country estate at Chanteloup, near Tours, Valenciennes made many studies from nature. In 1777 Valenciennes returned to Italy, staying until 1781. He first exhibited at the Salon in 1787, and was *agréé* and then *reçu* at the Académie royale that same year. Soon thereafter he opened his atelier to students and in 1800 published his treatise on perspective and landscape painting, *Elémens de perspective pratique à l'usage des artistes*, in which he stressed the value of sketching outdoors to truly capture nature on canvas. His book influenced countless neoclassical landscape painters, including Achille-Etna Michallon and Jean-Victor Bertin (q.v.). From that time he was considered the leading painter and teacher of landscape. He became the professor of perspective at the Ecole Impérial des Beaux-Arts in 1812 and was awarded the Légion d'Honneur in 1815. His greatest achievement was the creation in 1816 of a special Prix de Rome for historical landscape.

70. *Italian Landscape with Bathers*, 1790

Oil on canvas
21 1/4 × 32 1/8 in. (54 × 81.5 cm)
Signed and dated lower left: *P de Valenciennes 1790*
Gift of John Goelet
1980.658

PROVENANCE: Palais Galliera, Paris, by 1975; H. Schickman Gallery, New York; John Goelet, New York, by 1978.

EXHIBITION HISTORY: Paris, Salon of 1791, no. 11 or 132 (?); Tokyo 1983–84, no. 27; Museum of Fine Arts, Boston, *Romantic and Fantastic Landscapes*, 1991–92; Boston 1992–93.

REFERENCES: *Explication des peintures, sculptures et graveurs*, p. 26, no. 132 (?); Dezallier d'Argeville 1791, p. 4, no. 11 (?); *La Bequille de Voltaire au Salon* (Paris, 1791), p. 4, no. 11 (?); "Exposition de 1791," p. 11, no. 11 (?); Murphy 1985, p. 288.

CONDITION: The support is a glue-lined, plain woven fabric. The paint is applied smoothly and flatly over a white ground. Infrared examination reveals several pentimenti, including changes to the buildings and horizon line. The painting is moderately abraded, especially in the foreground. There is a network of age cracks throughout the painting, and in-painting is confined to the edges and foreground.

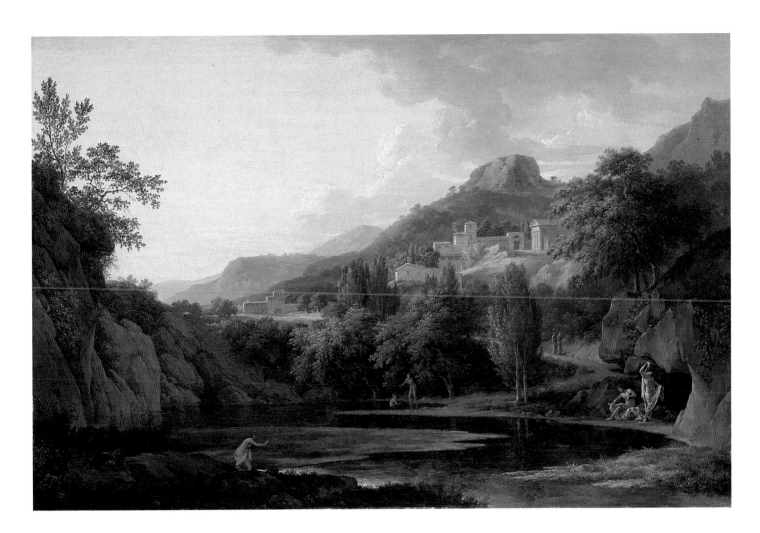

In an idealized mountain landscape cast in bright sun, Valenciennes has depicted five female figures in and around a large, tranquil pond. Two clothed figures walk down a path toward the women in the water. On a hilltop above are several Italianate buildings and a classical temple.

The *livret* of the Salon of 1791 describes number 11 as "a landscape with a view of Italy and bathers."[1] In another listing of the same Salon, number 132, by Valenciennes, is given as "view of Italy, with young girls bathing."[2] It is quite possible that one or both of these entries refer to the Museum's painting, which is dated 1790. After being *reçu* in 1787, Valenciennes exhibited regularly at the Salon until his death in 1819. During his stay in Italy between 1777 and 1781, he produced a large number of oil sketches and drawings, which are now mainly in the Louvre and the Bibliothèque Nationale. On returning to Paris, Valenciennes used these *plein-air* sketches of the Roman Campagna as the basis for his later work. As he noted, "though one may stay in Rome for years, finally one has to return home; but one should make good use of one's time there and bring back a rich harvest of sketches and drawings, to be used whenever necessary once one is no longer in that beautiful land which energizes the soul and encourages one's talent to grow."[3]

Using his views of Italy in works that evoked both the classical past and the example of Poussin, Valenciennes attempted to raise landscape to the level of history painting, then considered the noblest of the genres. His *paysages historiques*, like the neoclassical history paintings of his contemporary Jacques-Louis David, were meant to teach lessons of morality and virtue. In the Museum's painting, Valenciennes has created an idyllic vision of a golden age of Graeco-Roman antiquity that is not based on a particular myth or legend. Instead, his view of nature is an idealized and imaginary reconstruction that celebrates the beauty of the classically posed bathers and the sunlit Mediterranean setting.

1. "Exposition de 1791," p. 11.

2. *Explication des peintures, sculptures et graveurs*, p. 26.

3. Valenciennes, quoted in British Museum, *French Landscape Drawings and Sketches of the Eighteenth Century* (London, 1977), p. 99.

ADOLF ULRIC WERTMÜLLER

1751–1814

After training in his native Stockholm, Adolf Ulric Wertmüller went to Paris at the age of twenty-one to study with his uncle, the famous Swedish portrait painter Alexandre Roslin. In 1773 he became a student of Joseph-Marie Vien at the Académie royale and the next year, along with Jacques-Louis David, followed the master to Rome. During his four years there Wertmüller became conversant with the new neoclassical manner. After beginning his independent career as a portraitist in Lyon, he returned to Paris in 1781. Through Roslin he became a protégé of Gustaf Filip Creutz, the Swedish ambassador in Paris, and was appointed a Swedish court painter in 1783. The following year he was received as a member into the Académie royale and exhibited at the Salon of 1785 his two *morceaux de reception*, the *Portrait of Jean-Jacques*

Caffieri now in the Museum of Fine Arts, Boston, and that of J.-J. Bachelier as well as a portrait commissioned by the Swedish king of Marie Antoinette and her children. The last, however, was not judged a success. He began traveling more widely in search of clients, going to Bordeaux in 1788, Madrid in 1790, and Cádiz in 1791. In 1793 he departed for America, initially settling in Philadelphia, where he exhibited the sensual *Danae and the Golden Shower* (Stockholm, Nationalmuseum), which he had hoped to sell to Catherine the Great. He returned briefly to Sweden in 1797 to become a professor at the Academy, but in 1800 went back to the United States, where he married. He gradually gave up his artistic activity for the management of his farm at Nammans Creek near Wilmington, Delaware.

71. *Portrait of Jean-Jacques Caffieri*, 1784

Oil on canvas
50 3/4 × 37 3/4 in. (129 × 96 cm)
Signed and dated lower left: *A. Wertmüller / Paris 1784*
Ernest Wadsworth Longfellow Fund
63.1082

PROVENANCE: Académie royale de peinture, Paris, 1785; Comte Jean de la Riboisière, Paris, by 1910–36; sale Hôtel Drouot, Paris, March 27, 1936, no. 9 (as David); Mrs. Meyer Sassoon, 1936; to her daughter, Mrs. Derek Fitzgerald, Heathfield Park, Sussex, to 1963; sale Sotheby's, London, July 3, 1963, no. 1; F. Kleinberger and Co., New York.

EXHIBITION HISTORY: Paris, Salon of 1785, no. 123; Berlin, Königliche Akademie der Künste, *Ausstellung der französischen rokokokunst*, 1910, no. 76; London, 25 Park Lane, *Three French Reigns*, 1933, no. 127; Château de Versailles, *Les Artistes suédois en France au XVIIIe siècle*, 1945, no. 359; Stockholm, National Museum, *Le Soleil et l'étoile du nord: La France et la Suède au XVIIIe siècle*, 1993–94, no. 691 (traveled to Paris, Grand Palais).

REFERENCES: *Réflexions impartiales* 1785, p. 32, no. 124; *Discours sur l'origine, les progrès et l'état actuel de la peinture en France* (Paris, 1785), p. 32; *Inscriptions* 1785, p. 9; Montaiglon 1889, vol. 9, pp. 169, 202, 203; O. Levertin, *Nicolas Lafrensen D.Y. . . .* (Stockholm, 1890), p. 157; J. L. Vaudoyer, "Exposition d'oeuvres de l'art français au XVIIIe siècle à Berlin," *Les Arts* 103 (July 1910), p. 29 and 31, ill. (as David); A. Gauffin, "A propos de l'exposition de l'art suédois à Paris," *RdA* 56 (1929), pp. 54ff.; R. Cantinelli, *Jacques-Louis David* (Paris, 1930), p. 117, no. 174; G. Lundberg, "Falsk David dolde eftersökt Wertmüller," *Svenska Dagbladet*, April 6, 1936; G. Lundberg, "Wertmüller receptionsstycken," *Svenska Dagbladet*, April 17, 1946; G. Lundberg, "La Suède et Paris," *Kunsthistorik Tidskrift* (1948), p. 66; M. Benisovich, "Wertmüller et son livre de raison intitulé la Notte," *GBA* 48 (1956), p. 37; Lundberg 1959, pp. 208–15; M. Benisovich, "Further Notes on A. U. Wertmüller in the U.S. and France," *Art Quarterly* 26, no. 1 (Spring 1963), pp. 22, 26n., 36; T. N. Maytham, "Jean-Jacques Caffieri," *BMFA* 61 (1963), pp. 121–22, no. 325, ill.; "Accessions of American and Canadian Museums, July–September 1963," *Art Quarterly* 26, no. 4 (1963), p. 491 ill.; Murphy 1985,

p. 300; M. Uggla, in *Marie-Antoinette Porträtt av en drottning* (Stockholm, 1989), p. 8.

CONDITION: The painting is in good condition. The plain woven linen support is glue-lined, heavily impregnated with adhesive, and possibly transferred. Tacking margins have been roughly cut away. In-painted fills along each side extend the original paint films. The original ground is a light color. Paint application is fairly thin with marked variation in opacity. An extensive, deep (age) crackle pattern reads prominently in the paint surface. Except for the extensive edge losses, paint films are very well preserved with only scattered discolored retouches, mostly to cancel crackle and light abrasion.

For his admittance to the French Académie royale, Wertmüller submitted two *morceaux de reception* painted in 1784. Both were portraits of older, established artists. One was of the painter Jean-Jacques Bachelier (1724–1806; fig. 71a), and the other was this one of the noted sculptor Jean-Jacques Caffieri (1725–92). These works were exhibited at the Salon of 1785[1] and can be seen in the engraving of that year's installation.[2] The printed reviews were positive. One praised "the great truth, beautiful poses, and faces which reflect the character of the sitters, which is the difficult but divine task of art";[3] and another commended Wertmüller for the generous way in which he depicted fellow artists.[4] The works became the property of the Académie following Wertmüller's unanimous election but disappeared during the Revolution. When the Caffieri portrait reappeared in a sale of 1936, it bore a false David signature and the date 1787. At the time of that sale, Gunnar Lundberg recognized its true artist. The subsequent removal of the false addition revealed the Wertmüller signature and original date of 1784.

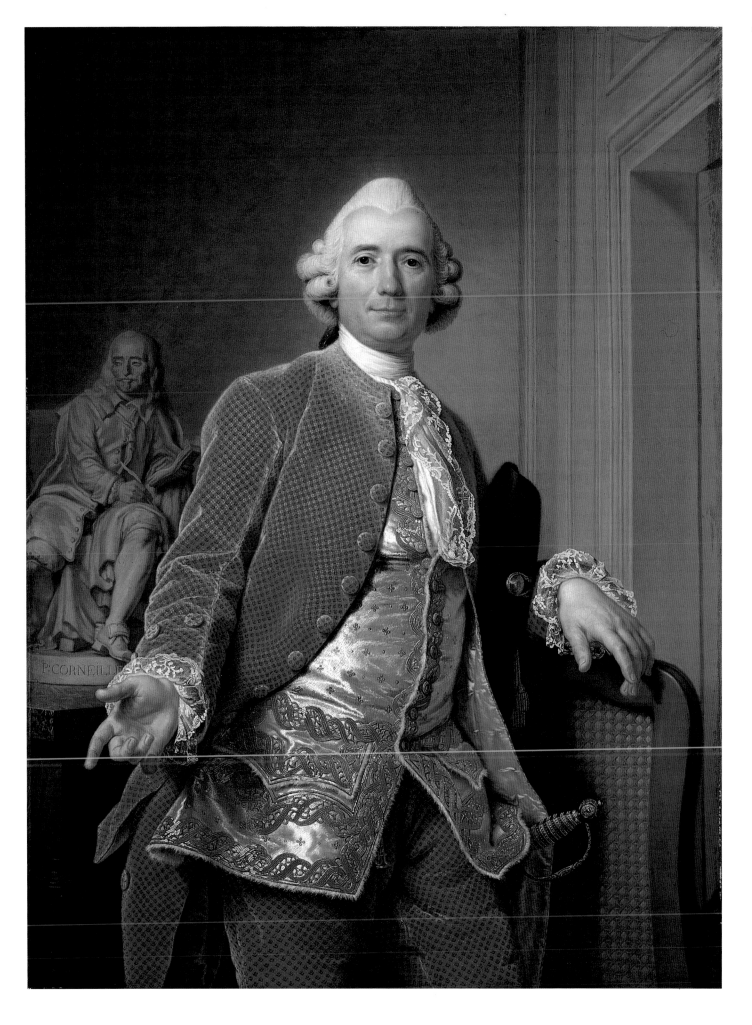

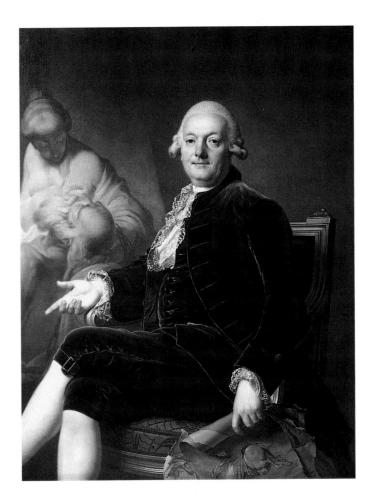

Fig. 71a. Adolf Ulric Wertmüller, *Jean-Jacques Bachelier*. Oil on canvas. Paris, Institut Tessin

This grandiose portrait, in its pose and rich treatment of fabrics, owes a great deal to the influence of Roslin. Caffieri, who won the Prix de Rome in 1748 and became a full professor at the Académie in 1773, is shown standing, leaning on the back of a chair. In the background can be seen one of his most famous works, the seated figure of Pierre Corneille, which was completed in 1777 and exhibited at the Salon of 1779,[5] in which year Caffieri also produced a full-length statue of Corneille for the king.

The portraits of Caffieri and Bachelier, nearly identical in size, worked very well as pendants, since both sitters make a similar gesture with their left hands. The blaze of red fabrics worn by Caffieri is complemented by the deep green of the suit worn by Bachelier, who is seated in front of his own *morceau de reception*, a painting of Roman Charity.

1. The two pieces are noted in Wertmüller's own handwritten record, Cod. Holm. Iv 24, p. 234 (Stockholm, Kungliga Biblioteket). See also Montaiglon 1889, vol. 9, pp. 169, 202–203.

2. The engraving, entitled *A Precise Look at the Arrangement of Paintings at the Salon du Louvre in 1785*, by P. A. Martini, was published by Bernet of Paris. An impression is in the Bibliothèque Nationale. See Lundberg 1959, pp. 208 and 214, and R. Wrigley, *The Origins of French Art Criticism* (Oxford, 1993), pl. IV.

3. *Réflexions impartiales* 1785, p. 32.

4. *Inscriptions* 1785, p. 9.

5. The terracotta model for this is in the Musée des Beaux-Arts, Rouen. See E. Minet, *Musée de Rouen: Catalogue des ouvrages* (Rouen, 1911), no. 1226.

JEAN-FRÉDÉRIC SCHALL

1752–1825

J ean-Frédéric Schall was one of the several foreign artists who had a successful career in Paris. Born in Strasbourg, he was trained there by the brothers Pierre and Henri Haldenwanger. With a letter of introduction to the engraver Jean-Georges Wille, Schall went to Paris and entered the school of the Académie royale in 1772. He studied primarily with Nicolas-Bernard Lépicié (q.v.), but his work, usually of small scale, was most greatly influenced by

Jean-Honoré Fragonard (q.v.) in its depiction of *fêtes galantes* and amorous erotica. After the Revolution, which he supported, Schall adopted a more-detailed narrative manner and also worked as a book illustrator.[1]

1. See A. Girodie, *Un Peintre de fêtes galantes—Jean-Frédéric Schall* (Strasbourg, 1927).

Attributed to Jean-Frédéric Schall

72. *La Sultana Valida*

Oil on copper
7 × 6 in. (17.7 × 15.2 cm)
The Forsyth Wickes Collection
65.2654

PROVENANCE: Georges de Batz and Co., New York; purchased October 26, 1951, by Forsyth Wickes.

REFERENCES: Murphy 1985, p. 260; Zafran, in Munger et al. 1992, pp. 81–82, no. 21.

CONDITION: The support is a copper panel, with the design confined to an oval within a painted border. The paint is applied over a granular gray ground, with

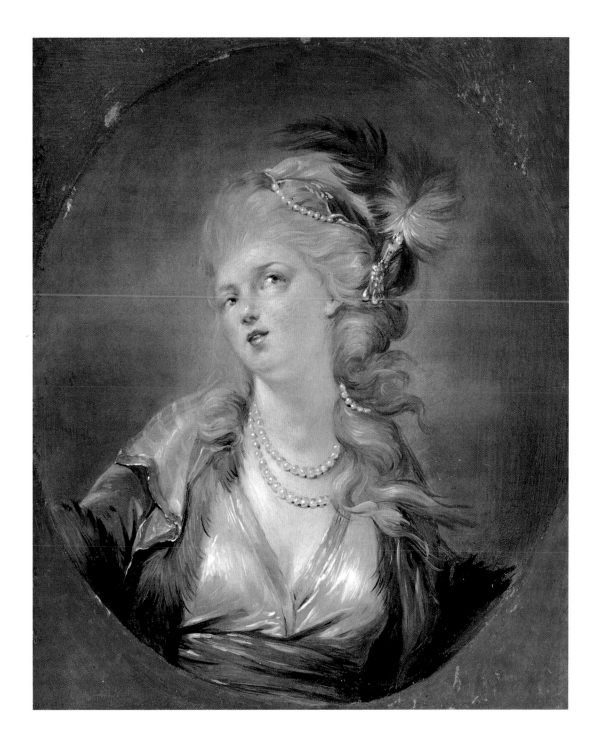

slightly impastoed, painterly brushstrokes. A contour drawing in a dry medium is visible under strong light and infrared. The paint layer is in excellent condition, with a few minor losses.

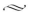

Schall's figures were usually angular and his brushwork painterly. He produced a great many small oval works, often of women dancing or making love.[1] This particular example, if not exactly comparable to others in technique, does possess the erotic charm characteristic of Schall. Fragonard painted a series of sultanas in the 1770s, and this painting reflects those as well as his more inventive *têtes de fantaisie*. The fetching woman here was thought to be shown in the midst of poetic inspiration, leading to her identification as an idealized portrait of the Princess Valida (or Valeda), daughter of the

Omayyad Calif Mohammed III al Moustafkin Billa, who was a famous orator and poetess at Córdoba in the eleventh century.[2]

1. See the examples in the Bardac sale, Galerie Georges Petit, Paris, May 10–11, 1920, nos. 37–40.

2. A drawing by Augustin de Saint-Aubin, identified as "La Sultane Validé," was sold at Galerie Georges Petit, Paris, June 16–19, 1919, no. 281.

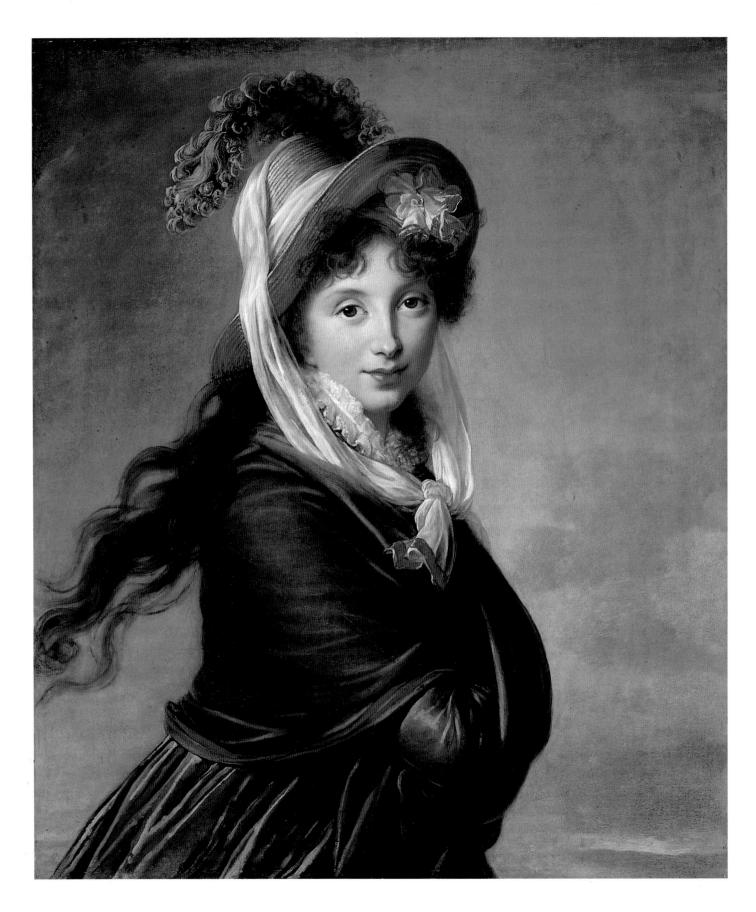

ELISABETH LOUISE VIGÉE-LE BRUN

1755–1842

Elisabeth Louise Vigée-Le Brun was born in Paris on April 16, 1755. Her father, a portrait painter and a professor at the Académie de Saint Luc, encouraged his daughter's artistic talent and introduced her to other important artists of the day, such as Joseph Vernet. Because women were not admitted to the Ecole des Beaux-Arts, Vigée-Le Brun was essentially self-taught. She copied and studied works by Rubens, van Dyck, Raphael, and other old masters. By the age of fifteen, her reputation as a skilled portraitist began to spread, and she soon acquired a large number of aristo-cratic patrons. Her most famous sitter was Queen Marie Antoinette, whom she painted more than twenty times. In 1783, with the queen's support, Vigée-Le Brun was accepted into the Académie royale, despite fierce opposition due both to her gender and to her marriage to an art dealer, which was considered a con-flict of interest. Her *morceau de reception* was *Peace Bringing back Abundance* (Paris, Louvre).

Vigée-Le Brun's fame as a painter coincided with her ascent in society. Her salon attracted notable celebrities and her parties were considered exceptional social events. By the mid-1780s, however, rumors of her putative marital infidelity began to surface, and by 1789 her personal reputation had been ruined. In October of that year, as the political situation worsened and her close relationship with the royal court put her at risk, Vigée-Le Brun fled from France to Italy with her daughter, Julie, and a governess. They re-mained in exile until 1802, and during that time Vigée-Le Brun painted numerous portraits of the aristocracy as she traveled to Naples, Austria, Poland, Russia, and Switzerland. Soon after her return to France, Vigée-Le Brun moved to London, where she pro-duced portraits of the Prince of Wales and Lord Byron. She returned again to France in 1805 and in 1809 bought a large house in Louveciennes. She spent the rest of her life commuting between Paris and Louveciennes, painting portraits, and exhibiting at the Salon. She published her autobiographical *Souvenirs*, in 1835 and 1837, providing an informative, if biased, account of her long and exciting career.

73. *Portrait of a Young Woman (Countess Worontzoff?)*, about 1797

Oil on canvas
32 3/8 × 27 3/4 in. (82.2 × 70.5 cm)
Robert Dawson Evans Collection
17.3256

PROVENANCE: Eugène Kraemer; sale Galerie Georges Petit, Paris, May 5–6, 1913, no. 50; E. M. Hodgkins; Robert Dawson Evans, Boston, d. 1909; Maria Antoinette Evans, d. 1917.

EXHIBITION HISTORY: Baltimore, Walters Art Gallery, *Old Mistresses: Women Artists of the Past*, 1972, cat. 14; Tokyo 1978, cat. 32; Fort Worth 1982, no. 45; Tokyo 1983–84, no. 28; Boston 1984, no. 25.

REFERENCES: *Catalogue des tableaux anciens . . . par suite du décès de M. Eugène Krae-mer* (Paris, 1913), p. 13, no. 50; Helm 1915, pp. 104 and 213, ill. opp. 178; F. J. Ingelfinger, "Case No. 45809," *Boston Medical Quarterly* 6 (Dec. 1955), p. 6, no. 4; E. Munhall, "Master Woman Painter in Retrospect," *New York Times*, Aug. 15, 1982, pp. 23, 25; B. Adams, "Privileged Portraits: Vigée Le Brun," *Art in America* 10 (Nov. 1982), p. 79; Murphy 1985, p. 294.

CONDITION: The plain woven fabric support has been glue-lined to a second fab-ric with the tacking margins trimmed. The lack of visible cusping at the edges suggests that the composition was originally larger. The extremely smooth paint layer is applied over a warm rose-colored ground with an additional, discontinu-ous blue layer in the sky. Infrared examination reveals that the background originally included a landscape with trees and water in the lower right, and there is some indication of it on the lower left. The paint in this area appears to be consistent with that of the figure, which suggests that the landscape was painted out by the artist. Aside from some minor retouched losses, the painting remains in excellent condition.

A young, attractive woman, who appears to be skating or walking, looks directly at the viewer while still in motion. Dressed in a dark-green silk dress and a violet-muslin shawl, she crosses her arms tightly in front of her. Her long curly hair, which is styled in a nat-ural and loose fashion, flows freely in the wind behind her. Wearing a straw hat adorned with a violet plume and a white scarf tied under her chin, she is placed before a cloud-filled sky.

In her portraits of women, Vigée-Le Brun was particularly ad-mired for her depiction of loose-fitting garments and natural, unpowdered hairstyles. She formed a large collection of scarves, shawls, robes, and hats to use as props in her works. Over half of her female sitters were portrayed wearing scarves, an effect inspired by the draperies in the works of the Italian painters who influenced her.[1] She wrote in her memoirs:

> As I had a horror of the current fashion, I did my best to make my models a little more picturesque. I was delighted when, having gained their trust, they allowed me to dress them after

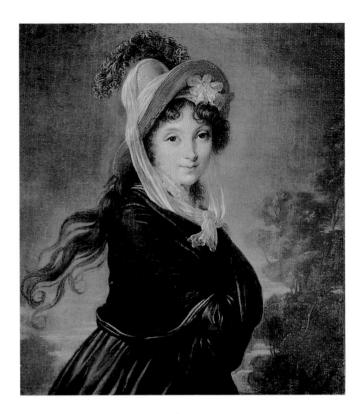

Fig. 73a. After Vigée-Le Brun, *Portrait of a Young Woman.* Oil on canvas. Photograph courtesy Sotheby's, New York

Fig. 73b. Vigée-Le Brun, *Portrait of Countess Worontzoff.* Oil on canvas. Present location unknown. Photograph courtesy Joseph Baillio, Wildenstein, New York

my fancy. No-one wore shawls then, but I liked to drape my models with long scarves, interlacing them around the body and through the arms, which was an attempt to imitate the beautiful style of draperies seen in the paintings of Raphael and Dominichino [*sic*]. Examples of this can be seen in several of the portraits I painted whilst in Russia.[2]

When this painting entered the Museum's collection, it was thought to be a portrait of the artist's daughter, Julie, for after the death of Vigée-Le Brun it had become a common practice to identify unknown youthful female sitters as such.[3] However, the artist described her daughter's eyes as being blue,[4] and in all of the certain portraits of Julie, Vigée-Le Brun portrayed her with blue eyes.[5] In the Museum's painting, not only does the woman not look particularly like Julie as she appears in other works of this period,[6] but her eyes are brown, making it certain that the sitter is someone else.

Joseph Baillio, in 1982, dated the painting to about 1797, during Vigée-Le Brun's stay in Russia. He also suggested that the sitter may be Countess Irina Ivanovna Worontzoff (1768–1848),[7] for a small copy of this portrait (fig. 73a), which has appeared in two sales, has a provenance going back to the Worontzoff estate, according to Baillio.[8] In her *Memoirs* Vigée-Le Brun recorded painting two "half-length" portraits of "Countess Worandxoff."[9] One of these must be the work signed and dated 1797, which showed the countess seated at a desk reading a play by Racine (fig. 73b),[10] and there is a definite, if not absolutely convincing, similarity between her and the woman in the Museum's painting, especially in the nose and arrangement of the hair. The two paintings would also have provided a lively contrast, with one set indoors and the other before the open sky.

Part of the difficulty in identifying the sitters in Vigée-Le Brun's portraits of women, especially those done in Russia, are the generic similarities of pose and fashion. As Baillio has pointed out, the pose and even the feather in the hat here repeat in reverse those which she had used in the three-quarter-length portrait of the actress Madame Molé Raymond of 1786 (Paris, Louvre).[11] Nearly identical in arrangement to the Museum's painting was another portrait of 1797 depicting the Grand Duchess Anna Fedorovna.[12]

The last-mentioned portrait, like the Museum's, shows the figure set before a broad sky and slightly to the left of center. The reduced copy of the Boston painting does show a cluster of trees to the right of the woman. Examination of the Boston canvas with infrared reflectography has revealed that it, too, originally had such a thicket in this position (fig. 73c). The small copy must then have been painted while Vigée-Le Brun's original was in progress, for the overpainted surface in the latter is consistent throughout, indicating that this change was probably carried out by the artist herself. The result is definitely more powerful, focusing all attention on the sitter and strengthening the severe outline of her body

Fig. 73c. Infrared
detail of cat. 73

against the sky. It is in this format that she is shown in another, clearly later, copy, which crops the empty space at the right to make the figure more central, thereby undermining the concept that made Vigée-Le Brun's original so striking.[13]

1. Helm 1915, p. 104.

2. *Memoirs* 1989, p. 27.

3. Tokyo 1978, no. 32.

4. *Memoirs* 1989, p. 211. This fact is also mentioned in correspondence from Ilse M. Bischoff, 1963, in the Paintings Department files.

5. *Self-Portrait with Daughter* (Paris, Louvre), *Julie Le Brun* (collection Michel David-Weill), and *Julie Le Brun Reading the Bible* (New York, private collection), all illustrated in Fort Worth 1982, pp. 24, 75, and 76.

6. See *Julie Le Brun as Flora* (private collection), illustrated in Fort Worth 1982, no. 50.

7. Fort Worth 1982, pp. 112–13, no. 45.

8. Sotheby's, New York, October 28–29, 1977, no. 249, and Sotheby's, New York, January 20, 1983, no. 57. At the second sale, the small copy was reattributed to Henri Nicolas van Gorp; however, Baillio disagrees with this attribution and considers it possibly the work of Auguste Rivière.

9. See the appendix to *Memoirs* 1989, p. 366.

10. See Nikolenko 1967, pp. 104–105, no. 14, who states that this work was last recorded in the Worontzoff-Dachkoff collection in St. Petersburg. More recently, according to a letter from Joseph Baillio of May 20, 1994 (Paintings Department files), it is reported to be in the collection of a Russian émigré in Toulouse, France.

11. Fort Worth 1982, p. 113, fig. 39.

12. Nikolenko 1967, p. 111, no. 37. This work, formerly in the Gotha Museum, was probably destroyed in World War II.

13. Illustrated in C. Saunier, "La Collection de Madame A. Arman de Caillavet," *Les Arts* 6 (1907), p. 17.

ROBERT LEFÈVRE

1755–1830

Robert Lefèvre was born in 1755 in the small Norman town of Bayeux. In his youth, he worked as a law clerk for an attorney in Caen while studying in his spare time to become an artist. He produced grisaille paintings for La Motte d'Airel, a manor house owned by the Marguerye family, and also began to paint portraits. Arriving in Paris in 1784, Lefèvre immediately began to study with Jean-Baptiste Regnault. In 1791 he exhibited six canvases at the Salon, which were well received. He concentrated on portraiture exclusively, and in 1801 he painted *The First Consul and General Berthier at the Battle of Marengo.* Joseph Boze (q.v.) was contracted by Lefèvre to show the painting to prospective buyers but then claimed it as his own creation, even having it engraved by Antoine-Alexandre-Joseph Cardon under his name. This led to a long legal battle between Lefèvre and Boze's wife.

Lefèvre's reputation as a portrait painter was truly established with his 1804 painting, *Napoleon in the Uniform of the First Consul* (formerly Dunkerque, City Hall; destroyed 1817). He received further commissions from the emperor, and his 1806 portrait *Napoleon in His Coronation Robes* was so admired that over thirty versions were produced by Lefèvre and his workshop after the original. His popularity continued after the fall of the Empire; in 1816 he was named *premier peintre du roi* (Louis XVIII) and was responsible for painting all portraits of the royal family. In the 1820s Lefèvre attempted history painting, executing religious canvases primarily for churches. At the age of seventy-five, after having been stripped of his titles in the Revolution of 1830, Lefèvre committed suicide.[1]

1. See J.-P. Cuzin in Detroit 1974–75, pp. 528–29.

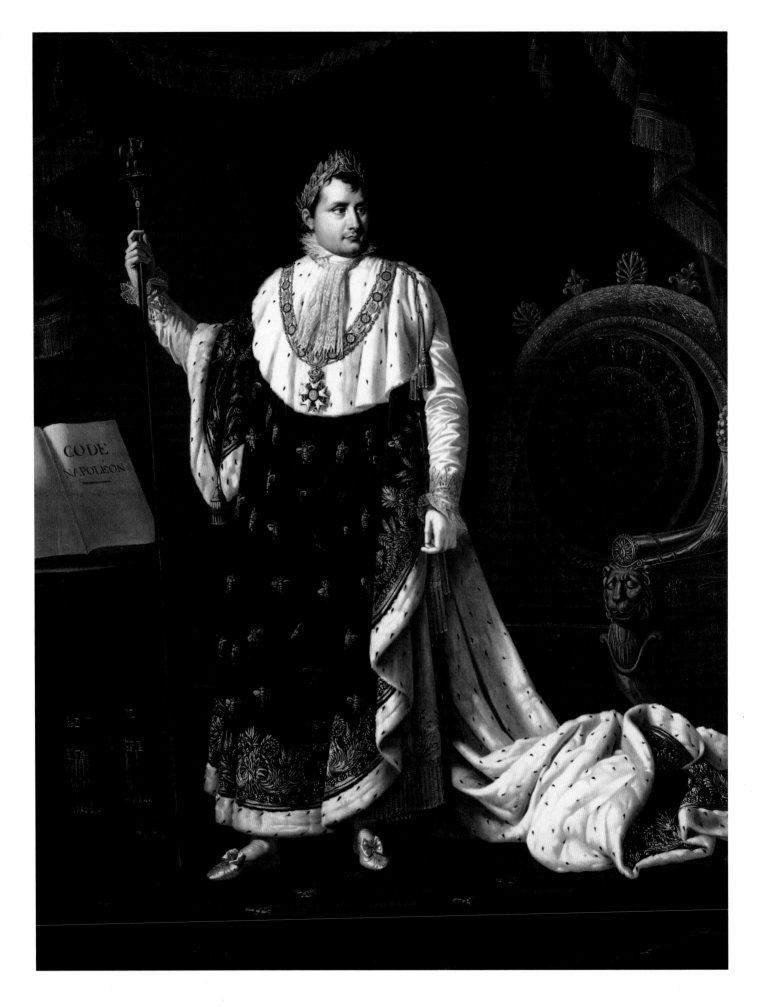

Robert Lefèvre and Studio

Robert Lefèvre and Studio

74. *Portrait of Napoleon I in His Coronation Robes*, 1812

Oil on canvas
102 1/2 × 78 in. (257 × 198 cm)
Signed and dated lower right: *Robert Lefèvre f¹. 1812.*
William Sturgis Bigelow Collection
26.789

PROVENANCE: Timothy K. Jones, Boston, by 1827; Leonard Jarvis, Boston, by 1837–at least 1856; William Sturgis Bigelow, Boston.

EXHIBITION HISTORY: Boston 1827, no. 68; Boston, Athenaeum, *The Eleventh Exhibition of Paintings in the Athenaeum Gallery*, 1837, no. 6; Boston, Athenaeum, *The Seventeenth Exhibition of Paintings in the Athenaeum Gallery*, 1843, no. 79; Boston, Athenaeum, *The Twenty-eighth Exhibition of Paintings and Statuary in the Athenaeum Gallery*, 1855, no. 150; Boston, Athenaeum, *The Twenty-ninth Exhibition of Paintings and Statuary in the Athenaeum Gallery*, 1856, no. 4; Boston 1978.

REFERENCES: Thieme and Becker 1928, vol. 22, p. 557; Boston 1955, p. 37; Murphy 1985, p. 163.

CONDITION: The fabric support has been wax-lined. The paint is applied over a pale ground. There is an extensive crack pattern throughout the painting.

In 1806 Napoleon commissioned Robert Lefèvre to paint an imperial portrait for the Salle des Séances du Sénat at the Palais du Luxembourg. When completed, the painting was exhibited at the Salon that year, as was Jean-Auguste-Dominique Ingres's portrait showing Napoleon on his imperial throne, which had not been commissioned by the emperor. Both paintings were hung in the Salon Carré, the most prestigious gallery in the exhibition. Despite their similar subject matter, the two portraits evoked different reactions. Some critics admired Lefèvre's more conservative image and derided the rigid frontality of Ingres's as too medieval and hieratic for a modern portrait.[1]

In a lengthy review by Pierre Jean-Baptiste Chaussard, Lefèvre's portrait was considered a fine composition, although not perfect: "The portrait of H. R. Emperor is a well-composed picture. The [emperor's] bearing is noble and majestic; however this pose needs some readying; . . . Unhappily the principal object, the head of Napoleon, lacks the virtue of resemblace that ordinarily characterizes the talent of Mr. Robert Lefèvre; he was not any more successful in this than many others who have undertaken the portrait of the Hero."[2] Chaussard concluded that his favorite imperial portrait exhibited in the Salon was actually that painted by Gérard.[3]

Lefèvre's original painting is known today only through a line engraving by Georges Devillers,[4] and through the nearly forty later versions that were produced by the artist and his studio. In Lefèvre's 1806 portrait, Napoleon was depicted in the full imperial regalia he wore on his coronation day, December 2, 1804. He wears a velvet mantle, an ermine cape, and the great collar of the Légion d'Honneur.[5] He stands stiffly by his throne, holding a scepter with

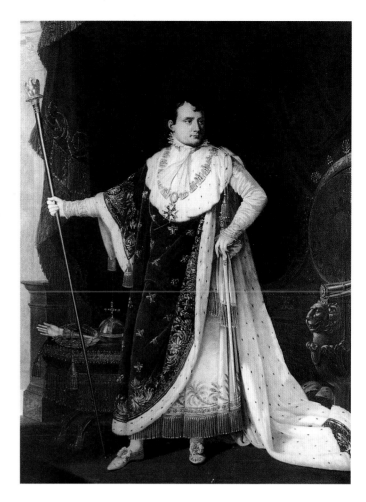

Fig. 74a. Robert Lefèvre, *Napoleon in His Coronation Robes*, 1807. Oil on canvas. Paris, Musée National de la Légion d'Honneur, inv. no. O 4380

his right hand and resting his left hand on his hip. Statues of past emperors, including Charlemagne, Alexander, and Julius Caesar, were shown in the gallery at the left to indicate that Napoleon was the most recent of a long line of eminent and enlightened rulers.[6]

This original pose—but not the background—was maintained in the version now at the Musée de la Légion d'Honneur (fig. 74a).[7] The Boston Museum's painting, dated 1812, is one of the many later versions of Lefèvre's 1806 imperial portrait in which the composition was changed considerably from the original.[8] Instead of showing the architecture and art surrounding the imperial throne, Lefèvre has narrowed the focus to the figure of Napoleon in his luxurious robes, surrounded by only a few select objects. His body is frontal but his head faces to the right, and he now wears a gold laurel-wreath crown. The carved throne is at the right and a large book inscribed "Code Napoleon" rests on a table to the left. He still holds his imperial staff with his right hand, but the grasp is now much more relaxed than in the original. A similar version at Versailles, which is dated 1811,[9] displays the same pose, costume, and throne. The Boston painting differs in some minor background details and most significantly in the substitution of the *Code Napoleon* at the left for the imperial symbols of power—the hand of Justice and an orb—on top of an ottoman. According to Susan Siegfried, the *Code Napoleon*, the emperor's famous legislative code

depicted in the Museum's painting, suggests that this work was intended to hang in "an administrative building," whereas the symbols of state in the Versailles version imply that it was "intended for an official residence."[10]

1. According to a letter in the Paintings Department files from Susan L. Siegfried, dated July 29, 1978, Lefèvre's work was especially well regarded by the critic C. P. Landon, a friend who published the *Annales du Musée et de l'école moderne des beaux-arts.* However, Ingres's painting was, poorly received by most critics. P. J. B. Chaussard wrote in his review:

> How with so much talent, with drawing so correct and exactitude so perfect, how could M. Ingres make such a bad painting? It's because he wants to be different and to do the extraordinary. . . . In the first place, why show the Emperor in this frontal view? The character of this great man, the profundity of his genius, his heroic physiognomy, the mobility of his expression, these flashes of inspiration that pass like lightning, are they not difficult enough to capture? One would say that M. Ingres has taken this pose, and all the rest from some gothic medals." (Chaussard 1808, pp. 177, 179)

For more information, see Susan L. Siegfried, "The Politics of Criticism at the Salon of 1806: Ingres's *Napoleon Enthroned,*" in The Consortium on Revolutionary Europe, 1750–1850, *Proceedings* (Athens, Ga., 1980), vol. 2, pp. 69–71.

2. See Chaussard 1808, p. 183, pl. 15.

3. See Art Institute of Chicago, *Treasures of Versailles,* 1962, no. 26; and sale, Hôtel Drouot, Paris, December 14, 1989, no. 82.

4. Chaussard 1808, p. 183.

5. See Metropolitan Museum of Art, *The Age of Napoleon: Costume from Revolution to Empire, 1789–1815* (New York, 1989), pp. 209–11.

6. The Légion d'Honneur's version was given by Napoleon to his mother. See V. Wiesinger and A. de Chefdebien, *Chefs-d'oeuvre du Musée National de la Légion d'Honneur* (Paris, 1994), pp. 58–59.

7. Bordes and Pougetoux 1983, p. 24.

8. Siegfried letter, 1978. She notes in addition to two versions in the Musée National de la Légion d'Honneur the following: Maison d'Education, Abbaye de St-Denis; in the private collection of M. Reille-Soult, the duc de Dalmatie; Versailles (Musée du Louvre no. 4422); Versailles-Palais du Trianon (Musée du Louvre no. 4423); Fontainebleau; Paris, private collection; and Senate, Palais du Luxembourg. A letter in the Paintings Department files from Guy Kuraszewski at Versailles lists still other versions in Bordeaux, Toulouse, and Holland; one in Florence, originally in the collection of Elisa Bacchiochi, the grand duchess of Tuscany; plus others at Aix-la-Chapelle and Mayenne. A version dated 1808 that had been given by Napoleon to his brother Joseph was formerly in a Parisian private collection. See Jacques Seligmann and Co., Inc., *Baron Antoine Jean Gros* (New York, 1955), no. 1.

9. Musée du Louvre no. 4423; Bordes and Pougetoux 1983, p. 30, ill.

10. Siegfried letter, 1978.

JEAN-JOSEPH-XAVIER BIDAULD

1758–1846

Jean-Joseph-Xavier Bidauld first studied art at the age of ten with his brother Jean-Pierre-Xavier, who was a genre and still life painter. Bidauld later enrolled at the Ecole des Beaux-Arts in Lyon for more formal training. In 1783 Bidauld left for Paris, where he met the landscape painter Joseph Vernet, with whom he spent a summer painting in the forest of Fontainebleau. Bidauld moved to Italy in 1785 and remained there for the next five years, working in Rome and Naples. During the mid-1780s, Rome was a major center for neoclassical artists and, while he lived there, Bidauld collaborated with them on many of his other paintings. After returning to Paris in 1790, Bidauld exhibited for the first time at the Salon of 1791 and successfully displayed his work at the Salon until 1844. He received commissions from Empress Josephine, King Joseph, King Charles IV of Spain, and King Louis XVIII. In 1823 he became the first landscape painter to be elected to the Académie des Beaux-Arts. He continued to paint his characteristic picturesque landscapes until the end of his career, despite a decline in his popularity due to changing taste.

75. *Monte Cavo from Lake Albano,* about 1790

Oil on canvas
12 3/4 × 18 in. (32.5 × 46 cm)
Charles Edward French Fund
43.130

PROVENANCE: purchased in France about 1870–80 by Seth Morton Vose, Boston; Vose Galleries, Boston, until 1943 (as Michallon).

EXHIBITION HISTORY: Detroit 1950, no. 68; New York, Wildenstein and Co., *Romance and Reality,* 1978, no. 2; Boston 1978; Washington, D.C., National Gallery of Art, *In the Light of Italy: Corot and Early Open-Air Painting,* 1996–97, no. 30 (also traveled to The Brooklyn Museum; St. Louis Museum).

REFERENCES: Gutwirth 1977, p. 150, fig. 4; Murphy 1985, p. 19; Memphis 1987–88, p. 51; New York 1990, p. 245, fig. 14.

CONDITION: The painting was executed on loosely woven plain cloth, which has been trimmed at the edges and glue-lined, emphasizing the canvas weave in the paint layer. The ground is a rosy-tan color and the paint layer is thinly applied over this. Under infrared, a few drawing lines are visible, indicating a change in the placement of the hills on the right.

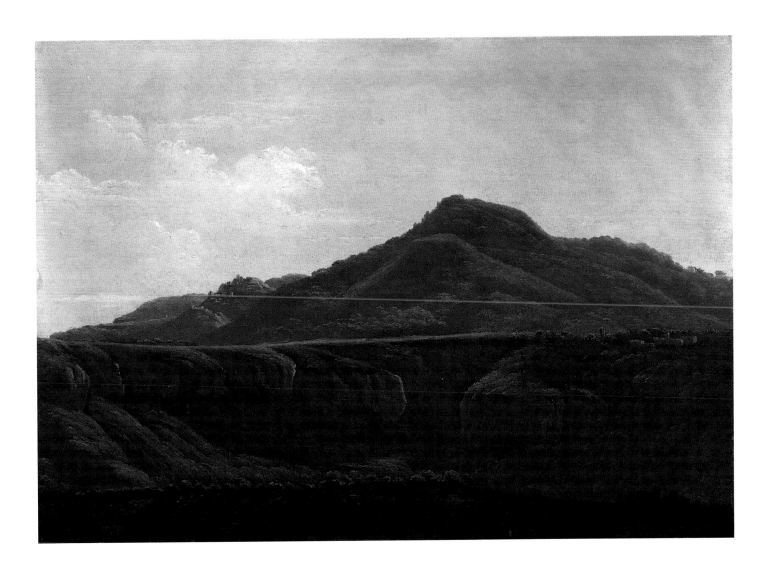

When this work entered the Museum's collection in 1943, it was attributed to Achille-Etna Michallon. Then in 1977 Suzanne Gutwirth identified the painter as Bidauld,[1] and this attribution has remained unchallenged. During the period from 1785 to 1790, Bidauld's years in Italy, he produced numerous oil studies, many of which were painted from nature. As he once said about his work, he learned "how to make *études* in making pictures, and how to create pictures in making *études*."[2]

The Museum's small painting depicts the mountainous landscape that surrounds Lake Albano, located southeast of Rome. Toward the end of his Italian visit, Bidauld painted several mountain landscapes that are similar in color and composition to *Monte Cavo from Lake Albano*, including another painting of the same site, which is now at the Philadelphia Museum of Art.[3] In addition, comparable views of Mount Soracte,[4] a valley in the Apennines, and a view in the Abruzzi,[5] were all painted during the artist's Italian sojourn. These works, with their firm horizontal lines, limited palette, and clearly delineated foregrounds, midgrounds, and backgrounds, reflect Bidauld's strong commitment to the neoclassical principles of formal landscape. Unlike Pierre-Henri de Valenciennes (q.v.), who often included historical subjects and figures within his landscapes, Bidauld presented no narrative in his precise and detailed studies of nature.

1. Gutwirth 1977, p. 150, fig. 4.

2. Quoted in A. Boime, *The Academy and French Painting in the Nineteenth Century* (London, 1971), p. 162.

3. Illustrated in Memphis 1987–88, no. 23. Other examples include *The Sabine Mountains* (Detroit Institute of Arts), *View from Subiaco* (Paris, Louvre), *View from Avezzano* (Paris, Louvre), and *Mountainous Italian Landscape* (Paris, private collection). They are all illustrated in Gutwirth 1977. See also one sold Christie's, London, July 4, 1997, no. 67.

4. See Musée Départemental de l'Oise, *Donation M. J. Boudot-Lamotte* (Beauvais, 1980), nos. 3 and 4.

5. See Matthiesen Gallery, *A Selection of French Paintings, 1700–1840, Offered for Sale* (London, 1989), no. 27.

PIERRE-PAUL PRUD'HON

1758–1823

Pierre-Paul Prud'hon's artistic education began in 1774, when his father sent him from his native Cluny to the school of art in Dijon. After his marriage in 1778, Prud'hon left for Paris, where he stayed for three years and studied at the Académie royale. He returned to Dijon in 1783 but competed for and won the Prix de Rome in 1784. This enabled him to spend three years in Rome, where he was influenced by the German neoclassicists Anton Raphael Mengs and Angelica Kauffmann. On returning to France, Prud'hon first settled in Paris, but then his enthusiasm for Robespierre caused him to go into exile in Franche-Comté in 1794. Two years later he returned to Paris and began to produce drawings for book illustrations and to work on large decorative projects. After the great success of his large drawing *Triumph of Bonaparte* (Paris, Louvre) at the Salon of 1801, he became popular with the emperor and his wife, executing numerous commissions for them and decorating the ceiling of Josephine's living room on rue Chantereine. Like Jacques-Louis David, Prud'hon became the Empire's designer of celebrations, including the wedding of Napoleon and Marie-Louise. He painted his greatest masterpieces between 1808 and 1815, including *Innocence Choosing Love over Riches, Justice and Vengeance Pursuing Crime,* and *Psyche Abducted by the Zephyrs* (Paris, Louvre). At the end of his life, however, Prud'hon, who was renowned for his portraits, found that his success began to wane as his paintings now seemed old-fashioned.

76. *Abundance*

Oil on canvas
45 7/8 × 35 in. (116.5 × 89 cm)
Special Fund for Purchase of Pictures
13.391

PROVENANCE: Boisfremont collection; to his daughter, Madame Power; given to Laurent Laperlier by 1874; sale Hôtel Drouot, Paris, February 17–18, 1879, no. 37; Henri Rouart; sale Galerie Manzi-Joyant, Paris, December 9–11, 1912, no. 62.

EXHIBITION HISTORY: Paris, Ecole des Beaux-Arts, *Exposition des oeuvres de Prud'hon,* 1874, no. 86; New York World's Fair, *Masterpieces of Art,* 1939–40, no. 232; Kyoto 1989, no. 1; Paris, Grand Palais, *Prud'hon ou la rêve du bonheur,* 1997, no. 105 (traveled to New York, Metropolitan Museum of Art).

REFERENCES: Goncourt 1876, p. 193; "Rouart Collections," *Les Arts* 11, no. 132 (Dec. 1912), p. 3, no. 132; Boston 1921, pp. 133–34, no. 372; Guiffrey 1923–24, p. 324, no. 881; Boston 1932, ill., n.p.; Boston 1955, p. 52; Murphy 1985, p. 232.

CONDITION: The fabric support has been glue-lined. The white ground is visible throughout the unfinished painting, and contour lines are visible. The paint is applied in a sketchy manner, with the major areas of color applied in thin washes, and no area is finished to a high degree. The work is varnished and it is in very good condition.

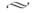

A standing young woman, clothed in a gold dress covered by violet drapery and wearing a broad blue band in her hair, holds in her hands a silver cornucopia with a gold rim. She looks down to a seated young woman who wears a silver dress and a blue cap and looks up to meet the standing woman's glance.

This unfinished composition was probably painted between 1812 and 1820[1] as a study for an unidentified mural decoration.[2] When it was sold at the Laperlier sale in 1879, it measured 45 1/4 × 35 3/8 inches (115 × 90 cm),[3] but by the time of the Rouart sale in 1912, the lower half had been folded back, reducing the dimensions to 36 1/4 × 34 1/4 inches (92 × 87 cm).[4] Once acquired by the Museum, the work was restored to its original size, displaying the unfinished lower section with the lot number 37 from the Laperlier sale in 1879 still in the lower-left corner.

The conventional image of Abundance, the allegorical figure of Plenty, was described by Cesare Ripa in 1603: "The personification of Abundance is a fair young woman dressed in a green gown embroidered with gold, the color of the fields and of ripening grain, and with a wreath of flowers, the harbingers of abundance and delight, in her hair. She holds a horn of plenty—the cornucopia filled with fruit—at her right side, and in her left arm she bears a sheaf of all sorts of grain. Many fallen ears of grain lie at her feet, and in the foreground are bags of money and containers of gold and jewels."[5] In the Museum's painting, Prud'hon has produced a modern version of Abundance, discarding many of her traditional attributes. He has also added a second female figure, who is clothed in a fashionable Empire-style dress.

Unlike most of his contemporaries, Prud'hon did not follow David's neoclassical manner, but instead was profoundly influenced by the German artists of the time. As Paul Marmottan noted in 1886: "In Rome, he separated himself from the mode recommended by Lagrenée, and even from that of François-Hubert Drouais; to the influence of David which dominated these masters, he preferred the approach brought to Italy at that time by the Germans, Raphael Mengs and Angelica Kauffmann."[6] This influence can be seen here in Prud'hon's use of pastel colors, dreamlike expressions, and the elongated proportions of his figures.

Prud'hon developed a complex and precise method of painting: He began by making a rough sketch, followed by a general

drawing, a painted sketch, individual studies for each part of the composition, and finally a grisaille outline that was eventually "colored in" with paint. If he was not pleased with any part of the process, instead of correcting a mistake he would begin again on a fresh canvas. After a composition had been successfully completed, Prud'hon, who considered himself an amateur alchemist, would layer the canvas with his own varnish. Unfortunately, this varnish often caused subsequent darkening and crackling of the pigment.[7] The Museum's painting has retained the original brilliance of the pastel hues that Prud'hon intended, because it was abandoned and never received the final layer of varnish.

Two preparatory studies for this work are at the Musée Condé, Chantilly. One is a small oil sketch in dark colors,[8] and the other is a black-and-white chalk drawing on blue paper.[9] In both, the two female figures are depicted full-length, with the details of their costumes and the fruit and vegetables spilling from the cornucopia fully completed. Edmond de Goncourt also mentions a third fragmentary drawing of the standing figure, originally in the Boisfremont collection, which was sold in 1864.[10] An engraving was made after the Museum's painting by A. Lalauze to illustrate the Laperlier sale catalogue.

1. Kyoto 1989, no. 1.

2. Guiffrey 1923–24, p. 324, no. 881.

3. Sale Hôtel Drouot, Paris, February 17–18, 1879, no. 37.

4. Sale Galerie Manzi-Joyant, Paris, December 9–11, 1912, no. 62.

5. C. Ripa, *Baroque and Rococo Pictorial Imagery*, trans. E. Maser (New York, 1971), p. 34.

6. P. Marmottan, *L'école française de Peinture (1789–1830)* (Paris, 1886), p. 310.

7. C. Clément, *Prud'hon* (Paris, 1872), pp. 380–81.

8. Guiffrey 1923–24, no. 882, Chantilly no. 423, which measures 7 7/8 × 4 3/4 in. (20 × 12 cm).

9. Guiffrey 1923–24, no. 883, which measures 9 7/8 × 5 1/8 in. (25 × 13 cm), reproduced in C. Martine, *Dessins des Maîtrès française, Pierre-Paul Prud'hon* (Paris, 1923), no. 39.

10. Goncourt 1876, p. 193.

JEAN-BAPTISTE MALLET

1759–1835

Like Jean-Honoré Fragonard (q.v.) Jean-Baptiste Mallet was born in Grasse. He first studied with Simon Julien in Toulon before going to Paris, where his masters were J.-F.-L. Mérimée and Pierre-Paul Prud'hon (q.v.). He painted a number of history and mythological paintings and some portraits but became best known for his risqué genre scenes in watercolor and gouache. Through a succession of periods and styles, Mallet documented the changing mores of social behavior.

77. *Young Woman Kneeling before a Priest*, 1826

Oil on canvas mounted on Masonite
9 1/2 × 12 7/8 in. (24.1 × 32.6)
Signed and dated lower right: *Mallet / 1826*
Gift of Julia Appleton Bird
1982.640

PROVENANCE: Julia Appleton Bird, Ipswich, Mass.

EXHIBITION HISTORY: Yokohama 1995, no. 1.

REFERENCE: Murphy 1985, p. 174.

CONDITION: The tight, plain woven fabric support has been mounted on Masonite, with the tacking margins trimmed. The extremely smooth paint layer is over a white ground and is in good condition.

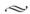

In a heavily shadowed room that appears to serve both as a bedroom and a study, a well-dressed young woman kneels on the floor. Flowers are scattered in front of her. Her extended right hand is held by a seated priest who, with a worried expression, looks sympathetically at her. Behind them, standing stiffly and looking out toward the viewer, is an older woman wearing a bonnet—perhaps a maid or lady-in-waiting. That the scene is taking place in a religious establishment such as a cloister is suggested by the stained-glass window at the left, in which two subjects, the Annunciation and the Visitation, can be deciphered.

Mallet turned from his rococo boudoir scenes to historical subjects about 1810. He was inspired in part by members of the Troubadour movement, such as Pierre Révoil and Fleury Richard,[1] who painted gothicizing narrative subjects derived from specific historical or literary sources, often of English origin. The subject here has elements suggestive of the last confession of Mary Stuart, a very popular figure in paintings of this period,[2] but it has not yet been convincingly identified. In correspondence, François Pupil observed that instead of being a scene of penitence, it may be one of renunciation, before the young lady takes up convent life.[3] This

would certainly account for the scenes within the window, and the flower petals on the floor may be a symbol of lost virginity. In these details the scene also recalls J. A. Laurent's 1812 painting *Heloise Embracing the Monastic Life* (Arenenburg, Napoleonmuseum).[4] In this theme, as well as in the intimate interior setting painted with great delicacy, Mallet also recalls the works of seventeenth-century Dutch painters, particularly Jan Steen. Mallet employed the effect of light entering through a stained-glass window in other of his historicizing works such as *La Toilette* (private collection), of 1815,[5] and *Geneviève de Brabant Baptizing Her Son in Her Prison Cell* (Cherbourg, Musée Thomas Henry), of 1824.[6]

1. See M.-C. Chaudonneret, *La Peinture troubadour* (Paris, 1980), for detailed interior settings as in Richard's *Blanche Bazu and Pierre le Long*, pl. 120.

2. See Tscherny and Stair Sainty 1996, pp. 63–64.

3. Letter of October 31, 1993, in the Paintings Department files.

4. Tscherny and Stair Sainty 1996, pp. 94–95, fig. 65.

5. See Wildenstein, *Consulat, Empire, Restauration: Art in Early-Nineteenth-Century France* (New York, 1982), p. 115, ill. p. 52.

6. See Art Gallery of New South Wales, *French Painting: The Revolutionary Decades 1760–1830* (Sydney, 1980), no. 40.

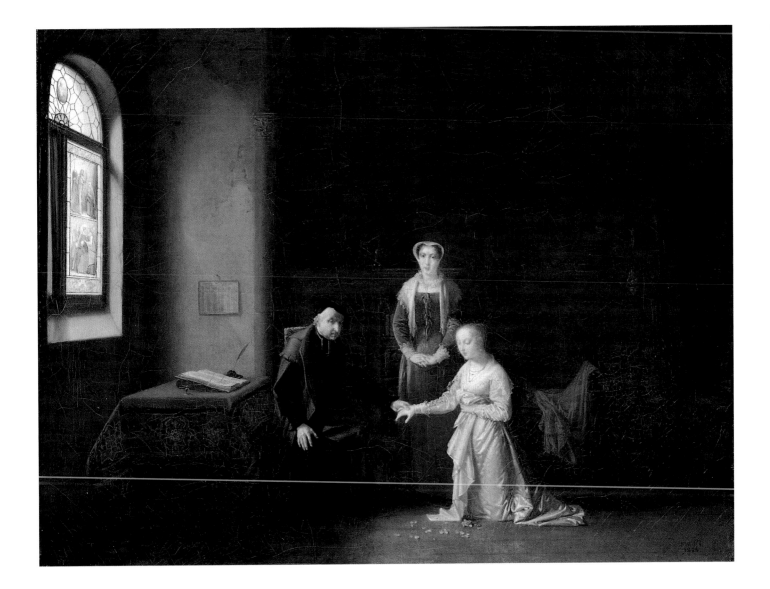

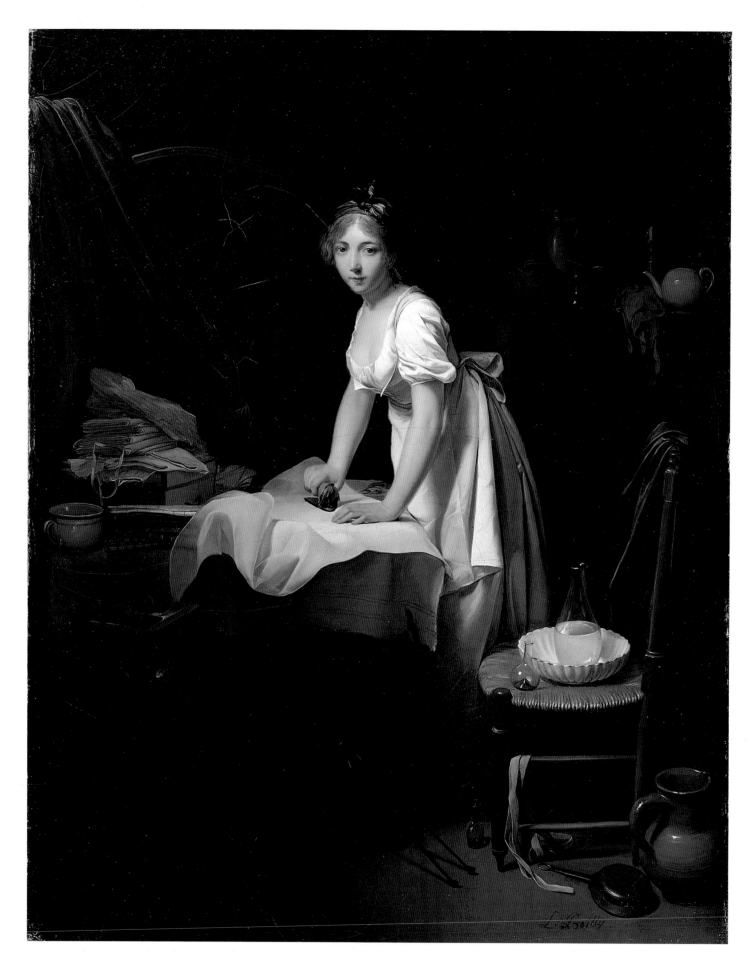

Louis-Léopold Boilly

LOUIS-LÉOPOLD BOILLY

1761–1845

Louis-Léopold Boilly was born near Lille and worked first at Arras, where he developed a talent for portraiture and *trompe l'oeil* under the influence of the painter G.-D. Doncre. After moving to Paris in 1785, he made a specialty of risqué boudoir scenes painted with exquisite finish. Although not involved in official circles, during the Reign of Terror Boilly was denounced before the powerful Comité de Sûreté Public by a fellow artist from Lille, Jean-Baptiste Wicar, for painting immoral subjects. To save himself, Boilly painted the patriotic work *The Triumph of Marat* (Lille, Musée des Beaux-Arts). He was able to resume his career and, for the naughty subjects, substituted bourgeois genre scenes inspired by seventeenth-century Dutch examples. Prints, especially those in the then-new medium of lithography, served to popularize many of Boilly's often humorous subjects.

78. *Young Woman Ironing*, about 1800

Oil on canvas
16 × 12 3/4 in. (40.7 × 32.4 cm)
Signed lower right: *L. Boilly*
Charles H. Bayley Picture and Painting Fund
1983.10

PROVENANCE: Private collection, Paris; Niklaus Reber (d. 1821), Basel; private Swiss collection, possibly Burchardt, at Basel, from about 1810; by inheritance to Madame von der Muehl, Basel; sale Sotheby's, London, December 9, 1981, no. 2; Hazlitt, Gooden, and Fox, London.

EXHIBITION HISTORY: Tokyo 1983–84, no. 29; Fort Worth, Kimbell Art Museum, *The Art of Louis-Léopold Boilly*, 1995 (traveled to Washington, D.C., National Gallery of Art), pp. 167–69, pls. 142–43.

REFERENCES: *Art at Auction: The Year at Sotheby's, 1981–1982* (London and New York, 1982) p. 28, ill.; "La Chronique des arts," *GBA* 103, no. 1382 (March 1984), p. 31, no. 193, ill.; Murphy 1985, p. 22; Stebbins and Sutton 1986, p. 55.

CONDITION: The medium-weight, plain woven fabric support is unlined. The paint is very smoothly applied over a cool gray commercially prepared ground. Infrared examination reveals a contour underdrawing in both dry and brushed media and includes several pentimenti. These are mostly changes in the locations of objects in the picture and a sketch of a cat under the chair. Aside from an overall network of shallow, cupped cracks, the paint layer is in excellent condition.

～

This is one of a number of small paintings of young working women produced by Boilly around 1800. These include *The Flower Girl* (Paris, Collection Didier Aaron), *The Cherished Dog, The Lazy Girl, The Mansard,*[1] and most especially *A Girl Grinding Coffee* (fig. 78a), which was in the same 1981 sale as the Museum's painting and was probably a pendant to it.[2]

At the Salon of 1800, Boilly exhibited several paintings of which one, *Woman Seated by a Stove Doing Housework*, was highly praised for the realism of its still life objects and the clear influence of seventeenth-century Dutch prototypes.[3] The same qualities are evident here. A remarkable array of still life elements—from the glowing brazier on which the iron is heated to the glass vessels and objects on the chair and the floor—are depicted. To the Dutch tra-

Fig. 78a. Louis-Léopold Boilly, *A Girl Grinding Coffee*. Oil on canvas. Present location unknown. Photograph courtesy of Sotheby's, London

Fig. 78b. Infrared detail of cat. 78

dition of kitchen-maid scenes, Boilly has added a sensual element, as the young woman in a suggestively low-cut dress looks directly, perhaps a bit coyly, out at the viewer. This work may be an antecedent of those later nineteenth-century images portraying laundresses and ironers as promiscuous women.[4]

In a number of his domestic interior scenes, Boilly showed a woman accompanied by a cat or a dog.[5] As the infrared reflectography reveals, he originally included a cat here (fig. 78b), but then changed his mind and painted over it.

1. See Harrisse 1898, pp. 94, and 179, and nos. 125, and1080; Paris 1984, no. 15; and sale Sotheby's, New York, June 3, 1980, no. 50.

2. Sale Sotheby's, London, December 9, 1981, no. 3.

3. Harrisse 1898, p. 77.

4. See E. Lipton, "The Laundresses in Late-Nineteenth-Century French Culture," *Art History* 3, no. 3 (Sept. 1980), pp. 300–301.

5. Harrisse 1898, p. 94, nos. 121–28.

MARGUERITE GÉRARD
1761–1837

Marguerite Gérard, the daughter of a perfume distiller from Grasse, went to Paris about 1775 to join her older sister, Marie-Anne, who had married the painter Jean-Honoré Fragonard (q.v.). He became the young woman's teacher and also used her as his model in many works. They collaborated on genre paintings in the 1780s, and eventually she perfected her own intimate style in Dutch-inspired, anecdotal scenes of family life. Later in the century she turned to the more fashionable neoclassical style. Gérard exhibited at the Salon from 1799 to 1824 and also provided illustrations for various texts, including Choderlos de Laclos's *Liaisons dangereuses*. In 1808 the emperor purchased her one attempt at a contemporary history theme, *The Clemency of Napoleon at Berlin*. (Musée Nationale des Châteaux des Malmaison et Bois-Préau).

79. *Portrait of a Man in His Study*, about 1785

Oil on panel
8 5/8 × 6 1/4 in. (21.7 × 16 cm)
According to the bill of sale, inscribed on the verso: *Portrait de Monsieur Le Comte dans son bureau*, but now not evident
The Forsyth Wickes Collection
65.2645

PROVENANCE: Mrs. George A. Brackett, Minneapolis; gift to the Minneapolis Institute of Arts, 1918; Minneapolis Institute of Arts; sold to Victor Spark, New York, July 9, 1952; Wildenstein and Co., New York, 1952; purchased December 8, 1952, by Forsyth Wickes.

REFERENCES: Wells-Robertson 1978, p. 894, no. 110; Murphy 1985, p. 114; Zafran, in Munger et al. 1992, p. 74, no. 14.

CONDITION: The support is a wood panel. The paint is smoothly and thinly applied over a tan-colored ground. Aside from some abrasion in the background and areas of minor retouching, the painting is in excellent state.

This small painting of an unknown man is one of a number of such informal portraits of seated gentlemen caught in the midst of their studies that Marguerite Gérard painted in the 1780s and 1790s.

Others include *Portrait of the Architect Ledoux*, *Portrait of Henri Gérard* (both Grasse, Musée Fragonard), and *Portrait of François Yves Ronband* (private collection).[1] The Boston example, painted with great spontaneity, is dated by Wells-Robertson to about 1785. She notes that despite the supposed inscription on the verso, the work was probably posed in the artist's studio, for the globe and "guéridon" table were "studio props prominent in many portraits and genre scenes of the 1780s."[2] Nevertheless, these elements along with the large album of prints or drawings from which the sitter has been distracted, are all attributes of an enlightened and worldly connoisseur.

1. See Wells-Robertson 1978, cats. 114, 123, 128. The last is also included in Baillio 1989, no. 98. Two others were sold by Ader Picard Tajan, Paris, June 22, 1990, no. 114.

2. Wells-Robertson 1978, p. 894.

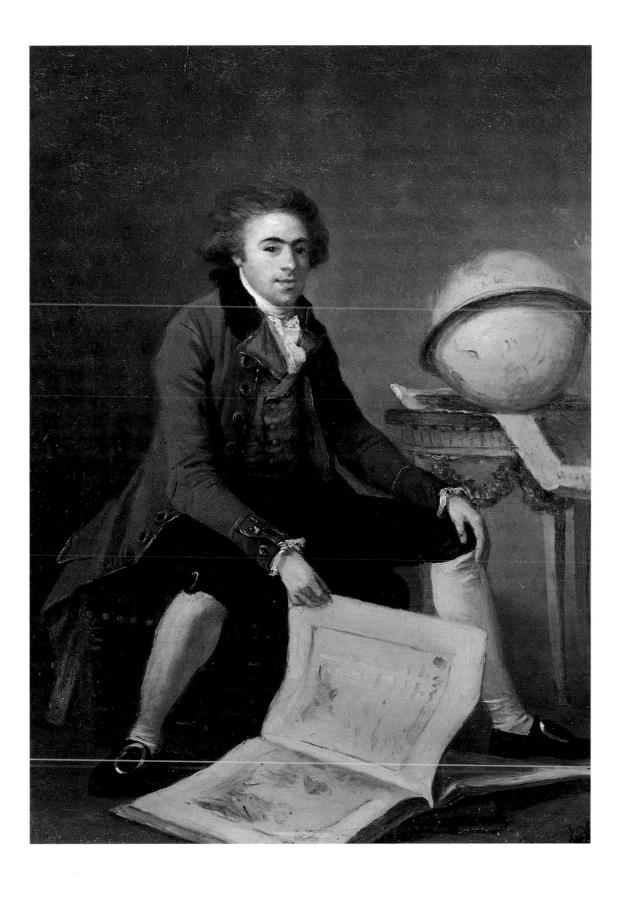

GEORGES MICHEL

1763–1843

Although the son of a market worker at Les Halles in Paris, Georges Michel was sent as a youngster to a curé on the plain of Saint-Denis, north of the city, and there developed his lifelong love for the countryside. After studying with minor artists and relying on his own abilities, he found employment with the steward to the king's brother's household, which allowed him to travel to Switzerland and Germany. During the 1780s the dealer Le Brun (husband of the painter Elisabeth Louise Vigée-Le Brun [q.v.]) allowed the young artist to copy the seventeenth-century Dutch works in his possession, and Michel sought to apply what he learned to landscapes he did on the outskirts of Paris. He first showed at the Salon in 1791 but did not gain much attention and had to support himself by teaching. About 1800, the Louvre hired him to work as a conservator on its Dutch and Flemish paintings.

This experience of studying intimately works by such artists as Rembrandt, Ruisdael, and Hobbema had a profound effect both on Michel's technique and his subject matter, and helped him move from a detailed to a broader style. After his wife and their eight children died, he became something of a recluse before remarrying. His only patron was the baron d'Ivry, but in 1830 they had a falling-out over politics. From this date onward, however, Michel produced his most original work. He rarely signed his dramatic landscapes and vistas, and many were dispersed in a sale he held two years before his death in Paris. They had a tremendous impact on the Barbizon school of painters, who felt he had freed landscape painting from classical conventions. Michel was rescued from obscurity by Alfred Sensier's biography of him, which was published in 1873.

80. *Landscape with a Windmill*

Oil on paper mounted on canvas
13 3/8 3 18 1/2 in. (34 3 47 cm)
Gift of John H. Sturgis
Res. 22.298

PROVENANCE: John H. Sturgis, Boston, by 1882.

EXHIBITION HISTORY: Kyoto 1989, no. 7, pp. 133–34.

CONDITION: The painting is on a complex support composed of paper glued to a fine tabby weave canvas. In a number of areas the paper has separated from the secondary canvas support, causing bulges to form. Thickly impastoed paint, found mainly in the sky, has been flattened considerably by the lining process, while the resinous brown paint in the foreground shows evidence of abrasion. There are at least two varnish layers extant on the painting: a more recent layer of dammar varnish, which is reasonably even and saturating, and below this an older discolored natural resin, which has been unevenly removed.

This painting is more somber than the Museum's other example done on paper (cat. 81). Here there is no figure and the windmill is more monumental. The formula of the windmill on a hill at the left, with a road running in front of it and a protruding tree trunk in the foreground occurs in an example sold in 1968,[1] and in another called *The Coming Storm*, sold in 1980.[2] A nearly identical composition, except for the addition of a small house on the hill behind the windmill, was included in the historic 1927 Michel exhibition at the Hôtel Charpentier, Paris.[3]

1. Sale Sotheby's, London, April 25, 1968, no. 310.
2. Sale Sotheby Parke-Bernet, New York, January 25, 1980, no. 209. Also similar

in format is *A Windmill on the Plain of St. Denis*, formerly with Durand-Ruel (photograph in the Frick Art Reference Library), and another titled *Approaching Storm*, sold at Christie's, London, April 23, 1941, no. 109.

3. Paris 1927. Reproduced in R. Rey, "Georges Michel," *L'Art vivant* (April 15, 1927), p. 295.

81. *Windmill on a Bluff*

Oil on paper mounted on canvas
18 1/8 × 21 7/8 in. (46 × 55.5 cm)
Deposited by the Trustees of the White Fund, Lawrence, Massachusetts
1325.12

PROVENANCE: Senator E. O. Wolcott, Colorado Springs; to his brother the Rev. William E. Wolcott, Lawrence, Mass. (d. 1911); bequeathed to the White Fund of Lawrence, Mass.

EXHIBITION HISTORY: Lawrence, Mass., Public Library, 1911.

REFERENCE: Murphy 1985, p. 189.

CONDITION: The paper support, mounted on plain cloth, has been lined onto a second layer of plain cloth attached to a stretcher. The impasto of the heavily applied paint layer has been slightly flattened by the lining process and is somewhat abraded. The painting is in generally good condition.

Windmills, particularly the nearly forty to be seen in the nineteenth century on the hills of Montmartre,[1] which was then the outskirts of Paris, were the most frequent motif in Michel's stormy landscapes. In this example, painted on paper that was then pasted on canvas,[2] as his works often were, the little windmill sitting on a bluff is balanced by a figure seated in the foreground. Such an arrange-

ment occurs in a number of other paintings by Michel, including one shown at the Galerie Guy Stein in 1938,[3] and another that appeared in several sales in the 1930s and 1940s.[4] The dramatic effect of highlighting the side of the bluff or sand dune and the road to contrast with the surrounding dark areas was also a common practice of Michel.[5] This Rembrandtesque chiaroscuro and the freedom of the brushwork suggest that this work is from the artist's final period, after 1830.

1. See C. Sterling and M. Salinger, *French Paintings: A Catalogue of the Collection of the Metropolitan Museum of Art*, vol. 2 (New York, 1966), p. 1.

2. See F. Leeman and H. Pennock, *Catalogue of Paintings and Drawings, Museum Mesdag, Amsterdam* (Amsterdam, 1996), p. 331, no. 258.

3. Galerie Guy Stein, *Michel* (Paris, 1938), cover ill.

4. Illustrated in Sensier 1873, opp. p. 65. Sold Galerie Georges Petit, Paris, May 11–12, 1931, no. 24; Parke-Bernet, New York, November 26, 1943, no. 38; and again May 8, 1947, no. 35.

5. As seen in *Landscape with Windmill*, for which see M. Vincent, *La Peinture des XIX et XX siècles, Musée des Beaux-Arts de Lyon* (Lyon, 1958), pp. 117–18, no. VII-82.

Attributed to Georges Michel

82. *Castle in Ruins*

Oil on paper mounted on canvas
21 1/4 × 29 7/8 in. (54 × 76 cm)
Bequest of Mrs. Martin Brimmer
06.2420

PROVENANCE: Doll and Richards, Boston; E. W. Rollins, Boston; Martin Brimmer; bequeathed to his wife (d. 1906).

REFERENCES: *BMFA*, no. 22 (1906), p. 33; Murphy 1985, p. 189.

CONDITION: The primary paper support, which has been mounted to a fine, plainly woven canvas, has separated from this secondary support in a number of areas, causing blisters to form. The impasto of the heavily applied paint layer has been flattened significantly by the lining process, while the resinous brown paint in the foreground has a pronounced drying craquelure and is somewhat abraded. The painting has been unevenly cleaned, and deposits of darkened varnish are found throughout the painting and are particularly visible in the sky.

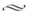

This is an unusual but not unprecedented composition for Michel. A similarly powerful depiction of a ruined building towering above a distant plain and silhouetted against the sky is found in a painting exhibited in 1927.[1] A ruined castle seen in a distant view is also part of the background of the painting entitled *The Castle* (Ottawa, National Gallery of Canada).[2] The unfortunately flattened quality of the Museum's painting makes it difficult to attribute this conclusively to Michel, although it accords with the style of his last period.

1. Paris 1927, p. 23, no. 68. Another, with the ruin on the right side of the composition, was once with the dealer Guy Stein, Paris (photograph in the Frick Art Reference Library).

2. R. H. Hubbard, *The National Gallery of Canada, Catalogue of Paintings and Sculpture. Vol. II: Modern European Schools* (Ottawa, 1959), p. 26, no. 179.

FRANÇOIS-XAVIER FABRE

1766–1837

François-Xavier Fabre received his early training in his native city of Montpellier and then entered the Paris studio of Jacques-Louis David. In 1783, on the recommendation of Joseph-Marie Vien, Fabre was admitted to the Ecole de l'Académie royale, and in 1787 he won the Prix de Rome. In Rome, Fabre produced religious and historical works in the neoclassical, Davidian manner. A *Death of Abel* (Montpellier, Musée Fabre) painted in 1790 was a great success when shown at the Salon the following year. The unrest in Rome following the execution of Louis XVI and the disruption of Fabre's stipend by the French Revolution led him to flee to Florence in January 1793. There a community of French émigrés provided him with commissions for his striking portraits as well as his historical and mythological subjects.

In Florence, Fabre soon became friends with the poet Count Vittorio Alfieri and his mistress, Louise, countess of Albany, who commissioned Fabre's most important history painting, *Saul Crazed by Remorse* (Montpellier, Musée Fabre), which was inspired by Alfieri's famous tragedy *Saul*, published in 1784.

With the ascendancy of Napoleon, Fabre worked for the emperor's sister, the grand duchess of Tuscany, and then moved back to Paris with the countess of Albany. He exhibited both religious subjects and official portraits at the Salons of 1806 and 1810. Among those whose portraits he painted were Lucien Bonaparte and the poet Ugo Foscolo. These later paintings are in a more romantic vein, often with landscape backgrounds.

Following the countess of Albany's death in 1824, Fabre returned to Montpellier, taking with him an extensive art collection, which became the foundation of the Musée Fabre. He was the first director of the museum and of the Ecole des beaux-arts in Montpellier.

Attributed to François-Xavier Fabre

83. *Portrait of a Man (Rosario Persico?)*

Oil on canvas
39 × 31 in. (99 × 78.6 cm)
S. A. Denio Collection
24.342

PROVENANCE: Persico family, Naples (?); Germaro Volpe, Paris; Trotti and Co.; Marcel Nicolle, Paris; H. Heilbuth, Copenhagen; Ehrich Galleries, New York; Vose Galleries, Boston, 1924.

EXHIBITION HISTORY: Hanover, N. H., Dartmouth College Museum and Galleries, *The Napoleonic Era: The Emergence of the Modern World*, 1979, no. 1; Tokyo 1983–84, no. 32; Kyoto 1989, no. 2.

REFERENCES: "Boston Acquires a Portrait by Ingres," *Art News* 22, no. 40 (Sept. 13, 1924), p. 1; Henry La Pauze, "Un Ingres qui n'est pas un Ingres," *La Renaissance* 7, no. 11 (Nov. 1924), p. 620; Murphy 1985, p. 94.

CONDITION: The original plain woven fabric support has been glue-lined to a loosely woven fabric, with the original tacking margins intact. The smoothly applied, resinous paint covers a white ground. Aside from some abrasion of the glazes on the face and some minor retouching, the painting is in very good condition.

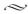

Shown three-quarter length, standing on a balcony that overlooks a bay (which is probably that at Naples), the figure looks directly out at the viewer. He has removed one glove and places his bare hand, which is adorned with a diamond ring, on his silk sash. On the lapel of his dark coat is a medal.

When acquired by the Museum in 1924, this painting was believed to be by Ingres, but almost immediately that attribution was dismissed by Henry La Pauze.[1] In an oral opinion of 1943, Charles Sterling said it was definitely not by Ingres but suggested it was close in style to the work of Fabre.[2] This suggestion was supported in correspondence of 1983 and 1989 by Laura Pellicer.[3] She felt confident that it was a work painted when Fabre was in Naples in 1812, finding not only the sympathetic treatment of the face, but also "his tendency to stiffen postures" to be characteristic of Fabre's portraits. The fact that it lacks a signature led her to suggest that it might be either a replica or a pendant to a portrait of the sitter's wife, which bore the signature.

The provenance of the painting traces it back to the Persico family, and the subject was identified as Rosario Persico, a tax and customs agent in Naples. It is certainly a portrait of a distinguished gentleman who proudly displays a royal decoration.[4]

1. La Pauze's opinion appeared in a letter sent to *Art News* on October 6, 1924, and published in his own magazine, *La Renaissance*, in November of that year.

2. Opinion of March 26, 1943, recorded in the Paintings Department files.

3. Letters of January 20, 1983, and September 9, 1989, in the Paintings Department files.

4. Although of a similar design to the *Croix du mérite militaire* created by Louis XV and the *Croix de l'ordre de Saint Louis*, which was founded by Louis XVI, it is closest in design to an order of the Kingdom of the Two Sicilies, that of François I, which, however, was not founded until 1829. An example is at the Musée de la Légion d'Honneur in Paris. See also Sir B. Burke, ed., *The Book of Orders of Knighthood and Decorations of All Nations* (London, 1858), pp. 294–95, pl. 86, nos. 11 and 12.

Attributed to François-Xavier Fabre

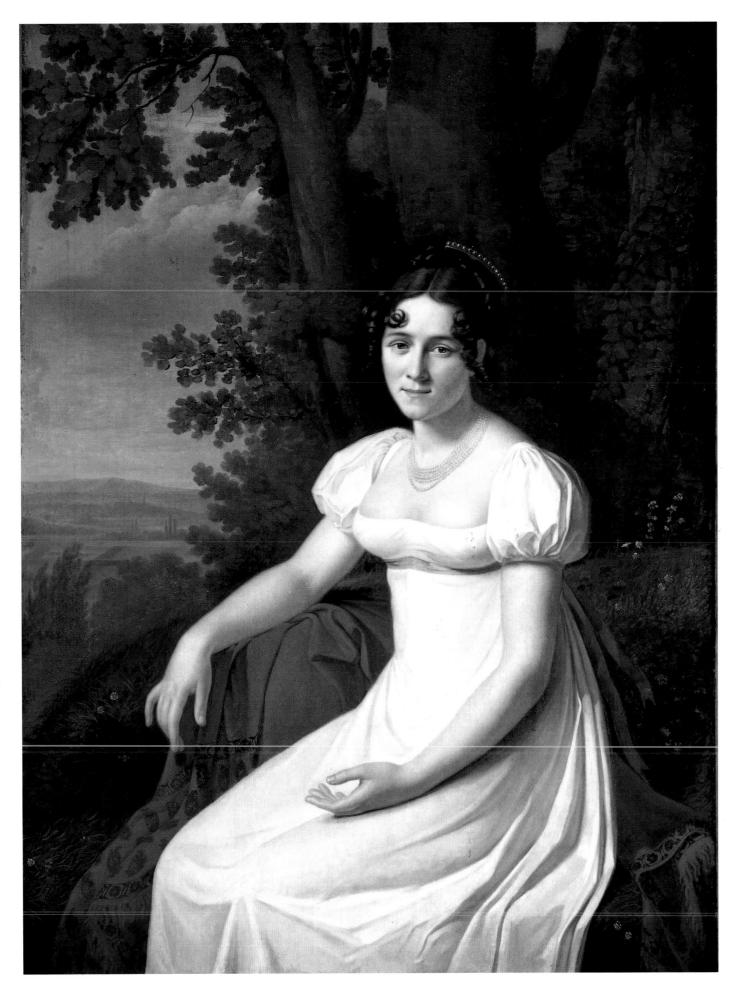

French School, early 19th century

84. *Portrait of a Woman*

Oil on canvas
51 1/8 × 38 in. (130 × 97 cm)
Seth K. Sweetser Fund
27.449

PROVENANCE: Mrs. Hanway Cumming, Paris, by 1927.

EXHIBITION HISTORY: Kyoto 1989, no. 3.

REFERENCE: Murphy 1985, p. 119.

CONDITION: The painting is in fair condition. The medium-weight, plain weave fabric support is strongly glue-lined, with resultant weave enhancement. The tacking margins are missing, and there are several old repaired tears. The thin paint films, mostly opaque with glazes used in the shadows, were applied over a light ground. There are numerous losses, and abrasion is extensive. Examination with IR vidicon reveals fine underdrawing in the face and a painted cross or crucifix below the necklace.

At the time of its acquisiton, this painting was thought to be a portrait of Madame Récamier by Baron François Gérard.[1] The subject is certainly not identical to Madame Récamier as she is known from other portraits.[2] The artist has been identified as a follower of Girodet de Roucy-Trioson,[3] by whom there is a somewhat similar painting of Madame Begon de Misery seated outdoors in a work of 1807 (Ottawa, National Gallery of Canada).[4] Girodet, who exhibited a group of fifteen paintings at the Salon of 1814, was a great influence on other portraitists. One of these was Henri-François Riesener (1767–1828), son of Louis XVI's famous cabinetmaker, who became a pupil of Antoine Vestier, entered the Ecole of the Académie in 1788, and first exhibited at the Salon in 1793 and thereafter fairly regularly until 1814. With the return of the Bourbons he lost patrons and, in 1816, left for Russia, where he worked for seven years. Philip Conisbee has pointed out the similarity in pose and setting of a Riesener portrait of a lady in a landscape (Paris art market)[5] to the Boston painting, and Lucy MacClintock has also noted the relationship to a signed work by Riesener, *Portrait of the Princesse de Ponte-Corvo* done in about 1818 when Riesener was already working in Russia.[6] However, the general Empire style found in portraits at this time does not allow for a conclusive attribution.[7]

1. The Museum's adviser, Walter Gay, cabled his appraisal of the picture on July 1, 1927.

2. The most famous of these is the portrait by Jacques-Louis David, in the Louvre. See Paris 1989, no. 158.

3. Murphy 1985, p. 119.

4. L. MacClintock in Kyoto 1989, p. 131, no. 3.

5. Last with Didier Aaron and Cie., Paris, in 1995.

6. Sale Sotheby's, New York, February 13, 1985, no. 2. Another portrait from

Riesener's Russian period that is also reminiscent of the Boston painting, although with less landscape, is *Portrait of Josephine Fredericks* in the Hermitage. See V. Beresina, *La Peinture française . . . Musée de l'Ermitage* (Leningrad, 1983), pp. 199–200, no. 333.

7. See, for example, *Portrait of a Woman* by Robert Lefèvre, sold at Sotheby's, London, March 16, 1994, no. 70; one by Jean Vignaud sold Christie's, New York, May 19, 1993, no. 84; and a portrait of Pauline Bonaparte by Marie-Victoire Lemoine in Baillio 1989, no. 102.

French School, early 19th century

85. *Achilles Displaying the Body of Hector before Priam and the Body of Patroclus*

Oil on paper mounted on canvas
13 1/4 × 18 3/8 in. (33.6 × 46.8 cm)
Gift of Ednah Dow Cheney
77.151

PROVENANCE: Seth Wells Cheney, Boston, d. 1856; inherited by his wife, Ednah Dow Cheney, Boston.[1]

REFERENCES: Museum of Fine Arts, Boston, *Second Annual Report for the Year Ending December 31, 1877* (Boston, 1878), p. 13; Downes 1888, p. 502; Addison, 1910, p. 88; Whitehill 1970, vol. 1, p. 49; Murphy 1985, p. 105.

CONDITION: The painting is mounted on loosely woven fabric, which has been flattened by a glue lining. There are large losses in the top right at the conjunction of three tears, and also one in the upper left corner. The paint layer is abraded and has become more transparent over time. The painting is in fair condition.

When given to the Museum of Fine Arts in 1877, this small painting was identified as *Hector at the Car of Achilles* by Jacques-Louis David.[2] More recently, the subject has been designated as given above and the attribution to David replaced by an identification as "French, third quarter, 18th century, sketch for 1769 Prix de Rome competition."[3] The subject chosen for that competition was indeed "Achilles having the body of Hector deposited at the bier upon which rests the body of the dead Patroclus," and the winner was Joseph Le Bouteux,[4] whose finished painting is now at the Ecole des Beaux-Arts in Paris (fig. 85a). The second place went to Pierre La Cour and the other competitors were Jean-François Godefroy, Joseph Benoît Suvée, Etienne Aubry, and Jean-Joseph Taillasson (q.v.).[5] Suvée's picture is now at the Louvre (fig. 85b).[6] Another sketch, possibly related to this competition, is at the Krannert Art Museum, University of Illinois, Champaign (fig. 85c).

It seems significant that the paintings by both Le Bouteux and Suvée adhere to the subject as stated in the *procès-verbaux*, while the Boston sketch, although in the same format, incorporates the figure of the old king, Priam, with the treasure he brought to ransom the body of his slain son, Hector. If one accepts this seated figure as Priam and not Agamemnon or another of the Greeks, then the artist has deliberately conflated different moments of the Homeric narrative. In Homer's *Iliad*, the body of Patroclus had been burned

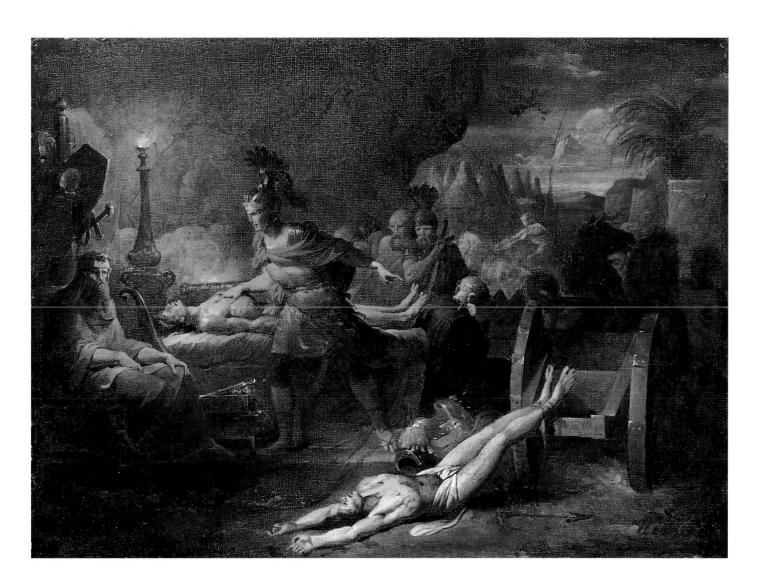

before Priam's visit to the Greek camp. This inconsistency of detail, however, is not the only reason to doubt the connection of the present sketch to the 1769 competition. Stylistically and compositionally it has elements that suggest an artist working in a later period. Most specifically, it recalls elements from several compositions by David, who had not participated in the 1769 competition. When he was in Rome, however, he painted an *académie* of the dead Hector in 1778 and, the following year, a large, complex picture of the funeral of Patroclus[7] with a large, plumed, centrally placed figure of Achilles, who reaches out to the corpse of Patroclus while the body of Hector lies on the ground at the right (fig. 85d). David's *Grieving Andromache* of 1783 also presents the image of another heroic torso laid out on a bier flanked by a large burning lamp.[8] Reminiscent of yet another Davidian composition is the seated mourner at the foot of Patroclus's bier, which recalls a similar one in *The Death of Socrates* of 1786 (New York, Metropolitan Museum of Art).[9] Finally, the treatment of the seated figure at the left and the flickering light have a protoromantic quality like that of the Ossian subjects by such students of David as François Gérard and Anne-Louis Girodet de Roucy-Trioson; the latter entered the master's studio in 1785, assisted on *The Death of Socrates*, and painted and sketched many Homeric subjects.[10] These various Da-

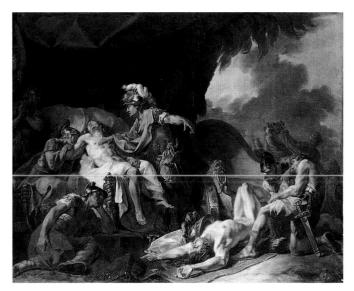

Fig. 85a. Joseph Le Bouteux, *Achilles Displaying the Body of Hector next to the Body of Patroclus*. Paris, Musée du Ecole des Beaux-Arts, inv. no. LA 91318. © Giraudon

vidian derivations suggest that this sketch painted on paper is the work of a younger artist, who created a pastiche in the manner of David. Pierre Rosenberg has confirmed in correspondence that the

painting is "clearly much later than the date of 1769 which is generally proposed and is clearly impossible."[11]

1. There has been some confusion concerning the donor of the painting. The original 1877 committee papers in the registrar's office of the Museum record it as "gift of Mrs. E. D. Cheney, purchased by her husband," and the Annual Report of 1877 lists the donor as "E. Cheney." At some later date it was changed to Mrs. John Cheney and as such is noted in both Whitehill 1970 and Murphy 1985. However, as noted in the *Dictionary of American Biography* (New York, 1930), vol. 10, pp. 51–52, in 1853 the writer Ednah Dow Cheney was married to the artist Seth Wells Cheney, who died three years later. His brother, John Cheney (1801–85), who was a printmaker, never married but was the subject of a memoir by Ednah D. Cheney. It may have been mistakenly believed Ednah and John were married and the credit line was changed on that assumption. It is here restored to its rightful form.

2. Second Annual Report 1878, p. 13.

3. Murphy 1985, p. 105.

4. See A. de Montaiglon, *Procès-verbaux de l'Académie royale de peinture et de sculpture, 1648–1793* (Paris, 1888), vol. 8, pp. 20–21.

5. Ibid.

6. See I. Compin and A. Roquebert, *Catalogue sommaire illustré des peintures du Musée du Louvre et du Musée d'Orsay* (Paris, 1986), vol. 5, p. 229.

7. See Paris 1989, p. 93, nos. 30, 31.

8. Ibid., no. 56.

9. Ibid., p. 122, fig. 44.

10. On Girodet see G. Levitine, *Girodet-Trioson: An Iconographic Study* (New York, 1978).

11. Letter of October 11, 1994, in the Paintings Department files.

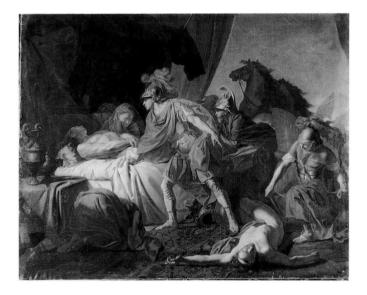

Fig. 85b. Joseph Benoît Suvée, *Achilles Displaying the Body of Hector at the Feet of Patroclus*. Oil on canvas. Paris, Musée du Louvre. R.F. 1969-11

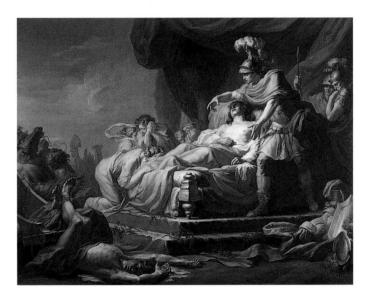

Fig. 85c. Anonymous, *Achilles Displaying the Body of Hector at the Feet of Patroclus*. Oil on canvas. University of Illinois, Champaign, Krannert Art Museum, Gift of Mrs. Ellnora D. Krannert, no. 65-16-5

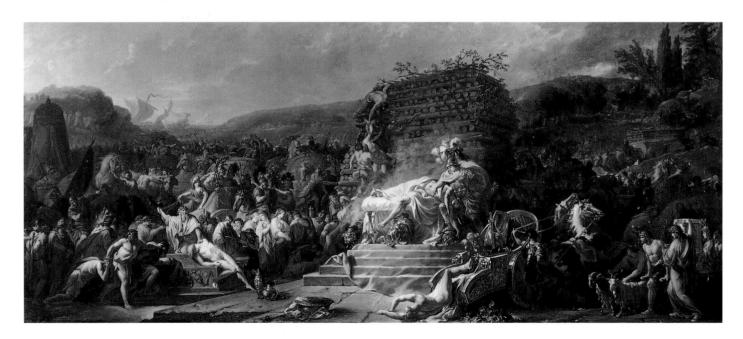

Fig. 85d. Jacques-Louis David, *The Funeral of Patroclus*, 1778. Oil on canvas. Dublin, National Gallery of Ireland

AUGUSTE-HYACINTHE DEBAY

1804–1865

Auguste-Hyacinthe Debay was born in Nantes in 1804. He first studied with his father, Jean-Baptiste-Joseph Debay, who was a noted sculptor. Debay was admitted to the Ecole des Beaux-Arts on August 28, 1817, and exhibited his work for the first time in the Salon of that year with a bronze bust of Louis XVIII. Debay entered Baron Antoine-Jean Gros's studio in 1818 and soon became the master's favorite pupil. He received a medal in the Salon of 1819 and won the Prix de Rome in 1823 with his painting *Aegisthus Discovering the Body of Clytemnestra*. He remained in Rome until 1830. Soon thereafter, Debay turned primarily to sculpture. At the Exposition Universelle of 1855, he received a medal for his sculpture and in 1861 was decorated with the Légion d'Honneur.

BARON ANTOINE-JEAN GROS

1771–1835

Antoine-Jean Gros was born in Paris. His parents were artists who encouraged his precocious artistic talent. By the age of fifteen, he was admitted to the studio of Jacques-Louis David, and two years later he began to study at the Ecole des Beaux-Arts. In 1792 he unsuccessfully competed for the Prix de Rome. One year later, with David's help, he obtained a passport to visit Italy, where he went to Florence and Milan before settling in Genoa. There, in 1796, Gros met Josephine Bonaparte, who took the artist to Milan to introduce him to Napoleon and to paint the general's portrait. Gros became a member of Napoleon's art-advisory committee, choosing paintings to be taken back to Paris as spoils of war. During his seven-year stay in Italy, Gros studied the works of Peter Paul Rubens as well as the Italian artists of the sixteenth century. After his return to Paris in October 1800, Gros won the competition for the *The Battle of Nazareth* (Nantes, Musée des Beaux-Arts), a commission that was to depict the heroic victory of the French army against the Egyptians in 1799. Napoleon later canceled the commission, and Gros used half of the canvas intended for the Nazareth composition for *General Bonaparte Visiting the Plague-Stricken at Jaffa* (Paris, Musée du Louvre).

After the triumphant success of this work at the Salon of 1804, Gros was commissioned to paint other military subjects celebrating Napoleon's campaigns, notably *The Battle of Aboukir* (Versailles, château de Versailles) and *Napoleon on the Battlefield at Eylau* (Paris, Musée du Louvre). Despite his influence on the younger romantic painters, such as Eugène Delacroix and Théodore Géricault, Gros remained loyal to his teacher, David. After the fall of the Empire in 1814 and his exile to Brussels, David entrusted his atelier to Gros. Gros received the commission for the cupola of the Pantheon in 1811, eventually finishing the project in 1824. Gros, able to transfer his loyalty to Louis XVIII, became the official portraitist to the king in 1814. One year later, he was made a member of the Académie and in 1816 was named professor at the Ecole. He decorated three ceilings for the Charles X Museum at the Louvre and was made a baron by that monarch in 1824. He continued to exhibit works at the Salon, but his allegorical paintings were harshly criticized. In 1835 he attempted to regain his reputation by exhibiting a *Hercules and Diomedes* (Toulouse, Musée des Augustins) at the Salon, but it was not well received by the critics either. In despair, Gros committed suicide by drowning himself in the Seine.[1]

1. See G. Lacambre in Detroit 1974–75, pp. 465–66.

Auguste-Hyacinthe Debay after Antoine-Jean Gros

86. *General Bonaparte Visiting the Plague-Stricken at Jaffa*, 1823

Oil on canvas
46 3/4 × 64 1/2 in. (118.5 × 164 cm)
S. A. Denio Collection
47.1059

PROVENANCE: Baron Gros, d. 1835; atelier sale, November 23, 1835, no. 130; Vicomte Aguado, château de Petit-Bourg; his sale, place Vendôme 14, Paris, April 22, 1840, no. 113; Monsieur le Docteur X, England (?); Jean M. Schmidt (?), by 1934; fifth duc de Trévise, Paris, 1934–46; Julius H. Weitzner, New York.

EXHIBITION HISTORY: Paris, Petit Palais, *Gros, ses amis, ses élèves*, 1936, no. 29; New York, Knoedler and Co., *Gros, Géricault, Delacroix*, 1938, no. 3; Paris, Musée de l'Orangerie, *Bonaparte en Egypte*, 1938, no. 78; Springfield, Mass., Museum of Fine Arts, *The Romantic Revolt*, 1939, no. 1; San Francisco Museum of Art, *French Romantic Artists*, 1939, no. 3; San Francisco Palace of Fine Arts, *Golden Gate International Exposition*, 1940, no. 273; Detroit 1950, no. 7; New York, Jacques Seligman and Co., *Baron Antoine-Jean Gros (1771–1835): Painter of Battles, the First Romantic Painter*, 1955–56, no. 14 (traveled to Minneapolis Institute of Arts; Cleveland Museum of Art); Los Angeles, University of California, *French Masters, Rococo to Romanticism*, 1961, p. 32; Minneapolis Institute of Arts, *The Past Rediscovered: French Painting, 1800–1900*, 1969, no. 44; Kansas City, The William

Rockhill Nelson Gallery of Art, *The Taste of Napoleon*, 1969, no. 25; Providence, Museum of Art, Rhode Island School of Design, *Napoleon*, 1978; Providence, R.I., Brown University, Bell Gallery, *All the Banners Wave: Art and War in the Romantic Era, 1792–1851*, 1982, no. 38; London 1984, no. 65. Memphis, Tenn., The Memphis Cook Convention Center, *Napoleon*, 1993, no. 23; Boston, Isabella Stewart Gardner Museum, *Art's Lament*, 1994, no. 12 (traveled to Brunswick, Maine, Bowdoin College Museum of Art).

REFERENCES: "The Museums," *London Studio* 12 (Aug. 1936) p. 104, ill.; Museum of Fine Arts, Boston, *Seventy-second Annual Report for the Year 1947* (Boston, 1948), p. 43; W. Friedlaender, *David to Delacroix* (Cambridge, Mass., 1952), pp. 62–63, fig. 34; Boston 1955, p. 30; M. Sharp Young, "Napoleon, Trend-setter," *Apollo* 91, no. 96 (Feb. 1970), pp. 154, 155, fig. 2; M. Fried, "Thomas Couture and the Theatricalization of Action in Nineteenth-Century French Painting," *Artforum* 8, no. 10 (June 1970), pp. 42–43, ill.; Chapel Hill 1978, p. 85; K. L. Brush, in Bell Gallery, Brown University, *Edouard Manet and the Execution of Maximilian* (Providence, R.I., 1981), p. 159, no. 3; Murphy 1985, p. 125 (as Baron Antoine-Jean Gros and Studio); Stebbins and Sutton 1986, p. 58; C. F. Stuckey, *French Painting* (New York, 1991), p. 90, ill.

CONDITION: The plain woven fabric support, which has been lined, with the original tacking edges intact, has a repaired rectangular tear in the central upper section. The majority of the picture is very thinly painted over a buff ground, but Napoleon and the figures around him are painted with impasto and in greater detail. Analysis of various pigments is consistent with the painting's having been produced during Gros's lifetime. Infrared examination reveals drawn lines throughout, with only small artist's changes revealed in the placement of the architecture. The paint layer is in very good condition, and in-painting is confined to the repaired area.

After a four-day siege at the start of the Syrian campaign, on March 7, 1799, Napoleon Bonaparte and his forces captured the town of Jaffa (near present-day Tel Aviv). After entering the city, the troops were infected by an outbreak of the bubonic plague, and as many as eight thousand died.[1] To house the soldiers wounded in the fighting and the growing number of plague victims, a makeshift hospital was erected in what was later described as a mosque but, as Henri Mollaret and Jacqueline Brossollet have pointed out, was actually an Armenian monastery.[2] There, on March 11, accompanied by his chiefs of staff and the Army of the Orient's chief doctor, Nicolas-René Desgenettes, Napoleon visited the plague victims in an attempt to stem a growing sense of panic, to improve morale, and to demonstrate his own bravery and immunity to the disease. By the end of the campaign, reports began to circulate that accused Napoleon of abandoning his troops to the plague, issuing orders to poison the remaining victims with opium, and ruthlessly massacring over three thousand Turkish prisoners.[3]

In a calculated attempt to improve his public image, Bonaparte commissioned the young artist Antoine-Jean Gros—who had already executed the flattering portrait of 1796, *Napoleon at the Bridge of Arcole* (Versailles)—to paint a noble depiction of his visit to the hospital in Jaffa.[4] This was part of a larger propagandistic campaign, which called on the skills of the leading French artists, including David, Anne-Louis Girodet de Roucy-Trioson, and Baron François-Pascal-Simon Gérard. Gros completed his enormous canvas in remarkably short time,[5] and it was exhibited at the Salon of 1804, which opened in September of that year in the Musée Napoléon. The painting was titled *Bonaparte, Chief General of the Army of the Orient, at the Moment when He Touched a Pestilential Tumor on Visiting the Hospital at Jaffa*, and the Salon *livret* described it as follows:

> The ravages visited by the plague upon the Eastern Army since the beginning of the Syrian campaign caused a general disquiet. The effects of the scourge were felt with increasing force immediately after the siege of the city of Jaffa which had been taken by storm.
>
> The commanding General, Bonaparte, wishing to dispel any pretext for becoming disheartened that an exaggerated feeling of fear of this disease might give rise to among the army and to prove that its effects were less terrible than the fear which they caused, visited the hospital of the plague-stricken in Jaffa with the greatest thoroughness. After having provided all the help that could be obtained for the hospital, and having even sent a portion of his private provisions, the commanding General, followed by his general staff and the doctor in chief of the army who tried to persuade him not to overly prolong his visit, nevertheless paid great attention to every detail of the hospital. What is more, he consoled the sick by all means of persuasion; to some he offered hope of an impending relief, to others a certain recovery, and inspired all

Fig. 86a. Antoine-Jean Gros, *General Bonaparte Visiting the Plague-Stricken at Jaffa*, 1804. Oil on canvas. New Orleans Museum of Art, Museum Purchase and the Ella West Freeman Foundation Matching Funds, acc. no. 67.24

> with confidence in the efficacy of the treatments being employed.
>
> To further dispel the fearful idea of a sudden and incurable contagion, he had some of the pestilential tumors opened in front of him and touched several of them. By this generous devotion he gave the first example of a sort of courage unknown until then and which has since created imitators.[6]

This work, now in the Louvre, was a great success and launched the artist's career.[7] Gros's contemporary, Girodet, was so inspired by the painting that he wrote a poem in its honor,[8] and Eugène Delacroix later recalled the memorable mob scene of those wishing to view the canvas in Gros's studio.[9] Napoleon himself was evidently pleased, as he came to the Salon to honor the prize-winning artists that year and dramatically pinned on Gros his own cross of the Légion d'Honneur.[10] Not only prints, but also a large Gobelins tapestry were copied after the painting.[11]

Two oil sketches of the subject by Gros document significant changes in its conception throughout the preparatory stage. The earlier sketch (fig. 86a), now in the New Orleans Museum of Art, as well as a drawing at the Louvre, both depict Napoleon visiting the plague-stricken soldiers in the interior of the hospital and—depending on the interpretation—either assisting in removing a body or trying to raise the victim.[12] In his memoirs of 1802, Desgenettes described how, much to his concern, Napoleon had not only ordered some of the poor victims' sores, or buboes, lanced so that he could touch them to inspire courage, but also that the general had indeed helped carry a corpse out of the main ward in the hospital.[13] The drawing of this stage belonged originally to one of the surgeons present at the scene, Dominique-Jean Larrey, who published his own memoirs in 1803 and 1812,[14] and to whom Gros

may logically have turned for information. This composition, however, must have been deemed too unfocused and not grand enough and Gros probably modified his approach dramatically at the prompting of Dominique Vivant Denon, Napoleon's *directeur général des musées*, who had also witnessed and chronicled the actual military campaign and was eager to enhance Napoleon's reputation.[15]

The second sketch is at the Musée Condé in Chantilly and ostensibly was the one done for official approval.[16] It is closer in composition to the finished painting, focusing on the incident of Napoleon extending his hand to touch the victim's sore. The scene is set in an open courtyard, surrounded by Moorish architecture, with a view of the hills in the distance and opening to the sea at the right. In this sketch, the army doctor Desgenettes, to Napoleon's right, turns to examine the victim's plague sores or boils, which typically were the swollen lymphatic glands in the armpit, which Napoleon is touching. This was changed in the final conception, so that Napoleon's gesture is more clearly seen and the doctor looks out at the viewer while, as described in the *livret*, he and one of the military aides react in horror and try to lead Napoleon away. Some further modifications of the composition remained to be done, as evidenced by a drawing now in the collection of Louis-Antoine Prat, Paris.[17]

In the final composition, which, in his glowing report to Napoleon, Vivant Denon called "truly a masterpiece,"[18] the general stands calmly in the center of the hospital courtyard, his serene demeanor in vivid contrast to the horror and fear of his aides. Likewise, Napoleon's meticulously depicted full regalia as the general in chief contrasts with the near nudity of most of the ragged victims. One of these stands before Napoleon, his arm raised to reveal his plague sore. Napoleon, shown in profile, his glove removed, courageously touches the victim with a reassuring gesture. In the background, the French flag flies above the Moorish architecture, indicating the general's military victory over the enemy. The clear implication is that by his force of character he will also overcome the disease.

To the right of Napoleon, between him and the victim he touches, can be seen the anxious chief doctor, Desgenettes. To the left directly behind Napoleon is General Berthier, who in a gesture traditional in plague subjects, turns away and holds a cloth to his nose, denoting the stench of the disease. The officer behind him is General Bessières. At the extreme right is an obviously dying young doctor. He is sometimes identified as Masclet, an army surgeon who was active at Alexandria, but is more likely another surgeon, Saint-Ours, who did die of the plague at Jaffa.[19]

Gros intertwined the various people present as part of the military campaign. In addition to the French soldiers, there are Arabs, Turks, and Africans. The kneeling Turk who pierces a bubo of the nude victim kneeling to the right of Napoleon was an actual person, a Christian who worked tirelessly at the makeshift hospital and never contracted the disease.[20]

Gros carefully delineated certain historical details of the event that he could have garnered from reading the published accounts or speaking with the survivors. For example, the afflicted soldier standing next to the one Napoleon touches has on his headdress the number *32*, which, as Mollaret and Brossollet have discovered, refers to the thirty-second demibrigade of General Bon, a division of grenadiers that was badly decimated by the plague. Likewise, the camels seen in the background were really part of the scene, a small regiment of four-legged ambulances created by Napoleon.[21]

Writing in 1880, Arsène Alexandre noted that "in all the different figures all the phases of the contagious disease" are illustrated.[22] An army report of 1803 by Surgeon in Chief Larrey described the diseases encountered in the Syrian campaign, and Gros perhaps derived from this his accurate representation of the different stages of the plague.[23] The blindfolded soldier who clings to the column at the right is suffering from opthamalia, an eye disorder that increases sensitivity to bright light. The two highlighted figures in the center of the composition are in the first stages of the disease, with contracted limbs and fits of excessive restlessness. The group of soldiers at the left exemplifies the next stage, which includes symptoms of general weakness and uncontrollable shivers. Behind them, victims in the final stages suffer from convulsions and delusions.[24]

Just as he strove for a certain basis in fact in his depictions of the event, Gros sought to create an authentic Near Eastern setting. Never having traveled to the region, he had to rely on pictorial sources. As Norman Schlenoff discovered, a print by Taracheny of the ramparts of Jaffa served as the background.[25] For the great mosque courtyard, Gros clearly employed another source: The most comprehensive study of Egyptian sites he could have consulted was the monumental *Description of Egypt*, in which is one plate of Alexandria that shows a minaret rising behind a crenellated wall is similar to the one in the background of his painting.[26] The chief inspiration for this space, however, seems to be the courtyard of the famous Fatimid-period mosque of al-Azhar at the citadel in Cairo, which Gros could have known from drawings or printed sources.[27] For the exotic Eastern costumes, one wonders if Gros had not been inspired in part by Gérard's illustrations of 1801 for Racine's *Bajazet*.[28]

Despite its indebtedness to historical incident and characters, Gros's masterpiece is distinctly a constructed view of the event at Jaffa. Astute critics, such as Vicomte François-René de Châteaubriand, quickly recognized that Gros had transformed Napoleon into a miraculous healer, a modern-day Saint Louis.[29] Walter Friedlaender later pointed out that Gros not only employed imagery associated with sixteenth- and seventeenth-century Italian saints, particularly Saint Roche and Saint Carlo Borromeo, who were able to heal through touch, but he also cast Napoleon as a *roi thaumaturge*, a ruler or king who, according to French tradition, could heal scrofulous abscesses through touch.[30] Subsequently Robert Rosenblum drew attention to the visual tradition of the

exemplum virtutis, especially in works by Joseph-Marie Vien, that provided a source for Gros.[31] Two large Arab figures on the left side of the composition are shown distributing bread to the huddled and imploring mass of wounded and dying. Their generous deed recalls images of one of the traditional Acts of Mercy— feeding the poor and needy.[32] These two noble figures serve to balance the group of figures standing at the right side. In this group, Napoleon is the central figure, and in this context of charitable acts, his touching of the sick soldier's wound and the implied healing power it bestows serve to identify him with the miraculous powers of Christ. The image of Christ curing the blind, the lame, or even raising the dead was a long-established tradition in Western art and one on which Gros clearly modeled his subject.[33]

Compositionally, Gros also combined inspiration from both Italian and French art. His extended stay in Italy provided the painter with first-hand knowledge of the works of Michelangelo; the grim seated figure at the left with his head resting on clenched hands is a nearly exact copy of one of the damned in Michelangelo's *Last Judgment* in the Sistine Chapel. Likewise, the emphasis on gesture or touch—Napoleon's own extended arm, the isolated finger, and the arm position of the victim whom he touches—seems to echo both the famous divine gesture of God in the Sistine ceiling's *Creation of Adam* and the risen Christ in Michelangelo's *Last Judgment*. Gros's reliance on another Italian master, Raphael, especially the scale and design of the latter's tapestry compositions, has been discussed by Sara Lichtenstein, and the relation of the general's pose to that of the *Apollo Belvedere* (Vatican) has been addressed by David O'Brien.[34] To contemporary writers, the then-brilliant color of the painting recalled the Venetian masters Titian and Veronese,[35] and the powerful design had overtones of Rubens, whose *Saint Ignatius Curing the Possessed* Gros had admired in Genoa.[36]

The telling use of gesture and the powerful male nudes, however, were also elements derived from Gros's master, David. Specifically, the striking depiction of a plague victim seen in the older master's *Saint Roche Interceding with the Virgin for the Cure of the Plague Victims* of 1780 (now in Marseille), which was shown in Paris at the Salon of 1781,[37] clearly made an impact. Even more notable is Gros's use of the dramatic arched setting as a backdrop. Here pointed Moorish arches open onto a distant vista, but David had employed the same effective device earlier in his *Oath of the Horatii* (Paris, Musée du Louvre) of 1784. Also like David's treatment of Napoleonic subjects, Gros's Jaffa had a specific political goal, for as Albert Boime has aptly described it, "while Napoleon [in 1799] was then only a general, his new status in 1804 as founder of an hereditary empire is projected in the picture. It is a picture that justified his election to emperor and rationalized his authority."[38]

According to an undated and unsigned typewritten note in the Paintings Department files, Marshal Mortier, the first duc de Trévise, on seeing the large painting at the Salon, commissioned Gros to produce another version for him, which was completed in

a few months.[39] Edouard Mortier had dutifully served Napoleon from 1792 until his surrender in 1814, and in recognition of his loyalty, Napoleon in 1804, the very year of the Jaffa painting, bestowed on him the newly created rank of marshal and then granted him the ducal title in 1806 with the territory of Treviso in the Venetian states.[40] The painting, according to the same note, did not remain in the Mortier family, but many years later, in 1934, the fifth duc de Trévise tracked it down in the collection of an unidentified English doctor.[41] There is, however, nothing in the extensive literature on Baron Gros and the Jaffa painting to confirm Mortier's commissioning of a reduced version or the presence of the work in England. Rather, the most thorough catalogue of Gros's *oeuvre*, that by J. Tripier le Franc, records that "Auguste Debay, one of the best students of Gros, who was the most faithful to his style, painted for his master a great deal later a reduced copy which Gros signed."[42] The Debay atelier-sale catalogue of 1865 has an unsigned introduction, which states that Debay painted the copy in 1823 before his departure for Rome.[43] Baron Gros himself kept this copy, for it was included, along with a Debay after David's *Adromache Mourning Hector*, in his estate sale of 1835. It was listed as by Debay and described in the catalogue as a "copy of the Pesthouse at Jaffa executed under the direction of Gros."[44] No measurements are given and no mention is made of a signature. According to Tripier le Franc, the painting then passed to Debay himself,[45] but it is not to be found in the sale after Debay's death in 1865.[46] Instead, what probably was this painting was sold in Paris in 1840 simply as "by a pupil of Gros, created under the direction of the master and which served as the model for the engraving by Mr. Jazet."[47] Again there were no measurements and no mention of a signature. This sale was apparently a portion of the extensive Aguado collection.[48] There is then no record of the painting until it surfaced again in 1934 in the possession of the fifth duc de Trévise.

Although not signed by Gros, as Tripier le Franc indicated, the Museum's painting is most likely the copy by Debay, who trained with Gros and assimilated his style so well that the master had him carry out the additions to his *Battle of the Pyramids* in 1836.[49] Debay painted in a neoclassical style before turning primarily to sculpture, for which he became better known.[50] The attribution of the Boston painting to Debay has been confirmed by François Delestre.[51]

This work has frequently been exhibited as by Gros, but the Museum has, since its acquisition, considered it a copy produced by Gros and his studio. It is one-quarter the size of the Louvre original (which measures 17 ft. 5 1/2 in. × 23 ft. 7 1/2 in.) and differs from it in minor details of the architectural background, specifically the arches and the crenellations. Thinly painted over drawn lines that are revealed by infrared examination, the Boston canvas has the characteristics of a work by a competent workman without the brilliance of direct inspiration or genuine involvement. It does, however, preserve the richness of color much better than the original, which was supposedly damaged during the process of making the tapestry version[52] and quickly darkened, so that

Delacroix, writing in 1848, could already state that the work had lost its *éclat*.[53]

In conceiving the large original, despite the exotic locale of his subject matter, Baron Gros remained faithful to the neoclassical ideals of David in his clear and rational use of space and lighting, in the emphasis on significant gestures, and in the portrayal of the misery of the soldiers through expression. These victims are portrayed with idealized bodies that remain remarkably untouched by their disease. Baron Gros's richness of invention, evident even in Debay's reduced replica, provided a key source for the transition from the neoclassicism of David to the romanticism of Delacroix and Géricault. As Delacroix wrote, the painting remains "clearly in the memory of all those who are interested in the development of our school."[54]

1. Schlenoff 1965, p. 158.

2. Mollaret and Brossollet 1968, p. 292.

3. See R. G. Richardson, *Larrey: Surgeon to Napoleon's Imperial Guard* (London, 1974), pp. 62–63 and 70–71.

4. See O'Brien 1995, p. 659, who has discovered a letter from Gros to Guérin crediting Napoleon himself with the commission. Previously it had been believed that Josephine Bonaparte commissioned this large-scale painting of her husband's deed, as was first mentioned by P. Lelièvre, *Vivant Denon* (Paris, 1942; Paris, 1993), p. 159, and reported by Mollaret and Brossollet 1968, p. 267. The evidence for this, as pointed out to us by Marc S. Gerstein in correspondence, was a letter of January 9, 1805, from Napoleon to his treasurer, Estève, stating that Josephine hired Gros to paint the Jaffa canvas: "To Mr. Gros, for *The Plague at Jaffa*, ordered by Her Majesty the Empress, without having determined the price, which should never be done, the sum of 16,000 francs, which will not satisfy the self-respect of this artist, considering the extravagant cost of the *Phaedrus* by Guérin [which was acquired in 1802 for 24,000 francs]." From Napoleon's *Correspondance*, no. 8.266. See also L. Lanzac de Laborie, *Paris sous Napoléon, VIII: Spectacles et Musées* (Paris, 1913), p. 374. Gerstein also has found in the Archives Nationales document 0²843 in the dossier Musées Impérieux, *Projets et minutes d'états de dépenses des Musées et des acquisitions d'objets d'art de l'an 13 à l'an 1810*, which shows that, for the year 13, *La Peste de Jaffa* is listed among "acquisitions," not the "works ordered." Similarly, in the Archives du Louvre, no. 1DD18, "Inventaire général du Musée Napoléon," the museum inventory of 1810 lists on page 536, no. 1782, Gros's *Peste de Jaffa* as "Acquired by His Majesty, 16,000 [francs]." Commissioned works by Gros are listed as "painting ordered."

5. J. B. Delestre, in his 1867 study (p. 85), stated that Gros had painted the canvas in less than six months. This assertion has frequently been repeated. However, as called to our attention by Gerstein, another of Gros's former students, the painter P.-R. Vigneron, wrote a letter to Delestre in 1849 to correct some of his errors and related that Gros told him that the composition was sketched out in twenty-one days from his drawn and painted studies. He left the canvas alone for three months and then, in a final burst of activity, corrected and completed it in another twenty-one days. If true, the whole campaign of painting thus took only forty-two days. It still remains unclear, however, when the commission was received; given this speed of production it could have been 1804. For Vigneron's letter, see P. Néagu, "Un Témoinage inédit du peintre P.-R. Vigneron sur le Baron Gros," *BSHAF* (1978), pp. 245–47.

6. *Explication des ouvrages de peinture, sculpture et gravure des artistes vivans exposés au Musée Napoléon . . .* (Paris, 1804), pp. 39–40, no. 224.

7. In 1810 Gros's painting received an honorable mention in the competition for the Prix décennaux. First prize went to David's *Coronation*. See *Rapports et discussions de toutes les classes de l'Institut de France sur les ouvrages admis au Concours pour les Prix décennaux* (Paris, 1810), pp. 28–32. These prizes were never actually awarded as there were disagreements between the Institut and Napoleon.

8. Quoted in Delestre 1867, pp. 92–93, and in part translated in London 1984, p. 164.

9. See Delacroix 1923, pp. 176–77.

10. Wrigley 1993, p. 75.

11. There are prints by Quéverdo, Laugier, and others. See Tripier le Franc 1880, p. 217; and also Mollaret and Brossollet 1968, p. 267, fig. 3. The tapestry, now in the Walters Art Gallery, Baltimore, is discussed in Johnston 1967, n.p.

12. For the New Orleans sketch see Chapel Hill 1978, no. 40. The Louvre drawing is reproduced in Mollaret and Brossollet 1968, p. 274, fig. 6.

13. R.-N. Desgenettes, *Histoire médical de l'armée d'Orient* (Paris, 1802). See also Porterfield 1991, p. 30.

14. Larrey 1803, p. 19, and D.-J. Larrey, *Mémoires de chiurgie militaire, et campagnes* (Paris, 1812–17).

15. Schlenoff 1965, pp. 154 and 159–61. Vivant Denon's role was also noted by P. Lelièvre, "Gros, peintre d'histoire," *GBA* 15 (1936), p. 294.

16. Mollaret and Brossollet 1968, p. 299, fig. 8; another oil sketch of this stage attributed to Gros was sold at the Salle de Fêtes, Deauville, August 29, 1969, no. 65.

17. A. Fyjis-Walker, "A Recently Discovered Drawing by Antoine-Jean Gros," *TBM* 127, no. 990 (Sept. 1985), pp. 621–22, fig. 67; and P. Rosenberg, in National Academy of Design, *Masterful Studies: Three Centuries of French Drawings from the Prat Collection* (New York, 1990), pp. 174–75, no. 70, who speculates that the drawing may be after the painting. Other presumed preliminary oil studies for portions of the composition that have recently appeared include a rough study of Napoleon touching the plague victim and the head of the dying doctor at the lower right, which were both with Adrian Ward-Jackson Ltd., London, in the summer of 1979.

18. See Delestre 1867, p. 95.

19. Mollaret and Brossollet 1968, pp. 300–301. See also J. H. Dible, *Napoleon's Surgeon* (London, 1970), p. 38.

20. Mollaret and Brossollet 1968, pp. 301–302.

21. Ibid., pp. 302–303.

22. A. Alexandre, *Histoire de la peintre militaire en France* (Paris, 1880), p. 140.

23. Larrey 1803, p. 19.

24. Porterfield 1991, p. 36.

25. Schlenoff 1965, p. 159.

26. See *La Description de l'Egypte* (Paris, 1809), reprinted as *Monuments of Egypt* (New York, 1987), vol. 5, pl. 35.

27. See K. A. C. Creswell, *The Muslim Architecture of Egypt* (Oxford, 1952), who lists a French publication of 1747–51. Also see G. Wiet, *The Mosques of Cairo* (Paris, 1966), p. 8; and M. Frishman and H.-U. Khan, eds., *The Mosque* (London, 1994), p. 97.

28. See *David contra David: Actes du colloque organizé au Musée du Louvre 1989* (Paris, 1993), vol. 2, p. 1150, fig. 249.

29. See Châteaubriand, *De Buonaparte, des Bourbons, et de la nécessité de se rallier à nos princes légitimes . . .* (Paris, 1814), p. 15.

30. W. Friedlaender, "Napoleon as Roi Thaumaturge," *Journal of the Warburg and Courtauld Institutes* 4 (1941–42), p. 140. On the tradition of the French king's power of healing the scrofulous, see also E. Zafran, "Six Drawings by Develly," *Journal of the Museum of Fine Arts, Boston* 3 (1991), p. 80.

31. See R. Rosenblum, *Transformations in Late-Eighteenth-Century Art* (Princeton, 1967), p. 96.

32. On the Seven Acts or Works of Mercy, see J. B. Knipping, *Iconography of the Counter-Reformation in the Netherlands* (London, 1974), vol. 2, pp. 328–43.

33. In this regard one thinks especially of Poussin's *Curing the Blind* in the Louvre. See Paris 1994, no. 20.

34. S. Lichtenstein, "The Baron Gros and Raphael," *Art Bulletin* 58, no. 1 (March 1928), pp. 128–30; and O'Brien 1995, pp. 659–60.

35. See Delestre 1867, p. 93, and H. Lemònnier, *Gros* (Paris, n.d.), p. 32.

36. Delestre 1867, p. 26. For this composition, see H. Vliege, *Saints II, Corpus Rubenianum*, pt. 8 (London and New York, 1973), pp. 78–79, no. 116, pl. 46.

37. See Paris 1989, pp. 105–107, no. 40.

38. Quoted from A. Boime, *Art in an Age of Bonapartism, 1800–1815* (Chicago and London, 1990), p. 86.

39. There is no direct correspondence from the fifth duc de Trévise nor from the dealer, Julius H. Weitzner, that states the work was commissioned by Marshal Mortier, the first duc de Trévise. Since the acquisition of the painting, however, this dubious history has been repeated as fact in several exhibition catalogues.

40. *The Cambridge Modern History*, vol. 9: *Napoleon* (Cambridge, 1906), p. 111, and R. P. Dunn-Pattison, *Napoleon's Marshals* (Boston, 1909), p. 280.

41. The fifth duc of Trévise (1883–1946) was known for his distinguished collection and his researches on Gros and other romantic painters. See the note about him by C. de Cossé Brissac in the sale catalogue of Hôtel Drouot, Paris, November 23, 1992, pp. 2–3.

42. Tripier le Franc 1880, pp. 217 and 673.

43. *Vent après décès, catalogue des tableaux . . . dessins de feu M. Auguste de Bay*, Paris, rue Notre-Dame-des-Champs 73 and 75, May 21, 26–27, 1865, p. 4.

44. Dezauche, *Catalogue des tableaux esquisses, dessins et croquis de M. Le Baron Gros* (Paris, 1835), p. 17, no. 130.

45. Tripier Le Franc 1880, p. 217.

46. See n. 43.

47. Place Vendôme, *Vente d'une nombreuse collection de tableaux provenant du château de Petit-Bourg* (Paris, April 27, 1840), p. 16, no. 113.

48. Although often given as "Agado," the name of the collector associated with this sale is undoubtedly, as given in F. Lugt, *Répertoire de catalogues de ventes publiques* (The Hague, 1953), vol. 2, n.p., "Aguado." The vicomte Aguado was also the marquis de las Marismas, who had a large collection of mainly Spanish paintings. The Gros copy was not listed in the 1839 catalogue of this collection or in any other of the family's many sales. However, the marquis's son Comte Olympe Aguado, who became noted as a photographer, lived at 18, place Vendôme, just next to where the Petit-Bourg pictures were sold in 1840, when he was a child. See Metropolitan Museum of Art, *After Daguerre: Masterworks of French Photography (1848–1900) from the Bibliothèque Nationale* (New York, 1980), p. 74, no. 3.

49. See Schlenoff 1965, p. 156.

50. See Bénézit 1976, vol. 3, p. 405; and S. Lami, *Dictionnaire des sculpteurs de l'école française* (Paris, 1916), vol. 2, pp. 132–33. For background and examples of Debay's painting, see P. Grunchec, in Ecole Nationale, *Le Grand Prix de Peinture: Les Concours des Prix de Rome de 1797 à 1863* (Paris, 1983), pp. 197 and 379; and C. Pinatel, "Les Mélanges des Niobides . . . ," *RdL* 3 (1989), p. 142, fig. 15. An *Andromache and Astyanax* of 1823 by Debay sold at Sotheby's, Monaco, June 22, 1991, no. 328; a later work dated 1851 was in *La Peinture à Nantes* in *Arts de l'ouest* (Feb. 1978), fig. 9; also see Los Angeles County Museum of Art, *The Romantics to Rodin* (Los Angeles, 1980), p. 226. Debay's portrait occurs among those students in Baron Gros's atelier drawn by Boilly. See Paris 1984, p. 93, no. 85.

51. In a letter of December 21, 1992.

52. Johnston 1967.

53. Delacroix 1923, vol. 2, p. 177.

54. Ibid., p. 176.

JEAN-VICTOR BERTIN

1775–1842

Jean-Victor Bertin entered the Académie royale de peinture et de sculpture in 1785 and soon thereafter became an esteemed pupil of Pierre-Henri de Valenciennes (q.v.). He first exhibited at the Salon in 1793 and continued to do so until his death, receiving prizes in 1799 and 1808. Bertin always acknowledged the debt to his master and even late in his life referred to himself as a "pupil of Valenciennes." Bertin painted both *paysages historiques* and *paysages*

après nature, and his technique evolved tremendously throughout his career. Before 1815 his work was very detailed and smooth, but afterward his brushwork became looser, and by 1825 his paintings were much freer. Bertin established an important atelier that produced most of the winners of the Prix de Rome for *paysages historiques*, a category that was instituted in 1817. His most famous student was Camille Corot.

87. *Entrance to the Park at Saint-Cloud*, ca. 1800

Oil on canvas
10 1/4 × 14 1/8 in. (25.9 × 36 cm)
Signed lower left: *V. Bertin*
Bequest of Julia C. Prendergast in Memory of her brother, James
Maurice Prendergast
44.39

PROVENANCE: sale Leonard and Co., Boston, April 12, 1890, no. 141; James
Maurice Prendergast; by descent to Julia C. Prendergast.

EXHIBITION HISTORY: Boston 1978.

REFERENCES: Boston 1955, p. 4; Gutwirth 1974, p. 344, no. 39; Murphy 1985,
p. 18; P. Galassi, "Nineteenth Century: Valenciennes to Corot," in New York
1990, pp. 242–43, fig. 11.

CONDITION: The painting is on a plain woven fabric support, which has been
glue-lined, with the tacking margins trimmed. The pale ground is visible in many
areas through the very thin paint. The painting has been abraded in areas, leav-
ing the shadows almost transparent, and the signature has also been reinforced
over the abraded original lines.

In the center of the composition, a rustic gatehouse attached to a
low stone wall is surrounded by trees. The main gate is cropped at
the left, allowing only a partial view into the park beyond. The
picturesque park of the palace at Saint-Cloud, which was located
outside Paris and has since been destroyed, was painted several times
by Bertin in the early years of the nineteenth century. He depicted
two different entrances to the park. One showing a large stone gate
in the center of the composition, with a two-story gatehouse
attached, is known in several versions with and without figures.[1]

The Museum's painting is of a different entrance with a rustic
one-story gatehouse to the right and has been dated by Suzanne
Gutwirth to the years 1800–1805.[2] It is Bertin's only known paint-
ing of this particular composition, but there is a preparatory
gouache study in the British Museum (fig. 87a). This is remarkably
similar in composition to the finished work, despite the differences
in technique. Bertin's use of earthy colors and simple compositions
had a great influence on later artists, particularly his student Corot,
who painted the same motif in an early work of 1822–23.[3] Despite
its modest size, Bertin's work, which is devoid of figures, has a pow-
erful presence. The depiction of the abandoned, once-popular park
provides a poignant sense of nostalgia for the *ancien régime*.

1. For examples at Sceaux and Boulogne-sur-Seine, see Gutwirth 1974, pp.
 343–44, 348, nos. 37 and 72. Also a third undated view without figures is at
 the Art Institute of Chicago, and yet another, with a man on horseback, is at
 the Musée Municipal, Dole. See Simpson, in Memphis 1987–88, p. 49, no. 21;
 and Gray, Musée Baron Martin, *Peinture et dessin en France de 1750 à 1830 à
 partir des collections des Musées de Belfort, Besançon, Dole, Gray* (Gray, 1977),
 no. 4.

2. See Gutwirth 1974, p. 344, no. 39.

3. Camille Corot, *Entrance to the Park of Saint-Cloud*, 1822–23 (Paris, private
 collection). See Galassi 1991, p. 78, fig. 86.

Fig. 87a. Jean-Victor Bertin, gouache study for cat. 87. London, British
Museum, inv. no. 1988-6-18-19

88. *Landscape with Bathers and Shepherds*, 1804

Oil on canvas
50 1/8 × 44 1/2 in. (127.3 × 113.1 cm)
Signed and dated lower right: *Bertin 1804*
Gift of Julia Appleton Bird
1981.721

PROVENANCE: Mrs. Charles Sumner Bird, Ipswich, Mass.

REFERENCE: Murphy 1985, p. 18.

CONDITION: The painting is substantially altered, making it impossible to
know the original dimensions and composition from the physical evidence.
X-radiographs are fundamental to understanding the changes, none of which
were made by the artist. The original support was a plain weave, medium-weight
fabric. It was enlarged through the addition of a 6 1/2-inch strip of fabric along
the top. The extended composition was transferred and glue-lined to fine canvas
with a gauze interlayer. Date(s) of the addition and transfer are not known.

With the addition, new sky was added, the original sky was overpainted to
match, the large tree at right greatly enlarged, small buildings and trees added in
the left middle distance, and the foreground pool and foliage toned. The heavy,
medium-rich overpainting has darkened considerably in contrast to the thin,
finely applied original paint, which has unfortunately suffered extensive abrasion
and loss from overcleaning, overpainting, and structural changes.

In the foreground of this large pastoral landscape, a young woman
sits as her goats graze in the grass beside her. A shepherd tends to
his flock of sheep in the background while he watches a group of
bathers who frolic in a nearby pond. On the hilltop above is a
town with Italianate buildings and an aqueduct.

Throughout his career, Bertin's works ranged from grand,
idyllic landscapes to small rustic scenes. The large scale and pas-
toral theme of this work places it in the former category. Like
his teacher Pierre-Henri de Valenciennes (q.v.), Bertin painted
numerous *paysages historiques*—landscapes imbued with a classical
sensibility—inspired by the works of Nicolas Poussin (q.v.). In a

treatise written in 1800, Valenciennes provided a simple description of appropriate motifs that should be included in neoclassical landscapes, such as large, well-formed trees, a calm source of water, a group of figures scattered throughout the scene, a cluster of classical buildings, a beautiful sky, and a hill or mountain in the distance.[1] In this example, even despite the extensive reworking, one can see that Bertin adhered to Valenciennes's formula, combining all the elements into a harmonious composition. Similar motifs are found

in other paintings by Bertin of this period, particularly in two other landscapes of 1804.[2]

1. See Pierre-Henri de Valenciennes, *Elémens de perspective pratique* (1800; reprint, Geneva, 1973), pp. 420–22. See also Galassi 1991, pp. 45–46.

2. See Gutwirth 1974, p. 344, nos. 40 and 41, for illustrations. The location of these two works is currently unknown.

LANCELOT-THÉODORE
TURPIN DE CRISSÉ

1781–1859

Lancelot-Théodore Turpin de Crissé's father, an artist as well as a military officer, was his first teacher. When his father emigrated to England, Turpin turned to art full time, specializing in archaeological studies for the well-known diplomat Marie-Gabriel-Auguste-Florent Choiseul-Gouffier who financed his travels to Switzerland and Italy. Turpin de Crissé first exhibited at the Salon in 1806 with both historical and archaeological subjects. He continued to exhibit there until 1835, primarily with historical landscapes.

During the Napoleonic era, the artist had great success, being patronized by Empress Josephine, Queen Hortense, and Prince Eugène. He even remained popular during the Restoration. He was appointed an independent member of the Académie royale in 1816 and in 1824 he became the king's *inspecteur général des beaux-arts*. From 1835, Turpin de Crissé devoted himself primarily to his art collection, which he bequeathed to the city of Angers.

89. *Temple of Antoninus and Faustina*, 1808

Oil on canvas
45 1/2 × 64 1/2 in. (116 × 163.5 cm)
Signed and dated lower left: *T. Turpin de Crisse, 1808*
Bequest of Emma B. Culbertson
~~Res~~. 20.852

PROVENANCE: Dr. Emma B. Culbertson.

EXHIBITION HISTORY: Kyoto 1989, no. 4; Boston 1991–92.

REFERENCES: Boston 1955, pp. 64–65; Murphy 1985, p. 285.

CONDITION: The support, a plain-weave fabric with trimmed original tacking
margins and a horizontal seam, has been strongly lined with a white-lead adhesive, with resultant dents and weave enhancement. Five long-repaired, complex
tears are found in the center and upper right. Infrared reveals underdrawing of
the architecture in a dry medium. In normal light, the underdrawing is visible in
some areas through the thin paint applied over a light-colored ground. Drying
crackle and abrasion are evident in the darks. A two-inch, horizontal band of
brighter blue, presumably covered for a long time, is visible at the top. With the
exception of the losses related to the tears, the seam, and the large loss at upper
right, the paint layers are quite well preserved. The in-painting is limited to the
areas of loss. The painting was cleaned in 1954 and again in the early 1980s.

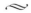

This painting dates from Turpin de Crissé's first visit to Rome in
1807–1808. The view is of the Via Sacra in the Roman Forum with,
at the right, the church of SS. Cosmas and Damian and the ancient

Temple of Antoninus and Faustina. Built in the sixth and seventh
centuries, the temple later became the church of S. Lorenzo in
Miranda. In the seventeenth century it was given a baroque façade,
which is seen here only from the side, so that the ancient character
of the monuments is emphasized. It was in the early nineteenth
century that this temple portal was exposed and became a notable
tourist attraction, recorded by such other foreign artists as the
Scandinavian painter Christoffer Wilhelm Eckersberg.[1] Through
the columns of the temple can be seen the tower of the Senators'
Palace; at the left are the columns of the Temple of Castor and
Pollux and beyond that is probably the Basilica Julia.[2]

Turpin de Crissé populated his vista with a variety of
picturesque Italian peasants to provide a sense of scale and to
animate the scene, which is painted with a brilliant clarity that
captures the intensity of the Roman light reflected on ancient stone
monuments. A detailed drawing by the artist of a different view of
the Forum, also with tiny figures, is in the Louvre.[3]

1. Eckersberg's painting of 1814 is in the Ny Carlsberg Glyptotek, Copenhagen,
 inv. no. 2611.

2. For other views of this section of the Forum, see Museums der Stadt Dortmund, *Roma Antica* (Dortmund, 1994), pp. 162–65.

3. R.F. M1610, 67-En.4790. Another example of Turpin's early paintings of ancient ruins is *View of the Temple of Minerva, Athens*, 1805, which was sold at
 Sotheby's, London, November 25, 1981, no. 7.

90. *The Bay of Naples*, 1840

Oil on canvas
38 1/8 × 57 1/2 in. (95.5 × 144 cm)
Signed center left with the artist's crowned TT monogram
and dated 1840
Charles H. Bayley Picture and Painting Fund
1980.3

PROVENANCE: sale Galerie des Chevau-Légers, Versailles, July 10, 1974, no. 235; Hazlitt, Gooden and Fox Ltd., London, 1980.

EXHIBITION HISTORY: London, Hazlitt, Gooden and Fox, *The Lure of Rome: Some Northern Artists in Italy in the Nineteenth Century*, 1979, no. 18; Tokyo 1983–84, no. 33; Kyoto 1989, no. 5; Boston 1991–92.

REFERENCES: Museum of Fine Arts, Boston, *The Museum Year, 1979–1980* (Boston, 1980), pp. 28–29, ill.; Murphy 1985, p. 285.

CONDITION: The original plain woven fabric support has been lined. The paint is applied over a ground of undetermined color. There has been some tonal change over time, most notably the darks of the rocks and shadows have sunk. The paint layer is in excellent condition.

≈

The queen of Naples was among the patrons of Turpin de Crissé, and several of his works shown at the Salon in 1819 and 1822 were of views in the region of Naples.[1] Two elaborate oil studies on paper, both of 1824, now in Cologne, depict scenes around Naples.[2] In 1828 he published a set of thirty-nine lithographs entitled *Remembrances of the Bay of Naples*.[3] This later painting by the artist creates a fantastic vision of the rocky Neapolitan coastline. The scene is set before a glowing sunset and was undoubtedly inspired by the paintings of the seventeenth-century Neapolitan painter Salvator Rosa; the picturesque figures here are not just colorful fisherfolk but *banditti* surveying the remains of a ship wrecked on the treacherous rocks. This romantic motif combined with the representation of the powerful wave make Turpin de Crissé's work an excellent embodiment of Edmund Burke's concept of the sublime in nature and art.

1. *View of the Villa to the West of Naples* in the Salon of 1819, in the Palais-Royal, Paris, and *Views in the Environs of Naples* in the Salon of 1822.

2. These are *View of Capri* and *Italian Landscape*. See Wallraf-Richartz Museum, *Vollständiges Verzeichnis der Gemäldesammlung* (Cologne, 1986), p. 86.

3. See H. Beraldi, *Les Graveurs du XIXe siècle* (Paris, 1892), vol. 12, p. 165, no. 1.

EMILE-JEAN-HORACE (CALLED HORACE) VERNET
1789–1863

Horace Vernet came from a distinguished family of artists and was actually born in the Louvre, where his father, the painter Carle Vernet, was lodging. He was talented from childhood and received his training from François-André Vincent. Vernet produced popular caricatures during the years 1811–15, and he first showed at the Salon in 1812 with a military subject. Its success earned him a commission from Jerome Bonaparte for an equestrian portrait. Despite his liberal views, Vernet was to continue to win official approval during his career—first from Louis-Philippe and then from Charles X. He went to Rome in 1820, then again in 1828, when he returned as director of the French Académie there. He remained in Rome until 1833, when, after a voyage to Algiers, he settled in Paris where his many history, military, and anecdotal works brought him great fame.

91. *Study of Olympe Pélissier as Judith*, 1830

Oil on canvas
25 5/8 × 21 3/4 in. (65.2 × 55.2 cm)
Signed, dated, and inscribed lower left: *Rome 1830 / H Vernet*
Gift of Mrs. Samuel Dennis Warren
89.157

PROVENANCE: James H. Stebbins, New York; sale American Art Association, New York, February 12, 1889, no. 66; Mrs. Samuel Dennis Warren, Boston.

EXHIBITION HISTORY: Hartford, Wadsworth Atheneum, *French Romantic Painting*, 1952; New York 1975, no. 22; Boston 1978; Kyoto 1989, no. 45.

REFERENCES: Murphy 1985, p. 291; Rome and Paris 1980, p. 80.

CONDITION: The loosely woven fabric support has been lined. The paint is fluidly applied over a white ground, which is visible at the surface. The study is in excellent condition.

Horace Vernet

Shortly after arriving in Rome as the director of the French Académie there, Vernet set about producing a traditional large-scale history painting. This was *Judith and Holofernes* (Pau, Musée des Beaux-Arts), which he exhibited at the Salon of 1831 (fig. 91a).[1] In the center of this composition, the powerful standing figure of the Old Testament heroine Judith holds a sword and turns to regard the sleeping King Holofernes, whom she will soon decapitate. In preparation for his *grand oeuvre*, Vernet did a number of preliminary oil sketches of the entire composition,[2] and this study, dated 1830, is for the figure of Judith. The model was Olympe Pélissier, a mistress of Vernet's as well as of the novelist Eugène Sue and the composer Gioachino Rossini, who married her.[3] A critic writing of the Salon work described this Judith as "elegant and tenderly passionate and sensitive,"[4] and the work also inspired a chapter of Gustave Flaubert's *Salammbo*.[5] Although painted from life, the features are nevertheless cast in a classical manner derived from Raphael. The pink flesh tones are set off by the startlingly vivid yellow background. During the late nineteenth century the work became famous in America as a prototype of a particular Italian type "in which is perpetuated the barbarically patrician pride and haughty beauty of an Italy that has long since vanished into history."[6]

1. See Rome and Paris 1980, no. 52; and Comte 1993, n.p.

2. One is in the Museum of Fine Arts, Houston (acc. no. 79.3), and another was in the Encil collection. See Comte 1977, p. 139, fig. 2; and G. Encil, *Experiences and Adventures of a Collector* (Paris, 1989), pp. 210–11.

3. See H. Weinstock, *Rossini: A Biography* (New York, 1968), p. 182.

4. Quoted in Comte 1977, p. 137.

5. Noted in Comte 1993.

6. See Stebbins sale catalogue, 1889.

Fig. 91a. Emile-Jean-Horace (called Horace) Vernet, *Judith and Holofernes*, 1831. Oil on canvas. Pau, Musée des Beaux-Arts, inv. no. 12.15.3 (Reproduced from *RdL* 27, no. 3 [1977], p. 138)

ABBREVIATIONS

CONCORDANCE

GENERAL INDEX

INDEX *of Owners, Collectors, and Dealers*

ABBREVIATIONS

BMFA
Bulletin of the Museum of Fine Arts, Boston 1–75 (1903–1977). Title varies: *Bulletin of the Museum of Fine Arts* 1–54 (March 1903–Spring 1956); *Bulletin* 54–71 (Summer 1956–73).

BSHAF
Bulletin de la société de l'histoire de l'art français

GBA
Gazette des beaux-arts

RdA
La Revue de l'art

RdL
La Revue du Louvre

TBM
The Burlington Magazine

Actes 1960
Centre national de la recherche scientifique, *Colloques internationaux. Nicolas Poussin.* 2 vols. Paris, 1960.

Addison 1910
Addison, J. W. *The Boston Museum of Fine Arts.* Boston, 1910.

Adhémar and Huyghe 1950
Adhémar, H., and R. Huyghe. *Watteau, sa vie, son oeuvre.* Paris, 1950.

Ananoff 1966
Ananoff, A. *L'Oeuvre dessiné de François Boucher (1703–1770).* Paris, 1966.

Ananoff and Wildenstein 1976
Ananoff, A., and D. Wildenstein. *François Boucher.* 2 vols. Lausanne and Paris, 1976.

Andresen 1863
Andresen, A. *Nicolas Poussin: Verzeichnis der nach seinen Gemälden gefertigten gleichzeitigen und späteren Kupferstiche.* Leipzig, 1863.

Atlanta 1983
High Museum of Art. *The Rococo Age.* Atlanta, 1983.

Bailey 1988
Bailey, C. B. *Ange-Laurent de La Live de Jully.* New York, 1988.

Baillet de Saint-Julien 1750
Baillet de Saint-Julien, G. *Lettre sur la peinture à un amateur.* Geneva, 1750.

Baillio 1989
Baillio, J. *The Winds of Revolution.* New York, 1989.

Baumstark 1974
Baumstark, R. "Ikonographische Studien zu Rubens Kriegs- und Friedensallegorien." *Aachener Kunstblätter* 45 (1974), pp. 125–234.

Bean and Turčić 1986
Bean, J., and L. Turčić. *Fifteenth–Eighteenth-Century French Drawings in the Metropolitan Museum of Art.* New York, 1986.

Bellori 1672
Bellori, G. P. *Vite de' pittori, scultori et architetti moderni.* Rome, 1672. Facs. Rome, 1935.

Bénézit 1976
Bénézit, E., ed. *Dictionnaire . . . des peintres, sculpteurs, dessinateurs et graveurs.* 10 vols. Paris, 1976.

Besnard and Wildenstein 1928
Besnard, A., and G. Wildenstein. *La Tour: La Vie et l'oeuvre de l'artiste.* Paris, 1928.

Blunt 1952
Blunt, A. "Philippe de Champaigne at the Orangerie, Paris." *TBM* 94 (June 1952), pp. 172–75.

Blunt 1966
Blunt, A. *The Paintings of Nicolas Poussin: A Critical Catalogue.* London, 1966.

Blunt 1967
Blunt, A. *Nicolas Poussin. The A. W. Mellon Lectures in the Fine Arts.* 2 vols. London and New York, 1967.

Blunt 1978
Blunt, A. "The Le Nain Exhibition." *TBM* 120, no. 909 (Dec. 1978), pp. 870–75.

Boime 1987
Boime, A. *Art in an Age of Revolution, 1750–1800.* Chicago, 1987.

Boisclair 1978
Boisclair, M.-N. "Gaspard Dughet." 2 vols. Thesis, Sorbonne, 1978.

Boisclair 1986
Boisclair, M.-N. *Gaspard Dughet, sa vie et son oeuvre (1615–1675).* Paris, 1986.

Bonfante and de Grummond 1980
Bonfante, L., and N. T. de Grummond. "Poussin e gli specchi etruschi." *Prospettiva: Rivista di storia dell'arte antica e moderna* 20 (Jan. 1980), pp. 75, 78–80, fig. 9.

Bordeaux 1980
Galerie des Beaux-Arts. *Les Arts du théâtre de Watteau à Fragonard.* Bordeaux, 1980.

Bordeaux 1989
Musée des Beaux-Arts. *La Port des lumières: La Peinture à Bordeaux, 1750–1800.* Bordeaux, 1989.

Bordes and Pougetoux 1983
Bordes, P., and A. Pougetoux. "Les Portraits de Napoléon en Habits Impériaux par Jacques-Louis David." *GBA* 102 (July–Aug. 1983), pp. 21–34.

Boston 1827
A Catalogue of the First Exhibition of Paintings in the Athenaeum Gallery Consisting of Specimens by American Artists and a Selection of the Works by the Old Masters from the Various Cabinets in This City and Its Vicinity. Boston, 1827.

Boston 1921
Museum of Fine Arts, Boston. *Catalogue of Paintings.* Boston, 1921.

Boston 1932
Museum of Fine Arts, Boston. *Selected Oil and Tempera Paintings and Three Pastels.* Boston, 1932.

Boston 1939
Museum of Fine Arts, Boston. *Art in New England.* Boston, 1939.

Boston 1955
Museum of Fine Arts, Boston. *Summary Catalogue of European Paintings.* Boston, 1955.

Boston 1970
Museum of Fine Arts, Boston. *Centennial Acquisitions: Art Treasures for Tomorrow.* Boston, 1970.

Boston 1972
Museum of Fine Arts, Boston. *The Rathbone Years: Masterpieces Acquired for the Museum of Fine Arts, Boston, 1955–1972, and for the St. Louis Art Museum, 1940–1955.* Boston, 1972.

Boston 1978
Museum of Fine Arts, Boston. *French Paintings from the Storerooms and Some Recent Acquisitions.* Boston, 1978.

Boston 1984
Museum of Fine Arts, Boston. *The Great Boston Collectors: Paintings from the Museum of Fine Arts, Boston.* Boston, 1984.

Boston 1991–92
Museum of Fine Arts, Boston. *Romantic and Fantastic Landscapes.* Boston, 1991–92.

Boston 1992–93
Museum of Fine Arts, Boston. *The Grand Tour: European and American Views of Italy.* Boston, 1992–93.

Boston 1993
Museum of Fine Arts, Boston. *Duccio to Delacroix.* Boston, 1993.

Boston 1994
Museum of Fine Arts, Boston. *Grand Illusions.* Boston, 1994.

Del Bravo 1988
Del Bravo, C. "Letture di Poussin e Claude." *Artibus et historiae* 18, IX (1988).

Brejon de Lavergnée 1973
Brejon de Lavergnée, A. "Tableaux de Poussin et d'autres artistes français dans la collection Dal Pozzo: Deux Inventaires inédits." *RdA* 19 (1973), pp. 79–97.

Brejon de Lavergnée and Mérot 1984
Brejon de Lavergnée, B., and A. Mérot. *Simon Vouet—Eustache Le Sueur, dessins du Musée de Besançon.* Besançon, 1984.

Carrier 1993
Carrier, D. *Poussin's Paintings: Historical Methodology.* University Park, Pa., 1993.

Cavallo et al. 1974
Cavallo, A. J., Perry T. Rathbone, et al. *Museum of Fine Arts, Boston: Western Art.* Boston, 1974.

Chapel Hill 1978
Ackland Memorial Art Center. *French Nineteenth-Century Oil Sketches: David to Degas.* Chapel Hill, N.C., 1978.

Chaussard 1808
Chaussard, P. J.-B. *Le Pausanias français. Etat des arts du dessin en France à la ouverture du XIXe siècle. Salon de 1806 . . .* Paris, 1808.

Chiba 1994
Sogo Museum of Art. *Still-Life Painting from the Museum of Fine Arts, Boston.* Chiba, 1994. Also traveled to Nara, Sogo Museum of Art; Yokohama, Sogo Museum of Art.

Cleveland 1989
Cleveland Museum of Art. *From Fontainebleau to the Louvre: French Drawing from the Seventeenth Century.* Cleveland, 1989.

Cologne 1987–88
Wallraf-Richartz Museum. *Triumph and Death of the Hero.* Cologne, 1987–88. Traveled to Zurich, Kunsthaus; Lyon, Musée des Beaux-Arts.

Comte 1977
Comte, P. "Judith et Holopherne." *RdL* 27, no. 3 (1977), pp. 137–39.

Comte 1993
Comte, P. *Ville du Pau, Musée des Beaux-Arts, catalogue des peintures.* Pau, 1993.

Conisbee 1985
Conisbee, P. *Chardin.* Lewisburg, Pa., 1985.

Constable 1940
Constable, W. G. "The Escaped Bird by Nicolas Lancret." *BMFA* 38 (Dec.1940), pp. 86–89.

Constable 1944
Constable, W. G. "The Early Work of Claude Lorrain." *GBA* 26 (July–Dec. 1944), pp. 305–14.

Cooper 1983
Cooper, T. "Notes on Selected French Old Master Drawings." *Record of the Art Museum, Princeton University* 42, no. 1 (1983), pp. 4–42.

Copenhagen 1935
Palais de Charlottenborg. *Exposition de l'art français au XVIIIe siècle.* Copenhagen, 1935.

Cunningham 1940
Cunningham, C.C. "A Great Poussin Goes to Boston." *Art News* 38, no. 36 (June 1940), pp. 10, 18.

Cuzin 1978
Cuzin, J.-P. "A Hypothesis Concerning the Le Nain Brothers." *TBM* 120, no. 909 (Dec. 1978), pp. 875–76.

Cuzin 1988
Cuzin, J.-P. *Jean-Honoré Fragonard: Life and Work.* New York, 1988.

Dacier and Ratouis de Limay 1927
Dacier, E., and P. Ratouis de Limay. *Pastels français de XVIIe et XVIIIe siècles.* Paris and Brussels, 1927.

Dacier and Vuaflart 1921–29
Dacier, E., and A. Vuaflart. *Jean de Julienne et les graveurs de Watteau au XVIIIe siècle.* 4 vols. Paris, 1921–29.

Davies and Blunt 1962
Davies, M., and A. Blunt. "Some Corrections and Additions to M. Wildenstein's 'Graveurs de Poussin au XVIIIe siècle.' " *GBA* 105 (1962), pp. 205–22.

Delacroix 1923
Delacroix, E. "Notice historique sur Gros." *Revue des deux mondes* (Sept. 1848). Reprinted in idem, *Oeuvres littéraires.* vol. 2. Paris, 1923.

Delestre 1867
Delestre, J. B. *Gros et ses ouvrages.* Paris, 1867.

Dempsey 1992
Dempsey, C. "Mavors Armipotens: The Poetics of Self-Representation in Poussin's *Mars and Venus.*" In *Der Künstler über sich in seinem Werk: Internationales Symposium der Bibliotheca Hertziana 1989.* Rome, 1992.

Detroit 1950
Detroit Institute of Arts. *From David to Courbet.* Detroit, 1950.

Detroit 1974–75
Detroit Institute of Arts. *French Painting, 1774–1830: The Age of Revolution.* Detroit, 1974–75. Also traveled to Paris, Grand Palais; New York, Metropolitan Museum of Art.

Dezallier d'Argeville 1791
Dezallier d'Argeville, A. *Explication et critique impartiale de toutes les peintures au mois du Septembre 1791.* Paris, 1791.

Dimier 1924–26
Dimier, L. *Histoire de la peinture de portrait en France au XVIe siècle.* 3 vols. Paris and Brussels, 1924–26.

Dorival 1958
Dorival, B. "Philippe de Champaigne et Robert Arnauld d'Andelely." *La Revue des Arts* 8 (1958), pp. 128–36.

Dorival 1976
Dorival, B. *Philippe de Champaigne (1602–1674): La Vie, l'oeuvre, et le catalogue raisonné de l'oeuvre.* 2 vols. Paris, 1976.

Downes 1888
Downes, W. H. "Boston Painters and Paintings. IV." *Atlantic Monthly* 62, no. 372 (Oct. 1888), pp. 500–10.

Dreyfus 1923
Dreyfus, P.-G. *Catalogue raisonné de l'oeuvre peint et dessiné de Nicholas-Bernard Lépicié.* Paris, 1923.

Dussieux et al. 1854
Dussieux, L. E., et al., eds. *Mémoires inédites sur la vie et les oeuvres des membres de l'Academie Royale . . .* 2 vols. Paris, 1854.

Esielonis 1993
Esielonis, K. *Still Life Painting from the Museum of Fine Arts, Boston.* Boston, 1993.

Estournet 1905
Estournet, O. *La Famille des Hallé.* Paris, 1905.

Explication des peintures, sculptures et graveurs
Explication des peintures, sculptures et graveurs. Paris, 1791.

"Exposition de 1791"
"Exposition de 1791." *Collection des livrets des anciennes expositions.* Paris, 1870.

Faré 1962
Faré, M. *La Nature morte en France.* 2 vols. Geneva, 1962.

Faré 1974
Faré, M. *Le Grand Siècle de la nature morte en France.* Fribourg and Paris, 1974.

Ferré 1972
Ferré, J. *Watteau.* 4 vols. Madrid, 1972.

Fort Worth 1982
Kimbell Art Museum. *Elisabeth Louise Vigée Le Brun, 1755–1842.* Fort Worth, 1982.

Fowle 1970
Fowle, G. E. "The Biblical Paintings of Sébastien Bourdon." 2 vols. Ph.D. diss., University of Michigan, 1970.

Fowle 1973
Fowle, G. E. "Two Pendants by Sébastien Bourdon." *BMFA* 71, no. 364 (1973), pp. 75–91.

Friedlaender 1926–27
Friedlaender, W. "Achilles auf Skyros von Nicolas Poussin." *Zeitschrift für Bildende Kunst* 36 (1926–27), pp. 141–43.

Friedlaender 1939
Friedlaender, W. *The Drawings of Nicolas Poussin.* Vol. 1. London, 1939.

Friedlaender 1940
Friedlaender, W. "America's First Poussin Show." *Art News* 38, no. 23 (March 9, 1940), pp. 11, 13, ill.

Friedlaender 1942
Friedlaender, W. "Iconographical Studies of Poussin's Works in American Public Collections." *GBA*, 22 (1942), pp. 17ff.

Friedlaender 1949
Friedlaender, W. *The Drawings of Nicolas Poussin.* Vol. 2. London, 1949.

Friedlaender 1964
Friedlaender, W. *Nicolas Poussin: A New Approach.* New York, 1964.

Friedlaender and Blunt 1953
Friedlaender, W., and A. Blunt. *The Drawings of Nicolas Poussin.* Vol. 3. London, 1953.

Furst 1911
Furst, H. *Chardin.* London, 1911.

Galassi 1991
Galassi, P. *Corot in Italy.* New Haven and London, 1991.

Girault 1994
Girault, P.-G. "Le Maître de Saint Gilles." Thesis, Université François Rabelais, Tours, 1994.

Goncourt 1876
Goncourt, E. de. *Catalogue de l'oeuvre de P.-P. Prud'hon.* Paris, 1876.

Grasselli 1985–86
Grasselli, M. M. "Eleven New Drawings by Nicolas Lancret." *Master Drawings* 23–24, no. 3 (1985–86), pp. 377–89.

Grautoff 1914
Grautoff, O. *Nicolas Poussin: Sein Werk und sein Leben.* 2 vols. Munich, 1914.

Grayson 1980
Grayson, M. L. "Fragonard's *La Bonne Mère* and the Symbolism of the Spacious Cradle." *Pharos* 17, no. 2 (1980), pp. 20–26.

de Groër 1978
de Groër, A. "Nouvelles Recherches sur Corneille: à la lumière du Portrait de Pierre Aymeric." *RdL* 1 (1978), pp. 36–41.

Guiffrey 1892
Guiffrey, M. Jean. "Les Peintres Philippe et Jean-Baptiste de Champaigne." *Nouvelles Archives de l'art français* 8 (1892), pp. 172–218.

Guiffrey 1913
Guiffrey, M. Jean. "Tableaux français conservés au musée de Boston et de quelques collections de cette ville." In Société de l'histoire et de l'art français, *Mélanges offerts à M. Henry Lemonnier.* Paris, 1913, p. 542.

Guiffrey 1923–24
Guiffrey, M. Jean. "L'Oeuvre de P.-P. Prud'hon." *Archives de l'art français* 13 (1923–24).

Gutwirth 1974
Gutwirth, S. "Jean-Victor Bertin, un paysagiste neo-classique." *GBA* per. 6, 83, no. 1263 (May–June 1974), pp. 337–40.

Gutwirth 1977
Gutwirth, S. "The Sabine Mountains: An Early Italian Landscape by Jean-Joseph-Xavier Bidauld." *Bulletin of the Detroit Institute of Art* 55, no. 3 (1977), pp. 147–52.

Hannema 1967
Hannema, D. *Beschrijvende Catalogus van de Schilderijen . . . de verzameling van de Stichting Hannema-De Stuers Fundatie.* Rotterdam, 1967.

Harrisse 1898
Harrisse, H. *L. L. Boilly.* Paris, 1898.

Hartford 1956
Wadsworth Atheneum. *Homage to Mozart: A Loan Exhibition of European Painting, 1750-1800, Honoring the 200th Anniversary of Mozart's Birth.* Hartford, 1956.

Hartford 1976–77
Wadsworth Atheneum. *Jean-Baptiste Greuze.* Hartford, 1976–77. Traveled to San Francisco, California, Palace of the Legion of Honor; Dijon, Musée des Beaux-Arts.

Haskell and Rinehart 1960
Haskell, F., and S. Rinehart. "The Dal Pozzo Collection: Some New Evidence." *TBM* 102, no. 688 (July 1960), pp. 318–26.

Hawes 1925
Hawes, C. H. "Portrait by the Maître de Moulins." *BMFA* 23 (Aug. 1925), 1925, p. 41.

Hazlitt 1844
Hazlitt, W. "On the Catalogue Raisonné of the British Institution." 1816. Reprinted in *Criticisms on Art.* London, 1844.

Heck 1997
Heck, M.-C. *Sébastien Stoskopf 1592–1697.* Strasbourg, 1997.

Helm 1915
Helm, W. H. *Vigée-LeBrun: Her Life, Works, and Friendships.* London, 1915.

Hendy 1927
Hendy, P. "Philippe de Champaigne." *Apollo* 5 (April 1927), pp. 166–72.

Henriot 1928
Henriot, G. *Collection David-Weill.* 3 vols. Paris, 1928.

Inscriptions 1785
Inscriptions pour mettre au bas de différents tableaux exposes au Sallon du Louvre en 1785. London and Paris, 1785.

Jean-Richard 1978
Jean-Richard, P. *L'Oeuvre gravé de François Boucher*. Paris, 1978.

Johnston 1967
Johnston, W. "Napoleon: The Cult of the Emperor." *Bulletin of the Walters Art Gallery* 19, no. 8 (May 1967), n.p.

Junecke 1960
Junecke, H. *Montmorency . . .* Berlin, 1960.

Kitson 1978
Kitson, M. *Claude Lorraine Liber Veritatis*. London, 1978.

Kyoto 1989
Municipal Art Museum, Kyoto. *From Neoclassicism to Impressionism: French Art from the Boston Museum of Fine Arts*. Kyoto, 1989. Traveled to Hokkaido, Museum of Modern Arts; Yokohama, Sogo Museum of Art.

Langdon 1989
Langdon, H. *Claude Lorrain*. Oxford, 1989.

Larrey 1803
Larrey, D. J. *Relation historique et chirurgical de l'expédition de l'armée d'Orient, en Egypt et en Syrie*. Paris, 1803.

Laveissière 1982
Laveissière, S. "Pierre Nichon Identified." *TBM* 124, no. 956 (Nov. 1982), p. 704.

Lee 1980
Lee, T. P. "Recently Acquired French Paintings: Reflections on the Past." *Apollo* 111, no. 217 (March 1980), pp. 212–21.

Lesné 1988
Lesné, C. "Jean-Baptiste Santerre (1651–1717)." *BSHAF* (1988), pp. 75–118.

Léveque 1988
Léveque, J.-J. *La Vie et l'oeuvre de Nicolas Poussin*. Paris, 1988.

Lewis 1989
Lewis, M. T. *Cézanne's Early Imagery*. Berkeley, 1989.

Lomax 1983
Lomax, D. "The Early Career of Noël Hallé." *Apollo* 117 (Feb. 1983), pp. 106–109.

London 1932
Royal Academy, London. *Exhibition of French Art, 1200–1900*. London, 1932.

London 1968
Royal Academy of Arts, London. *France in the Eighteenth Century*. London, 1968.

London 1984
Royal Academy, London. *The Orientalists: Delacroix to Matisse*. London, 1984. Traveled to Washington, D.C., National Gallery of Art.

London 1994
National Gallery, London. *Claude: The Poetic Landscape*. London, 1994.

Lundberg 1959
Lundberg, G. "Les Morceaux de reception de Wertmüller." *Archives de l'art français*. New ser. (Paris, 1959), pp. 208–15.

Macchia and Montagni 1968
Macchia, G., and E. C. Montagni. *L'Opera completa di Watteau*. Milan, 1968.

McLanathan 1947
McLanathan, R. B. K. "Achilles on Skyros." *BMFA* 45 (Feb. 1947), pp. 2–11, figs. 1, 2, 7.

Memoirs 1989
Vigée Le Brun, Elisabeth Louise. *The Memoirs of Elisabeth Vigée Le Brun*. Trans. Siân Evans. Bloomington, Ind., 1989.

Memphis 1987–88
The Dixon Galleries and Gardens, Memphis, Tenn. *From Arcadia to Barbizon*. Memphis, 1987–88. Traveled to Oberlin, Ohio, Allen Memorial Art Museum; Louisville, Ky., J. B. Speed Art Museum.

Mérot 1987
Mérot, A. *Eustache La Sueur, 1616–1655*. Paris, 1987.

Mérot 1990
Mérot, A. *Poussin*. Paris, 1990.

Michel 1906
Michel, A. *François Boucher*. Paris, 1906.

Mollaret and Brossollet 1968
Mollaret, H., and J. Brossollet. "A propos des *Pestiférés de Jaffa* de A. J. Gros." *Jaarboek van het Koninklijk Museum voor Schone Kunsten van Belge*. Antwerp, 1968. pp. 263–307.

Mongan 1963
Mongan, A. "Forsyth Wickes, Newport, Rhode Island: Porcelain, the French Eighteenth Century." In *Great Private Collections*, D. Cooper, ed. New York, 1963.

Montaiglon 1889
Montaiglon, A. de. *Procès-verbaux de l'Académie royale*. Paris, 1889.

Montreal 1981
Museum of Fine Arts, Montreal. *Largillière and the Eighteenth-Century Portrait*. Montreal, 1981.

Montreal 1993
Museum of Fine Arts, Montreal. *Century of Splendor: Seventeenth-Century French Painting in French Public Collections*. Montreal, 1993.

Munger et al. 1992
Munger, J., et al. *The Forsyth Wickes Collection in the Museum of Fine Arts*. Boston, 1992.

Murphy 1985
Murphy, A. R. *European Paintings in the Museum of Fine Arts, Boston*. Boston, 1985.

Neale 1994
J. Neale, "The Mystery of the Missing Fragonards." *The South End Historical Society Newsletter* 23, no. 1 (Winter 1994), pp. 2–5.

Newcastle upon Tyne 1969
Laing Gallery. *The Art of Claude Lorrain*. Newcastle upon Tyne, 1969.

New Haven 1956
Yale University Art Gallery. *Pictures Collected by Yale Alumni*. New Haven, 1956.

New York 1935–36
Metropolitan Museum of Art, New York. *French Painting and Sculpture in the Eighteenth Century*. New York, 1935–36.

New York 1946
Wildenstein, New York. *A Loan Exhibition of French Painting of the Time of Louis XIII and Louis XIV*. New York, 1946.

New York 1968–69
Wildenstein, New York. *Gods and Heroes: Baroque Images of Antiquity*. New York, 1968–69.

New York 1970
Metropolitan Museum of Art, New York. *100 Paintings from the Boston Museum*. New York, 1970.

New York 1975
Shepherd Gallery, New York. *Ingres and Delacroix through Degas and Puvis de Chavannes: The Figure in French Art, 1800–1870*. New York, 1975.

New York 1985–86
Stair Sainty Matthiesen, New York. *The First Painters of the King: French Royal Taste from Louis XIV to the Revolution*. New York, 1985–86. Also traveled to New Orleans Museum of Art; Columbus Museum of Art.

New York 1986
Metropolitan Museum of Art, New York. *François Boucher*. New York, 1986.

New York 1990
Colnaghi, New York. *Claude to Corot*. New York, 1990.

New York 1991
The Frick Collection, New York. *Nicolas Lancret, 1690–1743.* New York, 1991.

New York and London 1975
Richard Feigen and Co., New York, and Herner Wengraf Ltd., London. *Gaspard Dughet, Rome, 1615–1675.* New York and London, 1975.

Nikolenko 1967
Nikolenko, L. "The Russian Portraits of Madame Vigée-LeBrun." *GBA* 70 (July–Aug. 1967), pp. 91–120.

O'Brien 1995
O'Brien, D. "Antoine-Jean Gros in Italy." *TBM* 137, no. 1111 (Oct. 1995), pp. 651–60.

Paris 1927
Hôtel Jean Charpentier, Paris. *Retrospective Georges Michel, 1763–1843.* Paris, 1927.

Paris 1937
Palais national des arts, Paris. *Chefs-d'oeuvre de l'art français.* Paris, 1937.

Paris 1952
Orangerie des Tuileries, Paris. *Philippe de Champaigne.* Paris, 1952.

Paris 1978
Grand Palais, Paris. *Les Frères Le Nain.* Paris, 1978.

Paris 1979
Grand Palais, Paris. *Chardin.* Paris, 1979. Traveled to Cleveland Museum of Art; Museum of Fine Arts, Boston.

Paris 1982
Grand Palais, Paris. *France in the Golden Age: Seventeenth-Century French Paintings in American Collections.* Paris, 1982. Traveled to New York, Metropolitan Museum of Art; Art Institute of Chicago.

Paris 1984
Musée Marmottan, Paris. *Louis Boilly, 1761–1845.* Paris, 1984.

Paris 1987
Musée du Luxembourg, Paris. *Pierre Subleyras.* Paris, 1987. Also traveled to Rome, Villa Medici.

Paris 1987–88
Grand Palais, Paris. *Fragonard.* Paris, 1987–88. Traveled to New York, Metropolitan Museum of Art.

Paris 1989
Musée du Louvre, Paris. *Jacques-Louis David.* Paris, 1989.

Paris 1994
Musée du Louvre, Paris. *Autour de Poussin.* Paris, 1994.

Paris 1994–95
Grand Palais, Paris. *Nicolas Poussin 1594–1665.* Paris, 1994–95. Traveled to London, Royal Academy.

Parker and Mathey 1957
Parker, K. T., and J. Mathey. *Antoine Watteau: Catalogue complet de son oeuvre dessiné.* Paris, 1957.

Pattison 1884
Pattison, Mrs. M. (Emilia Francis Strong Dilke). *Claude Lorrain, sa vie et ses oeuvres, d'après des documents inédits.* Paris, 1884.

Pittsburgh 1951
Carnegie Institute, Pittsburgh. *French Painting, 1100–1900.* Pittsburgh, 1951.

Porterfield 1991
Porterfield, T. B. "Art in the Service of French Imperialism in the Near East, 1798–1848: Four Case Studies." Ph.D. diss., Boston University, 1991.

Posner 1984
Posner, D. *Antoine Watteau.* London, 1984.

Providence 1975
Rhode Island School of Design, Museum of Art, Providence. *Rubenism.* Providence, 1975.

Randall 1961
Randall, Jr., R. H. "German . . . ébénistes in Paris." *BMFA* 59, no. 316 (1961), pp. 32–39.

Rathbone 1968a
Rathbone, P. T. *The Forsyth Wickes Collection.* Boston, 1968.

Rathbone 1968b
Rathbone, P. T. "Paintings and Drawings in the Forsyth Wickes Collection." *Antiques* 94, no. 5 (Nov. 1968), pp. 736–43.

Réau 1926
Réau, L. *L'Art français aux Etats-Unis.* Paris, 1926.

Redford 1888
Redford, G. *Art Sales.* 2 vols. London, 1888.

Réflexions impartiales 1785
Réflexions impartiales sur le progrès de l'art en France et sur les tableaux exposés au Louvre, par ordre du Roi en 1785. London and Paris, 1785.

Ring 1949
Ring, G. *A Century of French Painting.* London, 1949.

Roethlisberger 1961
Roethlisberger, M. *Claude Lorrain. The Paintings: Critical Catalogue.* 2 vols. New Haven, 1961.

Roethlisberger 1968
Roethlisberger, M. *Claude Lorrain, The Drawings.* 2 vols. Berkeley and Los Angeles, 1968.

Roethlisberger 1975
Roethlisberger, M. *L'opera completa di Claude Lorrain.* Milan, 1975.

Roethlisberger 1986
Roethlisberger, M. "Claude Lorrain: Nouveaux Dessins, tableaux et lettres." *BSHAF* (1986), pp. 49–51.

Roland Michel 1984
Roland Michel, M. *Watteau, an Artist of the Eighteenth Century.* London, 1984.

Roland Michel 1994
Roland Michel, M. *Chardin.* Paris, 1994.

Rome and Paris 1980
Académie de France à Rome, and Ecole nationale supérieure des beaux-arts, Paris. *Horace Vernet (1789–1863).* Rome, 1980.

Rosenberg 1972
Rosenberg, P. *French Master Drawings of the Seventeenth and Eighteenth Centuries in North American Collections.* London, 1972.

Rosenberg 1979
Rosenberg, P. "L'Exposition Le Nain: Une Proposition." *RdA* 43 (1979), pp. 91–100.

Rosenberg 1983
Rosenberg, P. *Tout l'oeuvre peint de Chardin.* Paris, 1983.

Rosenberg 1984
Rosenberg, P. "*France in the Golden Age:* A Postscript." *Metropolitan Museum of Art Journal* 17 (1984), pp. 23–45.

Rosenberg 1989
Rosenberg, P. *Fragonard, tout l'oeuvre peint.* Paris, 1989.

Rosenberg 1993
Rosenberg, P. *Tout l'oeuvre peint des Le Nain.* Paris, 1993.

Rosenberg and Prat 1994
Rosenberg, P., and L.-A. Prat. *Nicolas Poussin, 1594–1665: Catalogue raisonné des dessins.* 2 vols. Milan, 1994.

Rosenberg, Prat, and Damian 1994
Rosenberg, P., L.-A. Prat, and V. Damian. *Nicolas Poussin: La Collection du Musée Condé à Chantilly.* Paris, 1994.

Rosenberg and Stewart 1987
Rosenberg, P., and M. Stewart. *French Paintings, 1500–1825.* San Francisco, 1987.

Rotterdam 1992
Boymans-Van Beuningen Museum. *French Paintings from Dutch Collections, 1600–1800.* Rotterdam, 1992. Also traveled to Dijon, Musée des Beaux-Arts; Paris, Institut néerlandais.

Roux 1940
Roux, M. *Paris Bibliothèque nationale: Inventaire du fonds français, graveurs du XVIIIe siècle.* 14 vols. Paris, 1940.

St. Petersburg 1982–83
Museum of Fine Arts. *Fragonard and His Friends: Changing Ideals in Eighteenth-Century Art.* St. Petersburg, Fla., 1982–83. Also traveled to Little Rock, Arkansas Art Center.

Sapin 1978
Sapin, M. "Contribution à l'étude de quelques oeuvres d'Eustache Le Sueur." *RdL* 28, no. 4 (1978), pp. 242–54.

Sapin 1984
Sapin, M. "Précisions sur l'histoire de quelques tableaux d'Eustache Le Sueur." *BSHAF* 1984 (1986), pp. 53–83.

Schlenoff 1965
Schlenoff, N. "Baron Gros and Napoleon's Egyptian Campaign." In *Essays in Honor of Walter J. Friedlaender.* Walter Kahn et al., eds. New York, 1965.

Schnapper 1968
Schnapper, A. "A propos de deux nouvelles acquisitions: 'Le Chef d'oeuvre d'un muet' ou la tentative de Charles Coypel." *RdL* 4–5 (1968), pp. 253–64.

Scott 1973
Scott, B. "La Live de Jully." *Apollo* 97, no. 131 (Jan. 1973), pp. 72–77.

Sensier 1873
Sensier, A. *Etude sur Georges Michel.* Paris, 1873.

Seznec and Adhémar 1967
Seznec, J., and J. Adhémar. *Diderot Salons.* 4 vols. Oxford, 1967.

Slatkin 1979
Slatkin, R. S., "The New Boucher Catalogue (Alexandre Ananoff)." *TBM* 121, no. 911 (Feb. 1979), pp. 117–23.

Smith 1837
Smith, J. A. *A Catalogue Raisonné of the Works of the Most Eminent Dutch, Flemish, and French Painters.* Vol. 8. London, 1837.

Standen 1981
Standen, E. A. "Tapestries in the Collection of the Museum of Art, Carnegie Institute." *Carnegie Magazine* 60, no. 10 (Dec. 1981), pp. 2–19.

Standen 1994
Standen, E. A. "Country Children: Some *Enfants de Boucher* in Gobelins Tapestry." *Metropolitan Museum Journal* 29 (1994), pp. 111–33.

Standring 1988
Standring, T. J. "Some Pictures by Poussin in the Dal Pozzo Collection: Three New Inventories." *TBM* 130, no. 1025 (Aug. 1988), pp. 611–13.

Stebbins and Sutton 1986
Stebbins, Jr., T. E., and P. C. Sutton. *Masterpiece Paintings from the Museum of Fine Arts, Boston.* Boston, 1986.

Sterling 1990
Sterling, C. *La Peinture médiévale à Paris, 1300–1500.* Vol. 2. Paris, 1990.

Sutherland Harris 1990
Sutherland Harris, A. Review of Konrad Oberhuber, *Poussin: The Early Years in Rome. Art Bulletin* 72, no. 1 (March 1990), p. 151.

Sutton 1995
Sutton, P. C. *The William Appleton Coolidge Collection.* Boston, 1995.

Takashina and Goto 1977
Takashina, S., and I. Goto. *Poussin.* Tokyo, 1977.

Thieme and Becker
Thieme, U., and F. Becker, eds. *Allgemines Lexikon der bildenden Kunstler.* 37 vols. Leipzig, 1907–50.

Thuillier 1974
Thuillier, J. *L'Opera completa di Poussin.* 2 vols. Milan, 1974.

Thuillier 1979
Thuillier, J. "Le Nain: Leçons d'une exposition." *RdL* 29, no. 2 (1979), pp. 158–66.

Thuillier 1994
Thuillier, J. *Nicolas Poussin.* Paris, 1994.

Tokyo 1978
National Museum of Western Art, Tokyo. *Boston Museum Exhibition: Human Figures in Fine Arts.* Tokyo, 1978. Traveled to Kyoto National Museum; Nagoya City Museum.

Tokyo 1980
National Museum of Western Art, Tokyo. *Fragonard.* Tokyo, 1980. Traveled to Kyoto Municipal Museum.

Tokyo 1982
Metropolitan Art Museum, Tokyo. *François Boucher.* Tokyo, 1982. Traveled to Kumamoto Prefectural Museum of Art.

Tokyo 1983
Isetan Museum of Fine Arts, Tokyo. *Masterpieces of European Painting from the Museum of Fine Arts, Boston.* Tokyo, 1983. Traveled to Fukuoka Art Museum; Kyoto Muncipal Museum of Art.

Tokyo 1990
Odakyu Grand Gallery, Tokyo. *Three Masters of French Rococo: Boucher, Fragonard, Lancret.* Tokyo, 1990. Traveled to Umeda-Osaka, Daimaru Museum; Hokkaido, Hakodate Museum of Art; Yokohama, Sogo Museum of Art.

Tokyo 1992
Bunkamura Museum of Art, Tokyo. *Monet and His Contemporaries from the Museum of Fine Arts, Boston.* Tokyo, 1992.

Tripier le Franc 1880
Tripier le Franc, J. *Histoire de la vie et de la mort du Baron Gros.* Paris, 1880.

Tscherny and Stair Sainty 1996
Tscherny, N., and G. Stair Sainty, *Romance and Chivalry: History Reflected in Early Nineteenth-Century French Painting.* London and New York, 1996.

Tsuji and Takashina 1984
Tsuji, K., and S. Takashina. *Les Grands Maîtres de la Peinture.* Vol. 14. *Poussin.* Tokyo, 1984.

Vaillat and Ratouis de Limay 1923
Vaillat, L., and P. Ratouis de Limay. *J.-B. Perronneau: Sa vie et son oeuvre.* Paris and Brussels, 1923.

Vermeule 1964
Vermeule, C. *European Art and the Classical Past.* Cambridge, Mass., 1964.

Vermeule 1976
Vermeule, C. "Classical Archaeology and French Painting in the Seventeenth Century." *BMFA* 74 (1976), pp. 94–109.

Waagen 1854
Waagen, G. F. *Treasures of Art in Great Britain,* Vol. 2. London, 1854.

Waagen 1857
Waagen, G. F. *Galleries and Cabinets of Art in Great Britain.* London, 1857.

Washington 1973
National Gallery of Art, Washington, D.C. *François Boucher in North American Collections: One Hundred Drawings.* Washington, D.C., 1973. Traveled to the Art Institute of Chicago.

Washington 1976
National Gallery of Art, Washington, D.C. *The Eye of Thomas Jefferson.* Washington, D.C., 1976.

Washington 1982
National Gallery of Art, Washington, D.C. *Claude Lorraine*. Washington, D.C., 1982.

Washington 1984–85
National Gallery of Art, Washington, D.C. *Watteau, 1684–1721*. Washington, D.C. 1984–85. Traveled to Paris, Grand Palais; Berlin, Schloss Charlottenburg.

Watson 1966
Watson, F. J. B. *The Wrightsman Collection*. 5 vols. New York, 1966.

Watson 1969
Watson, F. J. B. "The Forsyth Wickes Collection at the Boston Museum of Fine Arts." *TBM* 111, no. 793 (April 1969), pp. 216–19.

Watteau 1987
Antoine Watteau (1684–1721): The Painter, His Age, and His Legend. Ed. F. Moureau and M. Morgan Grasselli. Paris and Geneva, 1987.

Wells-Robertson 1978
Wells-Robertson, S. "Marguerite Gérard, 1761–1837." Ph.D. diss., Institute of Fine Arts, New York University, 1978.

Whitehill 1959
Whitehill, W. M. *Boston: A Topographical History*. Cambridge, Mass., 1959.

Whitehill 1970
Whitehill, W. M. *Museum of Fine Arts, Boston: A Centennial History*. 2 vols. Cambridge, Mass., 1970.

Whittingham 1985
Whittingham, S. "What You Will, or Some Notes Regarding the Influence of Watteau on Turner and Other British Artists." *Turner Studies* 5, no. 1 (Summer 1985), pp. 2–20.

Wild 1980
Wild, D. *Nicolas Poussin: Katalog der Werke*. 2 vols. Zurich, 1980.

Wildenstein 1924
Wildenstein, G. *Lancret*. Paris, 1924.

Wildenstein 1933
Wildenstein, G. *Chardin*. Paris, 1933.

Wildenstein 1957
Wildenstein, G. *Les Graveurs de Poussin au XVIIe siècle*. Paris, 1957.

Wildenstein 1960
Wildenstein, G. *The Paintings of Fragonard*. London, 1960.

Wildenstein 1963
Wildenstein, G. *Chardin*. Zurich, 1963.

Wildenstein 1982
Wildenstein, D. "Les Tableaux italiens dans les catalogues de ventes parisiennes du XVIIIe siècle." *GBA* 100 (July–Aug. 1982), pp. 1–48.

Wildenstein and Mandel 1972
Wildenstein, D., and G. Mandel. *L'opera completa di Fragonard*. Milan, 1972.

Wilenski 1949
Wilenski, R. H. *French Painting*. New York, 1949.

Willk-Brocard 1995
Willk-Brocard, N. *Une Dynastie Les Hallé*. Paris, 1995.

Wine 1994
Wine, H., in National Gallery, *Claude: The Poetic Landscape*. London, 1994.

Wright 1984
Wright, C. *Poussin Paintings: A Catalogue Raisonné*. New York, 1984.

Wright 1985
Wright, C. *The French Painters of the Seventeenth Century*. Boston, 1985.

Wrigley 1993
Wrigley, R. *The Origins of French Art Criticism*. Oxford, 1993.

Yokohama 1995
Sogo Museum of Art. *The Real World: Nineteenth-Century European Paintings from the Museum of Fine Arts, Boston*. Yokohama, 1995. Traveled to Chiba, Sogo Museum of Art; Nara, Sogo Museum of Art.

CONCORDANCE

Accession Number	Catalogue Number	Accession Number	Catalogue Number
71.2	42	65.2650	66
71.3	43	65.2651	45
77.151	85	65.2652	50
80.512	35	65.2653	61
83.177	36	65.2654	72
89.157	91	65.2657	48
06.119	16	65.2658	46
06.2420	82	65.2660	68
12.1050	11	65.2661	44
1325.12	81	65.2662	57
13.391	76	65.2663	65
17.3256	73	65.2664	47
19.764	7	65.2665	51
Res20.852	89	65.2668	3
21.137	6	68.23	19
Res22.298	80	68.24	18
22.611	12	68.764	20
23.573	30	1975.808	54
24.264	5	1978.123	49
24.342	83	1978.225	13
25.48	1	1979.555	23
26.789	74	1980.3	90
27.449	84	1980.658	70
28.821	4	1981.79	69
37.1211	29	1981.278	64
40.89	8	1981.283	27
40.478	32	1981.721	88
43.130	75	1981.722	62
44.39	87	1982.140	53
44.72	10	1982.640	77
44.777	58	1983.10	78
46.463	9	1983.592	38
47.245	26	1983.593	39
47.1059	86	1993.35	15
47.1252	25		
48.16	21		
48.526	37		
49.1145	55		
50.188	28		
52.393	17		
58.1197	14		
61.958	41		
63.1082	71		
63.1628	24		
65.2636	67		
65.2637	40		
65.2639	60		
65.2640	56		
65.2641	63		
65.2642	2		
65.2643	52		
65.2644	59		
65.2645	79		
65.2646	22		
65.2647	33		
65.2648	34		
65.2649	31		

GENERAL INDEX

Numbers in **boldface** type refer to page numbers of catalogue entries; numbers in *italics* refer to pages with illustrations.

Rouart, Henri, 16, 171
Rudinoff collection, 19

Saint, Daniel, 82
Saint collection, 18, 86nn6,17
Saint-Aignan, duc de, 99, 101
Saint-Georges, abbé de, 62, 64
Saint-Julien, baron de, 135
Salle de Fêtes (Deauville), 192n16
Salomon, (Mrs.) William, 105
Salomon, William, 105
Sandor, 47
Sassoon, (Mrs.) Meyer, 158
Schaeffer Gallery (New York), 84, 86n4
Schickman Gallery. *See* H. Schickman Gallery (New York)
Schmidt, Jean M., 188
Seilern collection, 86
Seligmann, André J., 71
Seligmann, Rey, and Co. *See* Arnold Seligmann, Rey, and Co.
Seligmann and Co. *See* Jacques Seligmann and Co.
Seligmann collection, 141n1
Sevin, 87
Shaw, James Byam, 19, 61
Sheffield, Berkeley, 47
Shummin (?), Charles F., 112n33
Signol collection, 96
Sigourney, Margaret Barker, 12
Sloane, Alexander, 49
Sloane, Robert, 49
Smith, D. Campbell, 55
Smith collection, 49
Somerville and Simpson (London), 24, 144
Sotheby Parke-Bernet (New York), 178n2. *See also* Parke-Bernet (New York)

Sotheby's
 London, 52, 73n2, 101, 141, 158, 175, 178n1, 198n3
 Monte Carlo, 76, 117, 151n5, 193n50
 New York, 90n3, 91, 140, 165n8
Sourches, marquis de, 76
Spark, Victor, 73, 176
Spaulding, John T., 23, 98
Spitzer, F., 136
Stamboi, F., 61
Stanley's (London), 49
Stebbins, James H., 13, 199
Stein, Guy. *See* Galerie Guy Stein (Paris)
Sterling (Mr.), 21
Stern collection, 105n5
Stiebel, Eric, 20
Stransky, Josef, 19
Strong, (Mrs.) Richard P., 19
Sturgis, John H., 178
Sumner, Charles, 12

Tessin, comte de, 87
Thomas, Washington B., 78
Thomas Agnew and Sons (London), 78, 82
Thompson, (Mrs.) Peter S., 128
Thomson collection, 12
Tournon, comte de, 132
Trévise, 1st duc de, 191, 193n39
Trévise, 5th duc de, 20, 21, 188, 191, 193nn39,41
Tronchin collection, 76
Trotti et Cie. (Paris), 49, 181
Turene collection, 36

Veil-Picard, Arthur, 132
Veil-Picard collection, 138
Vigna, 135

Volpe, Germaro, 181
Vose, Robert C., 18, 23
Vose, Seth Morton, 168
Vose Galleries (Boston), 23, 81, 168, 181

Wallace (lady), 82
Wallace, Richard, 82
Ward, Thomas Humphrey, 49
Ward-Jackson, Adrian. *See* Adrian Ward-Jackson Ltd. (London)
Warneck, Edouard, 32, 33
Warren, (Mrs.) Samuel Dennis Sr., 12–13, 199
Warren, Samuel Dennis Sr., 12
Waters, 49
Weil, André, 19–20, 90
Weitzner, Julius H., 20–21, 188, 193n39
White Fund, 178
Wickes, Forsyth, 24, 25, 32, 33, 71, 87, 92, 93, 105, 113, 117, 123, 125, 127, 132, 135, 138, 140, 141, 144, 146, 149, 151, 160, 176
Wildenstein, Felix, 22, 23
Wildenstein, Georges, 92, 146
Wildenstein and Co., 14, 19, 24
 London, 141
 New York, 33, 35, 43, 54, 62, 87, 92, 93, 98, 105, 113, 132, 138, 146, 176
 Paris and New York, 43, 123, 141
Wolcott, E. O., 178
Wolcott, William E., 178
Woodburn (London), 47
Worontzoff-Dachkoff collection, 165n10
Worontzoff estate, 164
Wright, Thomas, 47

Yarborough (lord), 23